Rubens Kristin Lohse Belkin

P9-BBV-140

ART&IDEAS

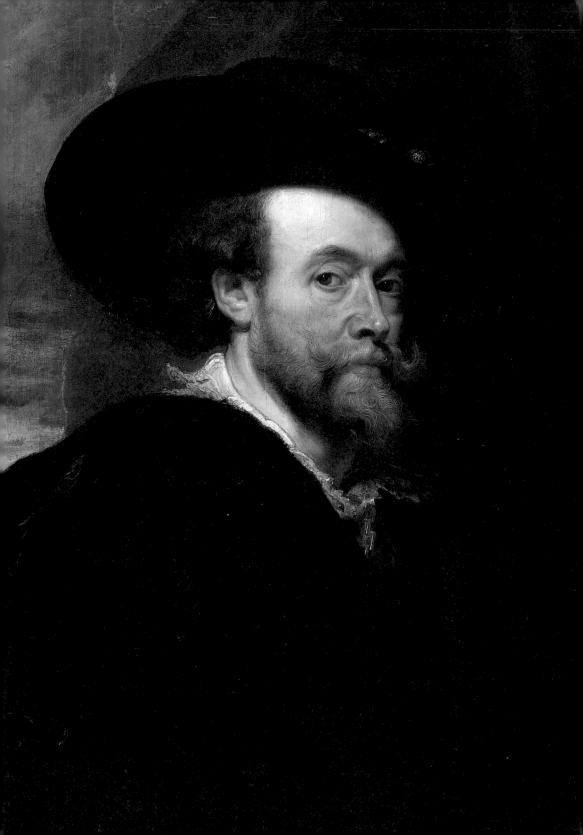

Rubens

Opposite
Self-Portrait
(detail of 148),
*c.*1623–4.
Oil on panel;
86×62·5 cm,
33⅞×24⅝ in.
Royal
Collection,
Windsor
Castle

Introduction

Peter Paul Rubens (1577–1640) was one of the most outstanding
figures of the seventeenth century. Primarily an artist, he was also
a man of learning, an enthusiastic collector of art and antiquities,
and an active diplomat on the international political stage. As his
extensive correspondence shows, Rubens was deeply involved in
the events and preoccupations of his time. He travelled widely
and, remarkable for an artist of any period, was on intimate terms
with many of the kings, princes and rulers of the major European
countries. When he died, he was rich and famous, the master of
a successful workshop, *seigneur* of a country manor, knighted by
two monarchs. Yet Rubens had not been born into a wealthy
family, and his early years were overshadowed by the political
storms of the time and his parents' misfortunes. His life story,
therefore, charts the success of a self-made man.

Rubens designed and executed, or oversaw the execution of, over
three thousand paintings, engravings and woodcuts. His enormous
productivity was matched by his impressive versatility: he created
vast decorative programmes, large altarpieces and other religious
paintings, as well as portraits, landscapes, allegories, mythologies
and paintings with historical subjects. He produced designs for
title-pages and book illustrations; and for printmakers, sculptors,
architects, silversmiths and tapestry weavers – there seemed to be
nothing at which he did not excel. In addition to his artistic talent
and ambition, Rubens' worldly success was due to many other
factors, not least his ability to recognize an opportune moment,
and to apply his skills fully to the task in hand. The artist's contem-
poraries frequently commented on his intellectual curiosity and
self discipline, and his charm and pleasing personality.

Rubens, it seems, was liked as well as admired. Even the eminent
French scholar and antiquarian Nicolas-Claude Fabri de Peiresc –

a man whose solemn and somewhat pedantic disposition might be thought to discourage hyperbole – exclaimed, 'I hold there is no more lovable soul in the world than Mr Rubens'. The geniality of Rubens' character is further confirmed by the testimony of Joachim von Sandrart (1606–88), a young painter from Germany, who accompanied his famous colleague on a tour of Holland in 1627. He described Rubens as 'quick and industrious in his work, courteous and friendly to everyone, well received and popular wherever he went', though not without adding that the great man was careful about money.

As a child and adolescent, Rubens had experienced financial hardship, and all his life he believed in hard work which, combined with his exceptional talents, secured him a fortune. He seems to have suffered no creative crises and few professional setbacks. His renowned powers of concentration were vividly described by the German Otto Sperling, physician to the Danish court, who visited Rubens' studio in 1621 and wrote (perhaps with some exaggeration) that he found

the great artist at work. While still painting, he was having Tacitus read aloud to him and at the same time dictating a letter. When we kept silent so as not to disturb him with our talk, he himself began to talk to us while still continuing to work, to listen to the reading and to dictate his letter, answering our questions and thus displaying his astonishing powers.

Such images of Rubens reflect his public persona. There are hundreds of letters and other documents by or addressed to him, but, with few exceptions, they are of an official or impersonal nature. Early biographies are hardly more revealing. They stress his role as the learned artist – the *pictor doctus* – who ennobled his status and his craft, but they do not present a man of flesh and blood. Was Rubens really the paragon his biographers make him out to be? Joachim von Sandrart claimed that he was careful about money, and Otto Sperling evidently thought he exploited the labours of his studio assistants for disproportionate personal gain (see Chapter 4). Was his easy familiarity with kings and

rulers of the day untainted by flattery and sycophancy? And what is one to make of the reports of jealousy and envy among some of Antwerp's artists, or of the possible motivation that led Rubens' most talented engraver, Lucas Vorsterman (1596–1675), to make an attempt on his life?

One of the aims of this book is to go beyond the public image, beyond the legends, rumours and exaggerations to understand Rubens in all his humanity. It does so by beginning with his art. For whatever the inadequacies of the surviving written sources, Rubens' art reveals its own version of the man and artist.

Another aim is to interpret some of those aspects of Rubens' subject matter that modern viewers often find difficult or abstruse. While his landscapes, portraits and some of his more straightforward religious and mythological paintings speak to us directly, other works cannot be fully understood without placing them in their intellectual and social context. Drawn from the Bible, especially its apocryphal writings, the lives of the saints and the teachings of the Roman Catholic Church of the Counter Reformation, and from the literature and history of ancient Greece and Rome, many of Rubens' subjects are not familiar to modern viewers. Concentrating on a few key works of religious, classical and allegorical content, this book elucidates their meaning by looking at their textual and visual sources, the circumstances behind their commissioning, and their original setting and function.

1
Venus at the Mirror, 1613–14. Oil on panel; 124×98 cm, 48⅞×38⅝ in. Sammlungen des Fürsten von Liechtenstein, Vaduz

A third aim throughout is to show Rubens' working methods and studio practices, and to examine the relationship between the personal element in his art and the production undertaken by his busy studio. Behind its vast output lay the intellectual discipline, imagination and vitality of a remarkable mind, as well as the meticulous draughtsmanship and rigorous attention to detail of a superb craftsman.

The full range of Rubens' work is covered by this book. With such a prodigious output, the choice of illustrations was difficult.

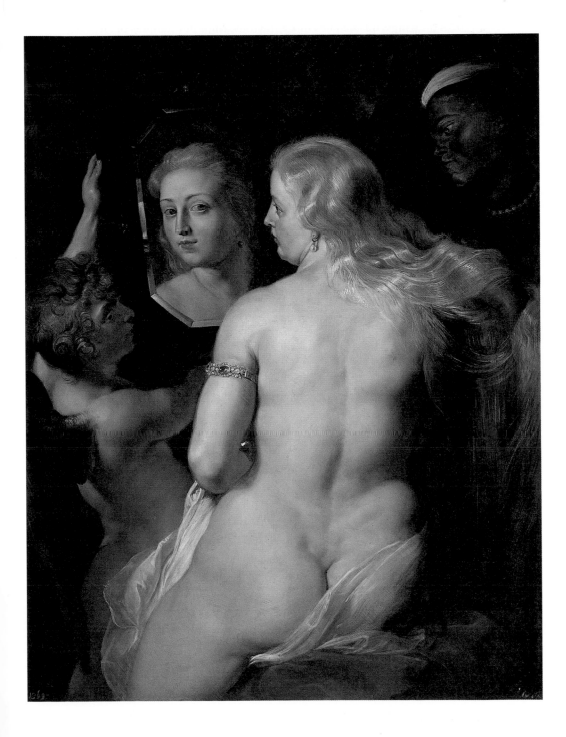

There is, overall, a slightly stronger emphasis here on secular themes than on religious works, and on finished paintings rather than drawings, oil sketches or engravings, though examples of all are included. The freshness and directness of Rubens' drawings and oil sketches make them particularly appealing to a modern audience, though they were not the works by which his own contemporaries judged him. Indeed, except for a few patrons and collectors, they were rarely seen outside the studio.

Two themes receive special attention: Rubens' relationship with and representation of women, and his preoccupation with peace, as diplomat and painter. In an artist best known today for his sensual treatment of female flesh (1) a link between two such subjects seems surprising. Yet in his late paintings, these two themes come together in his vision of women as bearers of peace in an age of violent European political turmoil. Even in Rubens' religious paintings, women often express the emotional content of the narrative. In scenes from the life of Christ, women are given roles as bystanders, often with children, and there is a predominance of female saints. But to understand just how his vision of women links different aspects of his work at different times, it is necessary to turn to the secular subjects and allegories of his last decade.

Finally, and perhaps most importantly, this book explores Rubens' rich visual vocabulary and the wide range of meaning he conveyed in painting. Based on his study of classical art, the Italian Renaissance, his own native Flemish tradition and, as always, on nature, Rubens created a pictorial language that, on the one hand, presents the culmination of older forms and concepts and, on the other, influenced not only countless contemporaries but also successive generations of artists.

Breaking and Making A Young Artist in Turbulent Times

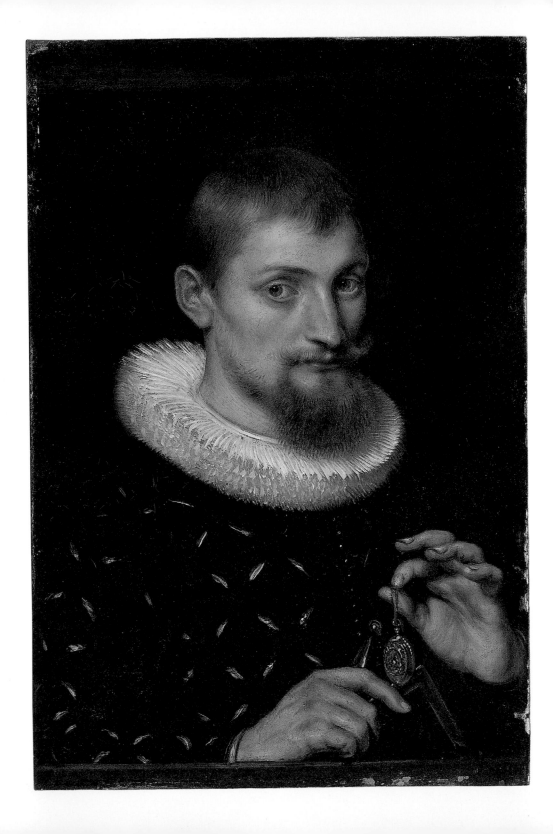

Peter Paul Rubens was born on 28 June 1577 in Siegen, Germany
(3), the sixth child of Jan Rubens and his wife, Maria Pypelincks,
who had moved there from nearby Cologne. Jan and Maria Rubens
originally came from Antwerp, in the Netherlands, which they
had fled in 1568 to escape religious persecution. In 1578, when
Peter Paul was barely a year old, the family returned to Cologne,
where Jan Rubens died in 1587. Two years later his widow, with
three of their children, moved back to her home town of Antwerp.
These are the bare facts. Behind them, however, lies the story of
a family uprooted by the political and religious turmoil of the
time, whose life in exile was fraught with further difficulties
through the actions of Rubens' father.

In the mid-sixteenth century Antwerp was the busiest port in
Europe, a commercial and banking centre for international trade
in a world that was rapidly expanding through European voyages
of exploration and conquest. The city was also known for its
printing houses – in other words, as a centre for the dissemina-
tion of ideas and information. Among the largest of these was the
Plantin Press, for which Rubens was later to produce designs.

Rubens' parents came from old Antwerp families; on his father's
side the line can be traced to the end of the fourteenth century.
His grandfather, Bartholomeus Rubens, was an apothecary who
had acquired considerable wealth (4, 5), and his father was a
distinguished lawyer who had been educated at the universities
of Padua and Rome, the foremost places of learning in sixteenth-
century Europe. Jan Rubens' career had had a promising start,
including his appointment in Antwerp to the office of alderman.
In religion, he was a Calvinist – a follower of the French religious
reformer John Calvin – and it was this that had led to his accusa-
tion in 1568 on a charge of heresy. The gravity of this charge,

2
*Portrait of
a Man,*
1597.
Rubens' first
signed and
dated work.
Oil on copper;
21·6×14·6cm,
8½×5¾in.
Metropolitan
Museum of
Art, New York

which, if proved, could spell ruin and even death, needs to be understood in the context of the political and religious conflicts taking place in the Netherlands in the sixteenth century. This turbulent and violent situation, which sent the Rubens family into exile for some two decades, will also be seen to have a bearing, directly and indirectly, on the later career of Peter Paul, not least in his lifelong pursuit of an ideal of harmony and peace.

In the sixteenth century, the Netherlands or Low Countries (present-day Holland, Belgium and Luxembourg) were part of the vast territories of the Habsburg dynasty, by whom they had been acquired on the marriage in 1477 of Mary of Burgundy and the Habsburg Archduke Maximilian of Austria. It was their grandson, Charles V, who in 1520 succeeded to the title of Holy Roman

3
Frans Hogenberg, *View of Siegen*, 1572. Engraving; 17.5×46 cm, 6⅞×18⅛ in

4–5
Jacob Claesz. van Utrecht, Portraits of *Bartholomeus Rubens*, *Grandfather of Peter Paul Rubens* and *Barbara Arents*, *Grandmother of Peter Paul Rubens*, 1530. Oil on panel; 57×38 cm, 22⅜×15 in. Rubenshuis, Antwerp

Emperor (by this date also part of the Habsburg birthright) as ruler not only of the Netherlands and the Austrian dominions, but also of Spain – a fact which was to carry enormous consequences for the Netherlands.

Charles V had been born and educated in Ghent (now in Belgium). His childhood had instilled in him a degree of sympathy and understanding for his Netherlandish subjects, including a recognition of their traditional forms of political organization, in which, under Burgundian rule, each province had to some extent had its own separate government. In 1555, however, Charles abdicated and retired to a monastery, dividing his cumbersome feudal empire between the Eastern (Austrian) dominions, ruled by his brother Ferdinand, and the Western dominions, which included

the Netherlands, ruled from Madrid by his son, Philip II, King of Spain (r. 1556–98). Unlike his father, Philip had been brought up in Spain and neither liked nor understood the Netherlands.

The imposition of unsympathetic authoritarian rule from Spain is not enough, however, to explain why Jan Rubens and thousands of his compatriots were effectively forced to flee for their lives. Philip II was a deeply devout Catholic, and, as elsewhere in sixteenth-century Europe, political control in the Netherlands was closely linked to the question of religion, to the struggle between the Catholic Church and the movement now known as the Protestant Reformation.

 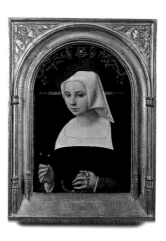

The Reformation had started in Germany as a protest or reform movement against abuses within the Catholic Church and had quickly turned into an open attack on the authority of the Church combined with a new statement of the Christian faith. Led by the dynamic German reformer Martin Luther, the Protestant movement, with its emphasis on a personal faith informed by reading of the Bible, rather than mediated by the priesthood, was widely accepted in Germany and beyond.

One of the greatest theologians of the Reformation was John Calvin, a Frenchman who worked in Geneva in Switzerland. Calvin took Luther's doctrines to their extremes. For example, where Luther tolerated the religious use of images, Calvin prohibited

them, viewing ornaments and pictures as idolatrous interventions between man and God. Moreover, they were symbols of the Catholic Church, with its belief – in Calvinist eyes corrupt – that works of art could inspire and help the worshipper. While Lutheranism remained the dominant Protestant faith in Germany, Calvinism gained a stronghold in the Netherlands, a development that was to have important consequences for art and artists.

Philip II was determined to stamp out both Protestant heresy and the stirrings of political independence in the Netherlands, which played an important role in the economy of the Spanish empire. He deprived the States General (a central assembly of deputies from the various provinces) of legislative and administrative power, and important political positions for which only natives had previously been eligible were now filled by Spaniards. Religious heretics – known Calvinist sympathizers – were vigorously persecuted. Hundreds of people, among them prominent citizens of Jan Rubens' own class, were sentenced to death and thousands were banished and had their properties confiscated.

The severity of Philip's religious policy and the presence of Spanish troops in the Netherlands eventually led to open protest and rebellion. Taking advantage of the general unrest, Calvinist preachers held well-attended public meetings, criticizing the official church and demanding Protestant places of worship. The situation erupted in August 1566, when an iconoclastic movement swept through the country and thousands of works of art were destroyed or looted from churches and monasteries (6). This destruction was motivated not only by Calvinist theology but also – more importantly – by the political identification of Spain with Catholicism.

Philip retaliated by sending a Spanish army under Fernando Alvarez de Toledo, Duke of Alva, who, as Governor-General and Regent of the Netherlands between 1567 and 1573, instituted a reign of terror. In the northern provinces, however, resistance to Spanish domination continued to stiffen. Here William, Count of Nassau and Prince of Orange (better known by his sobriquet

William the Silent), raised an army and, despite early setbacks, succeeded within four years to liberate the provinces of Holland and Zeeland. Thereafter, the predominantly Protestant northern provinces became increasingly separate from the Catholic, Spanish-dominated south, marking the emergence of a politically independent Dutch Republic.

Meanwhile, despite Alva's failure to crush resistance and his dismissal in 1573, the southern provinces fared less well. The citizens of Antwerp rose against their oppressors and for a time joined with the north in the fight against Spain. In November 1576, however, the Spanish army, demoralized by defeat in the

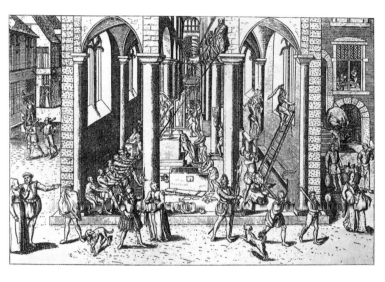

6
Frans Hogenberg, *The Iconoclasm*, c.1570. Etching

north and lack of pay, grew uncontrollable and Antwerp was ferociously sacked by mutineering troops in the notorious 'Spanish Fury'. Under the command of Alessandro, Prince of Parma, who was appointed Governor of the Netherlands in 1578, Spanish forces recovered control of the southern provinces as Calvinist enclaves fell one by one, culminating in 1585 in the capitulation of Antwerp after a long siege. From this point onwards, the political separation of the Southern and Northern Netherlands was sealed; while the North became an independent republic, the Southern Netherlands were to remain under Spanish rule for the next 130 years.

On fleeing Antwerp in 1568, the Rubens family sought exile in
Germany. Jan and Maria Rubens and their children first settled in
Cologne, which, despite being a Catholic city, showed tolerance
towards Protestant emigrées from the Netherlands. Here Jan
became secretary and legal adviser to Anne of Saxony, wife of
William of Orange, who had left her alone in the city while he
raised reinforcements in Germany for his battle against Spain.
In 1570 Anne moved to Siegen, then part of the territory belong-
ing to the House of Nassau, where Jan Rubens continued his
services. These services, however, clearly encompassed more
than legal advice, and it soon became apparent that Anne of
Saxony and Jan Rubens were lovers. When the affair was discov-
ered, Anne was divorced by her husband and Jan imprisoned in
the Nassau ancestral castle at Dillenburg.

The penalty in Germany for adultery between a bourgeois and
a princess was death, and Jan Rubens would have been executed
had it not been for his wife, who pleaded on his behalf. Letters
from Maria Rubens to her husband in prison testify to her loving
and generous spirit:

How could I be so hard as to burden you who are in such great distress:
where there has been such a long friendship as ours, how could there
now be so much hatred as to make me unable to forgive a little fault
against me ... I pray to God for you; our children do the same, and
send many greetings and are very anxious to see you, as I am ... Please
do not say again 'unworthy husband', for all is forgiven.

It is largely due to Maria's personal intervention with the House of
Nassau that Jan Rubens was released and eventually pardoned. But
the offence had been severe, and life did not immediately return
to normal; Jan was required to remain in Siegen, virtually under
house arrest, with no chance of work or other sources of financial
support. Again it was Maria Rubens who rescued the family: she
engaged in small-scale trading of meat and vegetables and took in
lodgers. Two more children were born – Philip in 1574 and Peter
Paul in 1577 – and, after a final pardon granted to Jan Rubens in
1578, the family was allowed to move back to Cologne.

Here Jan Rubens returned to the practice of law and the family rented a respectable house – the same house, coincidentally, where Rubens' most eminent patroness, Marie de' Medici, was to die in exile in 1642. Cologne, in fact, was traditionally cited as Rubens' own birthplace, since, although Peter Paul and his older brother Philip were only infants when they left Siegen, both seemed to wish to dissociate themselves from a place that was so strongly linked to family shame and hardship. Philip later claimed that he was born in Cologne, and Peter Paul himself, towards the end of his life, was to write with gratitude on 25 July 1637 of his 'great affection for the city of Cologne where I was brought up for the first ten years of my life'. It was not until the mid-nineteenth century that the discovery of documents and letters relating to Jan Rubens' imprisonment firmly established the family's presence in Siegen.

According to Rubens' first biographer – his nephew Philip – Rubens attended school in Cologne where, due to his 'fortunate disposition', he surpassed all fellow pupils. No other evidence for his early schooldays is known, but Rubens and his brother Philip, to whom he remained deeply attached until the latter's death in 1611, were undoubtedly instructed at home by their highly educated father. They would have studied grammar and rhetoric, as well as Latin (and some Greek) literature. Jan Rubens' teaching may not have been as structured as a school curriculum, but it was probably he who implanted in the boys a lasting love of learning and laid the foundation for their future studies. Rubens remained steeped in the classical tradition throughout his life, and Philip became a well-known classical scholar. Rubens may also have had some rudimentary instruction in art from his oldest brother, Jan-Baptist, who is documented in Cologne as a painter.

Jan Rubens died in March 1587. Shortly before his death he and his wife had officially returned to the Catholic faith, which became the religion of their children. The conversion was probably the result of expediency rather than of true conviction, since the magistrate of Cologne had repeatedly threatened to expel

practising Protestants from the city. To the dying man, anxious
about the future of his family, an official adherence to the Catholic
faith may have seemed a small price to pay for their safety. As a
Catholic, Jan Rubens was buried in St Peter's, the church for
which his son, half a century later, painted one of his greatest
altarpieces, *The Crucifixion of St Peter* (see 196). Since Rubens is
often seen as a Catholic artist *par excellence*, it is perhaps impor-
tant to recall the conflicts and expediencies that were associated
with his early experience of religion, and his upbringing as a
Protestant until at least the age of ten.

In the spring of 1589, two years after her husband's death, Maria
Rubens, with her children Blandina, Philip and Peter Paul, moved
from Cologne back to Antwerp (7), her home town. By that time,
the situation in the Netherlands had stabilized with the division
of north and south. Spain was still determined to reconquer its
rebellious northern provinces, and the war was ongoing, though
fighting was mostly restricted to the frontier.

7
Abel
Grimmer and
Hendrik van
Balen,
*View of
Antwerp with
the River
Scheldt,*
*c.*1600.
Oil on panel;
37×44 cm,
14^12×17^14 in.
Koninklijk
Museum voor
Schone
Kunsten,
Antwerp

The newly independent Dutch Republic was already very powerful, especially at sea, and was a strong economic force. The Southern Netherlands, meanwhile, accepted the sovereignty of the King of Spain, represented in the person of his appointed governor. The role of the governor was crucial: to choose a tyrant like Alva would risk rekindling anti-Spanish feeling, but a sympathetic governor could effectively nurture loyalty for Spain. In the event, the Archduke Albert (r.1596–1621) and Archduchess Isabella (r.1596–1633), who governed the Southern Netherlands during most of Rubens' lifetime, proved to be enlightened and conscientious rulers.

In 1589, however, Antwerp was still deeply affected by the recent horrors of the war. Moreover, despite the more peaceful situation that prevailed in the late 1580s, the blockade of the River Scheldt by the Dutch, who controlled the sea, had closed Antwerp's harbour to ships and was strangling the economy of this once prosperous trading city. Looting soldiers had left the surrounding countryside a waste of abandoned farms and ruined villages. But the religious persecutions, which had sent the Rubens family into exile, had stopped now that the country was again firmly in Spanish hands.

Gradually a revival began. The Spanish government made Antwerp the centre of provisioning for its armies in the Southern Netherlands, and the Dutch began to let ships pass up the Scheldt on payment of a toll, thus allowing limited overseas trade. Meanwhile, the Catholic Church, which was rebounding from the Protestant assaults in a movement known as the Counter Reformation (see chapters 2 and 4), encouraged a campaign of restoration and new building of churches which had been plundered or destroyed during the iconoclastic riots.

Thus Rubens passed his adolescence in a city that was slowly recovering from its wounds, though it was never to be what it once was. His mother's financial situation must also have improved, since she was able to take a house on the Meir, the main street in the centre of town. Rubens continued his

education, first at the school of Rombout Verdonck, a scholar of some reputation. There he met Balthasar Moretus, three years his junior, who was to remain a lifelong friend. Later, in a letter of 3 November 1600 to Rubens' brother Philip, Moretus described how at school he had 'loved this young man who had the kindest and most perfect character'. Moretus was the grandson of Christopher Plantin, founder of one of the foremost publishing houses in Europe, for which Rubens later designed title pages.

The type of school Rubens attended was to set him apart from many other painters of the time. Although by the sixteenth century most artists received some kind of primary education, including reading and writing in the vernacular, Verdonck's school was a Latin or Grammar school. Such schools were generally attended by upper-class boys until the age of sixteen, in preparation for a career in the church, government or as a scholar. Maria Rubens, despite some financial difficulties, was well aware of her and her late husband's relatively high social position, and it seems that she had no notion of desiring a career as an artist for either of her younger sons. Painting was (and continued to be throughout Rubens' own lifetime) considered a manual profession, and apprentice painters came above all from families of painters and artisans working in the allied crafts. Although Rubens' oldest brother, Jan-Baptist, was a painter, there were apparently no artists among his ancestors.

While it is true that in the sixteenth century painting began to offer a socially and economically respectable alternative for the sons of upper-class families that had come down in the world, Maria Rubens clearly had other careers in mind for her two sons when she sent them to the school of Rombout Verdonck. Its syllabus included a thorough study of Latin, with some Greek, and such classical texts as Virgil's *Aeneid*, *Eclogues* and *Georgics*. The boys probably also read works by Livy, Seneca, Tacitus, Horace, Cicero and Pliny, the standard reading material for the time. This early academic training provided the foundation for Rubens' later

studies. In adult life, he read widely in Latin and was able to write the language fluently to his scholarly correspondents.

During the Middle Ages, Latin had been the international language of law, diplomacy, trade and the Church. This last had been an early target for Protestant reformers, who pointed to the way in which the use of Latin, especially the corrupt Latin of poorly trained priests, made formal religion incomprehensible to most people. By Rubens' day, Latin was being superseded by the vernacular in many areas (aided by the spread of the printed word), but it remained in particular the language of scholarly discourse.

Rubens' schooldays did not last long. In 1590 his sister, Blandina, was married and the family were strained to provide her with a suitable dowry. As a result Philip and Peter Paul, now aged sixteen and thirteen, set out to earn their own living. Later, Maria Rubens was to note in her will: 'From the time of my daughter's marriage my sons lived at their own cost.' In Rubens' time it was quite usual for children of the middle classes (*ie* of tradesmen, merchants, craftsmen and artisans) to attend school for only a few years before being apprenticed to a master in whose workshop they acquired their professional training. The average age of a novice apprentice varied according to the profession, but for artists it was between twelve and fourteen years.

After leaving school, Philip was employed first as secretary in the office of Jean Richardot, President of the Privy Council of the Southern Netherlands, and shortly after as tutor to his two sons. This meant that he accompanied them to the University of Louvain where he was able to continue his own studies. He became one of the best pupils of the famous scholar and Latinist Justus Lipsius, editor of the works of the Roman philosopher Seneca, who taught a Christianized Stoicism as a guide to moral conduct. The influence of Neo-Stoic philosophy, with its emphasis on constancy and equanimity as spiritual weapons against the current political troubles, and the intellectual circle it attracted can be seen in the later careers of both the Rubens brothers (see chapters 3 and 4).

Rubens, meanwhile, did not take so well to his first appointment. His mother procured for him a position as a page in the household of the Countess de Ligne-Arenberg, widow of Philip, Count of Lalaing, at Oudenarde (now a suburb of Brussels). For the academically and artistically gifted boy, this may not have been a fortunate choice, but Maria Rubens possibly had aspirations to make her son a courtier. This was a customary route by which an accomplished young man of good family but limited means might make his way in the world, and, already at this early age, Rubens undoubtedly showed signs of those qualities which later distinguished him as a diplomat.

Rubens did not stay long at Oudenarde, however. Painting proved a stronger calling, and in 1591, at the age of fourteen, he was apprenticed to a minor local landscape painter, Tobias Verhaeght (1561–1631). The choice of Verhaeght as teacher is rather surprising; it may have been determined by financial considerations (Verhaeght was a distant relative), and possibly also by a reluctance on Maria Rubens' part to give in to her son's choice of profession.

In the last decade of the sixteenth century, Antwerp had a flourishing artistic community. Although the period is not characterized by a particular, distinctive style or by the work of a single major artist, such as Pieter Bruegel the Elder (c.1525–69) in the previous generation or Rubens in the next, there were a number of artists of considerably greater stature than Verhaeght. Foremost among the city's history painters (ie those specializing in narrative scenes taken from literary sources, including the Bible) was Marten de Vos (1531/2–1603). Today this artist is mainly known within Belgium and to historians of sixteenth-century Flemish art, but, as a visit to Antwerp's churches and museums will show, De Vos was an accomplished master ably suited to respond to the great demand for altarpieces for the city's recently depleted churches. His manner derived from Frans Floris (1519/20–70), the leading figure painter in mid-sixteenth-century Antwerp. Like Floris, he had travelled to Italy, where he may have worked in the studio of Tintoretto (1518–94) in Venice. His style is characterized by

8
Jacob Jordaens, *The Artist with the Van Noort Family*, c.1615–16. Oil on canvas; 130.5×159 cm, 51⅛×62⅝ in. Staatliche Gemäldegalerie, Kassel

9
Adam van Noort, *John the Baptist Preaching*, 1601. Oil on panel; 97×155 cm, 38⅛×61 in. Rubenshuis, Antwerp

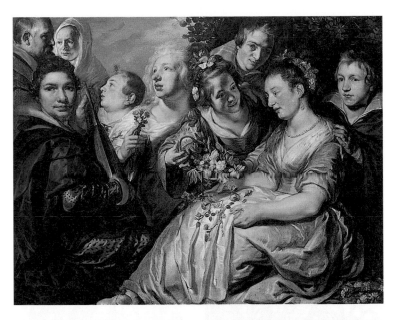

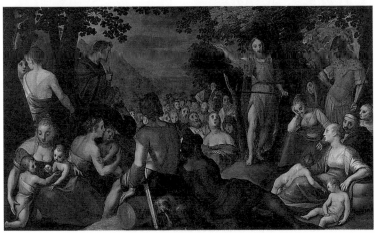

the monumental forms of the Italian Renaissance grafted on to a native tradition which emphasizes precision of draughtsmanship and meticulous attention to detail, while his experience of Venetian painting made him aware of the possibilities of colour.

Among landscape painters, the most prominent in Antwerp at this time was the prolific Joos de Momper (1564–1634/5), who ran a busy and successful workshop. The artistic awareness of landscape had been particularly marked in Flemish painting from an early date. In the fifteenth century it formed an important background element, while in the sixteenth it developed into a subject in its own right.

Rubens remained with the landscapist Verhaeght no longer than a year before moving on to his second teacher, Adam van Noort (1561–1641), whose studio he probably entered at the end of 1592, when he was fifteen. Van Noort is now hardly better known than Tobias Verhaeght, but in his day he had a reputation for being a popular master who attracted many pupils. Later he became the teacher, and father-in-law, of another famous Antwerp painter, Jacob Jordaens (1593–1678; 8). More significantly, unlike Verhaeght, Van Noort was a figure painter. The term applies to painters of scenes with human figures, including history painting, allegories (in which the figures personify abstract entities such

as Time or Love) and portraiture. Although he is listed in the Antwerp register of painters as a portraitist, no portrait by him has come to light, and his few surviving works are biblical or allegorical scenes, painted in a competent if dry and uninspired manner (9). Nevertheless, something of what Rubens learnt from Van Noort may be reflected in his first known inscribed and dated picture. Painted in 1597, at least two years after Rubens left Van Noort's studio, this is a highly accomplished small portrait of a man (see 2), identifiable from the square and dividers in his right hand as an architect or geographer.

In composition and iconography the portrait follows fifteenth- and early sixteenth-century Flemish traditions which were later abandoned. The sitter is placed behind a ledge, with his left hand he holds up a watch-case, a popular *vanitas* motif reminding the viewer of the brevity of life and the relative unimportance of worldly affairs. Both the reddish flesh colour and the strong modelling of the face and hands foreshadow future achievements. In later years, Rubens was a reluctant portraitist, but this picture proves that he could have made his career in this branch of painting if he had so chosen.

It was probably during his apprenticeship with Van Noort, at around the age of fifteen, that Rubens produced what are now his earliest firmly attributed works. They consist of a group of drawings after woodcuts of *The Dance of Death* (10), by the sixteenth-century German artist Hans Holbein the Younger (1497/8–1543). Even in these youthful exercises we can detect the seeds of the exuberance and energy that were to become the hallmark of his later style. In the drawing of *The Empress and Death* (11), he transformed the woodcut's linear design into an image of plasticity and depth. With a few strokes of the pen to costume and jewellery, he changed the somewhat sober figure of the empress into one of gaiety and youthfulness. And in the more pronounced modelling of her breasts we find a suggestion of the ample female form that came to be popularly associated with Rubens' name. If the purpose of copying was to help the aspiring artist to develop

10
Hans Holbein the Younger, *The Empress and Death.* Woodcut from *The Dance of Death,* 1537

11
The Empress and Death. Copy after Hans Holbein the Younger, *c.*1592–4. Pen and ink and wash, 10.3×7.4 cm, 4×2⅞ in. Private collection

'a free hand', as Albrecht Dürer (1471–1528) had advised, then Rubens was on his way.

In 1594 or 1595 Rubens turned to his third and most distinguished teacher, Otto van Veen (1556–1629), with whom he studied until he became a free master in 1598. Van Veen (12) was one of the most admired painters in Antwerp, and the only one whose influence can be clearly traced in his pupil's early works. A native of Leiden in the Northern Netherlands, he had moved to Antwerp at an early age with his family, who remained loyal to the Catholic

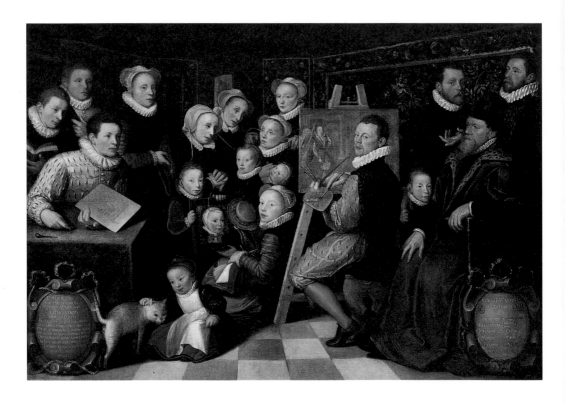

Church and their Spanish sovereign (in this context, it is interesting to note that emigration between the Southern and Northern Netherlands occurred in both directions). When Antwerp for a short period became a Protestant city, the family moved further south to Liège, where Van Veen was apprenticed to the artist and scholar Domenicus Lampsonius (1532–99). From 1575 to 1580, he was in Rome where he studied under Federico Zuccaro (c.1540–1609), one of the most successful artists of the time.

On his return to the Spanish Netherlands, Van Veen entered
the service of the governor Alessandro Farnese at his court in
Brussels. From 1589/90 until his death he lived in Antwerp,
after having been awarded the privilege of court painter *in absentia*,
which allowed him to work away from the court but, at the
same time, freed him from Antwerp's taxes and guild regulations
(a privilege later accorded to Rubens).

Van Veen was a man of considerable intellectual calibre. He was
a member of Antwerp's 'Romanists', a group of Flemish artists
who had studied in Italy and whose work was imbued with the

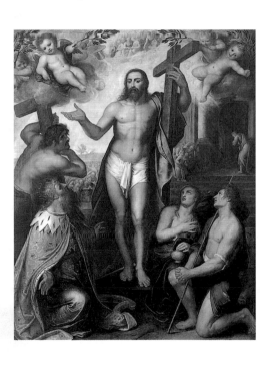

12
Otto van Veen,
*The Artist and
his Family*,
1584.
Oil on canvas;
176×250 cm,
69¼×98⅜ in.
Musée du
Louvre, Paris

13
Otto van Veen,
*Christ and the
Penitent Sinners*,
1605–7.
Oil on panel;
269×214 cm,
106×84¼ in.
Hessisches
Landesmuseum,
Mainz

Humanist learning of the Renaissance, a tradition founded on the
reading of Greek and Roman literature that balanced the Christian
world-view with a more secular, human-centred emphasis.
Following the Humanist fashion, Van Veen latinized his name as
Octavius Vaenius. For Rubens, the choice of Van Veen as a teacher
was a wise one: he was undoubtedly attracted to his intellectual
side – his interest in ancient art and literature, his knowledge
of the Italian Renaissance, his cosmopolitan outlook – precisely
those qualities which Rubens himself was to develop so strongly.

When Rubens entered Van Veen's studio he was seventeen or eighteen years old, an accomplished, highly intelligent and ambitious young man with four or five years of apprenticeship behind him. It seems likely that the relationship between teacher and pupil was one of friendship rather than of servitude, although if Rubens went beyond merely assisting his master and created original works at this time, these early works (with the exception of the 1597 portrait and a series of bust portraits of Roman emperors mainly recorded in replicas) have yet to be firmly identified.

In 1598 Rubens finished his training and became a master himself; he was now able to work independently and take on his own commissions. In the two years before 1600, when he left for Italy, he probably painted a fair number of pictures. His mother's will makes it clear that he left paintings in her house when he set off; these she described as 'the property of Peter Paul who has painted them', and the impression given is that they were rather numerous. Considering Rubens' prodigious output in later years, too, it is surprising how few works can confidently be ascribed to this early period. It may be that Rubens was a slow developer artistically, as has sometimes been claimed, or that his works have yet to be recognized among the many anonymous paintings of the time still lingering in museum storage rooms. Even later in his career, Rubens rarely signed his paintings, and without any other documentation, art historians are left with trying to establish a body of work based on stylistic criteria alone. This is made the more problematic, since the earliest paintings attributed to Rubens reflect quite closely those of his teacher Van Veen.

In Italy Van Veen had come under the influence of his own teacher, Federico Zuccaro, whose contorted forms and crowded designs in the dominant Mannerist style he imitated. After his return to Antwerp, he gradually abandoned Mannerist complexities and ambiguities for clear and rational, if somewhat lifeless, compositions. In *Christ and the Penitent Sinners* (13) Christ is depicted surrounded by King David, the Thief who repented on the cross, Mary Magdalen and the Prodigal Son (in other

paintings of this subject, this place is often given to St Peter). The figure of Christ is compactly modelled, and the four sinners are clearly arranged around this central image. Each relates to Christ and to each other in a convincing manner, though the whole composition lacks animation and energy. This picture dates from 1605–7, but it represents the style Van Veen began to evolve around the time Rubens entered his studio, and it is one the younger artist came to adopt. It may seem difficult, indeed impossible, to reconcile the exuberant, energetic forms and glowing colours of Rubens' mature work with Van Veen's dry manner, but even in his earliest attributed works there are differences which allow us to distinguish pupil from teacher and, at the same time, give us a glimpse of what was soon to follow.

One of the paintings now commonly attributed to Rubens is *Adam and Eve* (14). The composition is based on an engraving (15) by Marcantonio Raimondi (*c.*1480–1534) which in turn reproduces a design by Raphael (1483–1520). Although Rubens had yet to experience the art of the Italian Renaissance at first hand, he would have been familiar with it from engravings, such as Raimondi's after Raphael, that circulated throughout Europe. Here, the fact that Rubens did not invent his own composition but went back to an earlier design can be related to a process that became fundamental to his art (see Chapter 2).

If Rubens' figures are compared with those in Van Veen's *Christ and the Penitent Sinners* (see 13), the same artificiality and marble-like smoothness is evident – quite surprising in an artist who was to become the ultimate depictor of human flesh. This is especially pronounced in the figure of Eve, who gives the appearance of a statue. Rubens probably had only limited experience of the female nude (professional women models were rare at the time) so that, for the depiction of the female form, he was even more dependent on earlier images, usually classical statues. Although there were no examples of these in Antwerp at this time, Van Veen had probably brought back drawings of statues he had seen in Italy, which his pupil may have consulted.

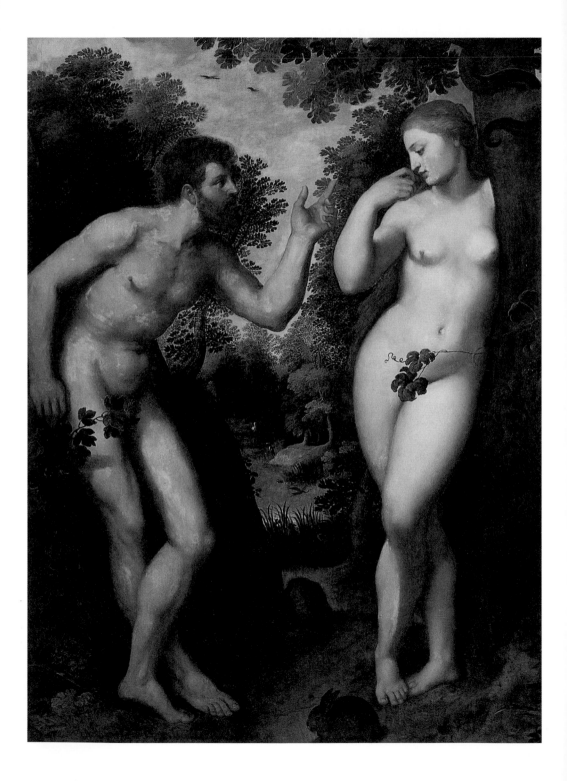

14
Adam and Eve,
c.1598–1600.
Oil on panel;
180·3×158·8 cm,
71×62½ in.
Rubenshuis,
Antwerp

15
**Marcantonio
Raimondi
after Raphael**,
Adam and Eve,
c.1512–14.
Engraving

In contrast to Eve, the figure of Adam deviates more strongly from Van Veen's Christ in its more pronounced musculature. As such it anticipates Rubens' later depictions of men more convincingly than Eve does those of women. His direct personal knowledge of the male body may have encouraged Rubens to follow his own inclinations, rather than the formulae established by older masters. In his later career, too, no matter how highly he valued earlier works of art, in the end his model was always the living human being. Yet although Rubens was to become a supreme master in giving life to his forms, this magic handling of paint evolved slowly, through a long process of studying, copying and assimilating the works of others. This process had its beginnings in the workshops of Rubens' Antwerp teachers, and even the obscure Verhaeght may have left his mark. The landscape background in *Adam and Eve*, filled with trees, grassy slopes, water, birds and animals, is of a kind developed by Netherlandish artists in the late sixteenth century. While some scholars believe that this element may in fact be the work of a different artist (perhaps the result of a collaboration with Van Veen), it may equally represent Rubens' debt to his first teacher, a landscape painter.

If Van Veen the painter was soon to be overshadowed by his more accomplished pupil, Van Veen the scholar had a more profound and lasting influence. His classical knowledge, coupled with his general intellectual disposition, led him to occupy himself with allegories and symbols, and he spent much time designing and writing emblem books. An emblem is made up of three parts: picture, motto and explanatory text, usually of moral content. Emblem books originated in Italy in the sixteenth century, but their importance for art history derives largely from their widespread use in the Netherlands in the seventeenth century. Taking the Latin writers Horace and Seneca as his source, Van Veen collected relevant passages which he illustrated with appropriate allegorical scenes. His emblem books, the *Emblemata Horatiana* ('Emblems of Quintus Horatius Flaccus') of 1607, the *Amores Emblemata* ('Cherubs' or 'Putti') of 1608, and the *Divini Amoris Emblemata* ('Divine Love') of 1615 are the perfect testimony to

the combination of moral concerns and erudition that character-
ized his work. Some of his emblems deal with the denunciation of
war and the benefits of peace, sentiments which were to become
the leitmotif of Rubens' life, and of which he was to create some
of his most powerful images (see Chapter 9).

Although Rubens never concerned himself specifically with
emblems, Van Veen's example arguably influenced his approach
to pictorial invention, especially regarding themes from Greek
and Roman mythology and history, and allegories, which often
made use of the figures of pagan gods. Throughout his life,
Rubens was in the habit of going back whenever possible to the
classical sources, which he read in the original Latin and Greek.
This was by no means common, since few artists shared his
education. The best-known literary texts, Ovid's *Metamorphoses*
and Virgil's *Aeneid*, and the narrative accounts by the ancient
historians Valerius Maximus, Plutarch, Pliny and Livy, were
almost all available in modern translations, although these were
often inaccurate and sometimes censored. There were also conve-
niently edited handbooks especially designed for artists, which
offered condensed versions of the most commonly accepted
themes. By contrast, Rubens' first-hand knowledge of classical
texts constitutes one of the most important elements in the
formation of his pictorial language; it enabled him to search for
new subjects and to give a fresh reading of established ones.

Rubens' knowledge of classical texts, no matter how vital to his
pictorial interpretation, did not make him a painter. More impor-
tant to his development as an artist was the familiarity with visual
source material that he acquired by making copies. Part of artistic
training since the Middle Ages, copying from the works of other
masters was customary practice in artists' studios, including those
of Adam van Noort and Otto van Veen. The role of copying was
twofold: it served as a learning tool and as a means of collecting a
repertoire of approved forms, so building up a visual art refer-
ence library. In the typical Renaissance workshop, copying gener-
ally fulfilled only the first role. In addition to the technical aspects

of painting, apprentices also learned the skills of representation: drawing, composition and style. Of these, the exercise of drawing (16), which provided the basis for the other two skills, began by copying the works of acknowledged masters. By their example the young student would eventually develop his own style.

In the studio of the more traditional Van Noort, copying undoubtedly served this end. It was here that Rubens probably produced his copies from Holbein's *Dance of Death* (see 10). For Van Veen,

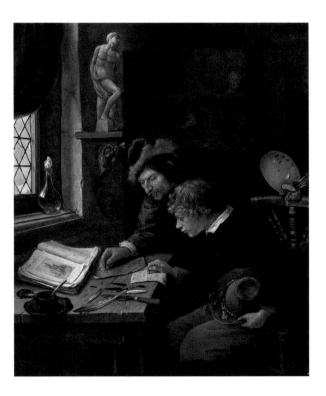

16
Jan Steen,
*The Drawing
Lesson*,
c.1665–70.
Oil on panel;
24×20·15 cm,
9½×8⅛ in.
Private
collection

however, with his scholarly appreciation of classical models, the two functions of copying – as a means both of learning skills and of collecting visual information – were equally important. This was the position that Rubens was to take throughout his life.

Today, copying has acquired rather negative connotations. Surrounded by photographic and digital reproductions of works of art, artists no longer need to go through this process in order to establish a visual reference library. Nor does the making

of copies constitute part of the curriculum in present-day art schools. Regardless of how important the achievements of the older masters are for the aspiring artist, to acknowledge such borrowings has become the mark of a lack of originality, unless older forms and motifs are treated as deliberate quotations, as in postmodern architecture. To copy and to create seem contradictory terms; yet it is precisely those artists whom we credit with the greatest originality who concerned themselves most intensely with the art of the past: Dürer, Michelangelo, Rembrandt, Watteau, Delacroix, Degas, Cézanne, Picasso – and, of course, Rubens, who made more copies than anyone.

Around 1595 7 Rubens again turned to sixteenth-century German woodcuts, specifically to book illustrations. It may have been in Van Veen's studio that he found a Bible in verse form with designs by Tobias Stimmer (1539–84), which he copied on to the pages of his sketchbook. However, since the Bible in question is a vernacular Protestant version illustrated by a Swiss artist, it is possible that it was part of Maria Rubens' library which she had brought with her from Cologne. Rubens would certainly have been aware of (and possibly sympathetic to) the Protestant content of both this Bible and the Holbein volume from which he had copied earlier, but above all such books provided him with visual source material. Holbein's little scenes are remarkable for their liveliness and invention, for their diversity of attitudes, and for their wit; Stimmer's woodcuts offered the young student a multitude of narrative compositions and competent renditions of the much sought-after female nude (17, 18). Whether Rubens made his copies in his teachers' workshops or at home, they testify to an activity which his teachers certainly encouraged.

Unlike *The Dance of Death* copies, which reproduce their models in their entirety, the slightly later drawings after Stimmer show individual figures extracted from their narrative scenes, grouped together by subject matter and arranged in patternbook fashion across the page. A collection of female nudes posed in front and side views (19) represents an early exercise in the elevation of the

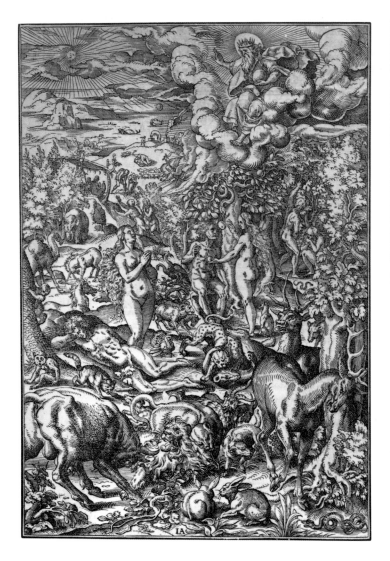

17–18
**Tobias
Stimmer**,
*Adam and Eve
under the Tree
of Sin.*
Woodcut from
*Neue Künstliche
Figuren
Biblischer
Historien*,
Basel,
1576
Above right
Detail

19
Four studies of
female nudes,
c.1595–7.
After Jost
Amman and
Tobias
Stimmer.
Pen and ink;
17·3×12·5 cm,
6⅞×4⅞ in.
Musée du
Louvre, Paris

human body from various angles. While it may seem ludicrous to relate such an awkward study to the glorious nudes we associate with Rubens' name (*eg* 157, 158), they were nevertheless created by the same hand. More importantly, taking a general view of Rubens' development rather than singling out a relationship between specific early and later works, the fully achieved painting would not have been possible without the drawing.

An important aspect of Rubens' copying process is that, regardless of the artistic merits of his models, he took from them whatever satisfied his needs. Stimmer's nudes (17) may not have had the qualities Rubens later found in Michelangelo, but he was still able to make creative use of them. This is what set him apart from the more ordinary run of novices, whose artistic sensibilities might have been compromised from copying less than perfect examples. Indeed, following Dürer, Leonardo da Vinci (1452–1519) and other artist-theoreticians, the general opinion was that an apprentice should only copy exemplary works of art. Rubens' confidence and talents were such, however, that he benefited from all art, great as well as not so great.

After 1598, when Rubens had finished his training and became a master in the Antwerp Painters' Guild, he was free to work independently and to take on pupils. It is not known whether he set up his own studio, but he had at least one pupil, Deodaat van der Mont (better known by the Italianized form of his name Deodat del Monte; 1582–1644). It has been suggested that Rubens stayed as an assistant in Van Veen's workshop. There is documentary evidence that the two collaborated on at least one painting (now lost) representing *Mount Parnassus*, home of the Muses, the Greek deities of the arts. Since the work involved a third artist, Jan Brueghel the Elder (1568–1625), who certainly had his own studio, it cannot be taken as proof that Rubens remained with Van Veen. In any case, collaboration between independent masters was common practice in Antwerp, and one Rubens was to employ later with considerable success (see Chapter 4). Meanwhile, however, his thoughts and ambitions had turned to Italy.

On 8 May 1600 Rubens obtained from the Antwerp Council the customary traveller's certificate that the city was free from plague or other dangerous diseases, and the next day he set off for Italy, accompanied by his pupil Deodat del Monte, who was to remain with him throughout his time in Italy. Ever since the German artist Albrecht Dürer had crossed the Alps in 1494, and again in 1505, to study the achievements of the Renaissance masters and to see at first hand the works of classical sculpture that were being rediscovered and acquired by wealthy connoisseurs, northern European artists had followed his example. By the time Rubens left for Italy, the journey had become a well-established tradition: Otto van Veen had studied there and Rubens' eldest brother, Jan-Baptist, is documented as having left Cologne for the south. His older brother, the classical scholar Philip, was soon to visit the country in the company of his pupil Guillaume Richardot.

20
Drawing of
the Laocoön
(detail of 30)

Although in the 1600s this journey was still a laborious undertaking, people travelled much more extensively than is realized today. Students, including Rubens' own father, journeyed far to the great European universities; artists visited the workshops of famous masters; gentlemen (and occasionally wealthy women) went on sightseeing tours, accompanied by their servants; and other long-distance travellers included merchants, diplomats, pilgrims and mercenaries. Communication in Europe worked remarkably well and quickly; even with the limited modes of transportation available – by foot, horseback, carriage or boat – diplomatic letters between London and Madrid might take less than two weeks. Rubens probably made the journey on horseback. When, on leaving Italy after eight years, he informed his employer of his hurried decision while 'leaping into the saddle', his phrase was not metaphorical – he was a competent rider who in later years maintained a stable near his home in Antwerp.

Rubens' nephew Philip recorded in his biography that, once Rubens reached Italy, he went straight to Venice. Here he had the good fortune to meet a gentleman in the service of Vincenzo Gonzaga, Duke of Mantua (r.1587–1612), who was impressed by the young Fleming. He recommended him to the duke, 'a man very fond of painting and all the liberal arts', and shortly afterwards Rubens became court painter to the Gonzaga, a position he retained throughout his eight years abroad. However, since Vincenzo was a cousin of Archduke Albert, Governor of the Netherlands, Rubens may have owed his introduction more to conventional social etiquette than to a fortuitous encounter with a stranger.

Before commencing his employment at the Gonzaga court, Rubens had time to explore Venice: its glorious architecture, picturesque canals and stepped bridges, and to encounter in its churches and public buildings the works of its greatest painters: Titian (c.1485–1576), Veronese (c.1528–88) and Tintoretto. There was no Venetian art in Antwerp in the sixteenth century; all Rubens knew, as a foretaste of the revelation to come, were the engravings of Cornelis Cort (c.1533–78), a printmaker working in Antwerp who had spent time in Titian's studio, and possibly the woodcuts by the master himself. Although there is no record of Rubens' visit to Venice in the form of diaries, sketchbooks or letters (as there is for Dürer), the Venetian experience was a profound one, which was to inspire his first major commissions in Italy, and which finally freed him from the rigid classicism of Otto van Veen.

From Venice, Rubens proceeded to Mantua, a city that presented a very different sight to the traveller. Situated among the swampy lagoons of the River Mincio, the city was frequently shrouded in mist, its silhouette dominated by the enormous buildings of the Gonzaga court, a massive complex of disparate styles quite unrelated to Venice's graceful architecture. Moreover, where Venice was a republic and a long-established trading port (sharing something in the latter respect with Antwerp), Mantua was

the seat of a feudal dynasty and the centre of a ducal court that, in true Renaissance style, combined secular power with artistic patronage and display.

The Gonzaga were not among the most powerful Italian nobility, but they distinguished themselves by military leadership and advantageous dynastic politics, and from the early fifteenth century onwards, nearly all the Gonzaga had been memorable patrons, attracting to their court the leading artists, scholars, poets and musicians of the day. In the fifteenth century, the great Renaissance artist Andrea Mantegna (1431–1506) was engaged as court painter, and Leon Battista Alberti (1404–72) designed the churches of San Andrea and San Sebastiano. Isabella d'Este (1474–1539), who married Francesco Gonzaga in 1490, was one of the foremost patrons and collectors of the age, and in the early sixteenth century, Giulio Romano (1499–1546), Raphael's most important pupil, designed and decorated palaces, chapels, gardens and houses for the Gonzaga. Besides commissioning buildings, the Gonzaga were also great collectors of paintings, sculpture (ancient and modern), tapestries, medals and jewels. They owned works by the most outstanding Renaissance masters, among them Titian, Raphael and Correggio (c.1482–1534). But it was not only the visual arts which were cultivated at the Gonzaga court: music, poetry and science played exceptional roles. For a while, during the last years of his restless life, the poet Torquato Tasso was attached to the court, and at the time of Rubens' employment, Claudio Monteverdi was the court musician. The astronomer, philosopher and physicist Galileo Galilei visited Mantua at least twice during Rubens' stay there.

Despite his impressive cultural milieu, Vincenzo Gonzaga was no true connoisseur; his patronage was mainly a means of keeping up aristocratic prestige. At heart, he was a lover of horses (the Gonzaga were known for raising magnificent steeds), and he had an eye for women. It was probably as a portraitist of court ladies that Rubens was initially employed. Northerners were particularly known as portrait painters, and another Flemish artist, Frans

Pourbus (1569–1622), had already received a court appointment. Vincenzo planned to establish a collection of pictures of beautiful women, and the undertaking went beyond one artist's capacity.

No sooner had Rubens arrived in Mantua than he was asked to accompany the Gonzaga to Florence to attend the marriage by proxy of Marie de' Medici to King Henry IV of France on 5 October 1600. As a young court painter, it is highly unlikely that Rubens came anywhere near the new queen. In retrospect, however, it was to be a momentous event, for Marie de' Medici later became the painter's patroness and confidante (see Chapter 6).

At the end of 1601 Rubens was given the opportunity to visit Rome, ostensibly to paint copies for the duke. It was here that he had his first direct experience of the major works of classical art that had done so much to shape Renaissance taste and artistic aspirations. At this date classical art meant Hellenistic art (*ie* from a relatively late age of Greek art) or, more commonly, Roman art or Roman copies of Greek art. Greece itself, under Ottoman Turkish rule, was practically inaccessible, and archaeological expeditions to its ancient sites did not take place until the nineteenth century. It also meant sculpture, since before the rediscovery of Pompeii in the mid-eighteenth century very little classical painting was known.

During the period when ancient Rome had dominated the Mediterranean, many famous Greek sculptures looted from temples or otherwise acquired found their way into the private art collections of Roman magnates. In the centuries after the fall of Rome, these works had been lost, but the Renaissance revival of classical learning brought with it a taste for the ancient carvings still to be found among, or unearthed beneath, the ruins of ancient Rome. In the sixteenth century collections of such antiquities had been assembled, and new discoveries were regularly made on building sites, in crypts and churchyards. Many such works were in fact Roman marble copies of Greek bronze originals, but it is unlikely that Rubens and his contemporaries distinguished, as we do today, between authentic Greek sculpture and Roman copies.

21
Drawing of the Belvedere Torso, *c.*1601–2. Black chalk; 37.5×26.9 cm, 14³⁄₄×10¹⁄₂ in. Rubenshuis, Antwerp

22
Belvedere Torso, *c.*50 AD. Marble; h.142 cm, 55⁷⁄₈ in. Vatican Museums, Rome

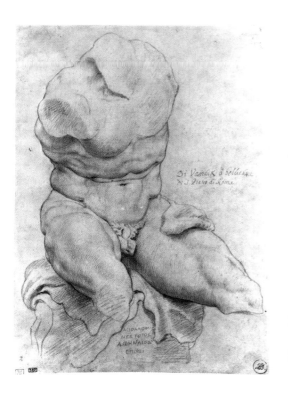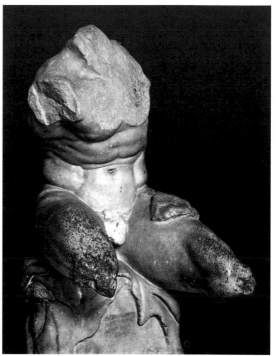

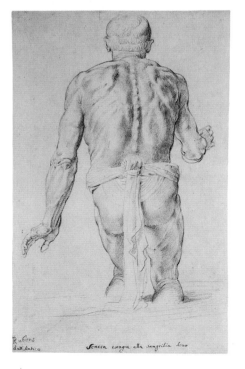

Rubens
dall'Antico Seneca exangue alla sanguisia dono

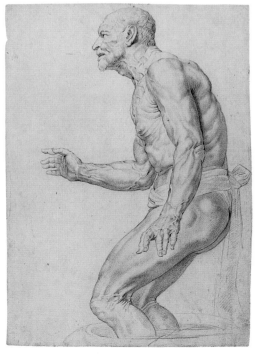

Rome was thus the centre of classical studies and rediscovery, as
well as the artistic capital of Europe, and both in 1601–2 and on
his second and longer visit towards the end of 1605, Rubens avidly
studied ancient Greek and Roman sculpture. Its impact on Rubens
and his immediate predecessors and contemporaries cannot be

23 Above far
left
An African
fisherman
('Dying
Seneca').
Roman copy of
a Hellenistic
statue.
Black marble,
enamel and
alabaster;
h.118 cm,
46¹⁄₂ in,
Musée du
Louvre, Paris

24 Above left
Drawing
showing front
view,
1601–2.
Black chalk;
46×32 cm,
18¹⁄₈×12⁵⁄₈ in.
Hermitage,
St Petersburg

25 Below far
left
Drawing
showing back
view,
1601–2.
Black chalk;
45·2×30 cm,
17³⁄₄×11³⁄₄ in.
Private
collection

26 Below left
Drawing
showing side
view,
1601–2.
Black chalk;
46×32 cm,
18¹⁄₈×12⁵⁄₈ in.
Biblioteca
Ambrosiana,
Milan

overestimated. They admired and copied images of the gods and
heroes of antiquity, either carved in marble or in the form of
plaster casts made from such statues, searching for perfection
in the human form. This activity should be seen in the context
of the Renaissance reassertion of the individual, after centuries of
medieval teaching on the humility of man. It brought with it the
discovery and enjoyment of human physical presence. However,
rather than relying solely on the imperfect (and in any case often
unavailable) living model, Renaissance artists turned to the ancient
ideal to guide them in their representations of the nude.

Rubens' own advice on this topic exists in his only surviving piece
of theoretical writing, from a lost notebook, *De imitatione statu-
arum* ('On the copying of sculpture'): 'I am convinced that in order
to achieve the highest perfection one needs a full understanding
of the statues, indeed a complete absorption in them; but one must
make judicious use of them and before all avoid the effect of stone.'
Although some of Rubens' copies faithfully record such features
of their stone originals as damage to the marble (see 21), they
nevertheless convey the feeling of work done from living models.
They are executed in chalk, a technique which softens the contours
and thus approximates to the texture of flesh more successfully
than the pen or stylus. More importantly, Rubens drew his models
from different angles, emphasizing their three-dimensionality.
Rubens' drawings after sculpture thus counter the tendency to
approach sculpture, like painting, from the frontal viewpoint only.
Confronted with the original, the viewer might indeed be tempted
to walk around it – in Rubens' footsteps, so to speak.

Rubens' copies after ancient sculpture are numerous and varied,
including statues of animals as well as deities and heroes. His
chalk sketches constitute a veritable inventory of famous statuary,

from the Belvedere Torso (21, 22), to the Farnese Bull and Apollo Belvedere. Two especially interesting sets of drawings are those after the so-called 'Dying Seneca' (23–26) and the Laocoön (29–32).

The work then thought to depict the 'Dying Seneca' and now considered to represent an African fisherman is a black marble statue of an aged man looking intensely and somewhat dreamily into the distance. This statue has survived in several versions; Rubens knew the one recorded in the Borghese collection in Rome in 1613, though he may have seen it when it was still in the collection of the Duke of Altemps, who presented it to Scipione Borghese (it is now in the Musée du Louvre, Paris; 23). The philosopher, dramatist and statesman Seneca (c.3 BC–65 AD) had been the tutor of the emperor Nero, on whose policies – while in favour – he had some influence. After being charged with conspiracy, he committed suicide on Nero's orders. Having delivered a dissertation, recorded by his scribe, in which he advised his friends to fortify themselves, as he had done, with philosophy, he opened his veins and then took poison. Finally, to hasten matters, he was placed in a bath of warm water. (Justus Lipsius, in his commentaries on Seneca, makes the nice point that the philosopher's asceticism did not allow him to indulge in bathing: this, his last hot bath, was also his first.) The Louvre version of the statue is cut above the feet, a fact which, combined with the figure's melancholy facial expression, had led to its identification as Seneca standing in a tub of water in the act of committing suicide. When the statue was displayed in the Villa Borghese it included a reconstruction of the tub added to the original after it was discovered in the sixteenth century, as suggested by the then current interpretation of the figure. Another version of the sculpture now in the Vatican, however, shows the man's feet. Together with other elements of the work, such as the black marble and the man's slightly negroid facial features, this has led to its now accepted identification as an African.

As was his custom, Rubens approached the statue from different angles: front, side and back (24–26). His drawings are faithful

27
Head of 'Seneca'. Roman copy of a Hellenistic bronze of c.2nd century BC. Marble; h.40 cm, 15¾ in. Ashmolean Museum, Oxford

28
Drawing of the head of 'Seneca'. Pen and brown ink over black chalk; 25.8×19 cm, 10⅛×7½ in. Metropolitan Museum of Art, New York

reproductions (including the addition of the tub), except for the
man's features, which resemble more those of a Roman portrait
bust of Seneca (27, 28). This bust, a copy of which Rubens
acquired in Italy, was later to feature prominently in the collec-
tion of ancient sculptures he assembled in his house in Antwerp
(by a further irony, the bust is now believed to be a Hellenistic
imaginary portrait of the Greek poet Hesiod).

A second example of Rubens' approach to ancient statuary
comprises his copies of the Laocoön in the Vatican Museum (29).
In the *Iliad*, Laocoön was a Trojan priest who had warned the
citizens of Troy not to bring the Greeks' wooden horse into the
city (disguised as an offering to the goddess Athena, the hollow

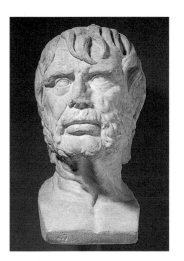
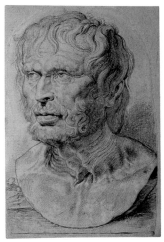

horse was in fact filled with Greek warriors). While he was
officiating at the altar of the sea god Poseidon, two huge snakes
emerged from the sea and entwined themselves around Laocoön
and his two sons, killing all three. The sculpture depicting this
incident was dramatically discovered in Rome in 1506 and had
a profound impact on artists from Michelangelo onwards. They
admired the dynamic composition, the powerfully modelled bodies,
the psychological tension, and above all the pathos and nobility
expressed by the priest and his sons in their fateful struggle with
the giant snakes.

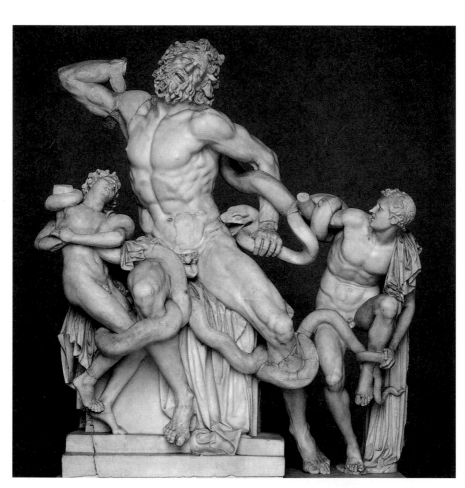

29 Left
Laocoön, copy
of a Greek
original of
*c.*150 BC.
Marble;
h.184 cm,
72³⁄₈ in.
Vatican
Museums,
Rome

30 Right
Drawing of
Laocoön,
1601–2.
Black chalk;
47·5×45·7 cm,
18⁵⁄₈×18 in.
Biblioteca
Ambrosiana,
Milan

31 Below right
Drawing of
the son of
Laocoön,
1601–2.
Black chalk;
41·1×26 cm,
16¹⁄₈×10¹⁄₄ in.
Biblioteca
Ambrosiana,
Milan

**32 Below far
right**
Drawing
showing back
view of
Laocoön,
1601–2.
Black chalk;
44×28·3 cm,
17³⁄₈×11¹⁄₈ in.
Biblioteca
Ambrosiana,
Milan

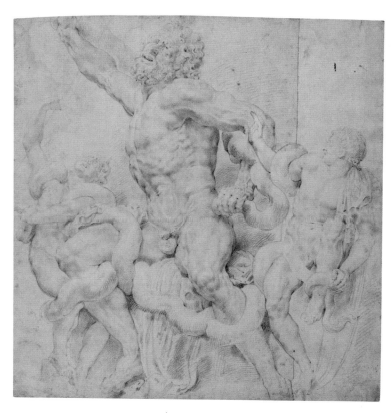

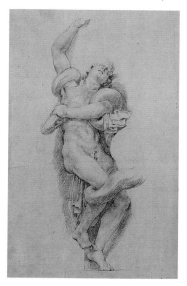

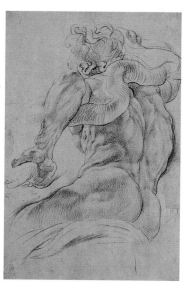

Rubens drew the group again and again from different angles and elevations, dissecting its individual parts. There is a frontal view of the whole group (30), side and back views of the father (32), front and back views of one of the sons (31), as well as studies of individual parts of Laocoön's body. No other statue seems to have occupied him as intently as this group of heroic, struggling nudes.

The many careful drawings Rubens made of classical statues provided him with a record of this great visual heritage. But Rubens' use of these copies went beyond the establishment of a repertoire of sculptural styles, iconographic types and expressive poses, and he did not hesitate to incorporate them into his own paintings. This artistic practice may today seem close to plagiarism, but in Rubens' time the boundaries between the various approaches to copying were rather fluid. Passing off entire compositions designed by others as one's own was indeed plagiarism; the practice was well known in the sixteenth and seventeenth centuries, and was one against which Rubens later felt compelled to protect himself (see Chapter 6). Including individual forms or motifs invented by others in one's own compositions, however, was quite a different matter.

This type of appropriation was common enough at the time, but what distinguishes Rubens is that he employed the process with more frequency and ingenuity than anyone else. It should be remembered that creativity was not then as closely linked to originality as it is today. Indeed, Rubens' creativity rested on and was inspired by his knowledge of older artistic forms. His borrowings from others are visual quotations, motivated by his admiration for the older images and perhaps also by their challenge. It was his talent to transform the forms and figures invented by others into his own personal language. As Roger de Piles, the seventeenth-century French critic and connoisseur, eloquently put it, Rubens used 'all that was most beautiful to stimulate his humour and warm his genius'. The number of such visual quotations in Rubens' compositions throughout his career is considerable. They vary from the adaptation of motifs without significant

changes either in content or form, to the truly creative reinter-
pretation of the inherited image.

It was not only the ancient world that held Rubens' attention.
In Rome he encountered the masterpieces of the greatest artists
of the High Renaissance: Michelangelo and Raphael. He must
have spent hours in the Sistine Chapel, craning his neck to copy
the poses of Michelangelo's prophets and sibyls, and those of the
incomparable nude young men (33, 34). Undoubtedly, Rubens
studied the decorations Raphael had created for the series of
papal apartments known as the Stanze. These copies have not
survived, although there is a set made from engravings after the
original frescos, probably before Rubens left Antwerp

It was not primarily through copying from original works,
however, that Rubens gained his knowledge of Renaissance art,
but rather through other artists' drawings, which he collected
and often retouched. Even when drawings by the masters them-
selves were not available or affordable, he was able to study and
assimilate their work at one remove by acquiring copies. This
process of creative reworking made his confrontation with the
art of his immediate predecessors quite different from his study
of Greco-Roman art. His reworkings, which often consisted of
corrections, show that it was indeed a confrontation – a meeting
of minds that went beyond mere admiration to include an
element of competition.

Art historians have not always recognized that many drawings
after sixteenth-century Italian art that unmistakably show
Rubens' imprint represent the work of other artists collected
and retouched by him. Moreover, this activity was not limited
to Rubens' Italian years but was a practice he continued through-
out his life. After his return to Antwerp he is known to have
employed artists specifically for the purpose of making copies
in Italy and elsewhere, and he eventually assembled a vast collec-
tion of drawings. While he tended not to interfere with original
drawings by the great Renaissance masters themselves, he felt
free to rework copies of their work made by minor artists. In

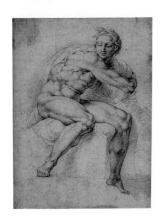 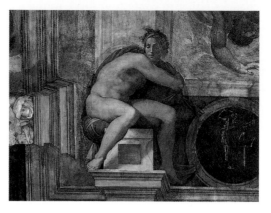

most such instances Rubens can be seen to have imposed his own ideas of composition, modelling and the use of light and shade upon the original design, where this design remains visible. Indeed, the sheets are often so vigorously retouched that it is impossible to make out the drawing underneath Rubens' additional reworking.

A case in point is an anonymous black chalk drawing after Michelangelo's statue of a female figure personifying *Night*, which forms part of the decorations for the mortuary chapel of the Medici family in the church of San Lorenzo in Florence (35, 36). The central section, depicting the statue from the front, was laid on to a larger sheet of paper, on which Rubens drew side and back views of the same figure, showing his model from different angles, as in his studies of the Laocoön and the so-called 'Dying Seneca'. Since Michelangelo's *Night* can only be viewed frontally, Rubens apparently invented the other views, although it is also possible that a small plaster cast of the original, of the kind in circulation from the mid-sixteenth century onwards, may have served as a model. Whatever the case, in the copying of sculpture Rubens insisted on actual or imaginative access from all sides. After making his additions to the original drawing, Rubens reworked the whole sheet with the point of the brush and ink, correcting and completing the central section and generally softening contours and texture of flesh. He then added yellow and white highlights.

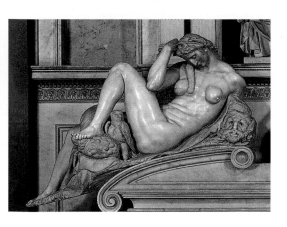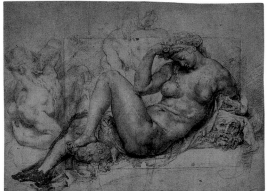

The result of Rubens' intervention is immediately apparent when
we compare the drawing with Michelangelo's sculpture. Most
striking in the drawing is the roundness of forms and the impres-
sion of softness in contrast to the angularity of the sculpture.
Such results are easier to achieve in the medium of chalk than in
marble, but even making allowances for the hardness of the stone,
it cannot be denied that Rubens' figure presents a more plausible
image of female anatomy than Michelangelo's muscular nude.
In the modelling of the breasts, however, neither artist seems to
have worked from life, since in both sculpture and drawing the
breasts give the appearance of afterthoughts applied to bodies
modelled on the male nude.

Why did Rubens not make his own copies of Italian Renaissance
works, as he did of antique sculpture, rather than collecting and
reworking other artists' work? Clearly, he must have had the
opportunity to draw Michelangelo's *Night* on one of his visits to
Florence – and the same applies to the majority of works assem-
bled by him in the form of anonymous copies. As often with
Rubens, the reasons for his behaviour are likely to have been
practical: reproductions of Renaissance paintings and sculptures
in the form of drawings or prints were plentiful and cheap,
whereas copies after ancient statues were not so readily available.
Buying such reproductions instead of making them saved time;
and after Rubens left Italy in 1608, this manner of assembling
visual source material was, in any case, the only one available to

him. Once they were assembled, Rubens could contemplate these forms and compositions at leisure, making changes as he saw fit (stylistic criteria suggest that most of the reworking was done after Rubens' return to Antwerp, some as late as the 1630s). In the changes he made, Rubens can clearly be seen to be recasting the originals in his own pictorial language, the language of a new age. Some of his contemporaries and immediate predecessors had only recently been working in a style ultimately derived from Raphael; Rubens imposed modern forms on their designs.

By contrast, it seems that Rubens never corrected the proportions or poses of classical statues while copying them. These exemplary works were too distant in time to invite competition with their creators; indeed, their very antiquity inspired the highest esteem. Towards the end of his life, Rubens himself expressed similar sentiments while discussing the attempt to recreate the famous lost works of the great Greek painters of antiquity, known to us only through literary descriptions. In a letter of 1637 to Franciscus Junius, the Earl of Arundel's librarian, he reflected that:

how few among us, in attempting to reproduce in fitting terms some famous work of Apelles or Timanthes that is graphically described by Pliny or by other authors, will not produce something insipid or inconsistent with the grandeur of the ancients; but each one, following his own bent, will bring forth some thin, new wine in place of that bittersweet Opimian vintage, and fail to do justice to those great spirits whom I honour with profoundest reverence, preferring indeed to admire the traces they have left, than to be so free as to proclaim myself capable of matching them, even in thought alone.

To what extent does the content of Rubens' collection of drawings indicate his tastes, interests and artistic preferences? On the basis of the drawings alone it would appear that the Italian artists who most caught his attention were the masters of the High Renaissance – Michelangelo, Raphael, Leonardo da Vinci, Correggio (37) and Andrea del Sarto (1486–1530). Of fifteenth-century painters, he studied only Andrea Mantegna, perhaps because of his Mantuan connection or because, like Rubens, he

was passionate about antiquity. His pictures are full of classical settings and motifs; his most famous work, *The Triumph of Caesar* (*c.*1480–95), is a reconstruction of a Roman triumphal procession. Of the generation following the High Renaissance masters, Rubens favoured above all his predecessor at the Mantuan court, Giulio Romano. He also acquired and reworked drawings after Giulio's assistant Francesco Primaticcio (1504/5–70), and after his near-contemporary in Rome, Annibale Carracci (1560–1609; 38).

With the exception of Correggio, who worked in Parma, these artists are of Florentine, Roman or Bolognese origin. Yet it was the Venetian painters Titian, Veronese and Tintoretto who had

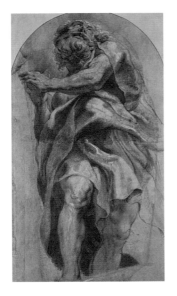

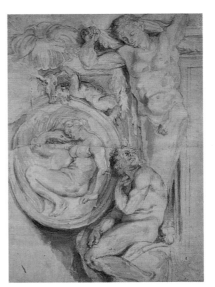

37
An apostle. Anonymous drawing after Correggio, retouched by Rubens. Red chalk and wash with touches of oil; 54·1×30cm, 21¼×11⅞ in. Musée du Louvre, Paris

38
Nude figures with Leda and the Swan. Anonymous drawing after Annibale Carracci, repaired and reworked by Rubens. Brown wash over black chalk, heightened with white; 55·3×40·7cm, 21¾×16in. Victoria and Albert Museum, London

the greatest impact on the work Rubens himself produced while in Italy. Titian's influence was to resurface strongly in the works of his last decade (see Chapter 9). What distinguished Venetian painters was their use of colour and brushwork, components in painting which do not lend themselves to linear reproduction. Artists of the Florentine–Roman school were noted for their emphasis on design or *disegno*. In Renaissance art theory, this term applied to the use of drawing as the foundation of a finished composition. *Colore*, by contrast, as practised by Venetian artists, implied the direct application of colour (*ie* paint) to the canvas or

panel. Unlike works based on design, those conceived in colour do not lend themselves to copying in the medium of drawing.

An artist such as Michelangelo, whose work was dependent on *disegno*, after long training in drawing from life and from exemplary models such as ancient sculpture, devised complex figure poses and combined them into meaningful compositions. Rubens' copies and retouched drawings constitute an impressive inventory of just such poses and compositions. He paid close attention to the monumental figures Michelangelo had created in marble (see 35), and in paint on the ceiling of the Sistine Chapel (see 34); he was fascinated by the violent display of horses and riders Leonardo da Vinci had painted for the Great Council Chamber in the Palazzo della Signoria in Florence (destroyed long before Rubens reached Italy, but known through copies, including the one he came to own); he valued the compositions and expressive gestures of Andrea del Sarto's frescos in the cloisters of the church of the SS Annunziata and the Chiostro dello Scalzo in Florence; and he felt a special attraction for Correggio's illusionistic decorations in the vault and dome of Parma cathedral. The most important influence, however, came from Raphael and his circle, extending even to the Raphaelesque forms of Annibale Carracci (see 38). In Rome, Rubens studied the designs of Raphael's decorations for the papal apartments in the Vatican and in the Villa Farnesina, while in Mantua he enjoyed daily access to the creations of Raphael's pupil Giulio Romano, whose designs in fresco and stucco he possessed in numerous drawings.

In copying and retouching, Rubens characteristically emphasized contours and shadows, enhancing the modelling of the original work. In almost all cases he finished by adding highlights in yellow, ochre, rose or white watercolour or oil. Ostensibly to cover up areas that had attracted his criticism, Rubens managed to impose in colour a sense of plasticity, movement and surface texture, such as he had seen in Venetian painting, on to the linear design. By adding a touch of sensuality to the perfectly constructed bodies and exemplary compositions of Roman and

Florentine masters, he combined the two Renaissance traditions of *disegno* and *colore*. While Rubens' talents were such that he was naturally more sympathetic to the Venetian tradition, his painterly style had its origin in his thorough study of those Italian predecessors who based their art on *disegno*. Only after he had achieved complete mastery in the design of figures and their relationships to each other in pictorial or architectonic space was he able to express his ideas with brush and paint directly on to his canvas.

The formative importance of Rubens' artistic encounters in Italy did not only involve the art of the classical and Renaissance past. Among contemporary Italian artists living in Rome, the most important for Rubens was Caravaggio (1571–1610), who was at the height of his fame when Rubens reached the city. It is unlikely that the two painters met, but Rubens was impressed by Caravaggio's work. The Italian painter was a master in the use of chiaroscuro, the dramatic balance of light and dark, to highlight his figures and their actions. The most innovative aspect of Caravaggio's art, however, was his realism. Instead of idealizing biblical figures in his paintings, he modelled them on ordinary people he knew from the streets and taverns of Rome. His apostles have rough faces and coarse, unshapely feet; his Virgin is bloated in death. Rubens' temperament was very different from Caravaggio's, his sense of artistic decorum more restrained, but he recognized the latter's talent, as witnessed by the copy he made of Caravaggio's *Entombment of Christ* (39, 40), and by the impact Caravaggio had on other paintings (see Chapter 4). Moreover, he convinced Vincenzo Gonzaga to buy *The Death of the Virgin* (now in the Musée du Louvre), as the swollen corpse of the Madonna had so offended the Fathers of Santa Maria della Scala (its intended location) that they had rejected it.

Rubens also had contact with the colony of northern artists living in Rome at the time, among them the German painter Adam Elsheimer (1578–1610) from Frankfurt. Most northerners working in Italy were landscape painters, and Elsheimer was no exception. He executed small, jewel-like pictures on copper, often of

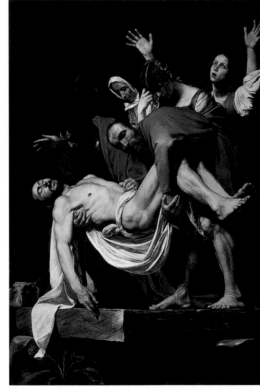

39 **Left**
Caravaggio,
The
Entombment
of Christ,
1603–4.
Oil on canvas;
300×203 cm,
118⅛×79⅞ in.
Vatican
Museums,
Rome
Far left
Details

40 **Right**
The
Entombment
of Christ.
Copy after
Caravaggio,
*c.*1614.
Oil on panel;
88·3×66·5 cm,
34¾×26⅛ in.
National
Gallery of
Canada,
Ottawa
Far right
Details

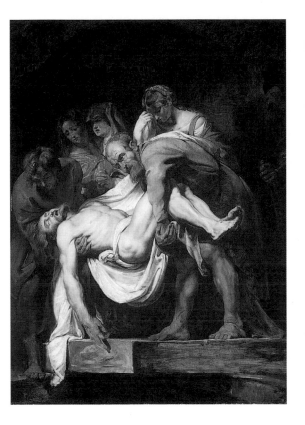

landscapes with figures illuminated by moonlight or torches (41).
Rubens was fascinated by Elsheimer's works. His own were
generally of quite different dimension and effect, though Rubens
did occasionally draw on Elsheimer's use of light and shadow. His
personality too was very different from that of the melancholic
Elsheimer, who suffered from bouts of depression which led to a
breakdown of his creative activities. Yet they became close friends
and following the German painter's early death in Rome in 1610,
Rubens wrote to Johann Faber on 14 January 1611:

Surely, after such a loss, our entire profession ought to clothe itself in
mourning. It will not easily succeed in replacing him; in my opinion he
had no equal in small figures, in landscapes, and in many other subjects.

Busy and successful himself, and lacking any understanding of
depression, Rubens also wrote that he prayed God would

forgive Signor Adam his sin of sloth, by which he has deprived the
world of the most beautiful things, caused himself much misery, and

finally, I believe, reduced himself to despair; whereas with his own hands he could have built up a great fortune and made himself respected by all the world.

For northerners such as Elsheimer and Rubens, Rome's vigorous and competitive artistic scene was perhaps as much of an attraction as its artistic glories – it was a city where powerful patrons could be found and reputations were made and sustained. It was also the nerve centre of the Counter Reformation, a movement which sought to re-establish the confidence of the Catholic Church and reassert its authority, which had been so battered by the Protestant Reformation. Activity on all fronts included the founding of new teaching and missionary orders within the Church, and a programme of architectural and artistic commissions. A new artistic style, the Baroque, came to be associated with the Counter Reformation, reflecting its dynamism with a sense of movement and drama – sometimes verging on propagandistic theatricality.

Confirmation of the unrivalled professional opportunities the city could provide came soon after Rubens' arrival. It happened that the Governor of the Netherlands, Archduke Albert, had instructed his representative at the papal court to employ a painter for an altarpiece he wished to donate to the small subterranean chapel of St Helena in the church of Santa Croce in Gerusalemme, Rome. It was in this important pilgrimage church that Albert, who had been a cardinal before his marriage, had received his cardinal's hat. The archduke's representative was none other than Jean Richardot, son of the Flemish statesman who had employed Philip Rubens as tutor to his sons. Since he happened to be in Rome at that time, this prestigious commission went to Philip's brother, Peter Paul.

Completed in 1602, this altarpiece, now in the chapel of the municipal hospital in Grasse in France, consists of a central panel showing the figure of St Helena, mother of Constantine the Great, the first Christian Roman emperor (42). Legend has it that Helena, on a visit to the Holy Land, discovered the cross

41
Adam Elsheimer,
The Flight into Egypt, 1609.
Oil on copper; 31×41cm, 12¼×16⅛ in.
Alte Pinakothek, Munich

on which Christ was crucified. She is usually portrayed as an elderly matron, regally dressed and wearing a crown (in Rubens' work a wreath is placed on Helena's head by an angel; her royal status affirmed by the sceptre in her right hand), while the cross, borne by angels, appears to her in a vision.

This is the iconographic tradition Rubens followed. St Helena is placed before an arch opening on to a balustraded terrace and distant vista. On the right are two twisted or Solomonic columns, decorated with reliefs of putti climbing on vines. The twisted

columns, which Rubens was to use repeatedly, were introduced
by Raphael in his *Healing of the Paralytic*, one of the tapestries
depicting *The Acts of the Apostles*, which he had designed for the
Sistine Chapel. They are modelled on a famous set of columns in
the earlier basilica of St Peter, which according to tradition had
come from the Temple of Solomon in Jerusalem.

The picture, on the whole, is not very successful. The figure
of St Helena and the dry rendering of her garments still reflect

42
*St Helena with
the True Cross*,
1601–2.
Oil on panel;
252×189 cm,
99¹⁄₄×74³⁄₈ in.
Notre Dame
Cathedral,
Grasse

43
*The Mocking
of Christ*,
1601–2.
Oil on panel;
224×130 cm,
88¹⁄₈×51¹⁄₈ in.
Notre Dame
Cathedral,
Grasse

the style of Otto van Veen, and the composition is crowded and
contrived – as if Rubens could not refrain from showing off all he
had learned. There are too many columns, billowing curtains and
angels, the latter seen in a confusing array of difficult poses. Yet it
is these same angels who exhibit the wit and playfulness that have
come to be associated with the mature Rubens. Flying around
the cross, climbing up its stem and straddling its crossbeam, they
remind us, on the one hand, that children delight in play, and,
on the other, that St Helena's vision was after all a joyful one.

The smaller panels, which were placed over the side altars in the chapel, show *The Mocking of Christ* (43) and *The Elevation of the Cross*. Of these, *The Mocking of Christ* is the more successful (*The Elevation of the Cross* is in any case destroyed, its composition known only from a copy). Here Rubens displays the immediate benefits derived from his study of Italian and antique art. The overall composition is inspired by Titian's famous treatment of the subject for Santa Maria delle Grazie in Milan, a city Rubens had visited from Mantua (44). The pose of Christ reflects those of the Belvedere Torso and Laocoön (see 22 and 29). On the other hand, the animated crowd of soldiers and spectators, the nocturnal setting, and the effective contrast created by the supernatural light emanating from the figure of Christ, the lantern light and the moonlight in the background show that Rubens had already encountered the works of Caravaggio and possibly also those of Elsheimer. The Baroque art of the Counter Reformation glorified heavenly visions and joyful celebrations, and this exuberant early work already points to Rubens' future development as one of its great masters.

44
Titian,
The Crowning with Thorns,
1540–2.
Oil on panel;
303×180 cm,
119⅜×70⅞ in.
Musée du
Louvre, Paris

In April 1602, after completion of the Santa Croce commission, Rubens returned to Mantua. Little is known about his tasks and movements for the remainder of the year, apart from one happy event: the reunion with his brother Philip, who had arrived in Italy at the end of the previous year in the company of Guillaume Richardot, the boy whose tutor he had been in Louvain and whose brother Jean had been instrumental in securing the Santa Croce commission for Rubens. The delight of the two brothers at the prospect of a meeting is evident from Philip's letter, written from Padua on 13 December 1601 shortly after his arrival: 'my first desire was to see Italy, my second to meet you there again: the first is fulfilled and the second will, I hope, soon be fulfilled'. The meeting took place in Verona in July 1602, where Jan Woverius, a mutual friend, and presumably Guillaume Richardot were also present. It was to be followed by many more such occasions.

It was probably during this period that Rubens painted the work known as the *Mantuan Friendship Portrait* (46); in any case, though its date cannot be precisely fixed, the picture surely commemorates the meeting of the two brothers and their bond of affection. The most prominent figure on the right is the painter himself – his first known self-portrait – with his brother to the left. But who are the other men? Immediately recognizable, on the extreme right of the canvas, is the profile view of Justus Lipsius, the eminent philosopher and Latin scholar who had been Philip Rubens' teacher at the University of Louvain. The people in the left half of the composition are not so easily identified. For the man facing the artist, Frans Pourbus, Rubens' fellow court painter at Mantua, seems the most likely candidate, though Galileo has been suggested as another possibility. The two shadowy figures on the extreme left remain unidentified: one may

be Gaspar Scioppius (or Kaspar Schoppe), a German philologist living in Rome and a friend of the Rubens brothers; the other Guillaume Richardot.

It is certain that Lipsius, at least, could not have been present when the Rubens brothers met in Italy, so the picture does not record an actual event. The great scholar and teacher is, however, the spirit behind the scene. With the exception of Pourbus, all

portrayed were his admirers: Philip Rubens and Guillaume Richardot were his pupils and both Rubens brothers had come under the influence of Lipsius' brand of Stoic philosophy. Thus the picture, rather than documenting a meeting of intellectually convivial friends, can be seen as a tribute to that conviviality. The curiously distant gaze in the eyes of the sitters and the impression of detachment conveyed by their grouping is explained by the fact that they never actually came together.

Following Rubens' return to Mantua in 1602, Vincenzo Gonzaga seems not to have employed his painter's outstanding gifts as an artist, but he did recognize his diplomatic skills. These he made use of in March 1603, when he sent Rubens on a good-will mission to Spain. Interestingly, at both the courts at which Rubens held employment during his career, in Mantua and later in Brussels, he was more highly valued as a courtier and diplomat than as a painter. At the time of Rubens' stay at the Gonzaga court, Spanish influence was considerable in northern Italy, and it was good diplomacy for the head of a small duchy such as Mantua to keep in the good graces of the Spanish king. Thus Rubens was entrusted with the task of bringing gifts to Philip III, who had succeeded his father on the Spanish throne in 1598, and the king's favourite, the Duke of Lerma, his highly influential first minister. These consisted of a small coach with six of the best horses from the famous Gonzaga stables; some interesting new firearms; gold, silver and crystal vases; and, diplomatic gift *par excellence*, pictures, in this case copies – not by Rubens – of the most famous paintings in Rome.

46
Peter Paul and Philip Rubens with their Friends or *Mantuan Friendship Portrait*, c.1602. Oil on canvas; 77·5×101 cm, 30½×39¾ in. Wallraf-Richartz Museum, Cologne

Rubens' Spanish mission is well documented from the many letters he wrote to Gonzaga's secretary of state, Annibale Chieppio. The journey to Spain was a hazardous one under the best of circumstances; Rubens took a slow route across the Apennines to Florence and Pisa, hoping to find in Livorno a ship bound for Spain. On 2 April 1603 he wrote to Chieppio:

The horses, the men and baggage are on board ship; we now need only a favourable wind, which we expect from hour to hour. We have taken provisions for one month and paid the charges … The expenses for the horses are large but necessary, including wine-baths and other costly things.

A few weeks later the Gonzaga train arrived in Spain. On 24 May Rubens reported back to Mantua that the horses had survived in good health – as indeed they should have after their curious and costly beauty treatments – but that the pictures were greatly damaged by rain:

Thus the pictures which were packed with all possible care by my own hand, in the presence of my Lord the Duke; then inspected at Alicante, at the demand of the customs officials, and found unharmed, were discovered today … to be so damaged and spoiled that I almost despair of being able to restore them. For the injury is not an accidental surface mould or stain, which can be removed; but the canvas itself is entirely rotted and destroyed (even though it was protected by a tin casing and a double oil-cloth and packed in a wooden chest). The deterioration is probably due to the continuous rains which lasted for twenty-five days – an incredible thing in Spain.

Rubens was able to touch up most of the pictures and those that were beyond repair he substituted with his own, painted on the spot. As we shall see, this turned out to be a fortuitous act.

At the time of Rubens' arrival in Spain, the court was not, as expected, in Madrid, but at Valladolid. Rubens proceeded with his precious load, through rain and violent storms, only to find, upon reaching the palace, that the royal party had gone to Aranjuez and Burgos. After further delay, the gifts were eventually presented to the king, not by Rubens, but by the Gonzaga representative at the Spanish court. After all his trouble, the young painter found himself relegated to the role of mere spectator in the crowd – a foretaste of the arrogance he was to meet in his later diplomatic career. There were, however, compensations. Waiting for the king and queen to return to Valladolid, Rubens managed to see the royal collections in Madrid and at the Escorial. In the same letter to Chieppio in which he reported the sad state of the rain-damaged pictures, he wrote of his delight at seeing 'so many splendid works of Titian, of Raphael and others, which have astonished me, both by their quality and quantity, in the King's palace, in the Escorial, and elsewhere'. Modern Spanish painters, however, he found 'nothing of any worth', a dismissal that may not have included El Greco (1541–1614), whose work Rubens probably did not see (though it is unlikely that El Greco's ecstatic spirituality and highly idiosyncratic style would have appealed to him).

Of equal significance to Rubens' encounter with the art in the Spanish royal collections was his meeting with the Duke of Lerma. Philip III's first minister was something of a connoisseur, who recognized Rubens' talents upon seeing the paintings he had substituted for those which had been damaged by rain. He commissioned the young Fleming to undertake his equestrian portrait, a work which, in its remarkable freedom from earlier influences, shows Rubens emerging for the first time as an independent talent.

The equestrian portrait, which originated with sculptural representations of Roman emperors, was revived by Titian in his famous *Charles V at Mühlberg*, a painting Rubens had seen in the Spanish royal collection (47). Titian had chosen a profile view, a compositional arrangement which allows the rider to assume the dominant role. Rubens chose a more challenging pose showing the rider moving forward directly towards the spectator (48). The perspective construction of such a composition meant that the oncoming horse might easily have dwarfed the rider, but Rubens cleverly resolved this problem: in *The Duke of Lerma on Horseback* the horse and rider form a spiral which forces the eye along the upward curve of the horse's front leg, neck and head to the military figure in the saddle. This dramatic pose is further enhanced by branches of palm and olive, symbolic of victory and peace, which, together with a bank of clouds, form a natural arch over the sitter, in imitation of the triumphal arches constructed for emperors and monarchs. If the iconography is somewhat over the top – Lerma was only a minister, not an emperor or king – we must remember that Rubens was young and eager to impress. Indeed, the painting was much admired by the Spanish court, and within a few years it set the style for a new type of equestrian portrait which other artists, notably Rubens' younger compatriot Anthony van Dyck (1599–1641), were to repeat.

At the end of 1603 Rubens set off from Spain to return to Mantua, but not before making his own travel arrangements. Vincenzo Gonzaga had requested him to go via France to paint

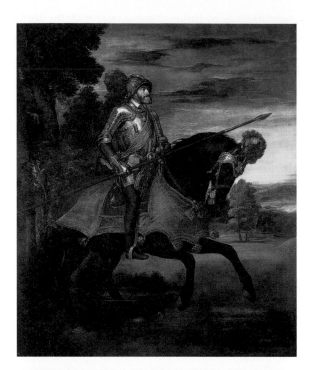

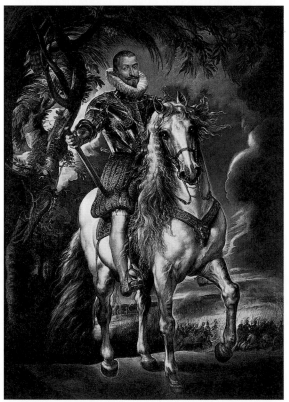

more women for his gallery of beauties. Rubens resented the job and politely but firmly refused:

That I should not have to waste more time, travel, expenses, salaries (even the munificence of His Highness will not repay all this) upon works unworthy of me, and which anyone can do to the Duke's taste … I beg him earnestly to employ me, at home or abroad, in works more appropriate to my talent.

Instead of France, the painter stopped at the Mediterranean port of Genoa in northwest Italy. This independent, wealthy republic was a centre of banking and commerce. Rubens may have gone there to see the banker to the Gonzaga, Nicolò Pallavicini, since the costs of his Spanish mission must have been extraordinary. He was to return on occasion during 1606 and 1607, to paint a series of portraits of members (mostly female) of the Genoese patriciate. In 1605, while staying in Rome, he was commissioned to paint *The Circumcision of Christ* for the high altar of the Jesuit church of San Ambrogio, and even after his return to Antwerp he remained in close contact with his Genoese patrons. The resulting commissions included another altarpiece for San Ambrogio, *The Miracles of St Ignatius*, and his first tapestry designs, depicting the life of the Roman consul and general Decius Mus.

In Genoa itself, however, Rubens' main artistic activity was painting portraits. With these works he established a type of full-length image from which later derived an entire tradition of aristocratic portraiture, from Van Dyck to eighteenth-century English works by Joshua Reynolds (1723–92) and Thomas Gainsborough (1727–88). Dating from a later visit around 1606, Rubens' *Portrait of the Marchesa Brigida Spinola-Doria* (45, 49), originally full-length (the bottom third was trimmed off during the nineteenth century), shows the young lady strolling through the portal on to the terrace of her villa, as seen in his preparatory drawing (50). Her satin gown, brocaded in silver and gold, with its stiff neck ruff, and her elaborate coiffure are dramatically framed by the red curtain and the austerely classical ionic columns and fluted pilasters. This formal representation is set

47
Titian,
Charles V at Mühlberg,
1548.
Oil on canvas;
332×279 cm,
130⅝×109⅞ in.
Museo del Prado, Madrid

48
The Duke of Lerma on Horseback,
1603.
Oil on canvas;
289×205 cm,
113¾×80⅝ in.
Museo del Prado, Madrid

49
*Portrait of
the Marchesa
Brigida Spinola-
Doria,*
*c.*1606.
Oil on canvas;
155·2×98·7 cm,
60×38⅞ in.
National
Gallery of Art,
Washington,
DC

50
Study for
*Portrait of the
Marchesa
Brigida Spinola-
Doria,*
*c.*1606.
Pen and ink
over black
chalk;
31·5×18·5 cm,
12⅜×7¼ in.
Pierpont
Morgan
Library, New
York

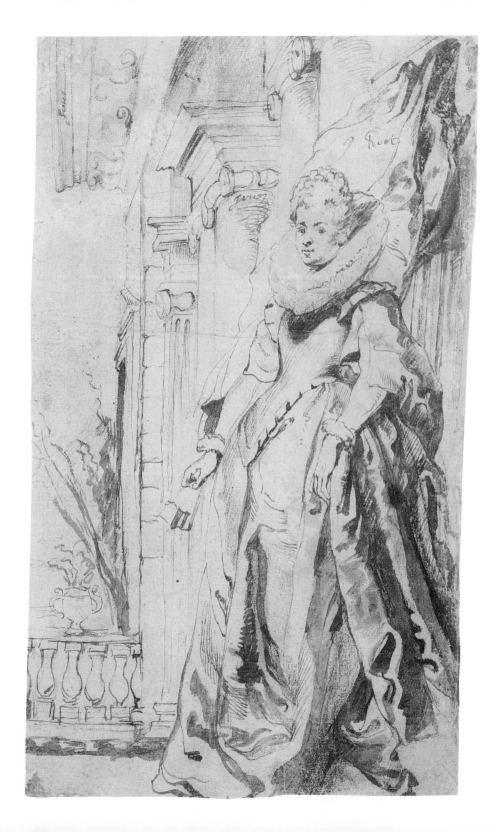

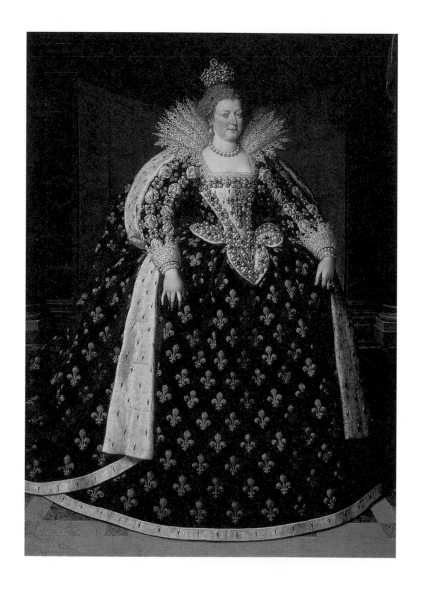

off by her young face with its hint of a smile and warm, brown eyes, and by the sense of movement conveyed by the shimmering highlights on her gown. Rubens' achievements are especially remarkable if we compare his portrait with one of a similar date by Frans Pourbus showing *Marie de' Medici* (51). Painted a few years later, shortly after Pourbus's appointment to the French court in 1609, it depicts the queen in the stiff pose established for aristocratic sitters in the Renaissance, a formula to which the artist adhered throughout his career.

It was following his return to Mantua at the beginning of 1604 that Rubens finally received from the duke the commission he had been waiting for, one that truly took account of his talents: he was to paint three large pictures to decorate the main chapel in the city's Jesuit church. The church was dedicated to the Holy Trinity, which provided the main subject for the central canvas, an altarpiece representing *The Trinity Adored by the Duke of Mantua and his Family*. The side walls were to be devoted to *The Baptism of Christ* and *The Transfiguration*, the two occasions from the life of Christ when the Trinity was believed to have appeared on earth. The paintings were completed in the summer of 1605, but are unfortunately no longer in their original setting; the decoration of the chapel was removed during the Napoleonic war, and *The Transfiguration* was taken to Paris (it is now in the Musée des Beaux-Arts in Nancy), while *The Baptism* was sold and is now in Antwerp (in the Koninklijk Museum voor Schone Kunsten). *The Adoration of the Trinity* was cut up, its main fragments stayed in Mantua, others were dispersed.

Although only fragments of Rubens' great picture remain (52), it is possible to determine its general appearance. In the lower half, members of the Gonzaga family kneel in adoration: on the left side are the dukes Vincenzo and his deceased father Guglielmo; on the right their respective wives, Eleonora de' Medici (sister of Marie de' Medici) and Eleonora of Austria. Other fragments inform us that they were attended by their children, also divided by sex, and by halberdiers. The entire group is placed on a

51
Frans
Pourbus the
Younger,
*Marie de'
Medici*,
1609.
Oil on canvas;
307×186 cm,
120⅞×73¼ in.
Musée du
Louvre, Paris

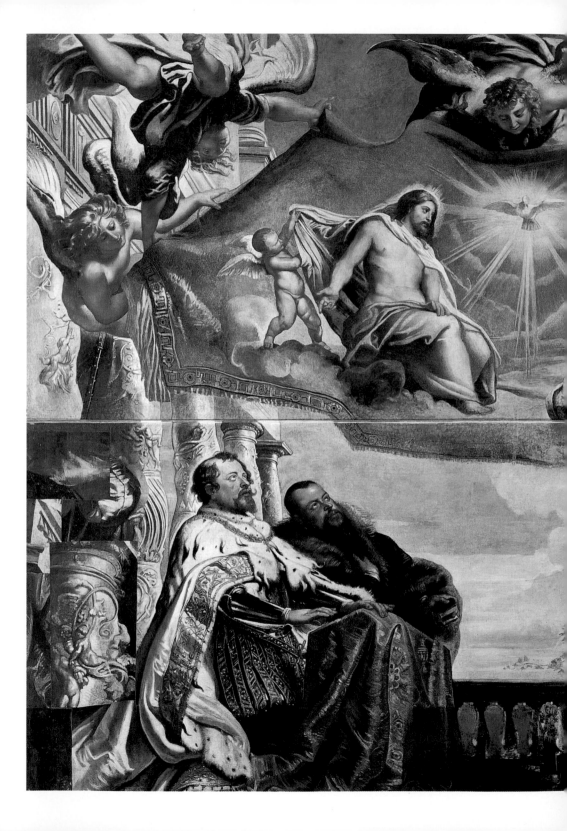

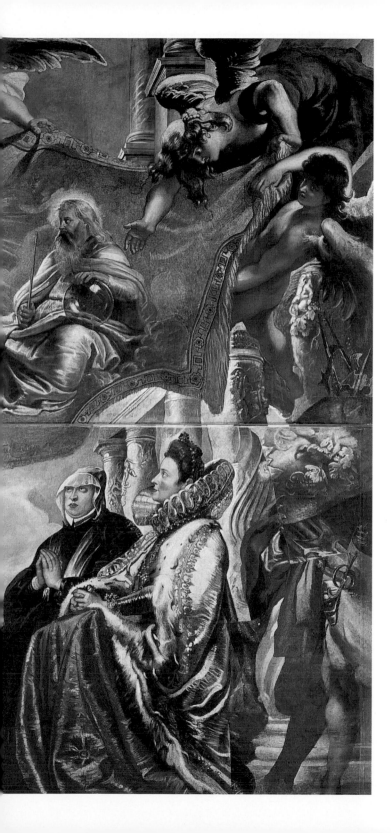

52
*The Gonzaga
Family Adoring
the Trinity*,
1604–5.
Oil on canvas;
each fragment
185×462 cm,
$72\frac{7}{8} \times 181\frac{7}{8}$ in.
Museo del
Palazzo
Ducale,
Mantua

terrace, flanked by twisted Solomonic columns decorated with vine reliefs already familiar from Rubens' Santa Croce altarpiece (see 42). In the upper half of the canvas appears a vision of the Trinity presented on a tapestry held by angels: on the right God the Father, on the left his son, Jesus Christ, with the Holy Spirit in the form of a dove between them.

The picture is a direct tribute to Venetian art. Its iconography, compositional arrangement, architecture, colour and texture all point to Venice as their source. The combination of sacred (Trinity) and secular (Gonzaga family) follows Venetian tradition, seen in the many images of doges with their patron saints and the Virgin or Christ; the monumental architecture, with its open-air perspective, columns and balustrade, is derived from Veronese, as is the use of halberdiers in such works as *The Wedding at Cana* (53) or *Feast in the House of Levi.* The strong local colours – gold, silver and red – and sumptuous textures also reflect Venetian painting, including the works of Tintoretto. It should be noted that the major Venetian influences in this and other early works by Rubens come from Veronese and Tintoretto, not Titian. Rubens' admiration for the greatest Venetian painter was total and complete, but it was acquired over a lifetime as he himself matured. Undoubtedly, he marvelled at the incomparable collection of portraits by Titian which he had seen on his recent visit to Spain (see 47). However, the intensity of perception and the ability to appear to penetrate a person's innermost being, which constitute the essence of Titian's portraiture, did not greatly interest Rubens at this time. He was more attracted by outward form than inward meaning, and when it came to organizing masses in space, grandiose architecture, sumptuous costumes and daring perspectives, Veronese and Tintoretto had no equal.

With the Mantuan commission completed, Rubens was free to leave the city once again, and by the end of 1605 he was back in Rome. What follows was the happiest and most rewarding part of his Italian journey. Philip Rubens, who by that time had received his degree of Doctor of Law at Rome, had accepted the

53
Paolo Veronese,
The Wedding at Cana,
1562–3.
Oil on canvas;
666×990 cm,
262⅛×389¾ in.
Musée du
Louvre, Paris

position of librarian to Cardinal Ascanio Colonna, so that the two brothers were able to live together in a house near the Piazza di Spagna. Unfortunately, the visit started badly for Rubens, who was stricken with pleurisy. He was cured by a German doctor and botanist, Johann Faber, physician to Pope Paul V. Faber had assembled around him a group of northerners, among them the painter Adam Elsheimer, the philologist Gaspar Scioppius, who may have posed for one of the sitters in the *Mantuan Friendship Portrait* (see 46), and the Flemish landscape painter Paul Bril

(1554–1626). These were the friends with whom Rubens shared intellectual exchange. Later, back in Antwerp in April 1609, he was to remember these carefree months with fondness, writing nostalgically of his 'friends whose good conversation makes one often long for Rome'.

As young boys in Cologne, Philip and Peter Paul had been introduced by their father to their first Latin texts, an education later continued in Antwerp at the grammar school of Rombout

Verdonck. Philip seriously pursued his classical studies at the University of Louvain, while Peter Paul devoted at least some of his time to the same concerns in the studio of Otto van Veen. In Rome the two brothers had the opportunity to follow their mutual interests as never before. They collaborated on research into customs and social life in antiquity, which bore fruit in a book later published in Antwerp (1608) by their childhood friend Balthasar Moretus, by then the head of the famous Plantin Press. On his excursions to private collections and libraries, frequently accompanied by Philip, Rubens not only studied the famous examples of ancient statuary, but sought out antiquities of any kind – gems, cameos, coins – of which he made careful copies worthy of any archaeologist's records. Given his fondness for Latin, he presumably also spent time with Philip and his learned friends reading and discussing classical authors. For the artist, then, these were important months. His absorption in the classical era – its art, literature and antiquities – provided him with an understanding of classical subjects. It is this understanding that informs his re-creations from ancient literature and history, and that enabled him to develop a style of religious figure painting that draws freely on classical models in representing Christian themes (see Chapter 4).

With Philip Rubens' departure for Antwerp in December 1606, the period the brothers had spent together came to an end. It had been a happy time, marred only by Rubens' initial illness and, more consistently and irritatingly, by his difficulties in obtaining his salary from his Mantuan employer. But while Vincenzo may have been unreliable in matters of finances, he was extremely generous in allowing the painter to use his time as he liked. Rubens was free to work for patrons more willing or able to pay him. Among them the Oratorians – a lay order founded by St Philip Neri in 1564 – offered him his most important commission to date: the decoration of the high altar of the church of Santa Maria in Vallicella, the so-called Chiesa Nuova, or New Church. The church already had several altarpieces for side chapels, among them Caravaggio's *Entombment of Christ* of which Rubens

later painted a copy, no doubt from a record he had made while working on the high altar (see 39, 40). Asking for further leave from his court duties, on 2 December 1606 Rubens wrote proudly to Annibale Chieppio in Mantua:

Therefore, when the finest and most splendid opportunity in all Rome presented itself, my ambition urged me to avail myself of the chance. It is the high altar of the new church of the Priests of the Oratory, called Santa Maria in Vallicella – without doubt the most celebrated and frequented church in Rome today, situated right in the centre of the city, and to be adorned by the combined efforts of all the most able painters in Italy. Although the work mentioned is not yet begun, personages of such rank are interested in it that I cannot honourably give up a contract obtained so gloriously, against the pretensions of all the leading painters of Rome.

The work shows six early Christian saints: St Domitilla, niece of the Roman emperor Domitian, and her two fellow martyrs St Nereus and St Achilleus; St Gregory the Great, the pope who reputedly built the original Santa Maria in Vallicella; and St Maurus and St Papianus (54). A crucial aspect of the commission was the stipulation that the work had to incorporate the miraculous image of the Virgin, taken from the older church. Rubens grouped the saints and martyrs before a Roman triumphal arch, while infant angels entwine a garland around an image of the Madonna and Child in a simulated stone frame at the top, presumably at the place where the holy icon was to be installed.

To the Oratorians, the transfer of this holy image was of the utmost concern. They undoubtedly desired its installation in suitably decorated surroundings, but Rubens' splendid painting was the result of more powerful patronage from outside the congregation. The commission offers an example of the influence of rich patrons in forcing prestigious art on an initially reluctant, austere new Counter Reformation order. The benefactor was Monsignor Jacomo Serra, Genovese by birth, Cardinal and Papal Treasurer. Not being an Oratorian himself, he seems to have been motivated by his personal preference for Rubens' art,

examples of which he could have seen in Genoa. The Oratorians had never heard of the artist, and the thought that the main commission in their church would go to a young Fleming could not have pleased them. But Serra insisted that if they did not accept his terms, he would donate the money elsewhere, and so, rather reluctantly, they agreed.

The altarpiece is painted in a lighter palette than Rubens' previous works. St Domitilla is resplendent in shimmering satin in blue, red, gold and violet, with pearls in her golden hair; St Gregory is shown in his white and gold papal vestments. No trace is left of the greenish-blue tonality of Rubens' earlier paintings (*eg* see 16, 18 and 19), which still betray Tintoretto's palette. Certainly, there are earlier influences at work here – Titian, Raphael and Correggio come to mind – but they are so well integrated that only art historians searching for visual clues will spot them; the unity of the composition and the brilliance of its colouring are entirely Rubens' own. One artist who has not been mentioned in connection with the painting is Rubens' predecessor at the Gonzaga court, Andrea Mantegna. To suggest any trace of this painter's dry and angular style in a picture of such Baroque exuberance and splendour might come as a surprise, but the mischievous little angel in the upper right of Rubens' composition, who pushes his arm through the picture of the Madonna, hugging its frame, may well have been inspired by Mantegna's paintings for the so-called Camera degli Sposi ('bridal chamber') in the ducal palace at Mantua, which has many such illusionistic elements. Another Gonzaga commission possibly echoed in this image is a series of tapestry designs by Giulio Romano featuring the games of playful putti.

Rubens was initially pleased with the finished work, which he praised in a letter to Chieppio on 2 February 1608 for the 'beauty of colouring, and the delicacy of the heads and draperies, which I executed with great care, from nature, and completely successfully, according to the judgement of all'. Rubens' high spirits, however, turned to disappointment when it was discovered that

54
St Gregory the Great Surrounded by Other Saints, 1607–8.
Oil on canvas; 477×288 cm, 187¾×113⅜ in.
Musée des Beaux-Arts, Grenoble

55
*The Virgin and
Child Adored by
Angels* (detail),
1608.
Oil on slate,
425×250 cm,
167³⁄₈×98³⁄₈ in.
Santa Maria in
Vallicella,
Rome

56
*Saints Gregory,
Maurus and
Papianus*,
1608.
Oil on slate;
425×280 cm,
167³⁄₈×110¹⁄₄ in.
Santa Maria in
Vallicella,
Rome

57
*Saints
Domitilla,
Nereus and
Achilleus*,
1608.
Oil on slate;
425×280 cm,
167³⁄₈×110¹⁄₄ in.
Santa Maria in
Vallicella,
Rome

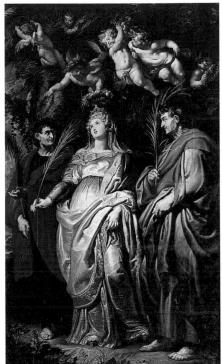

the reflections caused by bad lighting made the picture almost invisible when installed on the altar. To satisfy the Oratorians and save his reputation, he agreed to paint a substitute on slate, a non-reflecting material. Meanwhile, he was faced with the problem of what to do with the large original canvas. Surprisingly, given that it was an altarpiece painted for a specific location, in early 1608 he offered it to Vincenzo Gonzaga. He was quick to discount any objection to the painting having been a special commission by pointing out that:

although all these figures are saints, they have no special attributes or insignia which could not be applied to any other saints of similar rank. And finally, the size of the picture is not so excessive that it would require much space; it is narrow and tall. All in all, I am certain that their Highness, when they see it, will be completely satisfied, like the crowds who have seen it in Rome.

Vincenzo refused the offer, due to lack of funds or of interest. Rubens eventually took the painting back to Antwerp with him, and it was later installed over the altar in the chapel where his mother was buried.

As to the second version of the Chiesa Nuova altarpiece, still *in situ*, Rubens was not content to make only a copy of his earlier painting. He offered the Oratorians a new, more elaborate altarpiece while, at the same time, applying a more sober style and conventional iconographic programme. This second work consists of three panels, in contrast to the original single canvas. The central place is reserved for the picture of the Madonna and Child carried by a throng of cherubs, while a heavenly chorus of angels looks up in adoration (55). The miraculous image itself, actually a fourteenth-century fresco only displayed on special occasions, was placed inside a frame inserted in Rubens' picture. The six saints are relegated to two panels hung at the sides of the apse (56, 57).

While the Oratorians were undoubtedly pleased that Rubens had resolved the bothersome question of reflections, there may have

been other reasons for the changes. The new arrangement places greater emphasis on the miraculous icon of the Virgin, so greatly venerated by the Fathers. Moreover, Rubens' picture of the Madonna, which covers the sacred image, is carried aloft by angels in an orderly if exuberant manner, and there is no mischievous cherub sticking his arm through the frame. Finally, the saints are presented in a more subdued manner than in the original version, their garments less sumptuous and colourful. More significantly, each carries a palm branch, the traditional attribute of Christian martyrs. Unlike Rubens who, when it came to selling the work, considered the absence of attributes in the earlier version of his altarpiece a desirable feature, the Oratorians may not have approved of such unorthodoxy.

In the event, Rubens was prevented from seeing his Roman masterpiece unveiled. Departing from Rome at the end of October 1608, he wrote to Mantua:

My work in Rome on the three great pictures for the Chiesa Nuova is finished, and, if I am not mistaken, is the least unsuccessful work by my hand. However, I am leaving without unveiling it (the marble ornaments for it are not yet finished), for haste spurs me on. But this does not affect the essence of the picture, for it was painted in public, in its proper place, and on stone.

The artist's hurried departure was due to his mother's ill health. Maria Rubens, now seventy-two years old and suffering from severe asthma, was not expected to live. Rubens arrived home too late. His mother had died nine days before he left Rome.

Rubens had arrived in Italy, a young man of twenty-three, eager to see and absorb its artistic and cultural heritage and to establish himself as an artist in his own right; he left eight years later, a mature man and an accomplished painter able to compete with the best of his Italian colleagues. He had found employment, both as a painter and as a diplomatic emissary, at an Italian court, an experience which was to stand him in good stead in his later dealings with the major courts of Europe. The Gonzaga court at

Mantua had presented Rubens with a rich Renaissance cultural tradition and, more importantly, granted him the freedom to develop and apply his talents elsewhere. It had also provided him with useful contacts among the rich and famous of the day which Rubens, never one to ignore an opportunity, knew how to use to his advantage. In Mantua itself, Rubens had painted only one major work, the decorations for the main chapel of the new Jesuit church. However, his work for other patrons in Spain and Genoa had given him the chance to try his talents as a portrait painter on a grand scale, and in Rome, where he spent most of his time outside Mantua, he had completed two major commissions for church decorations. Separated by only six years, the altarpieces for Santa Croce in Gerusalemme and Santa Maria in Vallicella demonstrate more persuasively than any other of his Italian works the process of appropriation, assimilation and transformation of older forms and images which was the mainspring of Rubens' creative genius. Rome had also offered him the company of a group of kindred spirits, which he came to treasure throughout his life, and it was there that his studies of ancient sculpture, the masterpieces of the Renaissance and the works of his contemporaries had enabled him to absorb the Italian tradition far more thoroughly than any northern European artist before him.

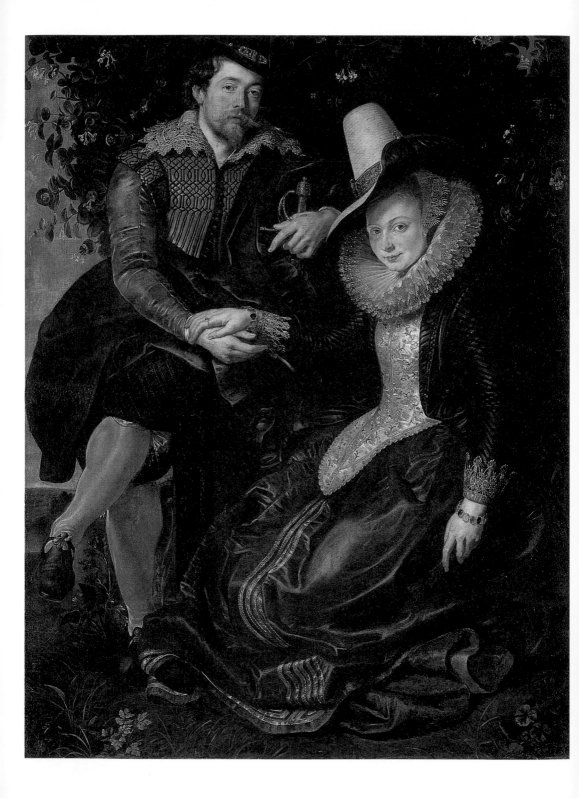

When Rubens arrived in Antwerp he apparently did not expect his stay to be long. On leaving Italy, he had informed his Mantuan employer that he was looking forward to returning. He was soon to have doubts, however, as he wrote on 10 April 1609 to his friend Johann Faber in Rome:

I have not yet made up my mind whether to remain in my own country or to return to Rome, where I am invited on the most favourable terms. Here also they do not fail to make every effort to keep me, by every sort of compliment. The Archduke and the Most Serene Infanta have had letters written urging me to remain in their service. Their offers are very generous, but I have little desire to become a courtier again. Antwerp and its citizens would satisfy me, if I could say farewell to Rome.

58
The Artist and his Wife in a Honeysuckle Bower,
*c.*1609.
Oil on canvas;
178×136·5 cm,
70¹⁄₈×53¹⁄₄ in.
Alte Pinakothek, Munich

In the event, Rubens decided to stay, but Italy was never far from his thoughts or his art. Twenty years later on 9 August 1629 he would write from London: 'I have not given up hope of fulfilling my wish to go to Italy. In fact this desire grows from day to day, and I declare that if Fortune does not grant it, I shall neither live nor die content.'

Fortune did not grant Rubens his wish. Instead he brought Italy to Antwerp. Of the five languages he came to read and write fluently, Italian remained his favourite for correspondence. This was not a choice solely motivated by personal preference. In the early sixteenth century Italian was the language of international communication, replacing Latin, which had served scholarly and diplomatic exchange for centuries. It is worth noting, for example, that Rubens and his friend, the French scholar Fabri de Peiresc, corresponded in Italian despite the fact that both men knew Latin and that their main topic of interest was classical antiquity. Curiously, even Rubens' letters to fellow Flemings are in Italian, as was the preferred form of his signature: Pietro Pauolo Rubens.

Yet it was Antwerp which became Rubens' home. There were several reasons for this. One was the signing in April 1609 of the Twelve Years' Truce which, by suspending the war between Spain and the Northern Netherlands until 1621, held out hope for renewed peace and prosperity for the Southern Netherlands. Under its terms, the blockade of the River Scheldt was lifted, and its reopening to shipping on the payment of dues brought to Antwerp, once the wealthiest city in northern Europe, a limited amount of its former trade.

The truce had been ardently promoted by the Archduke Albert and the Archduchess Isabella (59, 60), against opposition from the Spanish court. Albert, a prince of the Austrian branch of the Habsburgs, had been Governor-General of the Netherlands since 1598. On his marriage in 1599 to Philip II's favourite daughter, Isabella Clara Eugenia, the king had ceded the country to Isabella and the couple established their court at Brussels. It was Albert who had given Rubens his first commission in Rome, the altar-piece for Santa Croce in Gerusalemme (see Chapter 2).

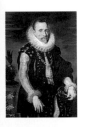

Shortly after Rubens' return, in September 1609, Albert and Isabella offered him employment as court painter on very gener-ous terms, which permitted him to live and work in Antwerp instead of at the palace in Brussels. This was another incentive. As he stated frankly in his letter to Faber, the arrangement offered by Albert and Isabella suited him well, for it guaranteed him a good income while at the same time allowing him to accept in addition the patronage of the clergy, confraternities and private citizens of Antwerp, on which he was to build his fame.

Moreover, he undoubtedly felt a great personal respect for these sympathetic and conscientious rulers. Of the two, the archduchess – or, as Rubens preferred to address her, the Most Serene Infanta – was perhaps the more remarkable: well informed on European politics, humane and intelligent, she had sound, independent judgement and strength of character. Much later, in 1628 after twenty years of close association, Rubens wrote of her: 'She is a princess endowed with all the virtues of her sex; and long

59–60
Rubens'
studio,
*The Archduke
Albert* and
*The Archduchess
Isabella*,
c.1620.
Copies after
prototypes by
Rubens of
c.1609.
Oil on panel;
each
105×74 cm,
41³⁄₈×29¹⁄₈ in.
Kunst-
historisches
Museum,
Vienna

experience has taught her to govern these people and remain uninfluenced by the false theories which all newcomers bring from Spain.'

Encouraged by the peace and economic recovery promised by the truce, the archducal couple generously supported the arts. While having painters, sculptors and architects attached to one's court was an established way of maintaining aristocratic prestige, Albert and Isabella seem also to have had a genuine desire to encourage the arts as part of the general revitalization of the country. Although as connoisseurs neither was the equal of Isabella's father, Philip II, who had patronized Titian, they had a real appreciation of the fine arts, and the archduke had a large collection of pictures. Moreover, art occupied an important role in the Counter Reformation. Albert and Isabella actively supported the clergy, wealthy burghers, confraternities and religious orders in the restoration of churches and other ecclesiastical buildings, which had suffered during the iconoclastic riots of 1566 and 1581 and the long years of war, and in the construction and decoration of new ones. In 1609, therefore, the Southern Netherlands were about to experience a burgeoning of religious art and architecture, in which Rubens was to play a leading role.

There were other, more personal factors, which tempted Rubens to remain in the Netherlands. His brother Philip, who had left Rome at the end of 1606, had become one of the four secretaries of Antwerp, at the time a prestigious post for learned men. He had found a bride and was ready to settle down. Rubens' delight at his brother's good fortune is expressed in his letter of 1609 to their mutual friend Faber:

In short, my brother has been favoured by Venus, the Cupids, Juno, and all the gods: there has fallen to his lot a mistress who is beautiful, learned, gracious, wealthy, and well-born, and alone able to refute the entire Sixth Satire of Juvenal [perhaps the most celebrated invective against women in classical literature]. It was a fortunate hour when he laid aside the scholar's gown and dedicated himself to the service of

Cupid. I myself will not dare to follow him, for he has made such a good choice that it seems inimitable.

Shortly afterwards, Rubens himself fell in love. The young woman was Isabella Brant, eighteen-year-old niece of Philip Rubens' new wife, whom Rubens had seen a good deal of during the festivities for his brother's wedding. She was the daughter of Jan Brant, like Philip one of the secretaries of Antwerp and one of the city's wealthiest and most cultured men, with whom Rubens was to retain close relations throughout the latter's long life. Like many men of his day who held public office, he pursued academic learning and even published a number of studies, among them a commentary on Julius Caesar. The marriage took place on 3 October 1609 in St Michael's Abbey, the church where Rubens' mother was buried and where the artist was soon to install the first version of the Chiesa Nuova altarpiece he had painted in Rome (see 54). The young couple settled down, first in the spacious home of Jan Brant, then, a few years later, in a newly purchased and refurbished house on the Wapper, then a canal near the fashionable thoroughfare of the Meir. The house exists today in a modern reconstruction.

Rubens celebrated the marriage by painting a full-length double portrait, one of his most delightful pictures (58). He and Isabella sit hand in hand in a bower of honeysuckle, the husband positioned slightly higher than his wife. Both are fashionably dressed in richly embroidered and decorated clothes. Rubens portrays himself not as a painter with palette and maulstick, but as an elegant gentleman, almost a little foppish in his yellow-orange silk stockings, leaning nonchalantly on a jewelled sword-hilt (a sword was usually worn only by members of the aristocracy). The painting surpasses previous portrayals of married couples, which tended to be small with the sitters shown in half length. An exception is the famous double portrait by Jan van Eyck (c.1395–1441) of Giovanni Arnolfini and his wife in the National Gallery, London (1434), which, though small, shows the pair full-length. But this enigmatic portrait is far from typical; moreover,

the sitters are formally and solemnly placed. Rubens' pose, on the other hand, is casual, with one leg crossed over the other.

Rubens' large canvas with its life-size figures in fact owes more to his earlier portraits of Genoese aristocrats than to previous marriage representations. In the *Portrait of the Marchesa Brigida Spinola-Doria* (see 49), for example, he had succeeded in combining the splendour of setting and dress with the charming freshness and vivacity of the youthful sitter. It is this combination of grandeur and intimacy that is especially striking in the double portrait of Rubens and Isabella.

Even so, it does not ignore older, especially Flemish conventions. Particularly noticeable is the brightness of colouring and the meticulous treatment of details of clothing. In this, the painting recalls the precious, jewel-like panels of earlier Flemish artists, such as Jan van Eyck, Hans Memling (*c.*1430/40–94) and Gerard David (*c.*1460–1523). So too does the bower of honeysuckle and carpet of grass and flowers, found in numerous fifteenth-century representations of the Virgin and Child. Thus the picture represents, personally and artistically, a true homecoming.

No sooner had Rubens arrived back in Antwerp – even before his appointment as court painter – than he was approached with offers for altarpieces for the most important of the city's churches, and the principal churches in nearby Malines, Brussels and Ghent. His first commission, however, was not for an ecclesiastical building but for Antwerp's town hall; it involved the decoration of the Chamber of States or Statenkamer, in which the truce was to be signed. For this Rubens painted an *Adoration of the Magi* (61), the first of many versions of the theme he was to execute for his Flemish patrons.

The subject of the wise men arriving at Bethlehem to pay their respects to the infant Jesus, the 'Prince of Peace', was especially suitable for a room which was to host a meeting of emissaries who had travelled to Antwerp to sign a peace treaty. Moreover, the theme was traditionally used to symbolize the submission

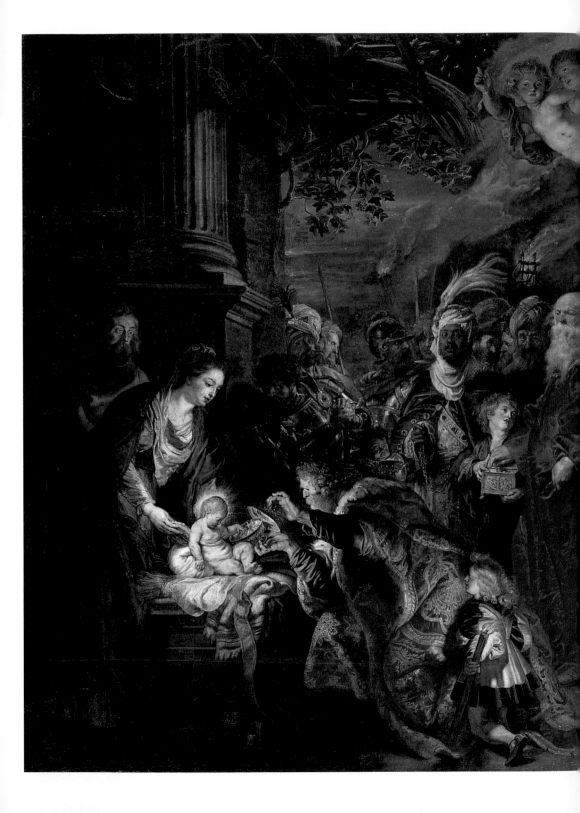

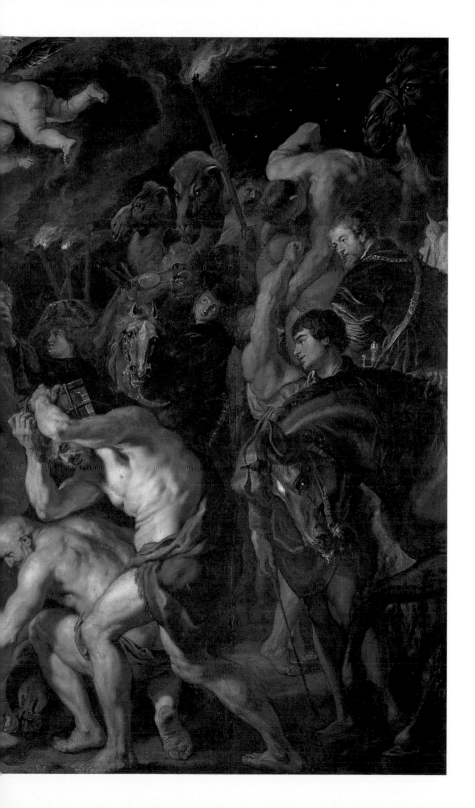

61
*The Adoration
of the Magi*,
1609.
Oil on canvas;
346×488 cm,
136¼×192⅛ in.
Museo del
Prado, Madrid

of the temporal powers – namely, the dignitaries meeting in the Statenkamer – to the authority of the Church. The subject itself provided an opportunity to indulge in grandiose pageantry, which Rubens exploited to the full. It is an immense, crowded composition, lit by flaring torches which illuminate the kings in their red and gold robes and the Holy Family, placed before a massive column. The kings offer their costly gifts to the infant, presented by the Virgin, who, unusually, is standing. The work is still typical of Rubens' Italian style: the lighting effects recall Caravaggio and Elsheimer as well as his own early Roman altarpiece for Santa Croce in Gerusalemme (see 42); the colouring and splendour of costume and architecture, and the golden-haired pages are reminiscent of Tintoretto and Veronese, while the muscular nude men recall Rubens' careful study of Michelangelo.

The painting remained in Antwerp only two years before it was presented by the magistrates to Don Rodrigo Calderón, an emissary from Spain, in gratitude for granting the city certain privileges in the spice trade; it was later bought by Philip IV. At some time, probably either in 1611 when the painting left Antwerp or in 1628, when Rubens himself was sent on a diplomatic peace mission to Madrid, he enlarged the canvas to include horsemen on the right, one of whom is the painter himself (62). If, as is usually assumed, the additions were made at the later date, they show Rubens consciously recreating his earlier style.

62
Rubens' self-portrait from *The Adoration of the Magi* (detail of 61)

Following *The Adoration of the Magi*, Rubens' major commissions from Netherlandish patrons were for religious works. The Counter Reformation had a powerful influence on the art produced in the first half of the seventeenth century in the Southern Netherlands, where the movement was particularly successful. A fundamental problem in ruling the region was the lack of a sense of national identity. Separated from its former countrymen in the north, to whom it was ethnically, culturally and historically closely bound; linguistically divided (the area covered, as it does today, three languages: Dutch, French and German); and administered from Spain, the Southern Netherlands

was a conglomeration of diverse entities in need of a national purpose. The lacuna was filled by the Church. In this new phase of optimism and revitalization, the Spanish Netherlands became one of the most Catholic nations on earth.

In Europe as a whole, the Counter Reformation was succeeding in many of its aims. At the end of the sixteenth century, approximately half of Europe was officially Protestant; by 1650 only one-fifth remained so, the other regions having reverted to Catholicism. Much of the initiative in the reform movement was taken by such gifted individuals as St Ignatius of Loyola, who established the missionary and teaching Society of Jesus, known as the Jesuits; St Francis Xavier, an early member of the Society and a missionary in the East; St Philip Neri, who founded the Oratorians; and St Theresa, who reformed the Carmelite Order. Rubens received commissions from all of these orders, most notably the Jesuits.

The process of Catholic reform was overseen by the Council of Trent (named after the city in northern Italy where it was convened), and the visual arts were accorded an important role. After decades of Protestant polemic regarding the validity and status of art itself (see Chapter 1), the Church turned wholeheartedly and triumphantly to visual images as a vehicle for instruction and propaganda. Artists were given the task of fashioning a new pictorial language that would at once edify, convert and arouse ever greater religious fervor. No artist was better suited to create such a language than Rubens.

In 1610 Rubens was commissioned to paint his first major altarpiece in Antwerp, for the high altar of the parish church of St Walburga (the church no longer exists, and the altarpiece is now in the cathedral of Antwerp). The subject is *The Raising of the Cross*, a theme he had first attempted eight years earlier for the church of Santa Croce (see Chapter 2). While the earlier work was on a side panel in an ensemble for a subterranean chapel, *The Raising of the Cross* for St Walburga comprised the central piece in a triptych which stood above the high altar in

a vast Gothic church, where it had to be seen from a distance. Moreover, owing to special architectural requirements, the choir of the church had to be raised, so that the altar was approached from the nave by a flight of steps. This meant that Rubens' picture was placed considerably higher than the usual altarpiece. Today, when visual information often takes the form of photographic reproductions, it is easy to lose sight of the size of the original, and of its intended location and function. With this in mind, it is important to convey some idea of the impact of the St Walburga altarpiece in its original setting (64).

Unlike Rubens' major Italian altarpieces, which consisted of a central panel and two side panels – the Santa Croce *St Helena with the True Cross*, the Mantuan *Adoration of the Trinity* and the second version of the work for the Chiesa Nuova – for this commission either Rubens or his patrons chose the structure of the triptych (65). This format, comprising a central panel with two hinged side panels or wings, had been used for altarpieces in northern Europe since the Middle Ages. The movable wings could be viewed on both sides and thus offer a different picture when closed, a feature exploited to great effect in the religious calendar. Thus the triptych would be presented in its closed state on ordinary days and opened on Sundays or special Feast Days, an arrangement which allowed for variations between the inside and outside scenes and for a certain complexity in the iconographic programme. Typically, the outside wings are painted in a simpler and more subdued style, being used to illustrate less liturgically significant figures or scenes.

While the structure and organization of Rubens' altarpiece are, to a large extent, traditional, its size surpasses any previous such work. Together with the wings, *The Raising of the Cross* is 6·4 m (21 ft) wide and 4·6 m (15 ft) high. It should be noted that the original structure included three predella paintings (small panels attached below the central piece), as well as a painting of God the Father placed directly above Christ. On either side of God the Father were angels painted on board (63) and cut along the

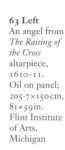

63 Left
An angel from *The Raising of the Cross* altarpiece, 1610–11. Oil on panel; 205·7×150 cm, 81×59 in. Flint Institute of Arts, Michigan

64 Right
Anthoon Gheringh, *Interior of the Church of St Walburga at Antwerp*, 1661. Oil on canvas. St Paul's, Antwerp

65–66 Overleaf
The Raising of the Cross with side panels *The Virgin and St John with Women and Children* and *Roman Soldiers*, 1610–11. Oil on panel; central panel: 462×300 cm, 181⅞×118⅛ in, side wings each: 462×150 cm, 181⅞×59 in. Cathedral, Antwerp
Right
Detail of *The Raising of the Cross*

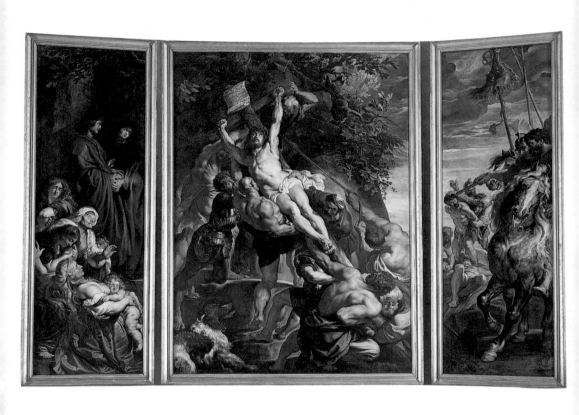

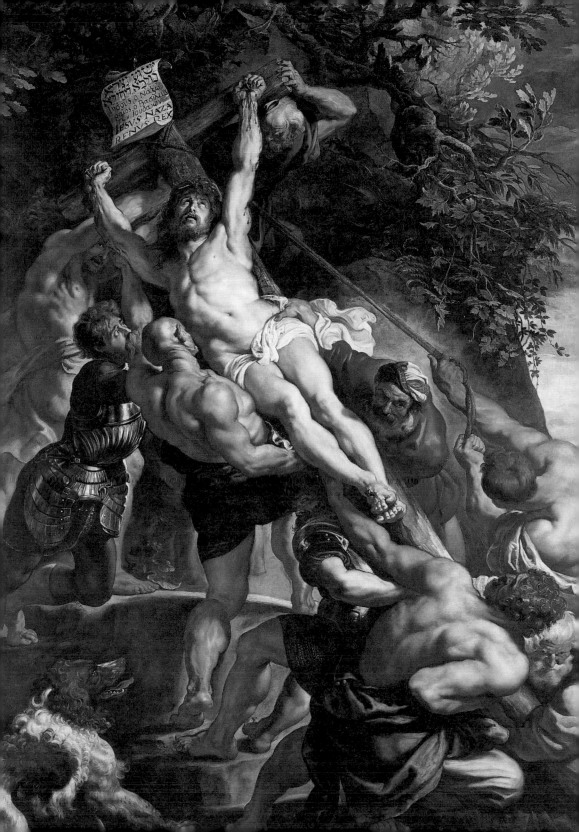

contours. The whole complex was crowned by a pelican in gilt wood (the pelican was an emblem of Christ's sacrifice, because it was believed that a pelican fed its young with its own blood), bringing it to a height of about 10·7 m (35 ft).

The principal subject, *The Raising of the Cross*, fills the large middle panel, but Rubens extended the figure groups and the landscape background into the wings on either side, so that the three panels present a continuous scene. In the wing at the left, the Virgin and St John (65) with a group of horrified women and children watch the executioners as they go about their task; on the right, the Roman officers issue their orders, while the two thieves are likewise prepared for execution. On the outside of the wings are four saints, Amandus, Walburga, Eligius and Catherine (67), all venerated in Flanders. Their placement and, indeed, inclusion in the ensemble is reminiscent of the second version of Rubens' Chiesa Nuova altarpiece (see 56, 57).

67
*Saints
Amandus,
Walburga,
Eligius and
Catherine*
(exterior of
wings of 65)

Not surprisingly, Rubens drew heavily on his Italian experience, and not only on the works he himself had executed in Italy. The body of Christ, viewed in diagonal foreshortening, recalls the elevation of the cross with the repentant thief in Tintoretto's *Crucifixion* in the Scuola di San Rocco in Venice (68). Comparing the two images we see how Rubens, by turning the axis of the cross so that the body of Christ appears in a more upright and frontal position, has transformed Tintoretto's invention into a more powerful composition in both emotional and visual terms. The action acquires intensity and force by being set against a dark wall of rock which extends behind the Virgin and St John on the left wing.

Besides Tintoretto, the influence of ancient sculpture and of Michelangelo is evident in the figure of Christ and the straining bodies of the executioners. Specifically, it is Rubens' copies of the Laocoön and nude youths from the Sistine ceiling (see 30–33) that come to mind. In evoking these sources, Rubens not only presented Christ as a powerfully modelled nude but also infused this image with the appropriate overtones of the humanistic

68–69
Tintoretto,
The Crucifixion,
1565.
Oil on canvas;
536×1224 cm,
211×481⅞ in.
Scuola di San
Rocco, Venice
Right
Detail
showing the
repentant thief

70 Far right
*The Raising of
the Cross*
(detail of 65)

tradition. Beyond the skilful depiction of the human form, the educated viewer of the time would have recognized its classical and Renaissance sources, whose very eminence lent nobility and pathos to the figure. Rubens enhances this heroic image by using strong contrasts of light and shade. The way in which the light is made to play over the bodies is quite different from anything Michelangelo did. This treatment of light, influenced by Caravaggio, is typically Baroque. It encourages an appeal to our emotions as no Renaissance work does.

Rubens' Christ, with his muscular body, upraised arms and lifted head, is far removed from the image of an emaciated, broken

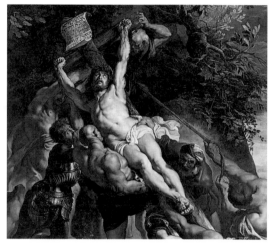

figure, head sunk low, which originated in the Middle Ages. True, in these images Christ is already dead, while in *The Raising of the Cross* he is still alive. But a comparison between Rubens' figure and earlier representations is still valid, since at the time the cross is being raised – an unusual subject in medieval and Renaissance art – Christ has already undergone a series of tortures, even if his final agony is still before him. In true Counter Reformation spirit, Rubens emphasizes the victorious aspect of the Cross, not because Christ has not yet experienced its full horror, but because he will overcome it. At the same time, the image is meant to remind the faithful of Christ's divine nature. While an emphasis

on the humanity of Christ which had developed towards the
end of the Middle Ages continued to play an important role in
Protestant art, Catholic art of the Counter Reformation needed
a more heroic, god-like image for the suffering Saviour.

Besides offering a more positive interpretation of Christ's
sacrifice, Rubens' painting observes one of the surprisingly
few specific recommendations made to artists by the Council
of Trent. Responding to Protestant objections, the Church
delegates demanded greater accuracy in the depiction of biblical
events. As a result, the lives of the Virgin, the infant Christ and
the saints, which had been so lovingly augmented with humanly
expressive details over the past centuries, were purged of some
apocryphal additions. One such detail is the Virgin collapsing at
the foot of the Cross, as she is frequently shown in fifteenth- and
sixteenth-century art. Referring to the words spoken by St John
(19:25), 'Near the cross … *stood* his mother', Church authorities
frowned on pictures of the Virgin swooning. A Virgin standing
upright, as in Rubens' painting, would shift the emphasis from
weakness and defeat to strength and courage. This image not only
adhered more closely to the Gospel text but accorded with the
positive, triumphant aspect of Counter Reformation Catholicism.

The earthly realism of Rubens' picture – the large, fleshy figures,
the excited little dog, the mother with her naked child at her
exposed breasts – may be disturbing. When it comes to arousing
religious feelings, many people today prefer the asceticism of
medieval art or the ethereal images of a painter such as El Greco.
In Rubens' art, celestial apparitions, spirituality and ecstasy are
represented with the same material solidity as events on the
physical plane. This gift for giving body and form to a spiritual
state is what provides Rubens' pictures with such vitality and
optimism. It was one of the principal reasons for his fame among
his contemporaries: he created robust images for a robust faith.
Simultaneously, it is their very corporeality that imbues Rubens'
religious figures – his Christ and saints, his apostles and holy
women, even his angels – with a humanity equal to the humbler

biblical images of Rubens' great Dutch contemporary, Rembrandt van Rijn (1606–69). Rubens' Christ is truly God made flesh.

Shortly after completion of *The Raising of the Cross*, Rubens received his second commission for a major triptych, *The Descent from the Cross*, for the altar of the Arquebusiers' (Musketeers') Guild in the transept of Antwerp cathedral (72). The Arquebusiers were a paramilitary group of the largely ceremonial kind so popular in the Netherlands in the sixteenth and seventeenth centuries (its counterpart in Amsterdam later commissioned Rembrandt's famous *Nightwatch*). *The Raising of the Cross* and *The Descent from the Cross* have been in the same church since 1815 and are usually discussed together. Their iconography complements each other; they are triptychs of roughly similar size (*The Descent* is somewhat smaller); and they represent two distinct styles that Rubens adopted in the early years after his return to Antwerp. It should be remembered, however, that they were commissioned independently, from different patrons and for different locations.

In *The Descent from the Cross* the three panels show separate scenes. The main subject occupies the central panel: a group of interlocking figures is arranged in elliptical form around the slumping body of the dead Christ. St John, in a scarlet cloak, one foot on the ladder for support, is the principal weight-bearer. He is assisted by Joseph of Arimathea, placed diagonally across him. Above him on the ladder is Nicodemus; two men leaning over the bar of the cross are engaged in lowering the body, one of them holding the winding sheet between his teeth, so as to free his hands. Mary Magdalen and Mary Cleophas kneel at the foot of the cross, while the Virgin is once again standing upright, her anguish and grief expressed in the pallor of her face rather than her pose. All participants are strongly lit, producing a relief-like effect. This is enhanced by the dark background, which opens, on the left, to a glimpse of evening sky.

As in *The Raising of the Cross*, there are references to the Laocoön group: the figure of Christ repeats that of Laocoön in reverse, while the pose of Nicodemus, descending the ladder on the right,

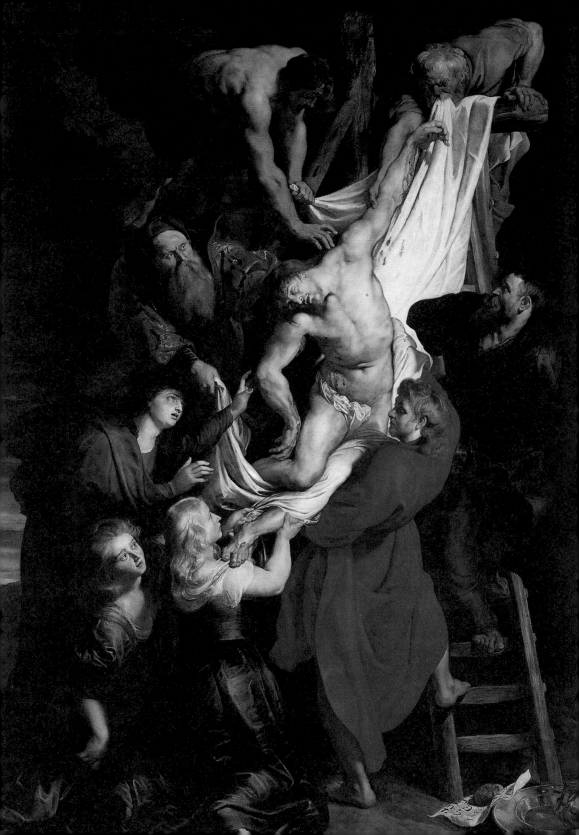

PHAIDON PRESS LIMITED

Customer Service Department

Regent's Wharf

All Saints Street

London N. 9PA

England

Dear Reader, Books by Phaidon are recognised world-wide for their beauty, scholarship and elegance.
We invite you to return this card with your name and address so that we can keep you informed
of our new publications, special offers and events.

Subjects in which I have a special interest

☐ Art ☐ Architecture ☐ Design ☐ Photography ☐ Decorative Arts

☐ Music ☐ Art Videos ☐ *Please send me a complimentary catalogue*

Name

Occupation

No./Street

City

Post code Country

E-mail

Book / Video purchased

Title

Author

ISBN

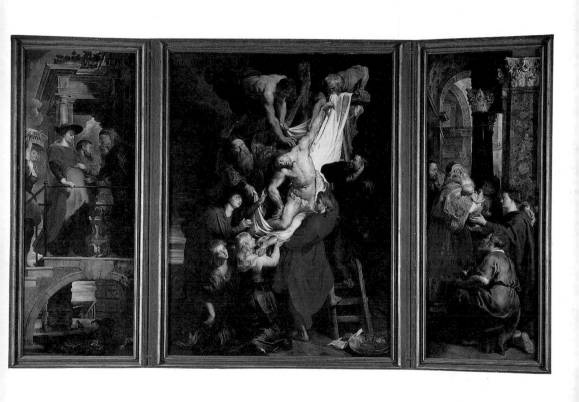

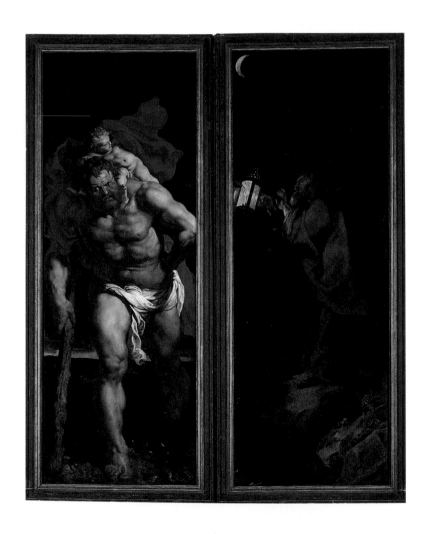

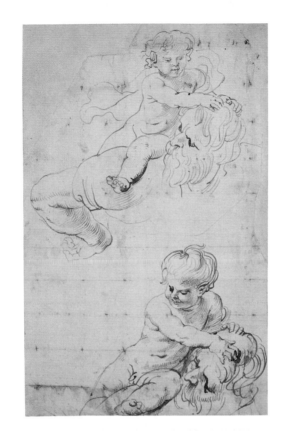

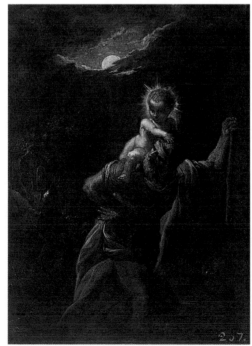

is derived from that of the elder (right-hand) son in the ancient marble sculpture (see 29). Rubens' decision to reverse the pose of the struggling Trojan priest for the depiction of the slack figure of the dead Christ constitutes a simple and effective change in form. More significant, however, is the change in content: by using the figure of the Trojan priest for the figure of the Saviour, the artist transformed a pagan into a Christian subject. One of the great achievements of Rubens' art, as of Michelangelo's before him, is that it distilled from the ancient stories, be they classical or biblical, a universal truth that went beyond the rigid division of the pagan and Christian world. Thus the death of Laocoön becomes the Passion of Christ.

Instead of continuing the central space throughout the three panels, as in *The Raising of the Cross*, the scenes on the wings of *The Descent* are set in separate surroundings, in both cases architectural. On the left, high up on a bridge in front of a classical portico, a pregnant Virgin Mary meets her older cousin Elizabeth, likewise pregnant, future mother of John the Baptist. On the right, in an elaborately structured temple interior, the Christ-child is being presented to the High Priest. Both scenes, *The Visitation* and *The Presentation in the Temple*, deal with the beginning of Christ's life, in contrast to his end depicted in the centre. Thus the three panels have neither the spatial nor temporal unity of *The Raising of the Cross*. Instead, they are joined iconographically. The theme that links the three subjects is suggested by the etymology of the name 'Christophorus', which in Greek means Christ-bearer. St Christopher was the patron saint of the Arquebusiers, who commissioned the altarpiece. According to legend, St Christopher, whose doubtful historicity had led the Council of Trent to try to abolish his cult (the saint was finally removed from the Church calendar only in 1969), had once carried the Christ-child across a river. Using the saint's role as the leitmotif for the entire triptych, the three scenes depict incidents in which Christ is being physically carried or supported: in *The Visitation*, the Virgin carries the unborn child in her womb; in *The Presentation*, the High Priest holds the child in his arms;

in *The Descent*, St John, assisted by the other mourners, supports the dead body of the Saviour.

On the outside wings of the altarpiece, Rubens painted St Christopher carrying the tiny Christ-child on his massive shoulders. He is lit by the lantern held by a hermit who is part of the legend (73). By devoting the inside panels to events in the life of Christ and relegating the dubious St Christopher to the outside, Rubens cleverly accommodated the theme desired by his patrons to Catholic requirements. For the figure of St Christopher, Rubens' inspiration once again came from a classical work, the famous statue of Hercules which the artist had studied in the Farnese Collection in Rome. In his depiction of the relationship between the diminutive child and his bearer, however, Rubens turned to a more recent precedent – a painting by Adam Elsheimer (75) of which he had made two studies, apparently in preparation for the triptych (74).

By unifying the three panels of the altarpiece iconographically rather than compositionally, Rubens went back to triptychs by early Netherlandish masters including Jan van Eyck, Rogier van der Weyden (1399/1400–64) and Hans Memling. In these, as in Rubens' altarpiece, scenes that either announce or prefigure the central event are frequently relegated to the side panels. In a similar way, Rubens had devised an iconographically unified scheme in his paintings for the Jesuit church in Mantua, where the Trinity provides the overall theme, as well as the Santa Croce altarpiece in Rome, in which the central subject of St Helena's vision of the Cross is framed by scenes from Christ's Passion (see chapters 2 and 3). The structure of these works, however, differs radically from that of *The Descent from the Cross* and *The Raising of the Cross*. It seems surprising that, after years in Italy, Rubens should return to the old-fashioned design of the triptych, but the decision probably had more to do with his patrons than with him. By around 1615, as his reputation grew, Rubens became increasingly responsible for designing his own altars, with the result that, except in special circumstances, he abandoned the triptych

form in favour of single panels incorporated into monumental architectural frameworks (see 212).

The two great triptychs established Rubens as the foremost artist of the Southern Netherlands, indeed northern Europe. They were easily accessible, being in churches, and not only to the local population. Antwerp attracted many foreign visitors, especially after the truce had taken effect, who marvelled at the city's splendid buildings and works of art within them. Rubens' fame for a long time rested largely on these and similar commissions rather than on the work he did for the nobility. In fact, Rubens' most important projects in the period of 1609 to 1620 – and those which established his reputation – came from wealthy burghers acting on behalf of churches or civic organizations. In this respect, Rubens' career in Catholic and Spanish-dominated Antwerp was not so dissimilar from the systems of patronage that later supported Rembrandt's work in Protestant and independent Amsterdam.

76
Portrait of
Nicolaas
Rockox
from *The
Presentation in
the Temple*
(detail of 72)

Instrumental in securing the commissions of *The Raising of the Cross* and *The Descent from the Cross* for Rubens were, respectively, Cornelis van der Geest, spice merchant and art lover, and Nicolaas Rockox, president of the Arquebusiers' Guild and mayor of Antwerp. Rockox's role in the ordering of *The Descent from the Cross* is acknowledged by the inclusion of his portrait among the faithful in *The Presentation in the Temple* (76). Although not present among the bystanders in *The Raising of the Cross*, Van der Geest's involvement in the negotiations for the altarpiece is recorded in the later print made after it, which is dedicated to him. Thus Rubens paid tribute to the two men who, by their considerable influence in city life, secured important commissions for him and who were also his friends.

Antwerp was also home to a community of artists with whom Rubens established professional and personal relations. In June 1609 he was elected to the prestigious brotherhood of Romanists, an association of men who had studied in Italy and whose most distinguished member was Rubens' former teacher, Otto van Veen. Another Romanist, and one Rubens especially came to

cherish as a friend and colleague, was Jan Brueghel (77), son of Pieter Bruegel the Elder, the famous sixteenth-century master who had immortalized Flemish peasant life (see 201 and 207). Jan himself was famous for his still-life paintings of flowers, which elicited Rubens' admiration, so that the two artists collaborated in a series of exquisite pictures (see 96). Besides Jan Brueghel, there were Frans Snyders (1579–1657; 78), a gifted painter of animals, and the landscape artist Jan Wildens (c.1586–1653; 79), who came to work with Rubens (see Chapter 5). Somewhat younger were Jacob Jordaens (80), who had studied with Rubens' second teacher, Adam van Noort, and who was to become the foremost painter of Antwerp after Rubens' death, and Anthony van Dyck (81), who started his career in Rubens' studio, working with the older master.

Rubens' circle of professional and personal contacts in Antwerp grew rapidly, but his happy reunion with his brother Philip came to a sudden end when Philip died unexpectedly in August 1611, at the age of thirty-eight. With the death of the painter Adam Elsheimer, news of which had reached Rubens in early 1611, and that of his brother, the artist not only lost two close friends but must also have been aware that this marked a break with the intellectual and artistic circle whose company he had enjoyed so much in Rome.

It was probably through Philip that Rubens re-established contact with the scholar and Lipsius pupil Jan Woverius, later town clerk of Antwerp, whom he had first met in Italy. Some time around 1612 he painted a group portrait known as *The Four Philosophers*, depicting Justus Lipsius, Jan Woverius and the two Rubens brothers (82). As in the *Mantuan Friendship Portrait* (see 46), the picture's focus is Lipsius, but while the earlier painting places him at the edge of the composition, in *The Four Philosophers* he takes centre stage, flanked at either side by his two pupils, Philip Rubens (on the left) and Jan Woverius. They are seated at a table on which lie a number of books and writing utensils. Wearing the fur-trimmed gown of a professor of Louvain University, Lipsius

points with his left hand to an open volume, presumably his Seneca edition (since the pages of the book are left blank, identification is not certain), while the right gestures rhetorically. He is thus seen in his role as teacher. In a niche behind Lipsius stands a bust of Seneca, which Rubens had acquired in Italy and which, once back in Antwerp, he placed above the entrance to his studio (see 27). Next to it is a vase with four tulips: two open, symbolizing the two living friends in the group, Jan Woverius and Rubens, and two closed, in reference to the two members in the circle who had died, for Lipsius had died in 1606. The view in the

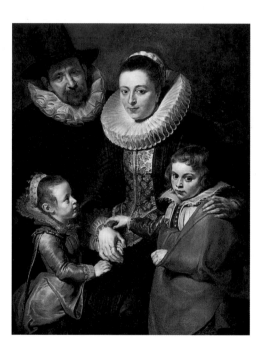

77–81
Rubens' friends and colleagues in Antwerp

Left
Jan Brueghel the Elder and his Family, c.1612–13. Oil on panel; 124.5×94.6cm, 49×37¼ in. Courtauld Institute Galleries, London

Right, l to r: *Frans Snyders, Jan Wildens* and *Jacob Jordaens* from *The Iconography*, a collection of etched and engraved portraits after works by Anthony van Dyck, c.1632–44

Far right Anthony van Dyck, An engraving after a self-portrait, the title-page from *Centrum Icones*, an edition of *The Iconography* published in 1645

distance is of the Palatine Hill in Rome, the place which symbolized the civilization of ancient Rome, revered by all four friends. *The Four Philosophers* primarily commemorates and honours the three classicists and their work, especially Philip Rubens and Lipsius. For this reason the painter is placed in the background. Drawing aside the curtain on the view of the ancient ruins, he is an observer of the lively debate before him. A touching note is introduced by the dog in the right foreground, identifiable as Lipsius' beloved Mopsulus.

Lipsius' Seneca edition was published by the Plantin Press whose head was, by this time, Rubens' childhood friend, Balthasar Moretus. The friendship between painter and publisher broadened over the years to include a close professional association. They had already collaborated on the publication, in 1608, of Philip Rubens' book on ancient Roman customs which was illustrated by Rubens (see Chapter 3). For the next thirty years, Rubens was to supply the Plantin Press with designs for title-pages for all kinds of books, from Lipsius' edition of the philosophical writings of Seneca to a treatise on optics (83); from Catholic liturgical and devotional texts, to books on statutes and local history. The arrangement was simple and practical: the artist would supply drawings suitable to be engraved in

return for books. Thus Moretus received beautifully designed title-pages for his publications, and Rubens was able to assemble a first-rate library.

The decade following Rubens' return from Italy was an especially busy period for the painter. He was responsible for more than sixty altarpieces; a major decorative programme for the new Jesuit church in Antwerp (see Chapter 5), as well as being involved in other aspects of the decorative scheme of that church; independent works for private clients and the open market; designs for tapestries and title-pages; and the supervision of prints after his paintings. Such enormous output would have been inconceivable without an efficiently organized studio.

The Romantic notion of creative genius stresses the imaginative isolation of the artist, and to modern eyes the workings of Rubens' studio can suggest assembly-line production. At the time, however, the practice of engaging assistants was of long standing: Italian Renaissance artists such as Raphael, Giulio Romano and Titian all had large studios, and in sixteenth-century Antwerp their example was followed by the painters Frans Floris and Marten de Vos. In Rubens' studio, there seems to have been a clear distinction between pupils or apprentices, assistants and collaborators. Pupils were probably confined to preparing pigments, panels or canvases and other preliminary work; more

82
Justus Lipsius and his Pupils or *The Four Philosophers*, *c.*1615.
Oil on panel; 167×143 cm, 65¾×56¼ in.
Galleria Pitti, Florence

83
Theodoor Galle,
Title-page after a design by Rubens for Franciscus Aguilon's *Opticorum libri sex*, 1613.
Engraving

advanced pupils were perhaps also involved in making copies after the master's works, for which there was a steady market. There is no record of just how the apprentices were instructed; it is possible that Rubens corrected their work, or informed them verbally of important points. Taking into account his busy schedule, he may have organized a teaching hierarchy, with more advanced pupils instructing novices.

Assistants were generally young artists who had finished their training (not necessarily with Rubens) but who wished to have

further experience of working in the studio of a leading artist. Rubens himself may have followed this course, if – as has been assumed – he stayed in the studio of his teacher Otto van Veen for two years after he had completed his own training. Assistants could carry out advanced work on the preparation and execution of paintings; Rubens' most gifted assistant was Anthony van Dyck. Collaborators were independent masters with their own workshops who contributed their specific talents, be it a landscape, still life or animals, to the final product. Among Rubens' collaborators, the most outstanding were Frans Snyders and Jan

Brueghel the Elder. Rubens would have done the preparatory designs for all works, even those for which the final version was largely painted by assistants.

The first step in the picture-making process was the layout of the composition. In some cases this took the form of a rapid pen drawing, but more often Rubens set down his first ideas directly with the brush and oils on a small panel. This oil sketch, or *modello*, served a double purpose: it would be submitted to the

patron for approval, and once that was obtained it would be given to the assistant as the model for the full-scale painting. In the case of altarpieces, ecclesiastical authorities would have the opportunity to check iconographic details. In *The Raising of the Cross*, iconographic corrections seem not to have been required, but there are formal and compositional changes between the oil sketch (84) and final painting (see 65). In the *modello*, the thieves appear twice: in the central panel as well as the right wing. Rubens must have had alternative solutions in mind when he presented his sketch, and these must have been resolved at this stage. Moreover, the cross in the *modello* is in a more horizontal position, recalling Tintoretto's *Repentant Thief* (see 69). By moving the cross to a more upright position, Rubens heightened the dramatic impact of the action. At the same time, he turned the body of Christ so that it faces the spectator, thereby giving greater emphasis to the anguish as well as triumph of the Saviour.

With the general composition established in the oil sketch, Rubens was able to turn his attention to individual figures, for which he made chalk drawings from the living model. In the oil sketch Rubens had determined the character of each figure and its place in the ensemble; he then positioned models in the various poses in order to clarify or correct the postures previously set down. These large, precise drawings were useful for both the master and any assistant involved in executing the final painting. The Danish court physician Otto Sperling was to observe on his visit to Rubens' studio in 1621,

a good number of young painters each occupied on a different work, for which Mr Rubens had provided chalk drawings with touches of colour added here and there. The young men had to work these up fully in paint, until finally Mr Rubens would add the last touches with the brush and colours. All this is considered as Rubens' work; thus he has gained a large fortune, and kings and princes have reaped gifts and jewels upon him.

Here Sperling may have been referring either to large chalk drawings or, as is more likely, to outlines drawn directly on to

84
Oil sketch for
*The Raising of
the Cross*,
c.1610.
Oil on panel;
central panel:
68×51cm,
26¾×20 in,
side wings
each:
67×25 cm,
26⅜×9⅞ in.
Musée du
Louvre, Paris

the canvas or panel which the assistants worked up in paint. These underdrawings are no longer visible in the finished paintings (they can still be detected in many of Rubens' oil sketches, in places where there is no covering layer other than varnish), but they must have been rough outlines of the compositional figures which served as their models.

A series of particularly handsome drawings is associated with *The Raising of the Cross* (see 65): the figure of a young man, arms raised, was used virtually unaltered for that of Christ in the large painting, the pose adjusted as set down in the oil sketch (84, 85), while the broad-shouldered, muscular man (88) reappears as the elderly bald-headed executioner, and the youth with outstretched arms (90) is the man wearing armour seen in profile next to the bald executioner, his head slightly turned to the front. Rubens was initially uncertain about the position of this man's left leg, which he drew twice. Another sheet which can be connected with *The Raising of the Cross* shows various studies, apparently executed at different times (92): two pairs of clasped hands done in preparation for those of the Virgin (93); a female head in profile (copied after a classical model, this study has no connection with the altarpiece); and a bearded man in a millstone ruff. The last may be a portrait of Cornelis van der Geest, who was instrumental in the commission of the triptych.

These magnificent chalk drawings were mostly done from the living model, Rubens' preferred method for such studies, though in some instances he used his copies after sculpture. In the copying of sculpture, Rubens' advice (as quoted in Chapter 2) was to avoid the effect of stone, so giving the copies the appearance of having been done from life. Art and nature thus become interchangeable.

With the preparatory work completed, assistants could take over the execution of the painting. Rubens himself would put the final touches to it, giving the work his personal stamp of approval. The painting was then ready to leave the studio as a work by the master. Although consistent with Renaissance art theory, which differentiated between the creative invention of a work and its

manual execution, Rubens' system of production did not meet with universal approval. Dr Sperling, for one, seems to have felt that the fortune amassed by the artist in this manner was not entirely deserved. Despite Rubens' assurances that works of the studio 'are so well retouched by my hand that they are hardly to be distinguished from originals', the more sophisticated patrons and collectors were well aware of the distinction and, consequently, an original entirely by the master's hand and a work largely executed by assistants accrued different values.

Another type of teamwork practised in Rubens' studio involved independent masters rather than apprentices or assistants. The process was one of collaboration between equal partners, each contributing his specific talent. This type of work relied on specialization, a practice which became widespread in Antwerp in the sixteenth century. Thus, for example, the figure painter Quentin Massys (1465/6–1530) and the landscapist Joachim Patinir (c.1480–1524) worked together on *The Temptation of St Anthony* now in the Prado in Madrid. By the turn of the century, this method had become a convention which Rubens employed with great success. He collaborated with specialists in animal, landscape and still-life painting, genres for which he generally did not show great concern at this time (an exception is the series of hunting pictures discussed in Chapter 5) and which contemporary art theory considered subordinate to history painting. Moreover, in so far as the collaborative effort originated with Rubens, he naturally took the dominant part as head of his studio and its production. His role in these collaborations was therefore strictly that of first among equals.

One of Rubens' most talented collaborators was Frans Snyders (see 78), who specialized in still-life and animal pictures. Around 1612 they painted *Prometheus Bound* (94), in which Rubens was responsible for the figure of Prometheus and Snyders for the eagle. According to classical legend, the demigod Prometheus stole the secret of fire from the gods and gave it to man. To punish him, Zeus, the ruler of the gods, bound him to a rock

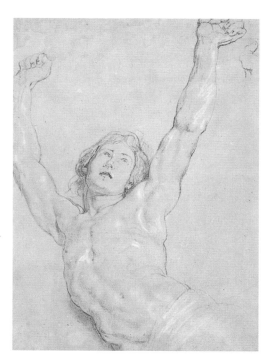

85 Far left
Study for the figure of Christ in *The Raising of the Cross*, *c.*1610.
Black chalk heightened with white; 40×29·8 cm, 15¾×11¾ in.
Fogg Art Museum, Harvard University Art Museums, Cambridge, Massachusetts

86 Above left
The Raising of the Cross (detail of 65)

87 Centre left
Oil sketch for *The Raising of the Cross* (detail of 84)

88 Below far left
Study for a figure in *The Raising of the Cross*, *c.*1610.
Black chalk heightened with white; 31·5×36·7 cm, 12⅜×14½ in.
Ashmolean Museum, Oxford

89 Below left
The Raising of the Cross (detail of 65)

90 Right
Study for a
figure in *The
Raising of the
Cross*,
c.1610.
Black chalk
heightened
with white;
48.8×31.5 cm,
19¼×12⅜ in.
Royal
Collection,
The Hague

91 Far right
*The Raising of
the Cross*
(detail of 65)

**92
Below right**
Studies of
heads and
hands for *The
Raising of the
Cross*,
c.1610.
Black chalk
heightened
with white;
39.2×26.9 cm,
15⅜×10⅝ in.
Albertina,
Vienna

**93
Below far
right**
*The Raising of
the Cross*
(detail of 65)

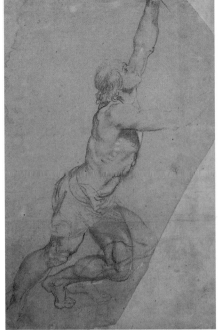

where he was to be tortured for all time by an eagle who fed on his liver. In this larger-than-life picture, Rubens created a powerful effect by showing Prometheus in strong foreshortening, his massive thighs drawn up in pain. The eagle's wings are spread wide so that they span the captive giant in a victorious arc. The collaboration is so seamless it might never have been noticed were it not for the existence of letters relating to an exchange of works of art between Rubens and the English diplomat and collector Sir Dudley Carleton, which took place in 1618. In these letters Rubens makes a clear distinction between works entirely

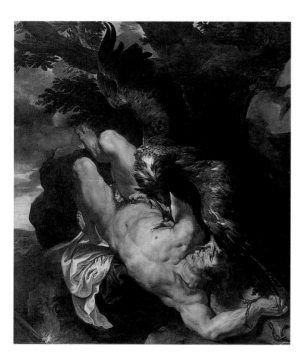

by his own hand, those executed by assistants that were afterwards retouched by him, and those produced in collaboration with another master. Among the latter he mentions 'A Prometheus bound on Mount Caucasus, with an eagle which pecks his liver. Original, by my hand, and the eagle done by Snyders'. A drawing of the eagle by Snyders also survives (95).

While Snyders' part in *Prometheus Bound* was that of an independent master who occasionally worked as Rubens' assistant, this

does not seem to have been the case in Rubens' collaborations with the flower and landscape painter Jan Brueghel the Elder. Motivated by friendship and professional cameraderie, the pictures they created together can be seen as a testimony to their relationship rather than a product of workshop pressure – a view supported by the fact that several of their paintings remained in Rubens' possession. Even before Rubens' departure for Italy he and Brueghel had collaborated on a picture of *Parnassus* (now lost), together with Otto van Veen (see Chapter 1). The collaboration continued after Rubens' return to Antwerp, in works for

94
Rubens and Frans Snyders,
Prometheus Bound,
*c.*1612.
Oil on canvas,
243×209 cm,
95⅝×82¼ in.
Philadelphia Museum of Art

95
Frans Snyders,
An Eagle,
*c.*1612.
Pen and ink with brown wash;
28·1×20·3 cm,
11⅛×8 in.
British Museum, London

96
Rubens and Jan Brueghel the Elder,
Madonna and Child with Garland of Flowers and Putti,
*c.*1618–20.
Oil on panel;
185×209·8 cm,
72⅞×82⅝ in.
Alte Pinakothek, Munich

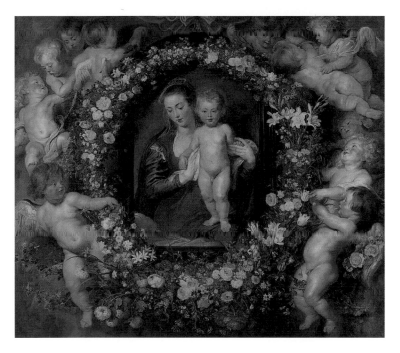

which Rubens executed the figures and Brueghel the landscape or still life of flowers. The two artists created several versions of the popular Counter Reformation subject of the Madonna and Child surrounded by a garland of flowers (96). In the centre Mary displays her infant son; around them is a floral wreath supported by putti. The picture is a clever display of illusionism: by enclosing the image of the Madonna and Child in a simulated wood frame, Rubens created a picture within the picture. This is surrounded by the garland of flowers which, in turn, is encircled

by the putti. The arrangement recalls Rubens' first altarpiece for the Chiesa Nuova, in which he placed at the top of a triumphal arch a similarly framed icon of the Madonna and Child (see 54). A charming detail is provided by the use of Rubens' second son Nicolas as the model for the Christ-child.

The final step in the process of picture-making in Rubens' studio was the reproductive print. Before the advent of photography, art lovers usually had to depend on engravings for their knowledge of works of art. These so-called reproductive prints originated in

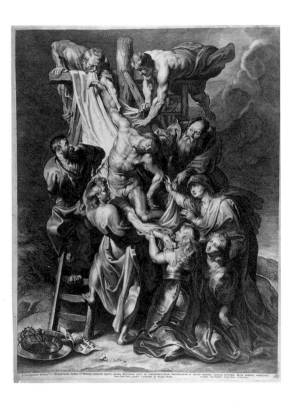

97
Lucas Vorsterman.
Copy after Rubens' *Descent from the Cross*, 1620.
Engraving;
57·2×42·4 cm,
22½×16¾ in.
British Museum, London

98
Rembrandt van Rijn,
The Descent from the Cross, 1633.
Oil on panel;
89·4×65·2 cm,
35¼×25⅝ in.
Alte Pinakothek, Munich

Italy in Raphael's workshop; Rubens had used one such design, by Marcantonio Raimondi, as his model for his early painting of *Adam and Eve* (see 14, 15). Yet while the production of such engravings in Raphael's workshop had been sporadic, Rubens' organizational talents and business acumen led him to exert more control over the engraving of his paintings. Their publication established him as the inventor of the designs and thus served as a kind of copyright.

Although Rubens did not do any engraving himself, he knew enough about the process to supervise it. He tried various engravers until some time before 1618, when he settled on the talented Lucas Vorsterman, who developed an astonishing skill in rendering subtle gradations of light and shade. It was through Vorsterman's engraving after *The Descent from the Cross* that the composition acquired widespread fame (97); its admirers later included the young Rembrandt, whose own rendition of the subject was influenced by it (98).

Rubens' association with Vorsterman lasted until 1622; but in the end it nearly cost Rubens his life. It seems that Rubens' designs, often executed in a painterly manner with the brush, wash and bodycolour, were not always easy to convert into the linear precision of the burin (engraving tool) working the copper plate. On the other hand Rubens, though not proficient in the practice of engraving himself, was evidently highly demanding. What exactly happened between the two artists is not known, but it seems that Vorsterman reached breaking point over one particularly elaborate and complicated design. Rubens had to be given court protection when threats were made on his life. Thereafter, the engravers employed by Rubens worked on commission, but it must be said that no one was to match the skill of the unfortunate Vorsterman.

Engravings after Rubens' paintings by Vorsterman and the numerous other competent engravers who worked for him sold in great numbers and at considerable profit to the master, not only in the Southern Netherlands but in the Northern Provinces and France. By the mid-1620s they were to find a market in England, Germany and Italy. Rubens, the most eminent painter of Antwerp, had established himself as an artist of international fame.

Combining the duties of court painter with those of directing a busy workshop may seem a daunting task, but Rubens' talents appear to have been well suited to demanding, large-scale endeavours. In a passage dated September 1621 he wrote:

I confess that I am, by natural instinct, better fitted to execute very large works than small curiosities. Everyone according to his gifts; my talent is such that no undertaking, however vast in size or diversified in subject, has ever surpassed my courage.

The passage refers to the decoration of the King of England's Banqueting House in Whitehall, London, then under construction, for which Rubens did indeed receive the commission many years later (see Chapter 8). And although his own view of his capabilities may appear immodest, even boastful, it is certainly honest.

99
Willem
van Haecht,
*The Studio
of Apelles*,
c.1630s.
Oil on panel;
105×149.5 cm,
41⅛×58⅞ in.
Mauritshuis,
The Hague

Rubens' appointment as court painter had gained him exemption from the usual regulations of the Antwerp Painters' Guild, which included the paying of taxes and restrictions on the number of pupils a master could admit. This arrangement enabled him to establish the kind of studio essential for the numerous commissions he was to receive. However, there are signs that even Rubens may at times have found his freedom a mixed blessing. Already by May 1611 he was writing to a friend in Brussels, who had recommended a young man to his care, that he was not in a position to offer him admittance to his workshop, because, as he continued with some concern, 'I can tell you truly, without exaggeration, that I have had to refuse over one hundred, even some of my own relatives or my wife's, and not without causing great displeasure among many of my best friends.'

Already two years after his return to Antwerp, Rubens' success and the volume of work being produced by his studio meant that

he needed more spacious accommodation than that provided by his father-in-law. With his first child on the way as well (Clara Serena was born in March 1611), in November 1610 he purchased a house on the Wapper, which he remodelled and enlarged over the next five years. The original building was a typical sixteenth-century Flemish house of timber and stone. It had a courtyard, a garden and some adjoining land, but it was not large enough for the artist's family, his studio and possessions. On the garden site, Rubens added a semicircular room to display the ancient busts and statues which he had begun to collect in Italy and continued to acquire after his return to Antwerp. The design of the room was based on the Pantheon, the famous ancient temple in Rome with its circular plan and dome, which had originally functioned as a sanctuary for images of the gods. On open land adjoining the house Rubens built his large studio on two levels, an upper floor for his pupils and assistants, the lower floor for himself. A picture by Willem van Haecht (1593–1637) gives an impression of the interior of Rubens' house, the 'pantheon' at the end of a series of rooms filled with works of art (99). Into this seventeenth-century setting is inserted, somewhat incongruously, the figure of the ancient Greek painter Apelles undertaking a portrait of Alexander the Great's lover Campaspe, while the king looks on. Though not an actual portrait of Rubens, the picture as a whole is meant to convey a sense of the world of the famous Antwerp painter, the 'Flemish Apelles'.

Although the old house, which Rubens essentially left unaltered, is in the northern European Late Gothic style, the additions are in the modern Italian manner, with broken pediments over the windows and richly carved busts and statues on the outer walls. In fact, it was above the door on the wall facing the courtyard that Rubens placed the bust of Seneca which he had acquired in Italy and which features so prominently in *The Four Philosophers* (see 82). Following a tradition for the decoration of houses that originated in Italy, Rubens painted the façade of his studio with grisaille (*ie* in shades of grey) scenes. Although these do not survive, engravings and other documents record that they were

recreations of works by or events from the lives of ancient Greek artists. The open space enclosed by the house and studio was separated from the garden by a stone screen divided into three arched doorways (100). Through the arches a formal garden and a small classical pavilion could be seen.

What is especially distinctive about the whole ensemble of Rubens' house, courtyard and garden is its iconography. Statues of Minerva (or Athena, her Greek name), goddess of wisdom and learning and patron of the arts, and Mercury (or Hermes), god of eloquence and reason and patron of painters and diplomats,

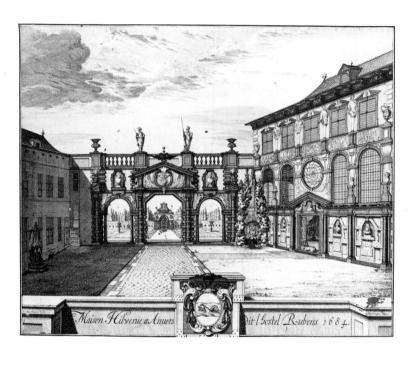

100
Jacob Harrewijn,
View of the Rubenshuis,
1684.
Copy after Jacob van Croes.
Engraving

surmount the central arch, from where they preside over the entire complex. The original screen contained two tablets above the flanking arches, inscribed with a passage from the writings of the Roman poet and satirist Juvenal: on the left, 'Leave it to the gods to give us what is fit and useful to us; dearer to them is man than he is to himself,' and, on the right, 'One must pray for a healthy mind in a healthy body, for a courageous soul which is not afraid of death … [and] which is free of wrath and desires nothing.' While Rubens has chosen a classical text, it is one that

offers that blend of Stoic thought and Christian piety that played such a central part in his art and life. The garden pavilion, appropriately, was crowned by the allegorical figure of Abundance, while the building itself may have held a statue of Hercules, with two further statues placed between the columns, of which one can be identified from the old engravings as Venus and Cupid. The theme of abundance was continued on the studio wall facing the garden where, among the rich display of carvings and paintings, stood statues of Bacchus, god of wine, and Flora, goddess of flowers.

Thus the decorative programme of Rubens' house and garden encompassed the entire spectrum of man's desires, hopes and ambitions, with Minerva and Mercury representing intellect, wisdom and professional success, Hercules fortitude and strength, Venus and Cupid ensuring love and fertility, Bacchus and Flora feasting and the bounty of nature. That such a pantheon of pagan deities presided over Rubens' home may surprise us. However, they were not present as gods to be worshipped but rather as allegorical personifications to remind the artist and his visitors of the desirability of those qualities symbolized. Rubens was not the first artist to include ancient gods in the decorative ensemble of his house. A statue of Mercury was placed above the door of Giulio Romano's residence in Mantua, which Rubens must have known well. Giulio's house also included *trompe l'oeil* sculptures of Mercury and Minerva painted on the wall of the *salone*. When it came to religious conduct, Rubens and his household were devout Catholics. As the artist's nephew Philip later recorded, his uncle attended mass every day. This was no mere conventional observance, but the guiding inspiration of his daily life.

Inside Rubens' grand house were the artist's magnificent collection of ancient sculptures, gems, coins and other antiquities, as well as a substantial library, an assortment of curiosities, including a real Egyptian mummy, and a large assembly of paintings. As might be expected, sixteenth-century Venetian works were especially dominant, with nine paintings by Titian, including a self-portrait, as well as pictures by Veronese and Tintoretto.

However, Rubens also showed considerable interest in northern European art. He owned twelve paintings by Pieter Bruegel the Elder and others by Quentin Massys, Hans Holbein the Younger and Albrecht Dürer. Even the fifteenth century was represented with panels by Jan van Eyck and Hugo van der Goes (c.1440–82).

Among his northern contemporaries were Adam Elsheimer, by whom Rubens owned twelve paintings, and Adriaen Brouwer (1605/6–38), a painter known for his rowdy peasant scenes, of whose work he possessed no less than seventeen examples. Though Rubens held Brouwer in high esteem, the predominance of the latter's works in his collection was partly motivated by personal concern for the welfare of the younger artist, who frequently experienced financial difficulties. In addition, Rubens bought pictures by his Antwerp colleagues, among them Van Dyck, Jordaens and Snyders. To some extent, the selection of works was obviously determined by market availability; but the large number of northern paintings in the artist's collection also had a deeper significance. With Rubens' return to Antwerp came a return to his native tradition. This was already evident in the portrait of himself and Isabella Brant (see 58), and can be seen in other works produced from this period onwards.

Undoubtedly, Rubens derived great pleasure as well as professional benefits from his possessions, including the drawings that played such an important role in his creative process (see Chapter 2). Ownership also carried with it social status, financial gain or at least security, and even diplomatic bargaining power (see chapters 3 and 7), as Rubens was to discover later in his career. Over the years, the artist's house and its contents acquired a fame and distinction which came to be identified with Rubens himself. As Jan Woverius wrote to Balthasar Moretus in 1620: 'Happy is our Antwerp to have two citizens like Rubens and Moretus! The houses of both will be admired by strangers and visited by travellers.' Indeed, travellers from near and far came to see Rubens' residence and meet its owner: the Archduchess Isabella, Prince Sigismund of Poland, Marie de' Medici, the

Cardinal-Infante Ferdinand and many others. Its modern reconstruction, carried out between 1939 and 1946 (surely one of very few buildings actually to be reconstructed during the Second World War!), is one of Antwerp's main tourist attractions.

It was the house on the Wapper, with its domestic and professional domains, that provided the centre of Rubens' life over the next two decades. The family grew as two more children were born, Albert in 1614, and Nicolas four years later, in 1618.

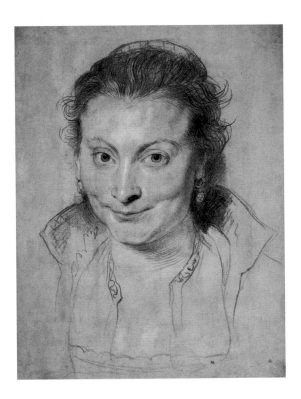

101 **Left**
Isabella Brant,
*c.*1622.
Black and red
chalk with pen
and wash,
heightened
with white;
38.1×22 cm,
15×8⅝ in.
British
Museum,
London

102 **Right**
Head of
a young girl,
probably
the artist's
daughter
Clara Serena,
*c.*1623.
Black, white
and red chalk
with pen and
ink;
35×28.3 cm,
13¾×11⅛ in.
Albertina,
Vienna

103
Far right
above
A boy with
a coral
necklace,
probably the
artist's son
Nicolas,
*c.*1619.
Black, red and
white chalk
with pen and
ink;
25.2×20.2 cm,
9⅞×8in.
Albertina,
Vienna

104
Far right
below
Nicolas Rubens,
*c.*1625.
Black and
white chalk;
22.7×18 cm,
8⅞×7⅛ in.
Albertina,
Vienna

Rubens' marriage to Isabella Brant was apparently a happy one. Although we have no record of her personality beyond the artist's own eulogy following her death, the portraits he drew and painted of her show her as intelligent and vivacious rather than conventionally pretty. A superbly finished drawing of Isabella in three shades of chalk (101) belongs to a whole series of incomparable portrait sketches of his family. Favourites of nurseries and pediatricians' offices, Rubens' drawings of his children have perhaps been overexposed, but their charm and freshness continue to

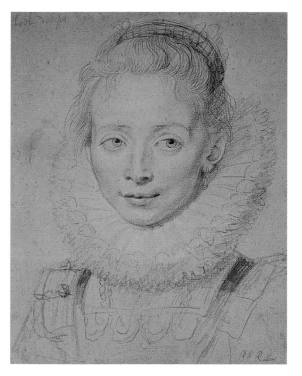

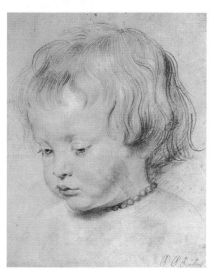

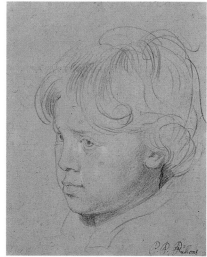

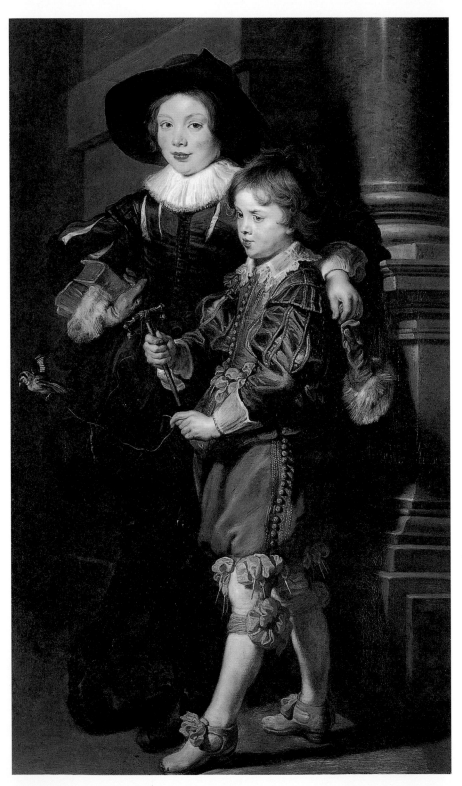

delight. There is a sketch probably of his second son, Nicolas, at a tender age, all chubby cheeks and silky hair (103), and a few years older, with a quizzical and slightly truculent expression (104). No documented portrait of Clara Serena exists, but on the basis of a likeness to Isabella Brant, the drawing of the head of a young girl with large liquid eyes, framed by her huge, formal collar has sometimes been identified as representing her (102).

These drawings were done as portrait studies, either as independent works or in preparation for paintings. The head of Nicolas appears in a splendid full-length double portrait of the artist's two sons, painted around 1626, when the boys were twelve and eight respectively (105). Both are elegantly dressed and pose before a grand architectural structure. Albert, in a wide-brimmed hat, leans against a pilaster, one leg crossed over the other, an arm placed around his brother's shoulder. From his fingers dangles a glove, in gentlemanly fashion. A large book is tucked under the other arm, no doubt in reference to his studiousness. By the age of sixteen Albert was already, as Rubens wrote proudly to his friend Peiresc in August 1630, 'seriously engaged in the study of antiquities, and … making progress in Greek letters'. The older boy's seriousness and sophistication is contrasted with the childishness of the younger, who is absorbed in manoeuvring a goldfinch attached to a perch. The contrast extends to their dress: Nicolas's brilliant blue jacket, tan breeches and orange-pink bows are offset by Albert's more sober black suit. The rich costumes and formal setting recall again Rubens' Genoese portraits (see 49).

In fact, Rubens had not painted this type of full-length, standing portrait in an architectural setting since his days in Genoa. His success and social advancement over the fifteen years following his return to Antwerp had bestowed upon his sons a position unique among artists' children, and one that effectively made them eligible for such grandiose representation. Rubens may well have liked to think of himself as on a par with the Genoese nobility, a class whose wealth and elevated status was due to mercantile

success rather than inheritance. By the time the double portrait was painted, the artist owned several other properties in Antwerp (most of which he let) and a farm of substantial size, in addition to the splendid house on the Wapper. The remodelling he had carried out on purchasing the house was in the style of the palaces of Genoa, built in the third quarter of the sixteenth century. Rubens' collection of plans and elevations of Genoese palaces was later published as an architectural patternbook, *Palazzi di Genova* (1622), intended to show his countrymen how to replace what he termed their 'barbaric or Gothic' style of architecture with one that conformed 'to the rules of the ancient Greeks and Romans'.

Not all was happiness and success in Rubens' life, however. His brother Philip's death in 1611 had left behind two young children (one of whom, also named Philip, became Rubens' first biographer). An even greater blow struck Rubens and his wife when their daughter Clara Serena died in 1623, at the age of twelve. Three years later, in 1626, Rubens suffered his greatest loss, the death of Isabella Brant, almost certainly of the plague which affected Antwerp in that year. In a moving testimony to her memory, the artist wrote to a friend in Paris:

Truly I have lost an excellent companion, whom one could love – indeed had to love, with good reason – as having none of the faults of her sex. She had no capricious moods, and no feminine weakness, but was all goodness and honesty. And because of her virtues she was loved during her lifetime, and mourned by all at her death. Such a loss seems to me worthy of deep feeling, and since the true remedy for all ills is Forgetfulness, daughter of time, I must … look to her for help.

For today's reader, Rubens' references to the typical faults and weaknesses of the female sex strike an uncomfortable note, but the sentiments expressed are those of his time. Within seventeenth-century discourse, his words convey in formal terms the true measure of his love and esteem for his wife. It may be relevant to recall the Sixth Satire of Juvenal, the most famously misogynistic of classical texts, to which Rubens had earlier referred in his letter to Johann Faber (see Chapter 4). Given

that Juvenal was part of the curriculum in Latin schools, formal education – available to boys only – probably encouraged such views. The Sixth Satire had, therefore, become an acceptable topos when writing about a wife. Moreover, Rubens' letter is a formal letter to a friend who had never met Isabella Brant and who was himself an old bachelor and misogynist. Far from reviling women, Rubens admired their strength, courage and compassion – 'feminine qualities' in which, in the great works of his last decade (see Chapter 9), he came to place his hope for a better humanity.

Although religious works constitute the major part of Rubens' production during the decade following his return from Italy, he also established himself as a painter of classical mythologies and histories as well as other secular subjects. He continued to design portraits and painted his first landscapes, but most of his secular themes involved scenes containing historical figures, gods and other mythical creatures from antiquity. There was nothing unusual in a painter who turned from subjects celebrating the Christian faith to those involving pagan deities, and Rubens did it with splendour and ease. Counter Reformation humanists, such as Justus Lipsius and Philip Rubens, admired the ancients for their ideas and the beauty of their poetry. In fact, a Roman philosopher such as Seneca inspired respect not only for the moral fitness of his writing, but also for his life, which could be interpreted in terms of Christian ethics.

Seneca, as one of the presiding spirits over Humanist thought (and – literally, in the form of his bust – over the courtyard of Rubens' house), forms the subject of a work Rubens painted around 1614–15. This history painting, not always judged a success pictorially, shows the moment of the philosopher's death (106). In relation to Rubens' work as a whole, it is interesting both as an intellectual profession of faith and for its use, almost unaltered, of an early copy he had made in Rome of the classical sculpture then thought to represent the 'Dying Seneca' (see 23–26). In the painting, Rubens shows Seneca standing in a bronze basin of water, with a young man writing down his last words.

A doctor attends to the opening of the veins, while soldiers of the emperor Nero, who had commanded the philosopher's death, watch from the background.

As young men, both Rubens and his brother Philip, pupil of the Seneca expert Justus Lipsius, had been influenced by Lipsius' Neo-Stoicism (see Chapter 3). For them, the death of Seneca appeared remarkably noble, his persecution by Nero foreshadowing Christian martyrdom. This classical subject, therefore, had a strong appeal to Rubens' Catholicism. Interestingly, where the Roman historian Tacitus records that Seneca cut his own veins, Rubens gives this task to a doctor in his painting, thus avoiding retrospectively convicting the philosopher of the sin of suicide. Rubens' religious convictions were clearly at variance here with his knowledge of Tacitus' original text. Not surprisingly, *The*

106
The Death of Seneca,
c.1614.
Oil on panel;
181×152 cm,
71¼×59⅞ in.
Alte
Pinakothek,
Munich

Death of Seneca invites comparison with saintly martyrdoms: the nude saint-philosopher stands upright, steadfast in his faith, a young disciple at his side; the executioner-doctor goes about his task while two soldiers stand by, the whole set in a gloomy interior.

Painted during the same period as *The Death of Seneca*, Rubens' *Descent from the Cross* altarpiece also incorporates figures derived from classical sculpture he had drawn in Rome (see Chapter 4). But not everyone shared Rubens' cross-cultural outlook. The Catholic Church of the Counter Reformation was not, strictly speaking, in favour of pagan gods and heroes invading the Christian domain. Fortunately, artists did not pay too much heed to these recommendations, and the Church mostly left them alone, unless they truly overstepped the limits of decorum, as Caravaggio had done with his *Death of the Virgin* (see Chapter 2). If transgressing the boundaries was initially a question of religious decorum, however, it soon became one of aesthetic sensibilities. The seventeenth-century French art critic and historiographer André Félibien questioned Rubens' unconventional use of ancient iconography: 'And what is the connection between the gods of the fables and the ceremonies of the church and our customs which justifies this painter's joining them together and confusing them?' The connection that escaped Félibien is, in fact, the common bond of human experience in all its manifestations, including sacrifice and death. For Rubens there existed a symbiosis between the 'gods of the fables' and the 'ceremonies of the church'. It is this symbiosis that allowed him to escape the narrow confines dictated by sectarian or aesthetic considerations to embrace more universal issues of human concern.

The classicism of Rubens' mythological paintings from this period is of a very different order from that which informs either *The Death of Seneca* or *The Descent from the Cross*, evoking as it does the sensual pleasures of a pagan pastoral world. These works are small or medium-sized pictures for private homes. His talent for monumental works was, at this time, largely fulfilled by ecclesiastical commissions, such as his great altarpieces (see Chapter 4)

and, at the end of the decade, his paintings for the Jesuit Church. In his mythological paintings, Rubens notably combined his mastery of colour, acquired through his study of Venetian art, with his knowledge of antiquity. The references to classical sculpture are predictably more direct than in his religious compositions. In *Venus, Ceres and Bacchus* (108) the three gods are arranged in a frieze across the picture plane, in imitation of Roman reliefs. The figure of Ceres, on the left, is derived from a statue of Venus, crouching to wash herself. This famous Greek sculpture was familiar to Rubens from a Roman copy, which survived in several versions, including one in the Gonzaga collection (109). Rubens used the statue again for the *Shivering Venus* (107), in

which the goddess huddles in the cold, protecting Cupid under her scanty veil, while a satyr is, figuratively, about to warm her with his cornucopia of fruit, providing sustenance to love (the strip of landscape on the left is a later addition).

The meaning of these two pictures derives from a popular maxim by the Roman playwright Terence, 'Sine Cerere et Libero [*ie* Bacchus] friget Venus' ('without food and wine love freezes'). The Latin quotation raises this observation on the fulfilment of basic human desires above the level of the comparable, if less elegant, popular saying, 'The way to a man's heart is through his stomach.' In *Venus, Ceres and Bacchus*, Venus sits relaxed, accepting

the offerings of the god of wine and the goddess of harvest fruits. Reversing Terence's quote, Rubens shows Venus warming herself, so to speak. In *Shivering Venus*, on the other hand, the goddess literally shivers from the cold that results from the absence of such gifts, although the satyr with the cornucopia is about to come to the rescue.

The anonymous patrons who acquired these works were surely members of Antwerp's classically educated bourgeoisie, whose Humanist tastes engendered an appreciation of the pictures' allusions to classical sources, literary and visual, the beautifully rendered nudes and, most of all, the delightful invitation to sensuous pleasures. Moreover, it is an interesting and well-known phenomenon that sincere commitment to religion is frequently accompanied by a predilection for eroticism as well as violence. The galleries of the Prado in Madrid, for example – hung with the devout images of Murillo, the seductive nudes of Titian and Rubens, and the horror-filled canvases of Hieronymus Bosch (acquired by Philip II, the most fervent of Catholic rulers) – testify to the close proximity of piety, sexual titillation and sadism. Admittedly, the many nudes by Rubens in the Prado are from his last decade, when concerns of a more private nature than those of the art market contributed to his choice of images (see Chapter 9). But even during the first decade of the seventeenth century, when he was establishing his reputation on all fronts, the many sensual nudes in his mythological and allegorical pictures were clearly designed to satisfy the taste of his clientele in Counter Reformation Antwerp.

Moreover, when it came to source material for the depiction of female nudes, artists did not have to restrict themselves to classical literature. Another ancient source, and one of even greater distinction, was the Old Testament. In Counter Reformation art, the old Jewish heroes and their stories could be interpreted in two ways: either placed within a Christian framework, becoming prefigurations of New Testament events (Rubens was soon to treat several such episodes in his monumental ceiling decorations

for Antwerp's Jesuit church), or presented as historical figures with no religious connotations. Seen in this context, the Old Testament could be perused for additional erotic source material. There are, after all, plenty of seductions in the Bible, often dramatic or even violent and scandalous in character: the two daughters of the patriarch Lot seduce their father; Tamar, twice slighted by her father-in-law, Judah, tricks him into sleeping with her, disguised as a prostitute; Judith saves her people by enamouring Holofernes, whom she then kills; and there are many more examples.

One of the more popular renditions of sex and betrayal is the story of **Samson and Delilah**, which Rubens painted shortly after his return to Antwerp (111). The muscular figure of Samson is slumped across Delilah's lap in post-coital sleep. Delilah, her bulbous breasts prominently revealed, looks down at her lover with a mixture of triumph and pity, while an attendant is cutting off Samson's hair, the source of his strength. The dark interior broken by patches of light, the brilliant colours, the curtain and richly patterned rug, all contribute to the atmosphere of eroticism, which provides the moral of the story. The presence of the old woman, who plays the role of procuress, indicates that Rubens intended the scene to take place in a brothel. It may come as a surprise to discover that this picture occupied pride of place above the fireplace in the great salon of burgomaster Nicolaas Rockox's house, where it could be admired by friends and visitors alike. It can clearly be seen in a contemporary painting by Frans Francken II (1581–1642), *The Great Salon of Nicolaas Rockox's House* (110). Of course, there was a lesson to be learned from the tale, but it seems highly doubtful that moral instruction was foremost on Rubens' mind when he painted the picture, or on those who contemplated it. With its powerful eroticism and sumptuous colours, the painting is designed to appeal to the senses, even those of the most upstanding of Antwerp's citizens.

The element of violence that so often goes hand in hand with eroticism can also be found in Rubens' work of this period – and

indeed throughout his career. He produced a series of remarkable and highly unusual hunting pictures. Some of them continue in the tradition of medieval hunting scenes by showing the aristocratic sport of chasing fox, deer or wild boar; others, however, depict cruel and bloody combats with more exotic beasts, such as lions, tigers, leopards and crocodiles, in which the outcome is less certain. In one of Rubens' most famous pictures, *The Lion Hunt*, now in Munich (112), men and animals are engaged in a fierce

battle, which the hunters are about to lose. One man lies prostrate, dying, while another, also thrown to the ground, wards off the lioness with his sword, and a third, spectacularly rendered falling from his horse, is being viciously attacked by another lion. The painting, with its exciting display of lions and horses in motion, demonstrates that Rubens' collaboration with Snyders on their *Prometheus Bound* (see 94) was certainly not motivated

by an inability on his part to paint animals. Indeed, when a patron took some of Rubens' own animal pictures for the work of Snyders, he objected. No one, he supposedly said, could depict *dead* animals better than Snyders, as for live animals, he was himself the better painter.

Since hunting was a privilege of royalty and nobility, Rubens' paintings were owned by kings and aristocrats, among them the Archduchess Isabella. The taste for violence, however, was not restricted to the upper classes. It is likely that *Prometheus Bound*,

**110
Frans
Francken II**,
*The Great
Salon of
Nicolaas
Rockox's House*,
c.1630–5.
Oil on panel;
62.3×96.5 cm,
24½×38in.
Alte
Pinakothek,
Munich

111
*Samson and
Delilah*,
c.1609.
Oil on panel;
185×205 cm,
72¾×80¾ in.
National
Gallery,
London

with its pronounced cruelty, was commissioned by one of Antwerp's burghers before it was acquired by Dudley Carleton, and the appeal of Rockox's *Samson and Delilah* was surely height-ened by the viewer's knowledge of Samson's blinding that was to follow the erotic encounter. Similarly, the refined and cultured Cornelis van der Geest owned a picture of *The Battle of the Amazons*, in which the cruelty of the combat acquires additional *frisson* by involving bare-breasted women (114). The Amazons were a legendary race of warrior-women believed to inhabit Asia

112
The Lion Hunt,
c. 1621.
Oil on canvas;
249×377 cm,
98×148⅛ in.
Alte
Pinakothek,
Munich

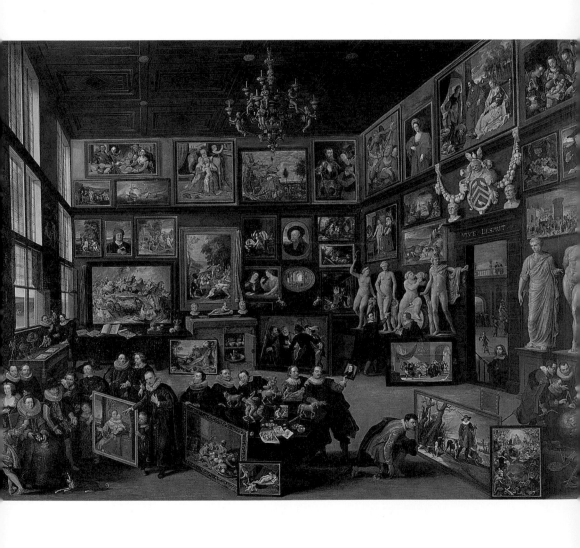

Minor. When they invaded Attica and its capital Athens, they were repulsed by Theseus. Rubens depicts one of their battles on a bridge – a violent mêlée of warriors and horses, in which vanquished riders and animals plunge headlong into the river. Like the erotically charged *Samson and Delilah*, which hung over Rockox's fireplace, *The Battle of the Amazons* took pride of place in Van der Geest's art collection, where it could be enjoyed by his distinguished visitors, including Albert and Isabella (113).

On 29 March 1620 Rubens signed the contract for his first decorative commission on a grand scale, the ceiling decorations for the new Jesuit church in Antwerp (now St Carlo Borromeo).

113
Willem van Haecht,
The Archduke Albert and the Archduchess Isabella Visiting the Picture Gallery of Cornelis van der Geest,
1628.
Oil on panel;
100×130 cm,
39⅜×51⅛ in.
Rubenshuis,
Antwerp

114
The Battle of the Amazons,
*c.*1618–20.
Oil on panel;
121×165 cm,
47⅝×65 in.
Alte
Pinakothek,
Munich

Begun in 1615, the church was consecrated six years later. Rubens may have played a role in its design, which repeats that of the new Baroque churches in Rome, consisting of a nave and two aisles (115). He certainly provided drawings for the sculptural programme, both on the façade and inside. But his most important contribution was in the form of painting. Before work on the ceiling began, he had already executed two major altarpieces showing the two chief Jesuit saints, Ignatius of Loyola and Francis Xavier, performing various types of miracle. Later he added a third painting to be hung in the Lady Chapel.

115
**Pieter Neeffs
and Sebastian
Vrancx,**
*The Interior
of the Jesuit
Church,
Antwerp.*
Oil on panel;
52×71 cm,
20½×28 in.
Kunst-
historisches
Museum,
Vienna

Rubens' contract stipulated that he would finish before the end of the year or, at the latest, the beginning of the next year, thirty-nine paintings which were to be installed on the ceilings of the upper aisle galleries and the lower aisles. An incomplete list of subjects was appended to the contract. Rubens was to prepare the designs with his own hands; the execution of the final paintings was to be carried out by his assistant Anthony van Dyck and others, but Rubens himself was to add such final touches to the canvases as might be necessary.

Rubens' most distinguished assistant, Anthony van Dyck (see 81), whose later career was in several ways to parallel, and indeed rival, Rubens' own, was born in 1599. He was trained at an early age by

the now little-known painter Hendrik van Balen (1575–1632) and in 1618, when only nineteen, he became a master in the Antwerp Painters' Guild. In the same year, in his correspondence with the English collector Sir Dudley Carleton, Rubens referred to him as 'the best of my disciples'. He is mentioned again two years later, this time by name, in the contract drawn up between Rubens and the Jesuits.

The nave of the church was divided into nine bays, creating spaces for eighteen paintings in the upper galleries and eighteen in the lower. An additional three paintings were positioned below the organ loft. The iconography was relatively simple: in the vaults

of the upper aisles, Old and New Testament subjects alternated, following the traditional programme of type and antitype, in which certain Old Testament scenes were seen as prefigurations of persons or events in the New Testament. Thus *The Sacrifice of Isaac* (116) prefigured the Crucifixion or, as chosen by Rubens, *The Raising of the Cross* (the contract actually specified a Crucifixion; 117), each event featuring a father – in the former Abraham, in the latter God – willing to sacrifice his son. In the lower aisles, male saints alternated with female saints. Unlike the preparatory work for, among others, the St Walburga *Raising of*

116
The Sacrifice of Isaac,
1620.
Oil sketch for
the Jesuit
ceiling.
Oil on panel;
50×65 cm,
19⅝×25⅝ in.
Musée du
Louvre, Paris

117
*The Raising of
the Cross*,
1620.
Oil sketch for
the Jesuit
ceiling.
Oil on panel;
32×37 cm,
12⅝×14⅝ in.
Musée du
Louvre, Paris

the Cross (see 65), which consists, in addition to the *modello*, of a series of elaborate chalk studies, there are hardly any drawings connected with the Jesuit ceiling. This may be largely due to the rapid pace with which Rubens was forced to work. However, it also demonstrates that, by the end of the decade, he had reached the certainty of eye and sureness of hand necessary to create – at incredible speed and with almost no corrections – directly with the brush on to the panel. It was a great loss to Antwerp and to art when, in 1718, fire destroyed the nave and Rubens' ceiling.

Its original appearance is thus known only from Rubens' oil sketches (116–119) and copies of the final works by later artists.

For the Jesuit ceiling (as well as some later projects) Rubens did, however, produce another type of preliminary work, consisting of monochrome oil sketches. These sketches, or *bozzetti* (a term first used in Italy for small models for sculpture), are even more rapidly executed than were subsequent, more finished *modelli*. They essentially employ lead white and a few darker lines on the light brown priming of the panels. *The Flight of St Barbara* is a beautiful example of this type of preliminary draft (118). The free and spontaneous handling of the brush is comparable to the use of the pen or chalk on paper. From the initial *bozzetto*, Rubens proceeded to execute the more finished *modello*. Working on a somewhat larger panel, he adjusted his first design and at the same time translated the whole conception from monochrome into colour (119). The Jesuit ceiling *bozzetti* and *modelli* – as is true of all Rubens' oil sketches – are situated somewhere between a drawing on paper and a finished painting. In freshness and intimacy they resemble drawings, whereas in durability (being in oil on panel) they hold the same status as panel paintings. Undoubtedly, this dualism contributed to their appeal for later collectors and owners.

The concept of ceiling decoration is Italian, and Rubens was of course familiar with the most famous of all, Michelangelo's ceiling in the Sistine Chapel. Closer to his own design, however, are Venetian examples, such as Titian's ceiling paintings for San Spirito in Isola (now Santa Maria della Saluta) and, for individual compositions, Veronese's ceiling for the church of San Sebastiano (120). One of the essential differences between Roman and Venetian models is the painting technique. Roman ceilings were painted in fresco (*ie* directly on to the plaster), a method not suitable for the damp climate of Venice and of northern Europe, where scenes were painted instead on canvases set within compartments carved in wood or moulded in plaster, like framed pictures. This was the case with both the Jesuit ceiling and

118
The Flight of St Barbara, 1620.
Grisaille sketch for the Jesuit ceiling. Oil on panel; 15·5×20·7 cm, 5⅞×8¼ in.
Ashmolean Museum, Oxford

119
The Flight of St Barbara, 1620.
Oil sketch for the Jesuit ceiling. Oil on panel; 32·6×46·2 cm, 12⅞×18⅛ in.
Dulwich Picture Gallery, London

120
**Paolo
Veronese**,
Ceiling of San
Sebastiano,
Venice
1555–6

121
**Paolo
Veronese**,
*Esther before
Ahasuerus*,
1556.
Oil on canvas.
Ceiling of San
Sebastiano,
Venice

122
*Esther before
Ahasuerus*,
1620.
Oil sketch
for the Jesuit
ceiling.
Oil on panel;
48·8×47 cm,
19¹⁄₄×18¹⁄₂ in.
Courtauld
Institute
Galleries,
London

Rubens' later scheme for the Banqueting House in Whitehall, London (see Chapter 8). The system of foreshortening used by Rubens, which assumes an angle of sight of forty-five degrees, is also Venetian. In his design for the subject of *Esther before Ahasuerus* it is clear how closely he followed Veronese in composition and in solving the difficult problem of perspective (121, 122). He took from his Venetian model the principal design of a rising diagonal, along which he arranged his figures, as well as the dramatically foreshortened man in armour, arm akimbo, who stands on the right. Even the dog in the foreground has its counterpart in the Venetian picture. The Old Testament episode of Esther pleading with the Persian king Ahasuerus (Xerxes) to prevent the massacre of the Jews was regarded by the Church as a prefiguration of the Virgin Mary as intercessor; thus on the Jesuit ceiling the finished painting was next to *The Assumption of the Virgin*.

By the time he had completed the Jesuit ceiling, Rubens was the most famous and successful painter in northern Europe. He had tried his hand in every area of the visual arts, even if, as in sculpture and engraving, his efforts were restricted to design only. He had evolved a new pictorial vocabulary based on the intellectual and artistic traditions of both the Christian and the classical past, a language perfectly suited to convey the religious spirit and ideas of the Counter Reformation and to satisfy contemporary aesthetic concerns. He had also created an exciting visual language, characterized by large, fleshy figures in motion or in an emotional atmosphere, by strong contrasts of light and shadow, and by warm, glowing colours, which gradually came to replace earlier more austere and impersonal styles. With the paintings for the Jesuit church, the crowning achievement of this remarkable decade, he established himself as the supreme impresario of large-scale decorative projects. It is this aspect of Rubens' talents that was to play the most important role in the artist's career as the arena of his activities shifted from his home town to the royal courts of Europe.

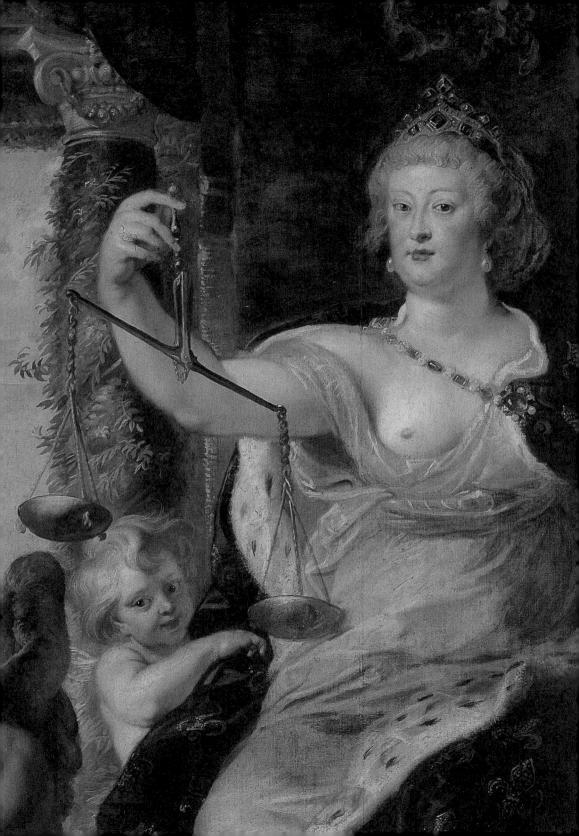

After the ceiling of the Jesuit church, Rubens was keen to try
his hand at decorating a great secular building, much as Titian,
Tintoretto and Veronese had glorified the palaces of Venice,
and Giulio Romano those of Mantua. An obvious candidate
had presented itself in the form of the King of England's new
Banqueting House in London, and Rubens was disappointed
to have heard nothing more about this project, about which he
had eagerly enquired. It must therefore have been with great
enthusiasm that he accepted, in the autumn of 1621, an offer to
provide the paintings for the new residence the Queen Mother
of France was building in Paris, the Luxembourg Palace.

123
*The Felicity of
the Regency of
Marie de'
Medici*
(detail of 126)

The Queen Mother was Marie de' Medici, the Florentine
princess whose wedding by proxy to King Henry IV of France
(124) Rubens had attended as a young man more than twenty
years before while working for the Duke of Mantua (see Chapter
2). Marie had led an eventful life since that time. In France the
Wars of Religion had divided the country between Protestant
and Catholic factions as bitterly as in the Netherlands. Henry IV
(r.1589–1610), a Protestant who had converted to Catholicism
for political reasons, had instituted a rule of religious tolerance
enshrined in the 1598 Edict of Nantes, which permitted Protestant
worship outside the court itself. In 1610 he had been assassinated,
leaving Marie as regent until their son, Louis XIII, came of age
in 1614. The young king and his mother (who, at his request,
continued as regent for two more years), both influenced by
their respective favourites at court, soon quarrelled, and in 1617
Marie was sent into exile. By 1621, however, mother and son had
reached a reconciliation and Marie was back in Paris, devoting
her energies to the building and decoration of the Luxembourg
Palace. Nevertheless, the differences between her and Louis were
by no means resolved, and in 1631 she was to be banished again,

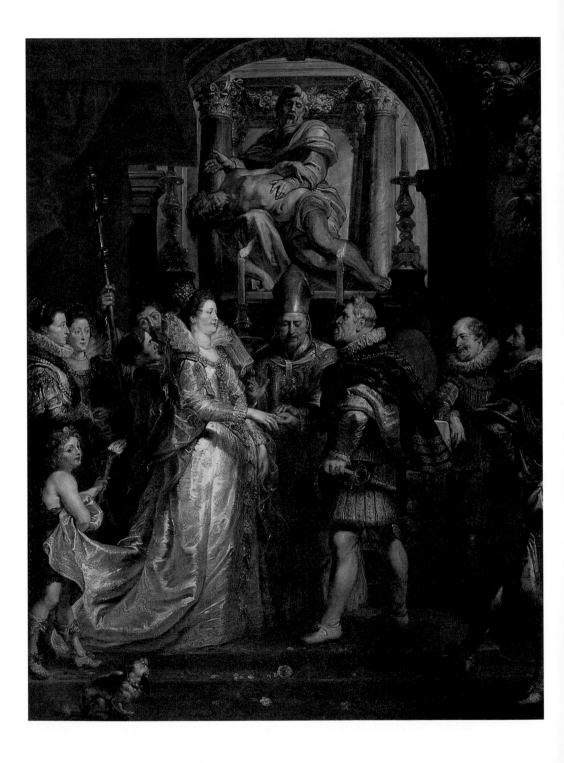

escaping to Brussels. It was on this occasion that she visited Rubens' house on the Wapper with its remarkable art collection. She died in 1642 in exile in Cologne, in the same house the Rubens family had occupied more than fifty years earlier.

The job Marie assigned to Rubens in 1621 was the decoration of two huge galleries running the length of the first floor of each wing of the palace. In the first there were to be twenty-one paintings devoted to the struggles and achievements of her own life, as well as portraits of herself and her parents, bringing the total to twenty-four. The second gallery was to be decorated with scenes from the career of her late husband, Henry IV. Rubens travelled to Paris early in 1622 to settle the terms of the commission; he left six weeks later with a signed contract and themes for the first seven pictures of the first gallery, devoted to the life of the Queen Mother. The series was to be finished in two years. The second gallery was to be completed two years after installation of the first, but details for it were yet to be arranged. The Henry cycle was indeed begun by Rubens soon after he had completed the Medici pictures, but continued only sporadically. After Marie's banishment in 1631 it was abandoned completely. Some sketches and the preliminary stages of some of the large canvases have survived. The reasons why Marie chose Rubens for this important task, in preference to French or Italian painters, are not stated. In true Medici tradition (from the fifteenth century onwards her ancestors had patronized many of the greatest artists of the Renaissance) she took an active interest in the arts, and the growing fame of the Flemish master could not have escaped her. She may also have been advised by her friend the Archduchess Isabella.

Back in Antwerp, Rubens set to work at once. In terms of organization, the Jesuit ceiling decorations had given him invaluable experience, so that he and his studio were well prepared to handle such a huge commission. It may be that, while still in Paris, Rubens had executed some grisaille sketches to show to the patron, a practice introduced with the Jesuit pictures. As soon as he returned home he prepared coloured oil sketches, before

124
The Wedding by Proxy of Marie de' Medici to King Henry IV, 1622–5. Oil on canvas; 394×295 cm, 155⅛×116⅛ in. Musée du Louvre, Paris

progressing to the final paintings, which were in part executed by assistants (the contract stated that Rubens was to paint all the figures, which presumably allowed him to employ assistants for backgrounds and other details). By May 1623 the artist was back in Paris with nine completed canvases. The Queen Mother went for a special inspection to the palace of Fontainebleau, where the canvases had to be kept in a locked room so that no unauthorized person would see them and start rumours about their content. Despite delays caused by the Queen Mother and the architect of the palace, Salomon de Brosse (1571–1626), the entire series was completed by the end of 1624, in time for the festivities in connection with the wedding on 11 May 1625 of Marie de' Medici's daughter, Henrietta Maria, to Charles I of England. Rubens was in Paris at the beginning of March 1625 to put the finishing touches to the works, which by then had been installed in the newly completed gallery.

While the Jesuit ceiling commission had prepared Rubens and his studio for the technical and organizational challenges of such a vast task, there were important differences between the two projects. First, there was the inconvenience of working for a patron and a location at considerable distance from Antwerp, so that all issues, from measurements to iconographic details, had to be dealt with by correspondence. More challenging, however, was the content itself. The subject matter of the Jesuit church cycle was relatively straightforward; when it came to Marie de' Medici, however, considerable tact and imagination were necessary to distil from her erratic and sometimes melodramatic life episodes that could be commemorated in a gallery of monumental paintings. Rubens had already designed a series of tapestries for a Genoese patron illustrating the heroic actions of the Roman consul and general Decius Mus, and was at the time of the Medici pictures engaged in another tapestry cycle, dealing with the life of the first Christian emperor, Constantine (see 129). But these were historical figures, safely removed in time, their deeds sanctioned by antiquity. Illustrating current events – some only precariously resolved – in a permanent

decoration was quite a different matter, one that could easily turn into lasting embarrassment.

Granted, illustrations of events in the lives of contemporary kings and princes were common enough at the time. They appeared in printed broadsheets, pamphlets and other ephemeral publications, where they served specific political agendas. Such images

125
Ghisbert
van Veen
after Otto
van Veen,
*Alessandro
Farnese as
Hercules
Choosing the
Path of Virtue.*
Engraving

commonly took the form of allegories or were embellished with allegorical personifications. Thus the victor of the day might be identified with an ancient hero, such as Perseus or Hercules (125), battling with his enemies, who were disguised, Hydra-like, as many-headed monsters. But the political vicissitudes of the religious wars of the later sixteenth and seventeenth centuries meant that today's Protestant Perseus combating the beast of

Spanish tyranny was tomorrow's Catholic hero fighting the rebel heretics. To accommodate the new interpretation required no more than a change in portrait-heads or, if features had been left conveniently vague, a change in the accompanying inscriptions. Marie de' Medici's gallery, on the other hand, was designed to play a more permanent role, and Rubens was uncomfortably aware that historical accuracy in the form of specific personal references might not always be diplomatic. He was to solve this problem by using in his iconographic scheme the sort of mythological creatures and personifications found in contemporary political prints. However, quite apart from transforming these crudely depicted images with the vibrant language of his brush, Rubens employed his strange cast of characters to appease factions, not to support them.

A different but equally demanding challenge facing the artist was that of glorifying the life of a woman. There were no victorious battles to be celebrated, no heroic sacrifices, no vanquished foes, the stuff of male heroism as exemplified in the person of Henry IV. Undoubtedly, Rubens was looking forward to illustrating the military career of this warrior king; it was a theme, he wrote, 'so vast and magnificent that it would suffice for ten galleries'. Meanwhile, however, he had to devote his imagination and skill to painting the less conventionally heroic life of Henry's widow.

Marie de' Medici was not the first powerful female patron for whom Rubens had worked, and with whom he had established a relationship of mutual personal respect. He had praised highly the 'virtues of the female sex' in the person of the Archduchess Isabella, whose courage to make decisions based on both reason and compassion had a direct bearing on important matters of state. Marie de' Medici, by contrast, was by all accounts wilful and obstinate, and her exercise of 'feminine virtues' apparently more closely limited to domestic and family issues. There was, to be sure, her remarkable marriage to celebrate, the births of her six children (of which one died in infancy) and, in turn, their marriages. But this hardly provided material for twenty-one

pictures. After the domestic events of Marie's life had been dealt with, Rubens was required to turn to her more sensitive public image. And this caused perhaps the greatest obstacle in the commission, for Marie's life had not been without scandal.

First there were rumours that hinted at her complicity in the assassination of her husband in 1610. Then there was the recent quarrel with her son, Louis XIII, the youthful monarch who, upon taking the throne, promptly sent his mother into exile. Even if the quarrel had been resolved by the time Rubens received the commission, it was clear to all that it was no more than a precarious reconciliation. Moreover, in 1621 the Twelve Years' Truce expired and Rubens, who by this time had become a close confidant and adviser of the Archduchess Isabella, was being drawn increasingly into political negotiations revolving around a new peace treaty between Spain and the Northern Provinces (see Chapter 7). As one of the most powerful European countries not under Habsburg rule, and the only such Catholic power, France's alliance was much coveted. Against this background, it was especially important for Rubens not to offend the reigning French monarch in images celebrating the life of his sometimes estranged mother. Thus he turned to mythological allusions, emblematic references, personifications of vices and virtues and religious analogies to veil an often unheroic or ambiguous reality.

In this context, Rubens' approach to 'historical truth' may appear selective or, worse, dishonest, but he was neither a historian in the modern sense nor a journalist; the Medici cycle is not reportage but poetic transformation. The advantage of the allegorical approach he adopted is its lack of specificity: generalized images can be interpreted in various ways, depending on the circumstances or attitudes of the viewer. This is precisely what happened when the court was introduced to the newly installed gallery under the guidance of the Abbé de St Ambroise, Marie de' Medici's adviser, who served as interpreter of the subjects, 'changing or concealing the true meaning with great skill', as Rubens reported with some satisfaction to a friend in May 1625.

The Medici cycle is a triumph of pictorial rhetoric. The vocabulary of this rhetoric consists of symbols which can be used either individually or, more commonly, as attributes associated with particular personifications. Thus the olive branch can stand for Peace; the scales for Justice; the palm for Victory; or, respectively, a female figure holding an olive branch (or wearing an olive crown); a woman, sometimes blindfolded, holding a pair of scales (both implying impartiality) and a sword (for power); and a winged female holding a palm branch or crown. In addition, the gods of the Greek and Roman pantheon represented not only the physical world but also abstract concepts, and thus lent themselves perfectly to allegorical representation. In this way, the Greek god Ares (or Mars, his Latin name) and the Roman goddess Bellona are not only deities of war but also personifications of war, just as Aphrodite, or Venus, is the goddess of love as well as its symbol, a role sometimes taken by her son Cupid. The courtyard of Rubens' house (see Chapter 5) was watched over by statues of Minerva and Mercury, not as deities but as personifications. In art the classical gods are usually accompanied by attributes, for example Venus is represented with a pair of doves or swans (either may draw her chariot), a scallop shell or dolphins (recalling her birth from the sea); her son Cupid with bow, arrow and quiver; and Mercury with the caduceus, the magician's wand, which originally ensured unmolested passage to the messenger but came to stand for eloquence and reason and, for Rubens, also peace. Isolated from their bearers, these attributes become symbols of them and can be used as such.

In the sixteenth and seventeenth centuries, the propagation of ideas by personifications and symbols was an accepted function of art. Every artist had to understand the use of this kind of symbolism, and there were handbooks to explain it. In the hands of a man of genius it allowed for infinite possibilities in the creation of new subjects and the interpretation of old ones.

Rubens' immense knowledge of symbols, stimulated by his early training in the studio of Otto van Veen, inventor of emblems

(see Chapter 1), and fostered by his interest in classical literature and customs, provided the fuel for his imagination. He was never at a loss to translate his ideas or those of his patrons into an array of visual images. This can be judged nowhere better than in the pictures he painted for Marie de' Medici. From the spinning of her destiny by the three Fates to what was hoped would be her final reconciliation with her son, Greek gods instruct her and watch over her like guardian angels, personifications offer useful advice, Nereides and Tritons pull her galley safely to shore. Sometimes Marie herself is transformed into one of these mythical creatures when she takes on the role of the goddess Juno or that of the personification of Just Rulership. Like Shakespeare's forest in *A Midsummer Night's Dream*, Marie's world seems to be inhabited by kindly ghosts and spirits – a glorious make-believe spectacle.

This spectacle, however, is more profound in scope than the recording of biographical facts or the uncritical glorification of a princely patron. By enlisting the powers of the supernatural, Rubens raised a merely human and transitory existence to a universal level. In glowing colours and seductive images, he presented to the court and subsequent generations a visual celebration of the benefits to be derived from responsible and just rulership (126). It may be because Marie's direct engagement in high political action was limited (though it should be stated that her reign was a peaceful one), that her regency lent itself so perfectly to allegorical generalizations.

As regards the arrangement of the gallery, the pictures were hung clockwise in chronological order, beginning at the entrance wall (the arrangement remains the same in the gallery at the Louvre where the pictures are now hung). They are all the same height but vary in width, which was determined by the design of their original setting. The sixteen canvases covering most of the length of the two sides of the gallery measure approximately 4×3 m (13×10 ft); the three rectangular paintings at the end of the room 4×7 m (13×23 ft). The first half of the cycle, which took up the first wall, depicted Marie's childhood years and her marriage,

culminating in a large representation of her coronation. On the wall facing the entrance was a similar-sized scene combining the assassination of her husband, portrayed as an apotheosis in which Henry IV is received into heaven, and the proclamation of her regency. The second wall was devoted to the more controversial subjects of Marie's reign, the quarrels with her son Louis XIII, and their reconciliation.

Right from the start, the entire cycle is characterized by an astonishing mélange of living personages and mythological creatures. Predictably, the emphasis on one or the other of the two worlds shifts, depending on how well informed Rubens was about the actual event, or how contentious it was. After the scenes devoted to Marie's birth and childhood, the cycle progresses to her marriage. For a mere Florentine princess, at the advanced age of twenty-seven (by the customs of the time, a woman of that age might well give up all thoughts of marriage), to wed the King of France was close to miraculous. No wonder Rubens devoted no less than four scenes to the subject. The marriage by proxy (Henry was too busy to attend his own wedding), which took place in the cathedral in Florence on 5 October 1600, is a relatively straightforward representation (see 124). In a ceremony presided over by Cardinal Pietro Aldobrandini, the bride's uncle, Grand Duke Ferdinand of Tuscany, who stood in for Henry IV, puts a ring on his niece's finger. The ladies and gentlemen in attendance are all identifiable, including the painter himself who appears behind and to the left of the bride, holding a cross. While Rubens was indeed present, it is hardly likely that, as a recent member of the Gonzaga household, he would have held such a prominent position (see Chapter 2). In an amusing gesture of vanity, the middle-aged Rubens, who was prematurely balding, portrayed himself with a full head of hair in a youthful image of himself.

The ceremony takes place before a marble group of God the Father sorrowing over the dead body of Christ, approximating to a sculpture by Baccio Bandinelli (1493–1560), a follower of

126
The Felicity of the Regency of Marie de' Medici,
1625.
Oil on canvas;
394×295 cm,
155⅛×116⅛ in.
Musée du
Louvre, Paris

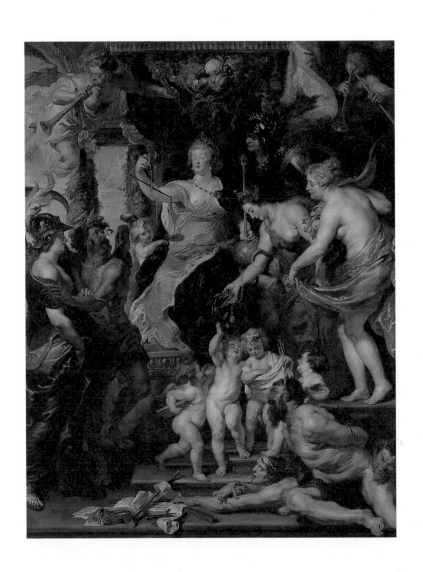

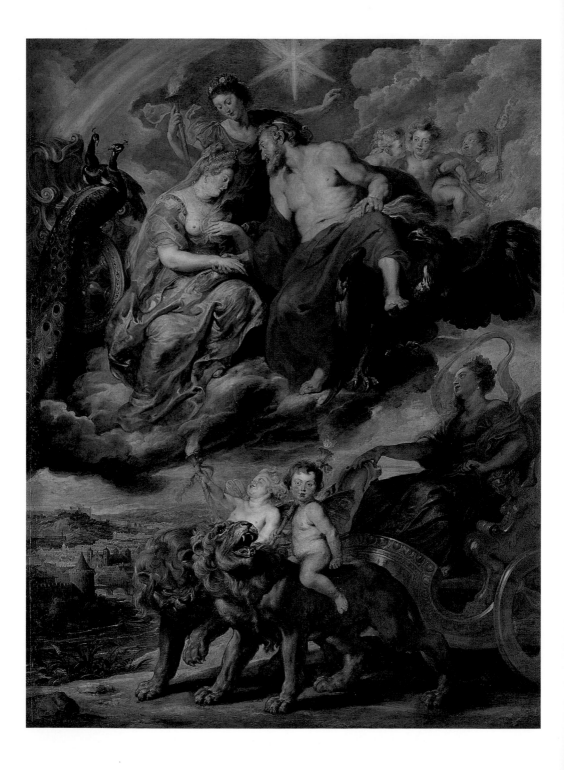

Michelangelo, which had actually surmounted the altar. Rubens had protested that such a mournful subject would make an inappropriate setting for a joyful celebration, and had instead suggested an allegorical conceit involving the goddess Juno and a rainbow. While there does not seem to have been much objection to the assemblage of pagan gods invading Marie's life, when it came to the interior of a cathedral, it was evidently felt that the painter had gone too far. Bandinelli's *Pietà* remained, but Rubens managed to include one mythological figure: carrying the bride's train in one hand and the nuptial torch in the other is Hymen, ancient god of marriage.

The first meeting of the betrothed, who had never set eyes upon each other, took place in Lyons (127). It was not a success: Henry arrived unexpectedly in the middle of the night, after Marie had been kept waiting for almost a week. The king, whose liaisons were the talk of Europe, was at the time passionately involved with his mistress, so that he had little interest in his new bride. Diplomatically, Rubens rendered the event in allegorical terms, depicting Henry in the guise of Jupiter (or Zeus, in Greek), ruler of Olympus, and Marie in that of his wife Juno (or Hera), queen of the gods and goddess of matrimony. United by Hymen, who stands behind them, they join their right hands in the traditional gesture of marriage. Marie, as Juno, is dressed in classical style, one breast exposed; on her head is a diadem, as befits the status of both women. Beside her is Juno's chariot and attribute, the peacock (indeed, there are two peacocks, a reference to conjugal union). Henry, as Jupiter, is equally scantily dressed, carrying the god's attribute, the thunderbolt (represented as a bunch of flames) in his left hand and slinging one leg over an eagle, his other attribute. The celestial apparition is topped by a rainbow, sign of concord and peace, and a large star. The scene in the sky is watched below by the personification of the city of Lyons (she wears the traditional crown of fortified walls), riding in a chariot pulled by lions (a pun on the city's name). Two putti (or cupids) sit astride the beasts, while a further three appear in the sky.

Rubens and his patron surely meant to illustrate the couple's elevated status in proper allegorical imagery, especially since the actual circumstances of the meeting were less than ideal. The metaphor backfired, however, since Jupiter was not only king of Olympus but also the god of many loves, who deceived young women, divine and mortal, by his metamorphoses, while Juno, angry and bitter, plotted revenge. Contemporaries would certainly have been aware of the irony, but fifteen years after Henry's death this aspect of the metaphor may have been no more than an amusing gloss on this image of divine matrimony.

The scenes of childhood and marriage culminate in a large canvas of Henry's death and the proclamation of Marie's regency on the following day. From this point the cycle turns to the events of the Queen Mother's reign and her reconciliation with her son, ending with a purely allegorical representation of *The Triumph of Truth*. During her husband's lifetime, Marie de' Medici had shown little sign of political interest, but after his murder she devoted herself to affairs of state with unwavering commitment. She was not responsible for any great number of government acts or royal decisions but, unlike her son, she advocated rapprochement between France and its political adversaries, above all Habsburg Spain. She believed in diplomacy by marriage. Indeed, the Medici cycle was rushed to completion in time for the marriage of her daughter Henrietta Maria to Charles I, and the marriages of her other children came to take the place of important political treaties.

The Exchange of Princesses (128) is a largely allegorical representation of the double marriage of the Infanta Anna of Spain (who, as a Habsburg, would always be known as Anna of Austria) to Louis XIII of France and of his sister, Isabella of Bourbon, to Philip IV, future king of Spain. The two princesses, their right hands joined, stand between helmeted personifications of France, whose drapery is decorated with the fleur-de-lis, and Spain, recognizable by the lion on her helmet. Anna, at age fourteen the older of the two, turns back as if to take leave of Spain, while France

gently pulls her by the left arm. In turn, Spain can be seen taking the thirteen-year-old Isabella by her left arm. The local river god appears in the foreground, accompanied by a water nymph offering the girls coral and pearls and a Triton (the actual event took place on a float midway across the Bidassoa River on the French–Spanish border). In the sky a circle of putti surround a figure in an aureole of light. She wears a diadem of ears of corn and showers golden rain from a cornucopia on to the two princesses. In her left hand she holds the caduceus, emblem of peace, which made possible the benefits so glowingly displayed. The figure is Felicity, specifically 'Felicity of a golden age', as she is identified in a contemporary manuscript. As a matter of history, Marie and her painter were not entirely wrong: it was not until 1644, in the final phase of the Thirty Years' War, that conflict between France and Spain again broke out.

The fruits of wise rulership are nowhere described in more glowing terms than in the following scene, entitled by Rubens himself *The Felicity of the Regency* (see 126). The double marriage the queen had arranged for her son and daughter was the single greatest act of her reign; from that point on, family problems and intrigues, flights and exiles dominated her life. It seems Marie would have preferred to portray her career in straightforward historical pictures, family struggles and all, and that Rubens' approach was not quite what she had intended. There were, in fact, occasions when he was overruled. One of those concerned the episode of Marie's flight from Paris in May 1617, to escape arrest after one of her favourites at court had been murdered at the instigation of Louis XIII. In the end, Rubens was proved to have been right: no sooner had the canvas been delivered than it was withdrawn – and presumably destroyed – as being too controversial (the design is preserved in a *modello*). The scene was hastily replaced by *The Felicity of the Regency*, a composition entirely of Rubens' devising and painted on the spot. The artist's own interpretation of this picture survives in a commentary of 13 May 1625: 'This shows the flowering of the Kingdom of France, with the revival of the sciences and the arts through the liberality and the

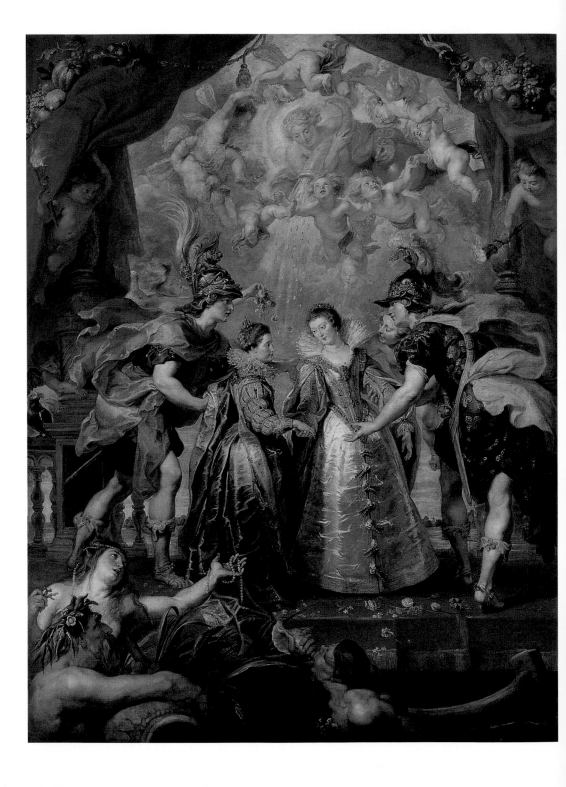

splendour of Her Majesty, who sits upon a shining throne and holds a scale in her hands, keeping the world in equilibrium by her prudence and equity.'

As the personification of just rulership, Marie is flanked by Cupid and Minerva (identified by her helmet and shield), goddess of wisdom and thus the goddess most closely associated with Marie's peaceful reign. The queen is bare-breasted, as befits her allegorical state, though it must be admitted that the semi-nude pose seems anomalous for this woman, at this date in her fifties. Minerva is assisted by Prudence (with a serpent around her arm, referring to the wisdom of serpents, as recorded in the Gospels) and Abundance (with a cornucopia) who, respectively, ensure Marie's wise conduct and display the fruits of her regency. At the left Saturn (with a sickle, his attribute), who personifies Time, is shown leading France forward to receive the blessings of the queen's reign. These blessings are shown in a multitude of images, from the garland of fruits suspended above the throne, to a golden chain, coins and laurel wreath – references to princely liberality – scattered over the heads of four putti, one of whom raises his hand to receive them. One putto carries panpipes, while another holds brushes; a book, manuscripts, compass and square and a trumpet lie on the ground, indicating that the 'sciences and the arts' mentioned in Rubens' description are indeed flourishing. The fourth putto at the right steps on the head of one of three evil creatures, identified as Envy, bound Ignorance (with asses' ears and hands tied behind his back) and Vice (a satyr). Two flying figures of Fame, each with trumpets, complete the composition.

Always prudent, Rubens would have preferred to limit himself to allegorical generalizations to avoid evoking specific and possibly contentious events, as he did later in the ceiling paintings for the Whitehall Banqueting House (see Chapter 8). Thus, after the court had approved of his invention, he wrote with some satisfaction that *The Felicity of the Regency*, 'which does not specifically touch upon the *raison d'état* of this reign, or apply to any individual, has evoked much pleasure, and I believe that if the other

subjects had been entrusted entirely to me, they would have passed, as far as the Court is concerned, without any scandal or murmur.' However, whether allegorical generalizations or historical reportage, the central theme of the gallery is peace and its benefits.

At the same time as he was working on the Medici cycle, Rubens was designing a series of tapestries of subjects taken from the life of Constantine (288–337 AD), the first Roman emperor to

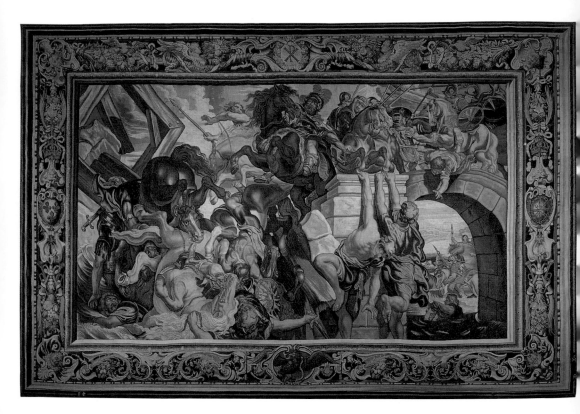

convert to Christianity (his mother, Helena, who was instrumental in the conversion, was the subject of Rubens' altarpiece for Santa Croce in Rome). These were to be woven in Paris in a workshop owned by two fellow Flemings, and, although there is no evidence that the tapestries were commissioned by Louis XIII, it seems that Rubens and the manufacturers had hoped from the outset to sell them to the king. The story of the Roman emperor provided a highly fitting theme to adorn the young king's palace

walls. Louis bought the seven tapestries, but, in the end, Marie's gallery outshone that of her son. The Constantine series did not remain long in the royal collection. In 1625 Louis presented the tapestries to the papal legate, Cardinal Francesco Barberini, who took them back to Rome, where the series was eventually finished by the Italian Baroque master Pietro da Cortona (1596–1669).

The commission must have been an attractive one for Rubens, for it gave him the opportunity to apply his considerable knowledge of ancient art and life. This was noted with appreciation in 1622 by his friend, the distinguished French antiquarian and archaeologist Nicolas-Claude Fabri de Peiresc (131), who, upon having inspected the first four cartoons (the patterns from which the tapestries were to be woven), commented to Rubens on his

129–130
The Battle of the Milvian Bridge, from *The Life of Constantine*, 1623–5. Tapestry; 493×738 cm, 194×290½ in. Philadelphia Museum of Art
Right
Detail

131 **Far right**
Nicolas-Claude Fabri de Peiresc from *The Iconography*, a collection of etched and engraved portraits after works by Anthony van Dyck, c.1632–44

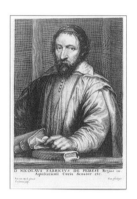

'preciseness in rendering the antique costumes, right down to the studs on the soldiers' boots which I noted with the greatest pleasure on the sole of the foot of a horseman pursuing Maxentius'. The scene in question is *The Battle of the Milvian Bridge* (129) which depicts the collapse of the bridge and subsequent defeat by Constantine of his co-emperor Maxentius in 312 AD. It is doubtful if, were it not for Peiresc's observation, the archaeologically correct nails on the boots of the horseman who is about to plunge into the river would still attract such approving attention (130).

In the end, the French court, for which Rubens had done some of his greatest work, left him bitter and disillusioned. The prime cause for his disappointment was Louis XIII's powerful minister

Cardinal Richelieu. In the course of the three years during which Rubens had been working on the Medici cycle, Richelieu had risen in status so that he was effectively controlling the king. In the process, he had switched allegiance from the Queen Mother to her son, although the former had 'raised him from the dirt', as Rubens was to observe in 1631. Richelieu's attitude towards the Fleming, which had begun amicably enough, had become more unfavourable as he – rightly, as it turned out – recognized the painter as a future political agent acting for the Habsburgs. Rubens, for his part, came to see in the cardinal a courtier who,

132
**Rubens'
assistant,**
Drawing of
Rubens'
Egyptian
mummy case.
Pen and ink.
Bibliothèque
Nationale,
Paris

133
Drawing of a
silver spoon,
1634.
Pen and ink
with brown
wash and
touches of
white.
Bibliothèque
Nationale,
Paris

as he wrote on 1 August 1631, 'is motivated more by personal ambition than regard for the public welfare and the service of his king'. Meanwhile, Rubens was ignored at court. Work on the cycle devoted to the life of Henry IV could not proceed because Richelieu, who had the programme in his hands, refused to discuss it on the excuse that he was fully occupied with affairs of state (he was in fact looking for another painter to take over the commission). Frustrated, Rubens complained to Peiresc in May 1625, 'I am tired of this court, and unless they give me prompt

satisfaction, comparable to the punctuality I have shown in the service of the queen mother, it may be (this said in confidence, *entre nous*) that I will not readily return.'

But there were compensations. Paris offered the opportunity to meet old friends and make new ones. At court, Rubens renewed his acquaintance with Frans Pourbus, his erstwhile fellow court painter at Mantua who had become Marie de' Medici's chief portraitist (see 51). More importantly, Paris was the centre of a lively intellectual community. It was there that Rubens finally met Peiresc, with whom he had already been corresponding for several years. In 1619 Peiresc had been instrumental in helping Rubens to obtain copyright for his prints in France, and two years

later they exchanged letters over a subject that interested them both deeply: antique gems and cameos. Their meeting in Paris in 1622 set the seal on a lifelong friendship. Despite the fact that in 1623, just after Rubens' second visit to Paris, Peiresc returned to his native Provence, they continued a lively and extensive correspondence that lasted until Peiresc's death in 1637 (134). They exchanged learned opinions on such archaeological items in Rubens' collection as an Egyptian mummy case (132) and an ancient silver spoon, suspected by Peiresc of being a modern fake (133). They also carried on preparations for a joint publication of the famous gems and cameos of antiquity, though the project was never completed.

presentir che [...] vivere con tutte le sue Grande
non potrebbi far meglio Quest[a] vagliono un [...]
anco sono inestimabili al parer mio, se mara[...]
[...]iamo tutti che VS in tanta Calamita Pablica [...]
[...] col animo tanto riposato che possa col qu[...]
solita continuar la sua nobiliss[i]ma Curiosita [...]
osservacione verum antiquarum ingeniis am
bene compositi et vera Philosophia imbuta
spero pero che al arrivo di questa havera [...]
il male e chella sara hormai di ritorno
suo sacro muszo, che piaccia al S.r Dio, si
con ogni felicita e Contentezza per molti anni
come giusto suo divotissimo [...] desidera con
tutti il cuore et gli bacia le mani.
d'Agosto 1630

d'Anversa il 22 [...]

Di V. S. [...]

quadri disegni sono isquisitamente ben fatte e [...]
in questo genere non si potrebbe far meglio
sara bene che VS tenga questo Virtuoso giovane
appresso di se per intendere delle sue bellissime Concetti

Il ritratto di VS e stato gratiss[i]mo a me et a questi
[...] che l'hanno veduto e restano interissima[mente] sodisfatti
della somiglianza ma io confesso non mi parere di
ritrarre a questa faccia non so che di

[...]toso et una Certa emphasi nel sembiance
che mi pare propria del Genio di VS la
la quale pero non si accerta facilm[en]te

Ritorno da ognuno
[...] a VS dinovo mille gratie per
tanti regali e la prego voler baciar le mani
con tutto il cuore da mia parte al gentiliss[i]mo Sig[no]r
de Valavez Vostro fratello che mi ha scritto
da Lyone agli quattro di Julio dandom nova d'havere
ricevuto il mio ritratto che mi dubito sara maltrattato
per il longo viaggio et per tutti modi indigno del muszo
di VS [...] qualche di virtuoso

Pietro Paolo Rubens

134
A letter from Rubens to Peiresc with sketches of an ancient tripod, 1630. Pierpont Morgan Library, New York

Before Peiresc's departure from Paris in 1623, he had made certain that Rubens would continue to have correspondents in the French capital. Among them was the royal librarian Pierre Dupuy, with whom the painter exchanged letters with unbroken regularity from 1626 to 1629. They differ in content from those to Peiresc in that political news, rather than classical studies and archaeology, is their main topic of discussion. This reflected the seriousness of the political situation in Europe, where times were turbulent, with the balance of power constantly shifting and war ever threatening. As the political situation worsened, Rubens found himself increasingly caught up in events of the day. The painter, who had been no more than a politically astute observer, commentator and adviser, was forced to become an active diplomat on behalf of his country.

Ambassador of Peace Madrid and London 1628–1630

135
*George Villiers,
1st Duke of
Buckingham,*
1625.
Black, red and
white chalk
with touches of
brush and ink;
38·3×26·6 cm,
15×10⅜ in.
Albertina,
Vienna

In 1621 the Twelve Years' Truce between the Northern and
Southern Netherlands had come to an end and open hostilities
resumed. But what had begun as a local struggle against Spanish
authority was soon to become part of a war that engulfed all of
Europe. At the time, the major European powers were divided
into two mutually hostile groups: those states, mainly Catholic,
that aligned themselves with Habsburg interests (Spain and
Portugal, southern Italy and Sicily, Austria, Bohemia, part of
Hungary, and numerous German states), and those that for
political, economic or religious reasons opposed Habsburg
power (England, France, Denmark and Sweden). In May 1618
the Protestants of Bohemia had revolted against their Catholic
Habsburg monarch, stormed the castle at Prague and thrown the
imperial governors out of an upper-storey window (the so-called
Defenestration of Prague). The rebels elected a new Protestant
king, the German Frederick V, Elector Palatine, who was married
to the daughter of King James I of England. The Bohemian
Protestants thus hoped to gain the alliance of other German
princes and of the English king. But this help was not forth-
coming, and Frederick V was overwhelmingly defeated by the
Habsburg forces at White Mountain in 1620. Unable to return
to his own German state, which was occupied by the forces of
the Catholic League, he was forced to take refuge in the Northern
Netherlands. And thus the war, which had begun in Prague almost
unnoticed, was gaining momentum on its eventual thirty years'
course of destruction.

Where did Rubens' homeland stand in this conflict? The Northern
Netherlands continued strongly to oppose Habsburg domination,
not least because of the conflict of Spanish and Dutch trade
interests in the East and West Indies. Fearing for their recently
won independence and economic strength, the Dutch welcomed

Frederick V, not to reinstall him as king of Bohemia but in the hope of expelling Spanish troops from his German lands which lay uncomfortably close to their borders. Meanwhile, in the Southern Netherlands, Albert and Isabella could not but support Spanish policies, although they were not blind to the lack of concern Spain had so often shown for its Netherlandish subjects. When the Twelve Years' Truce expired, they hoped for negotiations that would lead to lasting peace, or at least to a renewal of the truce. It soon became apparent, however, that the Spanish king, Philip III (soon to be succeeded by his son, Philip IV), wanted to resume military operations against the Northern Provinces with the aim of reuniting the Netherlands under the Catholic rule of the Spanish crown. The situation was not helped by the death of Archduke Albert in July 1621, following which the direct sovereignty of the Southern Netherlands reverted to Spain. In policies concerning war and peace, Isabella now had to follow the directives of her nephew, King Philip IV (136). It was under the threat of war that Isabella, overstepping her authority, took up secret diplomatic negotiations with the North, and it was Rubens who became her emissary.

In today's world of professional diplomats, it may be surprising that a painter, however great his stature, could be actively involved in this way in matters of state. Admittedly, the choice was unusual even in Rubens' time, when such positions were generally reserved for members of the aristocracy. But Rubens was not the first artist to be assigned political tasks. In the early fifteenth century Jan van Eyck undertook secret journeys for his patron, Philip the Good of Burgundy; and Rubens' fellow Fleming, the painter Balthasar Gerbier (1592–1663), was a political agent working for England. Court painters such as Van Eyck and Rubens, after all, had easy access to royalty, and secret diplomatic missions could be camouflaged fairly plausibly by their activities as painters, especially of portraits. In Rubens' case, his pleasing personality, sharp intellect and acute powers of observation made him an ideal candidate for sensitive political negotiations; his honesty and integrity, although initially regarded with

136
Diego
Velázquez,
*Philip IV in
Brown and
Silver*,
*c.*1631–2.
Oil on canvas;
199.5 × 113 cm,
78½ × 44½ in.
National
Gallery,
London

suspicion in this profession ruled by intrigue, ultimately earned him the trust and respect of his superiors; his sincere wish for peace gave him the passion and dedication needed for his task. Finally, it was Rubens' close relationship with the Infanta Isabella – a relationship based on mutual respect, trust and what seems to have been genuine affection – that secured his appointment as political emissary and, eventually, as official Habsburg diplomat.

After attempts at direct negotiations with the Northern Netherlands failed, Rubens, with the full support of the Infanta, began working out a plan that would bring England on to the side of Spain. England, a Protestant country, had a long tradition of alliance with the Dutch; Charles I's only sister and her husband, Frederick V, had found refuge in the Northern Netherlands. It was Rubens' hope that, once a treaty between England and Spain was concluded, English influence would convince the Northern Netherlands to return to the conference table if not to the Spanish crown. Thus an English–Spanish agreement was the first in a series of peace treaties Rubens envisioned. As he wrote later from London to Madrid on 24 August 1629: 'I consider this peace to be of such consequence that it seems to me the connecting knot in the chain of all the confederations of Europe.' Once negotiations between Spain and the Northern Provinces were reopened, a settlement could be reached between the two countries that would renew the conditions and privileges the Southern Netherlands had enjoyed during the Twelve Years' Truce, foremost among them the partial lifting of the blockade of the River Scheldt. This concession, which had brought with it the reopening of the port of Antwerp, had been revoked in 1621; now, with its harbour closed once again, the city was declining day by day. In a moving account written in May 1627 to Pierre Dupuy, Rubens describes the sad state of his home town:

Here we remain inactive in a state midway between peace and war, but feeling all the hardships and violence resulting from war, without any of the benefits of peace. Our city is going step by step to ruin and lives only upon its savings; there remains not the slightest bit of trade

to support it. The Spanish imagine they are weakening the enemy by restricting commercial licence, but they are wrong, for all the loss falls upon the king's own subjects.

The negotiations towards a treaty between England and Spain marked the beginning of Rubens' involvement in international politics. Between 1627 and 1630 his time and energy were largely directed towards the completion of this goal. He travelled widely, at first on secret missions to the Northern Netherlands, later on official diplomatic journeys to the courts of Madrid and London. Although there can be no doubt about Rubens' sincere desire for peace, there may have been another, more private reason why he welcomed these absences. In the summer of 1626 his wife, Isabella Brant, had died, and Rubens felt that a change of surroundings would assuage his grief:

I should think a journey would be advisable, to take me away from the many things which necessarily renew my sorrow, *ut illa sola domo maeret vacua stratisque relictis incubat* ['just as she (Dido, who has been deserted by her lover Aeneas) mourns alone in the empty house, and broods over the abandoned couch' (*Aeneid* 4.82–3)]. The novelties which present themselves to the eye in a change of country occupy the imagination and leave no room for a relapse into grief.

Among the 'many things' that caused Rubens such painful memories may have been his antique statues, gems and coins, for he decided to sell them at the end of 1626, only six months after his wife's death. It seems unlikely that Isabella Brant shared her husband's passion for antiquities, but they had been acquired during their marriage and for the home Rubens had so lovingly designed for them. The buyer was the English nobleman George Villiers, Duke of Buckingham (135); the duke's agent in this transaction was Balthasar Gerbier.

At this time Buckingham was the absolute favourite at the English court, with considerable power over the king. Although contemporary opinion considered him unfit for the role of statesman and general, his influential position made him, for a while, one of the

major players on the European political stage. Rubens had met Buckingham in Paris in the spring of 1625, when he was completing the pictures for Marie de' Medici. The duke had come to act as escort to Henrietta Maria, whose marriage by proxy to Charles I (137) had been celebrated in the newly decorated Luxembourg Palace. Ever astute in such matters, Rubens recognized the importance of Buckingham in any negotiations involving Britain, but he was under no illusions about the English statesman and in December 1625, only a few months after meeting him, wrote:

When I consider the caprice and arrogance of Buckingham I pity the young king, who, through false counsel, is needlessly throwing himself and his kingdom into such extremity. For anyone can start a war when he wishes, but he cannot so easily end it.

However, as far as Rubens was concerned, Buckingham had one redeeming feature: he was a great collector of art. Despite their very different temperaments, this mutual interest must have helped to bridge personal animosities and conflicts. It was probably during their meetings in Paris that Rubens received the commissions for a ceiling illustrating *The Glorification of the Duke of Buckingham* and a large allegorical equestrian portrait to decorate York House, Buckingham's residence in London (destroyed in 1949). In preparation, he drew a portrait of the duke (see 135). The handsome, arrogant face is rendered in a combination of black and red chalk with white highlights, Rubens' preferred technique for drawings of this type, which he had developed for the studies of his children (see 102–104). In Paris, too, Buckingham must have learned of Rubens' outstanding collection of antiquities and other works of art (if he did not know about it already), for it was to Buckingham that Rubens turned when he offered his collection for sale in 1626.

While it may have been grief over his wife's death that prompted Rubens to sell their shared possessions (it certainly was not need of money), it also provided a plausible excuse for political negotiations. Undoubtedly, Rubens felt that a change in his house and lifestyle would help him to get over his loss, but he was too

rational a man to be solely guided by his emotions. With all hope of a Spanish–Dutch treaty dashed, a Spanish–English alliance seemed the only alternative, and art the perfect cover for preliminary negotiations. Thus, when Rubens and Gerbier met, ostensibly to discuss the Buckingham sale, they considered plans for what came to be known as the 'English peace'.

Unfortunately, these meetings were to have no real political consequences. The problem was that Rubens acted on behalf of the Infanta, not the Spanish king, and any serious approach to the English king had to come from the Spanish court. Philip IV, however, saw no need for any change of direction in his policies. 'If Spanish pride could be made to listen to reason,' Rubens wrote to Dupuy in May 1627, 'a way might be found to restore Europe (which seems all in chains together) to a better temperament.' A change in Spanish attitude did finally come in early 1628. The previous year Spain had formed an alliance with France to help the Catholic monarchy's fight against the French Protestants. Once this internal struggle had been resolved, the Spanish–French alliance was threatening to disintegrate. Philip IV and his ministers were worried that France would now look towards England as an ally, and it was at that moment that Philip remembered the peace plans of his aunt, the Infanta Isabella. As the acknowledged expert on the English peace negotiations, Rubens was hurriedly dispatched to the Spanish court for further consultation. Travelling in secret through France, he reached Madrid in August 1628.

138
Diego
Velázquez,
*Gaspar de
Guzman,
Count-Duke
of Olivares*,
c.1625.
Oil on canvas;
216×129·5 cm,
85×51 in.
Hispanic
Society of
America,
New York

Before Rubens' arrival in Madrid, Philip was unenthusiastic about his aunt's choice of diplomat. He wrote to her on 6 June 1628 that 'I am displeased at your mixing up a painter in affairs of such importance. You can easily understand how gravely it compromises the dignity of my kingdom, for our prestige must necessarily be lessened if we make so mean a person the representative with whom foreign envoys are to discuss affairs of such great importance.' But his scruples were quickly overcome, and Rubens was well received at court. Both Philip IV and his first

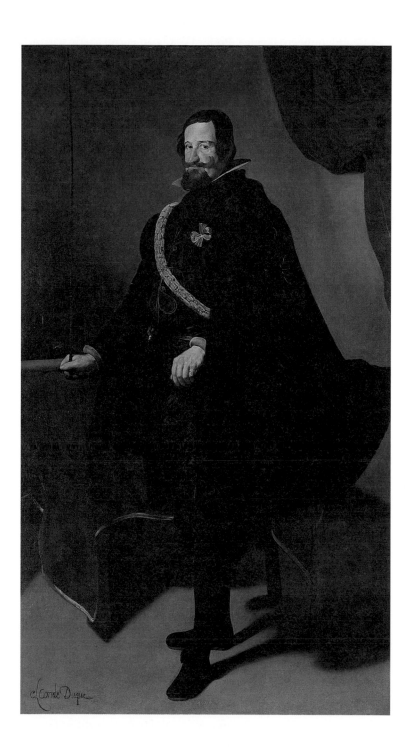

minister, Gaspar de Guzman, Count-Duke of Olivares (138), showed great friendliness towards him. Though by all accounts a weak and ineffectual ruler, Philip IV was an enthusiastic patron of the arts and much admired Rubens' paintings. He already owned several of his works, including the early *Adoration of the Magi* (see 61), which Rubens may have expanded at this time to include his self-portrait (see Chapter 4), and was later, in 1636, to commission him to decorate his new hunting lodge, the Torre de la Parada. After Rubens' death, he bought most of the paintings by Rubens left in the artist's collection.

Twenty-five years had passed since Rubens had been in Spain on his first diplomatic mission. He must have greatly enjoyed his change of position from junior emissary of the Duke of Mantua to major political figure, who held the attention of the king and his first minister. But no sooner had peace talks begun when news arrived that the Duke of Buckingham had been assassinated. Immediately doubts were raised as to whether England would continue on the same course of negotiations. After the initial hectic weeks of political meetings, Rubens settled down to await further developments from London. His true profession never far from his mind, he spent his time studying the royal collections and painting portraits of the royal family: 'Here I keep to painting as I do everywhere and already I have done the equestrian portrait of His Majesty, to his great pleasure and satisfaction. He really takes an extreme delight in painting, and in my opinion this prince is endowed with excellent qualities,' he wrote to Peiresc in December 1628.

It may seem surprising that Rubens, who only the previous year had complained to his friend Dupuy of the unfortunate results of 'Spanish pride', came to speak so favourably of the king. It is of course possible that Rubens' letters from Madrid were censored, but on the face of it his sympathy for Philip IV was genuine. Clearly he did not equate the person of the king with Spanish policies, of which he was so often critical. He even went as far as crediting Philip with superior qualities of leadership, 'were it not

that he mistrusts himself and defers too much to others', as he wrote to a friend in Antwerp. In a similar vein, Rubens had pitied Charles I for the 'false counsel' of the capricious and arrogant Buckingham, without considering that heeding such counsel is as much of a responsibility as giving it. Despite his usual shrewdness and level-headedness, when it came to kings – especially art-loving kings – Rubens seems to have been somewhat blinded.

In addition to the equestrian portrait of Philip IV (destroyed in the Escorial fire of 1734), Rubens painted four other portraits of the king. Since these are known only in rather pedantic versions

139
King Philip IV, 1628–9. Pen and brown ink over black and red chalk heightened with white; 38·3×26·5 cm, 15^1⁄$_8$×10^3⁄$_8$ in. Musée Bonnat, Bayonne

produced by the studio, the most spirited likeness of the monarch from Rubens' hand to survive is not a painting but a drawing (139). In this study, Philip is shown wearing a hat and cloak slung over his shoulder, as if about to leave. The informality of the pose corroborates Rubens' account that the king visited him in his rooms in the palace almost every day. The portraits of Philip IV, along with those of other members of the royal family, were done for the Archduchess Isabella to update her family gallery, as Rubens informed Peiresc: 'I have also done the heads of all the royal family, accurately and with great convenience, in their presence, for the service of the Most Serene Infanta, my patroness.' Though

portrait painting provided Rubens with a convenient camouflage for political negotiations, Isabella still wanted her pictures.

As Rubens already knew from his first visit to Spain, the royal palaces offered unsurpassable riches. The collection of paintings by Titian, built up by Charles V and Philip II, was unrivalled, and there were many other Italian masterpieces. It was the works of Titian, however, to which the Flemish master turned again and again. According to the Spanish painter and art historian Francisco Pacheco (1564–1644), teacher and father-in-law of Diego Velázquez (1599–1660), Rubens copied every Titian in the

140
Titian,
*Francesco
Maria della
Rovere, Duke
of Urbino*,
1536–8.
Oil on canvas;
114×103 cm,
44⁷/₈×40¹/₂ in.
Galleria degli
Uffizi,
Florence

king's possession. This may be an exaggeration, but judging from the artist's inventory and the surviving pictures, the Spaniard may not be too far wrong. Copying the works of others was of course standard procedure, and one Rubens pursued with greater enthusiasm and diligence than anyone (see Chapter 2). But it was an activity usually associated with an artist's early years, unless it served documentary or other practical purposes (*eg* the supply of copies for the art market). That a mature and busy artist should commit himself to such an exercise was unprecedented, and this encounter with Titian was to be of the greatest significance for

the future of Rubens' painting. The astounding fertility of his last decade, marked by both technical brilliance and a new approach to narrative and landscape, was largely inspired by Titian.

Although it is Rubens' copies after Titian's history paintings which will be the main focus here, most of the copies he made after Titian – known either in the original or from the artist's inventory – are portraits. With the exception of a few painted in Italy or during Rubens' first mission to Spain in 1603, they were executed in 1628–9, as were all the copies of history paintings. Considering that Rubens never was, strictly speaking, a portraitist, the predominance of portrait copies may seem surprising. One reason is that, since Titian painted many portraits, Rubens' copies simply reflect this. Furthermore, many of the personages represented are Habsburg emperors and their consorts or other rulers of the day (140), and, as painter and emissary of the Habsburg court of the Spanish Netherlands, Rubens' copies of portraits of former Habsburg rulers, their representatives and supporters may have been as much a tribute to Isabella's heritage as to the Venetian master. Rubens himself was involved in painting portraits of the Spanish royal family for the Infanta, so that copying Titian's portraits provided a natural and beneficial extension to his own efforts in that genre. As it was, the exuberant portrait style he had established in Genoa (see 49) was not entirely suitable to the more sombre Spanish court dictated by strict religious and political etiquette; Titian's perfectly balanced Renaissance compositions, his emphasis on psychological nuances rather than external splendour perhaps had a sobering effect on Rubens. With few exceptions, most noticeably the representations of his second wife, Helena Fourment (see Chapter 8), Rubens' late portraits are restrained and unembellished, lacking the balustraded terraces, massive pillars and billowing curtains of his earlier images. The fact that the artist was to retain the exuberant Baroque vocabulary he had created for the nobility for the portraits of his very young, bourgeois wife, while reverting to simpler styles in his portrayals of aristocratic society, is one of the ironies of Rubens' art.

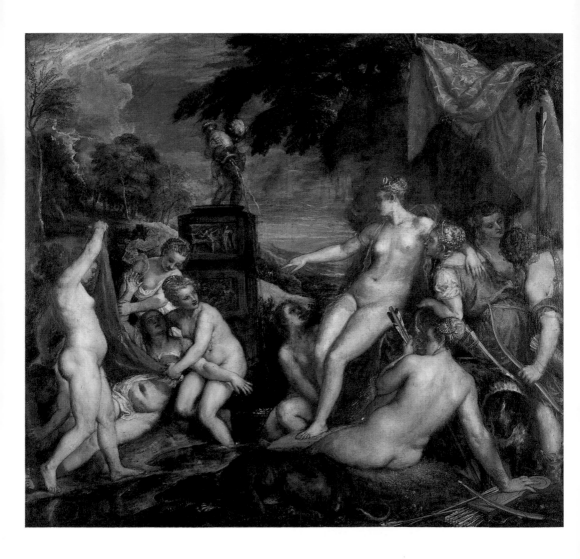

141
Titian,
*Diana and
Callisto*,
1556–9.
Oil on canvas;
188×203 cm,
74×79⅛ in.
National
Gallery of
Scotland,
Edinburgh

142
*Diana and
Callisto,*
1628–9.
Copy after
Titian.
Oil on canvas.
Private
collection

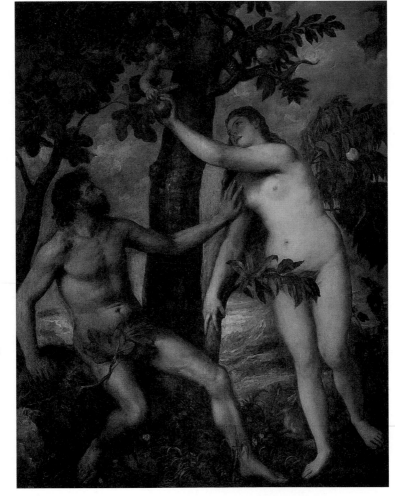

143
Titian,
The Fall of
Man,
*c.*1550.
Oil on canvas;
240×186 cm,
94¹₂×73¹₄ in.
Museo del
Prado, Madrid

144
The Fall of
Man,
1628–9.
Copy after
Titian.
Oil on canvas;
237×184 cm,
93¹₄×72³₈ in.
Museo del
Prado, Madrid

It was not, however, Titian's portraits but his paintings of biblical and mythological subjects which had the most decisive impact on Rubens. He made copies of the so-called *poesie*, six subjects from Greek mythology Titian had painted for Philip II, inspired by stories from the *Metamorphoses* by the Latin poet Ovid (43 BC–18 AD), of which two survive: *The Rape of Europa* and *Diana and Callisto* (141, 142). Rubens also painted the large canvas *The Fall of Man* (143, 144), of which original and copy are

145
Diego Velázquez,
Las Meninas,
1656.
Oil on canvas;
318×276 cm,
125¼×108 in.
Museo del
Prado, Madrid

today in the Prado. The Titians in this group are late works, from a period when his handling of paint had become looser, applied in bold strokes so that the contours are less defined than in his earlier works. Figures seem to be enveloped in a haze of light and colour. This manner of painting had meant comparatively little to the young Rubens of the Italian years, who had

been more interested in draughtsmanship and compositional
structure than in the exploration of tone and texture. Now the
late art of Titian became a revelation to the painter whose
own artistic style had developed in the direction of greater
colouristic splendour.

On the whole, Rubens' copies are surprisingly faithful to their
originals. His admiration for Titian left no room for criticism;
he had met in the Venetian master his equal, or rather a kindred
spirit, who shared the same painterly ideals. Yet when the two
versions of *Diana and Callisto* are viewed together, the differences
are obvious. Rubens' palette is somewhat lighter than Titian's,
his treatment of texture, especially of flesh, more tactile, and his
bodies less idealized: the nymphs are plumper, Callisto's stomach
rounder, as befits her pregnancy (the story is told in Chapter 9).
Even the goddess Diana is not exempt from the general make-
over the Flemish artist gave to his women: her body, and especially
her legs, are heavier, which makes her appear less regal in
demeanour. From these comparisons it is clear that, regardless
of how sympathetic he was to Titian's pictorial language, Rubens'
artistic temperament and milieu were markedly different
– he was a painter, not of the Italian Renaissance but of the
Flemish Baroque.

Rubens' own unfavourable view of contemporary Spanish
painters had changed little over the years since his earlier visit,
with one exception: Velázquez (145). According to Pacheco,
the Flemish master communicated little with painters, 'only
with Don Diego Velázquez [with whom he had corresponded,
although the correspondence has not survived] did he become
intimate, and he approved of his works because of his great
virtue and modesty'. Velázquez, twenty-nine years old, had been
appointed court painter in 1623. The two men, both with rooms
in the royal palace, must have spent much time together, watch-
ing each other at work and visiting the royal collections. They
apparently made a journey together to the Escorial, that severe
and forbidding palace which Philip II had built in the barren

hills near Madrid, where they admired more 'paintings by the greatest artists which have flourished in Europe', including those of Titian. It may well have been in front of these great masterpieces that the two artists decided to travel to Italy together. We know that Rubens hoped to visit Italy again before returning to the Netherlands, travelling overland so that he could stop at Aix-en-Provence, where his old friend Peiresc lived. As it happened, events decided otherwise, and it was Velázquez alone who left for Rome in August 1629, only a few months after Rubens' departure from Spain.

When it became apparent that there was no change of plans in England, and that the peace treaty with Spain was still desired, Rubens was sent to London as a negotiator. He left Madrid in April 1629, travelling via Paris and Brussels. In Paris he had time to visit Dupuy and other friends and look once again at the Luxembourg Palace, where one gallery was still awaiting his pictures; in Brussels he was informed by Isabella of a recently concluded peace treaty between England and France, which made his departure ever more urgent. After a quick trip to Antwerp to see his children and studio, Rubens was ready to sail for England, arriving in London at the beginning of June. He lodged in the house of Balthasar Gerbier, the man with whom he had arranged the Buckingham sale and initiated the negotiations, which were now to come to their final conclusion.

146
*The Family of
Sir Balthasar
Gerbier*,
1629–30.
Oil on canvas;
166×178 cm,
65⅜×70⅛ in.
National
Gallery of Art,
Washington,
DC

Gerbier was a man of somewhat dubious character; Flemish by birth, he had come to England as a minor portrait painter, when he was taken up by the Duke of Buckingham. He was employed on various artistic commissions and also acted as a secret agent and political negotiator, which brought him constantly into contact with Rubens. The latter could not have had any illusions about Gerbier but, as so often in his dealings with politically powerful or suspect men, Rubens found that a shared love of art provided a basis for further negotiations. On leaving London, the grateful guest presented his host with a portrait of his wife and children (146).

In England Rubens was received with mixed feelings. While his appointment as official Spanish envoy was generally met with approval at court, other factions were not so favourably disposed towards him or his mission. Foremost among them were those who supported an alliance with France against Spain, secretly fuelled by French agents of Cardinal Richelieu. Moreover, any change in the status quo among the three major powers, England, France and Spain, would necessarily alter the relations among all other players on the European stage. Thus Rubens' visit alarmed the Dutch, who feared the end of English aid to their country; the French Protestants, who looked to England for support in their struggle against Catholic ascendancy; while those who wanted to restore the Palatinate to Frederick V knew that their efforts would be severely compromised. To add to the complexities of the situation, Rubens was not empowered to draw up a treaty, as Charles I wished, but only to negotiate a truce. As to his personality, his direct and honest approach caused suspicion or, worse, was altogether mistrusted: 'an ambitious and greedy man, who wants only to be talked about, and is seeking some favour', is how the Venetian ambassador saw the painter-turned-diplomat.

In numerous letters to Olivares, Rubens described the difficulties and pitfalls of his mission. He complained bitterly of the intrigues and self-serving nature of many of the men surrounding the king. At one point, his distrust was so great that he felt compelled to get in writing from the king the promises and plans which had been made orally, because of the 'instability and diversity of opinion among these ministers'. Rubens recognized the weaknesses and duplicities that lay behind the lavish and costly lifestyle of the nobles, who, as he explained in a letter of 22 July 1629, 'for the most part, have inadequate revenues to support their rank, and are forced to provide for their needs as best they can. That is why public and private interests are sold here for ready money.' This money, as Rubens well knew, was amply supplied by Richelieu and his agents. Despite setbacks, disappointments and delays, Rubens persevered. With justifiable pride, he continued to Olivares in the same letter:

I do not feel that I have employed my time badly since I have been here, or that I have overstepped in any way the terms of my commission. I believe that I have served the king, our master, with the zeal and prudence appropriate to the importance of the negotiation which has been entrusted to me.

Finally, after three months of negotiations, an agreement was reached to exchange English and Spanish ambassadors. Rubens' efforts having been successful, he must have imagined that his task was at an end. Except for a brief stop-over in Brussels and Antwerp on his way from Madrid to London, he had been away from home for almost thirteen months. Deeply sincere in his desire for peace and willing to make personal sacrifices in the pursuit of this goal, he was nevertheless impatient to return to his children, friends and workshop. As he confessed in a letter on 23 November 1629 to a friend in Antwerp: 'I should be happier over our peace or truce than over anything else in the world. Best of all, I should like to go home and remain there all my life.' But his anticipation was premature. Another three months passed before the Spanish ambassador arrived in London, and several more before Rubens was allowed to leave England. His mission finally completed, he arrived back in Antwerp in April 1630.

Rubens had been in England for more than nine months. Making the most of the situation, he spent his time looking around the country and studying the great collections. Apart from a visit to Cambridge, where he was awarded a degree of Master of Arts by the university, we know little about his movements. His letters, however, are full of praise for his beautiful host country. As he wrote to Pierre Dupuy in August 1629:

This island seems to me to be a spectacle worthy of the interest of every gentleman, not only for the beauty of the countryside and the charm of the nation; not only for the splendour of the outward culture, which seems to be extreme, as of a people rich and happy in the lap of peace, but also for the incredible quantity of excellent pictures, statues and ancient inscriptions which are to be found in this court.

Rubens must have delighted in the royal collection with its predominance of Venetian paintings. He visited York House, residence of the late Duke of Buckingham, to whose decoration he himself had previously contributed the ceiling painting and equestrian portrait of the duke. He was pleased to find the collection of pictures, statues, gems and medals, many of which once graced his own home, intact and well cared for. Above all, he marvelled at the collection of antiquities owned by Thomas Howard, Earl of Arundel. Howard, who held the hereditary title of Earl Marshal of England, was ostracized from the court in

147
Thomas Howard, Earl of Arundel, 1629–30. Oil on canvas; 122×102 cm, 48×40⅛ in. Isabella Stewart Gardner Museum, Boston

148
Self-Portrait, c.1623–4. Oil on panel; 86×62·5 cm, 33⅞×24⅝ in. Royal Collection, Windsor Castle

1625 at the instigation of his rival Buckingham, but was restored to favour shortly before the latter's assassination in 1628. For the next decade he served Charles I as ambassador. His career as a statesman, however, was less spectacular than his artistic avocation. He was a great connoisseur, patron and collector, a man Rubens himself had praised on an earlier occasion as 'one of the four evangelists and the supporter of our art'. Although Rubens was not officially engaged as a portrait painter, as he had been in Spain, he accepted the commission to paint the earl (147).

The portrait shows Arundel as statesman rather than collector, wearing armour and the gold baton of his office as Earl Marshal. The sober portrayal, which contrasts with Rubens' earlier exuberant portrait style, not only emphasizes Arundel's stern and austere appearance but also betrays the influence of Titian's representations of men in armour which Rubens had studied in the Spanish collections (see 140).

Above all, however, it was the king himself with whom Rubens established a close relationship. Their mutual admiration can be traced back to 1623, when Charles, then Prince of Wales, had asked for a self-portrait by Rubens to be placed in the royal gallery (148 and frontispiece). Despite Rubens' initial protestations – 'it did not seem fitting to send my portrait to a prince of such rank' – he complied. The picture, still in the royal collection, presents the artist in his prime: elegant, self-assured and dignified. Rubens painted himself only four or five times (apart from group portraits or representations of himself in narrative scenes), as compared, for example, to Rembrandt who drew, painted or etched innumerable images of himself. And even Rubens' few self-portraits were apparently done on request, rather than as an exercise in self-scrutiny. He never showed himself as a painter, with brushes and palette, an image popular among seventeenth-century artists, especially in Holland. Conscious of the stigma still attached to manual labour, Rubens always portrayed himself as a gentleman. In the painting for Charles I he wears a wide-brimmed hat; ostensibly to hide his premature baldness, it adds to the elegance of the sitter.

With Rubens' stay in the English court, the relationship between painter and king flourished. Life at this most sophisticated of courts must have charmed Rubens, who, in a letter of 10 January 1625, had eulogized Charles as 'the greatest amateur of painting among the princes of the world'. Charles, for his part, honoured Rubens with a knighthood and presented him with the sword with which he performed the ceremony, as well as a ring from his finger and a bejewelled hatband.

It was also at court that Rubens met the English architect Inigo Jones (1573–1652), who had been responsible for the design of the Banqueting House. Constructed in 1619–22, it was the first of the buildings planned to make Whitehall into one of the largest and most sumptuous palaces in Europe. In this case, Rubens had a more direct interest: the decoration of its ceiling. His attempts at securing the commission eight years earlier had been in vain, but now the plan was revived, and the painter must have spent numerous hours with the court architect discussing the programme and appearance of the final ensemble, possibly even supplying a preliminary sketch (149). The ceiling was divided into nine partitions which allowed for a scheme of pictures comparable to the ceilings Rubens had admired in Venice. The theme was to be the blessings of the reign of King James I, Charles I's father, and Rubens was to begin the work as soon as he got back to Antwerp (see Chapter 8). The canvases were installed in 1635, but the artist never saw the final result; neither his health nor his by then frequently professed horror of courts made the journey desirable.

Although, surprisingly, Rubens painted no portrait of the king, he paid personal tribute to him in a picture he executed in London, *St George and the Dragon* (150), in which the saint bears the features of Charles I and the princess those of his wife, Henrietta Maria. The central scene shows the king, as St George, patron saint of England, who presents the slain dragon, symbol of war, to the young princess, alias Henrietta Maria (possibly also intended as a personification of England), so that she may enjoy the fruits of peace. The setting is an idealized landscape reminiscent of the Thames Valley; a cityscape with specific details of London, including the Banqueting House, is visible in the distance. X-ray evidence suggests that in its original state as painted in England, the picture was much smaller, including neither the horrendous victims in the fore-ground nor the group of frightened spectators on the rock at the right, who were added later by Rubens after his return to Antwerp.

149
The Apotheosis of James I and Other Studies,
c.1630.
Oil on panel;
95×63·1 cm,
37⅜×24⅞ in.
National
Gallery,
London

150
*Landscape with
St George and
the Dragon*,
1629–30.
Oil on canvas;
153×226 cm,
60¼×89 in.
Royal
Collection,
Windsor
Castle

It is not known why Rubens decided to keep the painting rather than present it to the king, whose royal person it so obviously celebrates (it was only later acquired for the royal collection). It has been suggested that the canvas was unfinished when Rubens left England and that he planned to send it to Charles as soon as it was completed, a plan never carried out. The nature of the additions, however, suggests that Rubens was motivated by deeper concerns. For it was not long after his return to Antwerp that the former diplomat was forced to acknowledge the futility of his attempts to end the war and reunite his country. He had made the mistake of assuming that the Dutch, weakened by the desertion of the English, would accept the sovereignty of Spain, while retaining substantial guarantees of self-government (this being the second 'knot in the chain of all the confederations of Europe' which Rubens had envisioned). The Dutch Republic, however, had no such inclinations. Thus what had started out as a hopeful allegory of peace, inspired by the fortunate outcome desired for the treaty, was turned into a picture that insists, with its horrific details, on the darker side of the story.

Increasingly disillusioned with the political situation in Europe, Rubens was to turn from serving its rulers to depicting their victims. *St George and the Dragon* is only the first in a series of allegories in which the artist expressed his political views – views no longer determined by diplomacy or the demands of royal patronage but by simple human concerns (see Chapter 9). Meanwhile the king did not go empty handed: while still in London Rubens painted *The Allegory of Peace*, which he presented to Charles I as a personal gift as well as a sincere tribute to this ruler's peace efforts (see 190). In rich colours and sumptuous imagery the painter-diplomat depicts the fruits of a peaceful government, protected from the evils of war. However disillusioned Rubens became later, the picture remains a glowing celebration of the benefits of peace – a peace which, he believed at the time, would in due course return to his own country.

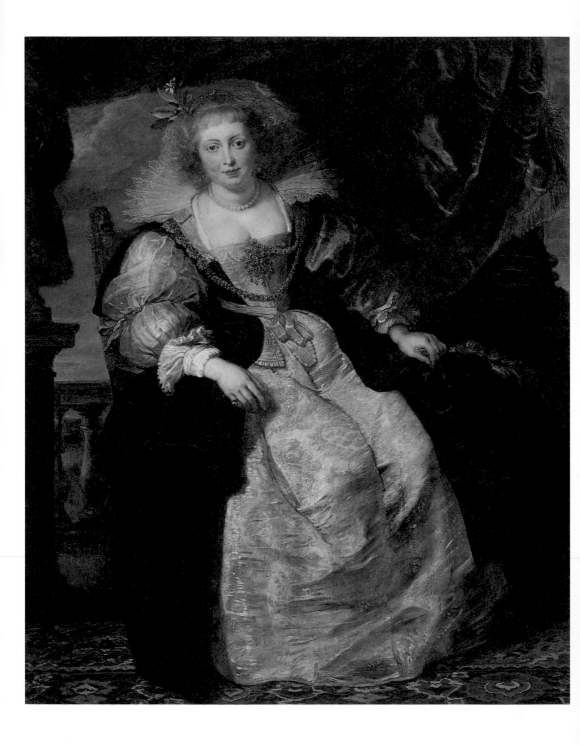

On the day before Rubens left London he paid a personal call on the Dutch ambassador, Albert Joachimi. His pretext for the visit was to ask for the release of a group of Flemish seamen held prisoner in Rotterdam. The real object of the meeting was to discuss the problem that was never far from his thoughts: peace between the Northern and Southern Netherlands. Rubens acted purely on his own initiative; in fact, he had been instructed not to deal with the Dutch. But encouraged by his recent success in the negotiations between England and Spain, he felt that a more direct approach would be profitable. He informed the Dutch ambassador that peace between England and Spain was assured and that the time was ripe for peace in the Netherlands. For Rubens this peace, however, essentially meant a return of the Northern Provinces to Spanish rule. Joachimi's answer must therefore have dismayed and, presumably, surprised him. According to Dudley Carleton, who reported the encounter to Sir Francis Cottington, English ambassador in Madrid, Joachimi told Rubens that peace in the Netherlands could be obtained 'but one way … by chasing the Spanyards from thence'.

It may seem surprising that a man as pragmatic as Rubens should hold on to the completely unrealistic belief that the Northern Netherlands would surrender their independence or so much as agree to a peaceful coexistence with Spain under Spanish terms. There were perhaps some extenuating factors – his faith and his dynastic loyalties, no doubt partly determined by his father's misfortunes and his childhood spent in exile; his remarkable relationship with the Archduchess Isabella; and the lack of access to reliable information in a divided country at war. Rubens' contacts in the North were Catholics like him (*eg* Pieter van Veen, Otto van Veen's brother), who may have presented him with a distorted view of the situation. Thus upon his return to the Netherlands,

151
Helena
Fourment
Seated on a
Terrace,
*c.*1630–1.
Oil on canvas;
163.5×137 cm,
64⅜×53⅞ in.
Alte
Pinakothek,
Munich

Rubens, on behalf of the archduchess, tried once more to negoti-
ate with the Northern Provinces. Secret missions to the Prince
of Orange in 1631 and 1632 were unsuccessful; the Dutch
had no intention of relinquishing their advantages. Spain, for
its part, was interested neither in peace nor in the welfare of its
Netherlandish subjects, as Rubens sadly came to acknowledge:
'It appears that Spain is willing to give this country as booty to the
first occupant, leaving it without money and without any order.'

On a personal level, Rubens' diplomatic activities had brought
him insult and financial loss. Writing to his friend Jan Woverius
in January 1631, he complained that, although generally happy
over the peace with England: 'I have occasion to lament my
misfortune in ever having become involved in that affair. For I
cannot obtain any reimbursement for what I spent in the service
of His Majesty on the journeys to Spain and England.' What
started out as administrative carelessness turned into humiliation
when, after repayment had finally been approved, Rubens found
that the order had been countermanded: 'This seems to me such
an insufferable affront and insult that I could almost abjure the
form of this government ... I am so disgusted with the Court that
I do not intend to go for some time to Brussels.' It did not help
that the trust Isabella had shown Rubens had aroused the envy
of a group of Flemish aristocrats, whose leader, the Duke of
Aerschot, rudely put the painter-turned-diplomat in his place
when he wrote in reply to one of Rubens' letters: 'All I can tell
you is that I shall be greatly obliged if you will learn from hence-
forth how persons of your station should write to men of mine.'
Disillusioned with the duplicities of court politics and Spain's lack
of concern for her loyal Netherlandish subjects, Rubens resolved
in 1633 to resign from his official position. As he explained to
Peiresc in a letter of December 1634:

I made the decision to force myself to cut this golden knot of ambition,
in order to recover my liberty. Realizing that a retirement of this sort
must be made while one is rising and not falling; that one must leave
Fortune while she is still favourable, and not wait until she has turned

her back, I seized the occasion of a short, secret journey to throw myself at Her Highness's feet and beg, as the sole reward for so many efforts, exemption from such assignments and permission to serve her in my own home. This favour I obtained with more difficulty than any other she ever granted me.

The Infanta Isabella, who had put such faith in Rubens in her vain attempt to bring peace to the Netherlands, died before the end of 1633. With her death, the artist's public career came to an end.

Although Rubens is not the only painter-diplomat in the history of western Europe, he is the most successful one. Jan van Eyck's mission to Portugal on behalf of Philip the Good takes its place in the painter's biography, but does not tend to appear in histories of the Burgundian empire. Rubens' diplomatic activities, on the other hand, deserve at least a footnote in any discussion of the Thirty Years' War. His role as political adviser was such that leading statesmen of the day regarded him as a serious player on the international stage. The Abbé Scaglia, ambassador of Savoy, paid tribute to Rubens' diplomatic skill when he said of him that he was 'a person capable of things much greater than the composition of a design coloured by the brush'. Puget de la Serre, biographer of Marie de' Medici, also referred to Rubens' art as the 'least of his qualities'. Given the initial hostility the painter had met in this area, such praise was indeed remarkable.

Despite his diplomatic success, Rubens never lost sight of his true profession, his '*dolcissima professione*', as he called it. Throughout the years of political engagement, he succeeded, against all odds, in the 'composition of designs coloured by the brush', to paraphrase Scaglia. Among the works executed by him and the studio between 1625 and 1630 were some of the designs for the ill-fated Henry IV cycle for the Luxembourg Palace. More successful was a cycle of tapestry cartoons illustrating the theme of *The Triumph of the Eucharist*, commissioned by the Archduchess Isabella for the convent of the Descalzas Reales in Madrid. This was the house of the Order of Poor Clares, an order which exemplified the Franciscan ideal of poverty and dependence on alms, thus the

name 'Descalzas' (unshod, *ie* barefoot). Isabella had recently become a member of the order – though this did not prevent her from governing the Southern Netherlands – and she intended to spend her retirement years there. Worship of the Eucharist (*ie* the bread and wine consecrated as the body and blood of Christ and distributed at communion) had been strengthened recently by the Council of Trent, and it constituted an important element in Counter Reformation Catholicism. In its mixture of allegory and religious propaganda, Rubens' Eucharist series may be seen as the sacred equivalent to the Medici cycle. For patrons in Antwerp itself, Rubens continued to produce altarpieces and other religious paintings, including his *Assumption of the Virgin* for Antwerp Cathedral, as well as smaller works of portraiture and mythological scenes in landscape settings.

It was thus without hesitation or difficulty that Rubens resumed his interrupted career upon his return to Antwerp from England in 1630. Soon his studio was fully occupied with large commissions: besides the nine canvases for the Whitehall Banqueting House, there was a new series of tapestries depicting the life of Achilles as well as the Henry IV cycle, which had not yet been abandoned. But painting did not fill Rubens' whole life; being settled again in his own home, he felt the need for a wife. Now fifty-three years old, he was 'not yet inclined to live the abstinent life of a celibate, thinking that, if we must give the first place to continence, *fruimur licita voluptate cum gratiarum actione* ["we may enjoy licit pleasures with thankfulness"]', as he confided with candour to Peiresc in December 1634, switching to Latin in light of the delicacy of the subject.

Some of Rubens' friends had urged him to mark his elevation in the world by choosing a noblewoman, but, as he informed Peiresc in the letter quoted above, he decided to marry 'a young wife of honest but middle-class family', for he 'feared pride, that inherent vice of the nobility, particularly in that sex, and that is why I chose one who would not blush to see me take my brushes in hand'. What he failed to mention was that the respectable

bourgeois wife he had chosen was sixteen years old. It may have been prudent for Rubens to marry a woman who would not object to his profession, but even by seventeenth-century standards the age gap was unusual. The relationship appears to have been genuinely affectionate, but beyond this it was an old man's passion for a young girl. Rubens, it seems, might have married a court lady but was put off by her haughty temper and, moreover, felt little inclined to exchange his precious liberty 'for the embraces of an old woman'.

The young and pretty bride was Helena Fourment, daughter of the silk and tapestry merchant Daniel Fourment, and niece of Rubens' first wife, Isabella Brant. Rubens had been on terms of friendship with the family who lived close by. The eldest daughter, Susanna, was painted by the artist several times; the most famous of the portraits is the so-called *Chapeau de Paille* ('The Straw Hat'), although the hat is actually made of felt (152). The wedding took place on 6 December 1630. One of Rubens' learned friends wrote a panegyric in honour of the occasion in which he declared that Helen of Antwerp, unlike Helen of Troy, would be the perfect wife, in whose arms the greatest of painters would renew his youth. The prediction came true, for Helena Fourment was to be the happiness and inspiration of Rubens' last ten years.

From his paintings it is abundantly clear that Rubens was infatuated with his young wife. In a little less than ten years of marriage, he painted considerably more portraits of Helena than he did of Isabella during the seventeen years he was wedded to her. The first portrait, done probably at the time of the marriage, shows Helena on a balustraded terrace, seated in a chair (151). She is richly dressed; a sprig of myrtle, the flower of Venus, is fastened to her hair. A scarlet curtain, suspended from two pillars on either side, frames her figure, and a richly patterned rug lies at her feet. These are the paraphernalia of high social standing which Rubens first introduced in his *Portrait of the Marchesa Brigida Spinola-Doria* and other Genoese portraits (see 49). As in that earlier picture, the elaborate costume and grandiose setting do not

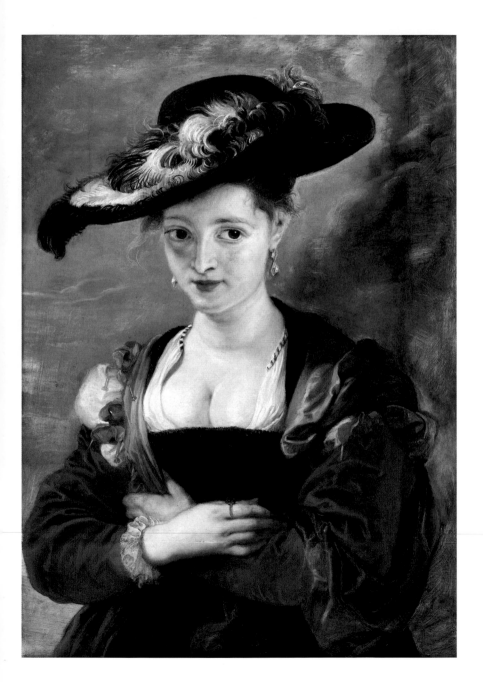

152
*Susanna
Fourment* or
*Le Chapeau
de Paille*,
*c.*1622–5.
Oil on panel;
79×54·5 cm,
31¹⁄₈×21¹⁄₂ in.
National
Gallery,
London

153
*Helena
Fourment
Holding a Book*,
*c.*1630–2.
Black and
red chalk
heightened
with white,
partially
reinforced with
pen and ink;
61·2×55 cm,
24×21⁵⁄₈ in.
Courtauld
Institute
Galleries,
London

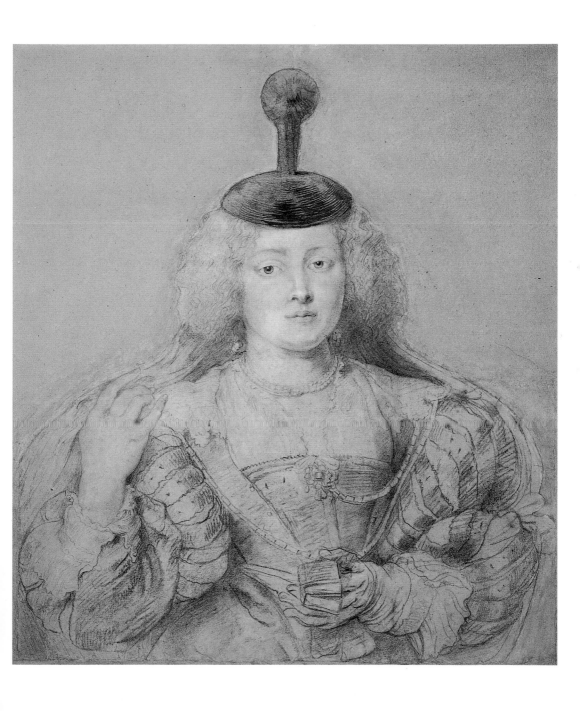

overpower the sitter. Both women bring freshness and liveliness to their images in their hesitant smiles, dimpled cheeks and direct open gazes. More importantly, they are caught in poses only momentarily at rest: Brigida has stopped to look at us and will soon move on; Helena has playfully tipped her chair as if to spring out of it.

Many other portraits followed, of Helena alone as well as with her children. One of the most exquisite is a half-length drawing whose high finish suggests that it was executed as a work in its own right and not as a preparatory study for a painting (153). Helena wears a mantle fastened to a special kind of hat worn by fashionable women in the Netherlands as a protection against rain. She holds a small book in her gloved left hand, probably a prayerbook; with her right hand she adjusts the mantle. Her placid, beautiful face has a slightly sullen, childlike look. Other portraits show Helena with her children. In frankly appealing, almost sentimental images the middle-aged father captured his young family. Rubens had always enjoyed painting and drawing his children (see 102–105), and this did not change after his second marriage. In an example in the Louvre (154), Helena holds her little boy Frans on her knee, and her eldest child, Clara Johanna, leans towards her on one side. The panel is unfinished; it must have been cut at a later time since a pair of hands, barely visible at the right, indicates that another child was intended to complete the family group. A beautiful drawing of a small girl gives an idea of the appearance of this figure (155). The informality of the composition suggests that Rubens recorded his wife and children at some ordinary domestic moment, with no thought of posing.

Rubens' intense feelings for his new bride are further revealed in her frequent appearances in other roles. She inspired his most beautiful and personal portrayals of the female nude: in *The Feast of Venus*, the nymph on the left, who is swept off her feet by an ageing satyr, bears her features (156); in *The Three Graces*, the face of the left-hand figure resembles hers (157).

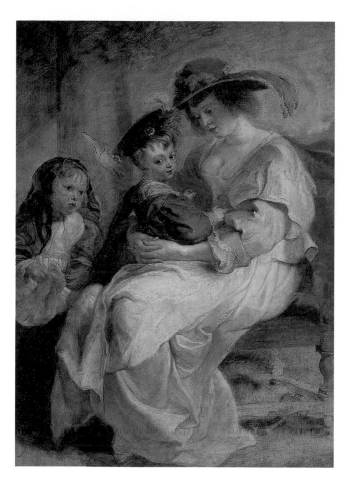

154
Helena Fourment with Two of her Children,
*c.*1636.
Oil on panel;
113×82 cm,
44½×32¼ in.
Musée du Louvre, Paris

155
Isabella Helena Rubens,
*c.*1636.
Black, white and red chalk;
39·8×28·7 cm,
15⅝×11¼ in.
Musée du Louvre, Paris

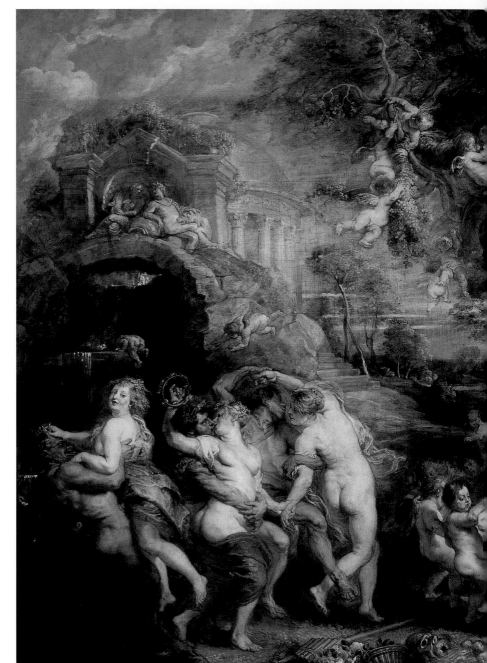

156
The Feast
of Venus,
mid-1630s.
Oil on canvas;
217×350 cm,
85⅜×137¾ in.
Kunst-
historisches
Museum,
Vienna

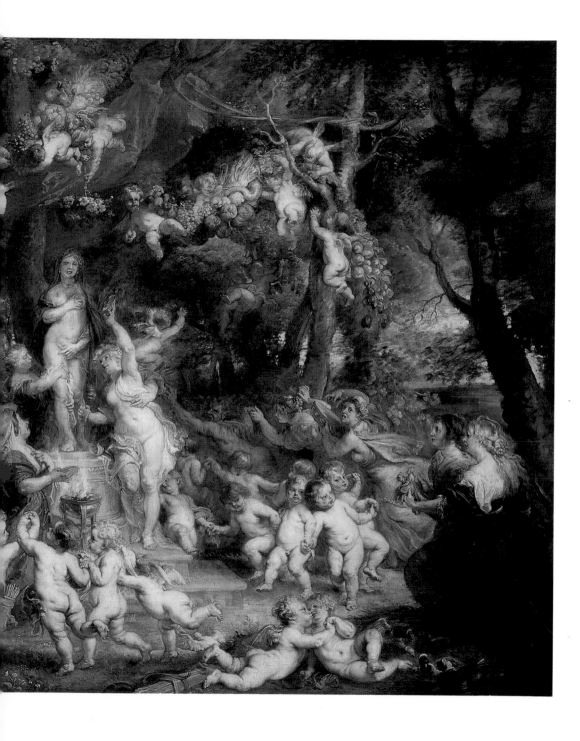

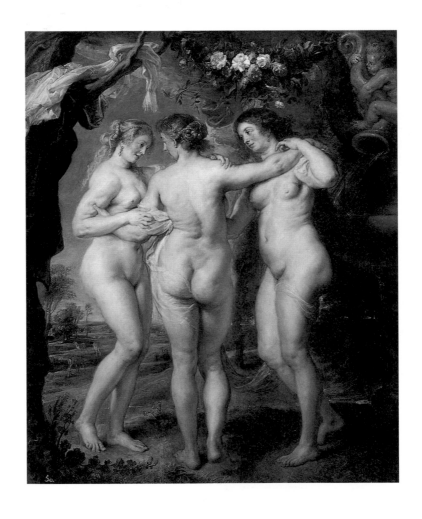

157
The Three Graces, mid-1630s.
Oil on panel;
221×181 cm,
87×71¼ in.
Museo del
Prado, Madrid

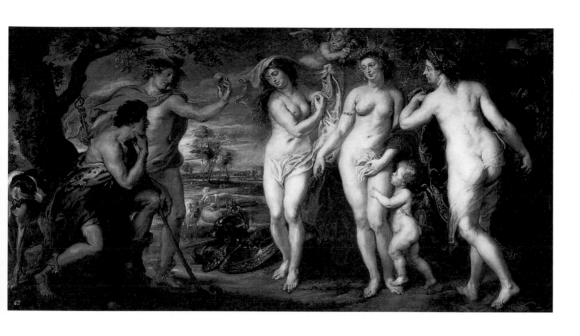

158
*The Judgement
of Paris*,
1638–9.
Oil on canvas;
199×379 cm,
78³⁄₈×149¹⁄₄ in.
Museo del
Prado, Madrid

While these references to Helena may have been a private matter between the painter and his model/bride, there is contemporary evidence that she was recognized as a model in *The Judgement of Paris*, a picture commissioned for the Spanish court (158). In a letter from Antwerp to Philip IV, the Cardinal-Infante Ferdinand wrote that 'the Venus in the centre is a very good likeness of his [Rubens'] wife, who is certainly the handsomest woman to be seen here'. It can have been no accident that Helena plays the role of the goddess of love who wins the prize for her beauty. The story itself recounts a contest in which Paris, a Trojan prince disguised as a shepherd, was instructed to judge which of three goddesses was the most beautiful: Juno, shown with her peacock, Minerva with her shield and helmet, and Venus accompanied by Cupid. Wishing to win, each goddess made attractive promises, but Paris chose Venus because she offered him the most beautiful woman on earth, Helen of Troy, wife of Menelaus, king of Sparta. Her abduction by Paris provoked the Trojan war.

Although facial similarities with Helena Fourment make it likely that the voluptuous blonde nude in these paintings was inspired by her, one should be careful in assigning specific features to the many nymphs and goddesses that decorate Rubens' late works. The truth is that he had always admired Helena's type of beauty – fair and white-skinned, with ample contours and luminous skin. There is, however, one painting in which she appears, half-naked, in her own character – the remarkable portrait *Helena Fourment in a Fur Wrap* known as *Het Pelsken* ('The Little Fur'; 159). Helena stands in an attitude that looks accidental, clutching a fur-lined cloak around her as though she had been surprised in her dressing-room. Despite its momentary appearance, however, this is no genre study but a portrait in a mythological role: Helena is portrayed as Venus. Although she stands on a rug with a cushion at her feet, a fountain, with water gushing from a lion's mouth, dimly visible in the background on the right, establishes that the setting is outdoors. The picture combines a tradition of images of Venus by a fountain or urn, derived from a famous statue by the ancient Greek sculptor Praxiteles (160), with the modest but

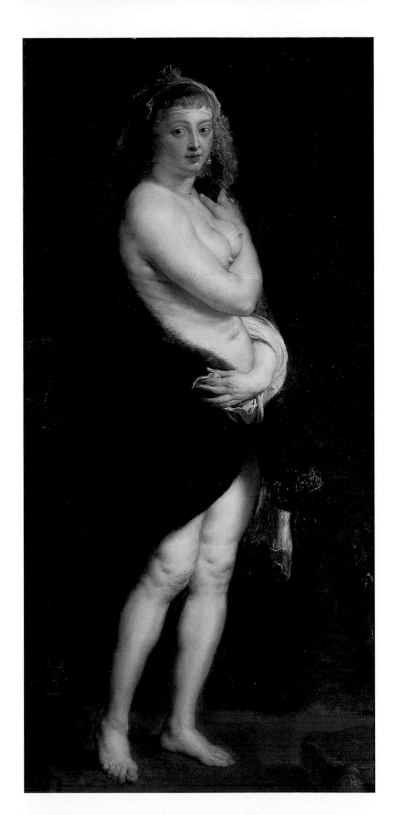

159
Helena
Fourment in a
Fur Wrap or
Het Pelsken,
*c.*1630s.
Oil on panel;
175×96 cm,
68⅞×37¼ in.
Kunst-
historisches
Museum,
Vienna

160
Statue of
Venus.
Roman copy
of an original
by Praxiteles
of *c*.350 BC.
Marble;
h.205 cm,
80¾ in.
Vatican
Museums,
Rome

161
Medici Venus.
Roman copy
of a Greek
original.
h.153 cm
60 in.
Galleria degli
Uffizi,
Florence

162
Titian,
*Lady in a Fur
Cloak*,
c.1536.
Oil on canvas;
95.9×63.2 cm,
37¾×24⅞ in.
Kunst-
historisches
Museum,
Vienna

163
*Lady in a Fur
Cloak*,
1629–30.
Copy after
Titian.
Oil on canvas;
91.8×68.3 cm,
36⅛×26⅞ in.
Queensland
Art Gallery,
Brisbane

revealing pose of the Medici Venus, the so-called Venus Pudica
(161). But if the source is classical, the actual painting owes more
to Titian than to ancient sculpture. Helena's fur wrap and the
position of her arms are modelled on Titian's *Lady in a Fur Cloak*
in Vienna (162), a painting Rubens saw and copied in London
when it was in the possession of Charles I (163).

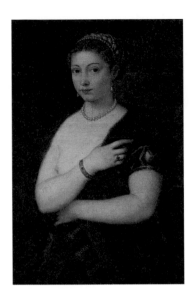
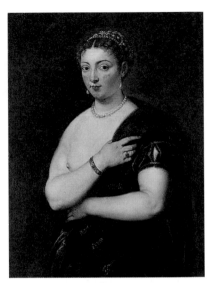

Titian's painting shows a beautiful, partially nude woman, presum-
ably a courtesan, hugging a fur-lined cloak to her body. Rubens
was inspired by the sensuous contrast of dark fur and naked flesh
that he saw in his Venetian model, but the vitality and realism
of his presentation of the female nude were quite different from
anything Italian artists had done, as was the full-length pose and
the painting's large size. Here Rubens painted flesh as it had
never been painted before, flesh that is alive, that breathes and
quivers, flesh that is soft and translucent. The beautiful young
face is surrounded by golden curls and an exquisitely painted
hand and wrist clutch the fur; but at the same time the naked
breasts are awkwardly pushed up, and there are folds of fat under
the arm, dimples around the knees, and bunioned feet, deformed
from wearing tight shoes. Rubens obviously did not believe in
an idealized female body: he painted what he saw, with all its

imperfections. The result suggests the different roles unified in the figure of Helena Fourment: the wife, whose body marked by childbirth is beautiful to the painter because it bore his children; the lover, whose sensuality is his to enjoy – the 'licit pleasures' he alluded to in his letter to Peiresc; and the goddess, whose divine status is bestowed upon her through his love. The picture is and was, even for the artist, a work out of the ordinary which retained special significance for him: it was the only picture which he specifically left in his will to his widow with the stipulation that it should not be sold.

Why did Rubens not simply portray his wife standing half-naked in her dressing-room wrapped in fur? Why did he bother with references to classical antiquity and to Titian? The latter may simply have been aesthetic, unless of course he knew that the sitter was likely to have been a courtesan, in which case Rubens' portrait of his wife acquires additional piquancy. But why the subtle references to Venus, which could be recognized only by a viewer with a knowledge of antique statuary? The matter is rather complex, and it is one that not only concerns Rubens, but the representation of the female nude in western art in general.

Painting from the naked female model was not generally practised until the nineteenth century; in fact, women were not allowed to pose in public art schools until 1850. It is known that Rembrandt conducted life-drawing classes, but the presence of female models even in the relatively private environment of a painter's studio was highly unusual. The earliest appearance in art of naked women without any classical or other connotations dates from the eighteenth century in such paintings as *The Nude Maja* by Francisco Goya (1746–1828) or *Mademoiselle Murphy* by François Boucher (1703–70). The subject of nude women surprised in the act of dressing or undressing, as Helena Fourment seems to be, comes later still, with the Impressionists, especially in the works of Edgar Degas (1834–1917) and Pierre-Auguste Renoir (1841–1919). In Europe in the Christian era, attitudes towards the naked body carried a variety of moral associations. In the Middle Ages, these

were of a religious nature, focusing on the transience of human life. In the Renaissance, with the rebirth of classical art and literature, these moral objections were replaced by cultural associations. It was acceptable to look for erotic sensations in a nude presented in the guise of classical antiquity. Beginning with *The Birth of Venus* by Botticelli (1444/5–1510), female nudes were most often represented in the figures of Greek deities and the mythical mortals associated with them.

Rubens, however, did not simply exploit an established convention as a pretext to portray his wife in the nude. For him there was no separation of form and content. The references to classical statues of Venus in *Helena Fourment in a Fur Wrap* not only raise an otherwise questionable subject to a higher level, but they also invest the painting with specific meaning. On a personal level, Helena is his Venus, his goddess of love. While Juno, patroness of marriage, may have been a more appropriate symbol (he had earlier portrayed Marie de' Medici in that role; see 127), her image was a matronly one, without the erotic connotations of Venus. Furthermore, over the years Venus came to represent more to Rubens than a symbol of physical love; she came to stand for love in all its aspects – compassion, charity, kindness – in short, for goodness in life. Experience had taught Rubens that these attributes were primarily the domain of women, especially wives and mothers. Helena-Venus, his goddess of love, fulfilled these roles as well. Ultimately, in a uniquely creative and highly personal iconographic transformation, she came to represent peace.

While Helena is not represented in every one of Rubens' late paintings which include beautiful women, there can be no doubt that she played an important role in his art. Apart from the heightened eroticism and infatuation that come with an older man's passion for a young girl, her frequent appearances in his work of this date can be ascribed to his changed working conditions. During his first marriage, Rubens' personal and professional worlds were separated. Starting out on his path to success and fortune, he coveted commissions and sought to please patrons;

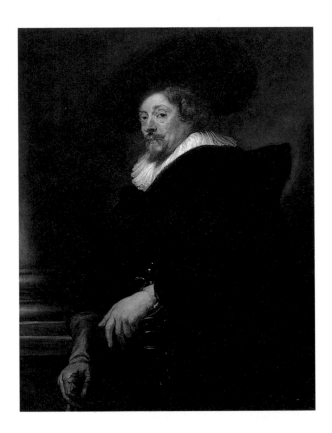

164
Self-Portrait,
*c.*1639.
Oil on canvas;
109×83 cm,
42⅞×32⅝ in.
Kunst-
historisches
Museum,
Vienna

165
*Self-Portrait
in Old Age*,
*c.*1639.
Black chalk
heightened
with white;
20×16 cm,
7⅞×6¼ in.
Royal Library,
Windsor
Castle

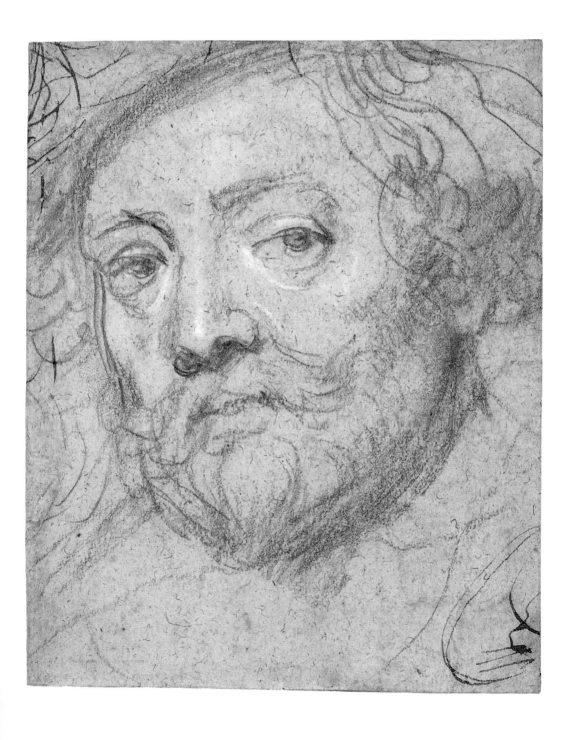

his art was, for the most part, a public art, largely detached from his feelings and private life. Throughout their years together, Isabella stood by his side – his companion, mother of his children and mistress of his house, but not his model. The portrait Rubens painted commemorating their union (see 58) shows a charming young couple, bound by love and affection for each other, while also, through the sword Rubens wears and other signs, asserting their social status as a gentleman and his wife.

In 1630, Rubens was rich and famous, the most celebrated artist of his time; he no longer needed to seek commissions or bow to every wish of his patrons. Although he retained detachment in many of his works, others reflect more personal feelings or interests, and his new love Helena was often the inspiration. In his art, she appears as one of the Three Graces, the goddess who won first prize for her beauty, the young nymph who playfully holds her satyr by his horns; she is the charming young bride, the mother of his children, but she is never his wife. Whereas Rubens portrayed himself together with Isabella, he never showed himself with Helena – two paintings of Rubens and Helena, accompanied by one of the children in the garden of their house in Antwerp (now in the Alte Pinakothek, Munich and the Metropolitan Museum of Art, New York), which are commonly attributed to the master, are probably not by him. This is significant in that it places Helena Fourment in the role of the model, but specifically not the partner.

Although Rubens did not depict himself with his second wife, he painted and drew three self-portraits during these years. In the only painted image, dating from the late 1630s, he is standing in a dignified pose beside a massive column, dressed in black and wearing a large hat (164). As in the earlier self-portrait presented to Charles I (see 148 and frontispiece), Rubens did not portray himself as an artist but as a gentleman and a knight: his left hand rests on his sword-hilt; his right, gloved, holds the other glove. If the pose is not greatly changed from the earlier work, the face is considerably aged and displays a hint of melancholy introspection.

166
*A Nude Couple
Embracing,*
*c.*1639.
Black chalk;
20×16 cm,
7⅞×6¼ in.
Royal Library,
Windsor
Castle

Plagued by gout, Rubens must have been keenly aware of the frailty of his body. Introspection and infirmity are even more pronounced in what seems to be the last self-portrait, a sketch which once covered a sheet of various studies later cut down (165). The drawing presents an unusually direct and unflattering image of old age, closer in spirit to Rembrandt's searching portrayals than Rubens' own earlier images of himself, which are marked by their composure and absence of personal feelings.

167
Interior of the
Banqueting
House,
Whitehall,
London

168
The
Banqueting
House
Ceiling,
1632–4.
Whitehall,
London

On the reverse side of the sheet the artist drew, in bold chalk strokes, with a hand crippled by gout, a nude couple embracing (166). The drawing is loosely related to another sheet, where similarly posed figures represent Jupiter and Callisto. But since this connection is at best tenuous, the Windsor sketch depicts, simply and movingly, the love and sexual passion between two people, presumably a man and a woman and not two women, as the story of Jupiter and Callisto requires (see Chapter 9).

Lacking either narrative content, identifying symbols (*eg* Diana's crescent moon) or facial features (even gender is difficult to recognize), there remains only the self-portrait on the other side to connect the sketch to a specific subject. But since Rubens frequently drew on both sides of his paper subjects which have nothing to do with one another, the autobiographical nature of this sketch remains no more than intriguing speculation.

Notwithstanding the new, more personal emphasis in his work, Rubens' last decade also contained major public commissions, and,

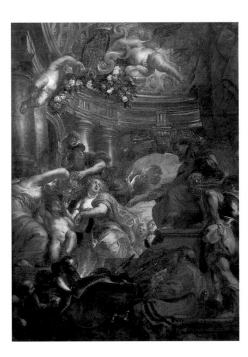

169 Far left
Minerva Conquering Ignorance, 1632–4.
Oil on canvas.
Banqueting House, Whitehall, London

170 Left
The Union of the Crowns, 1632–4.
Oil on canvas.
Banqueting House, Whitehall, London

171 Right
The Peaceful Reign of King James I, 1632–4.
Oil on canvas.
Banqueting House, Whitehall, London

172 Far right
Peace and Plenty Embracing, c.1632–3.
Oil sketch for *The Peaceful Reign of King James I*.
Oil on panel;
62·9×47 cm, 24³⁄₄×18¹⁄₂ in.
Yale Center for British Art, New Haven

if he had finished with politics as a diplomat, he had not done so as a painter. Now as never before he had the chance to express his political ideas in paint. The hope for peace – that peace which had evaded his diplomatic endeavours – is repeatedly depicted. The language is that of allegory which Rubens had used to such effect in the Medici cycle. But there the attention given to the details of a complicated and politically sensitive life had often interfered with the greater message Rubens wished to convey. Now, with absolute confidence in his position as man and artist,

he was free to create an allegorical language uniquely his own – a language that most powerfully and persuasively conveyed his ideas.

Rubens' first completed public commission of the 1630s comprised the ceiling paintings for the Whitehall Banqueting House, the only existing scheme of decoration by him still in its original position (167). Inigo Jones's designs for the Banqueting House had introduced a new classical style into England, based on Italian prototypes, especially Veronese's ceiling in San Sebastiano (see 120). Like the Jesuit ceiling (see Chapter 5),

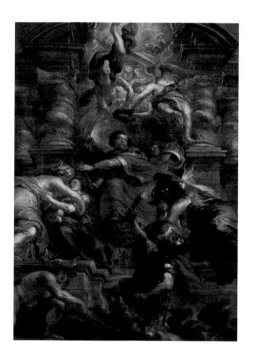
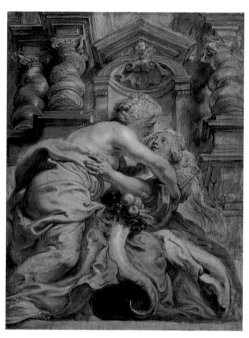

the ensemble consists of canvases set into compartments of carved mouldings. Here, however, they span the entire ceiling instead of running along the aisles and galleries. During the reigns of both James I and Charles I the building played an important role in court ceremonies.

Rubens was well prepared to deal with the commission: his paintings for the Jesuit church had taught him the complexities of ceiling decorations, and the cycle for Marie de' Medici those of modern historical allegories. The ceiling is divided into nine

compartments: in the centre an oval is bracketed at either end with a rectangle; the latter are flanked by smaller ovals, the former by elongated rectangles (168). The basic theme of the ceiling is the glorification of the reign of James I, who had died in 1625. However, unlike the Medici cycle, for which the involvement and intervention of the patron and her advisers are amply documented, there are no written details of the programme. Undoubtedly, both Jones and Charles I must have participated in the design of the ceiling's iconography, but it is possible that, beyond the overall theme, many of the details were left to Rubens.

The Stuart monarch King James had succeeded to the thrones of both Scotland (as James VI in 1567) and England (as James I in 1603) when the last Tudor monarch, Elizabeth I, died childless. His greatest political achievement was the unification of England and Scotland, which ensured a degree of harmony and peace after centuries of hostile relations between the two kingdoms as well as between Scottish barons warring among themselves. Although there was considerable opposition to English sovereignty, the internal conflicts involving rebellious Scottish nobles, which had long plagued the country, subsided since it was no longer possible to engage the English sovereign as a third party in these traditional family feuds. Nothing could have appealed more to Rubens than glorifying the union of two nations and the ensuing peace. In warm, glowing colours and joyous images he presented a celebration of the wise and benevolent reign of James I (171). That the inflexible Stuart insistence on the divine right of kings, which Charles I inherited from his father, was later to force the confrontation between king and Parliament that led to the outbreak of civil war, was an irony that could not have been foreseen by Rubens.

Rubens' visual language in the ceiling designs again comprises a mixture of classical gods and heroes and personifications of virtues and vices, surrounding the figure of the king. Many of the characters are familiar: there is Minerva defeating the personification of Ignorance, a horrid old woman with sagging

breasts (identification of this figure is difficult, but she clearly represents an evil; 169); and Mercury wielding his caduceus, traditional emblem of peace (171). There are two lovely young women locked in a warm embrace, symbolizing that Peace (holding the caduceus in the preliminary oil sketch of this group, which was later painted out) and Plenty (with a cornucopia) are the benefits of wise rulership (172); and there are the personifications of Scotland and England, identified by the colours of their gowns – England in red, the colour of the cross of St George; Scotland in white, the colour of St Andrew – who hold the two crowns of their respective kingdoms over the infant Charles, while the helmeted figure of Britain ties the crowns together (170). Charles is shown as the future king of the two countries united by his father. The composition offers a variation of the biblical Judgement of Solomon, in which the Old Testament king adjudicated between two mothers who both laid claim to the same child. King James – the 'New Solomon', as he was praised by contemporaries – presides over the two contending 'mothers', England and Scotland, and effects their reconciliation.

The canvases were completed in August 1634. They were shipped to London in October 1635, and were in place by the middle of March the following year. Rubens did not accompany them but preferred to remain at home: 'I have preserved my domestic leisure, and by the grace of God, find myself still at home, very contented,' he wrote to Peiresc in March 1636.

While Rubens may have enjoyed domestic happiness, leisure was neither his privilege nor his desire. In 1634, after the death of Archduchess Isabella, a new governor of the Southern Netherlands was appointed, the Cardinal-Infante Ferdinand, brother of Philip IV (173). As with so many political careers of the time – for example those of Archduke Albert or the French Cardinal Richelieu – his began in the Church. He had been made cardinal and archbishop of Toledo when still a child, but at age twenty he embarked on a military and political career. After defeating the Swedes in September 1634 at the Battle of

Nördlingen in southern Germany, one of the decisive Catholic victories of the Thirty Years' War, Ferdinand arrived in Brussels at the beginning of November of that year. Shortly afterwards the city council of Antwerp decided to welcome their new governor with the traditional Joyous Entry into their city.

From the days of the dukes of Burgundy, it had been the custom for the more important towns of the Netherlands to give their rulers a splendid civic reception. Triumphal arches spanned the streets and young men and women in allegorical costumes staged *tableaux vivants* on richly adorned stages or floats. The last time Antwerp had welcomed a new ruler was in 1599 when Albert and

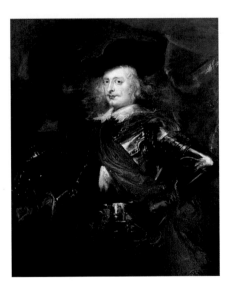

Isabella entered the city. This had been a comparatively modest affair, designed by none other than Rubens' old teacher Otto van Veen (174), possibly with the assistance of his young protégé. Now the commission went, naturally, to Rubens who, barely having prepared his Whitehall canvases for shipment, had to devote his energies and studio to yet another monumental project. He wrote to Peiresc in December 1634:

Today I am so overburdened with the preparations for the triumphal entry of the Cardinal-Infante (which takes place at the end of this month), that I have time neither to live nor to write. I am therefore

cheating my art by stealing a few evening hours to write this most inadequate and negligent reply to the courteous and elegant letter of yours. The magistrates of this city have laid upon my shoulders the entire burden of this festival, and I believe you would not be displeased at the invention and variety of subjects, the novelty of designs and the fitness of their application.

The subjects were devised by Rubens in conjunction with his old friend Nicolaas Rockox (see chapters 4 and 5) and another friend from the painter's Humanist circle, Caspar Gevaerts (175), a former pupil of Justus Lipsius. The design was composed of arches and stages erected throughout the city along the route

chosen for the triumphal procession. The structures consisted of timber frameworks, decorated with carved and painted wood into which were inserted painted canvases. To give an idea of the size of some of these edifices, the most elaborate, *The Portico of the Emperors*, measured some 30 m (100 ft) across, and the stone statues of the emperors were over life-size. The decorations were intended to be temporary and were dismantled in due course. Only Rubens' oil sketches and a commemorative publication by Caspar Gevaerts, illustrated with engravings after Rubens' designs (176), remain.

This time not even the busy Rubens studio was able to manage the task; it seems that all of Antwerp's painters, sculptors and carpenters were needed. In the event, the entry was postponed by several months, which gave Rubens and his team the extra time needed to bring the project to conclusion. Ferdinand arrived in April 1635 to be saluted by the sound of a cannon and a fanfare of trumpets. The procession, with the Cardinal-Infante on horseback, moved from decoration to decoration, musicians greeting him at each stop; fireworks ended the evening. He stayed for eight days, revisiting the stages and arches and other sights, including Rubens' house. The artist himself was confined to bed, suffering

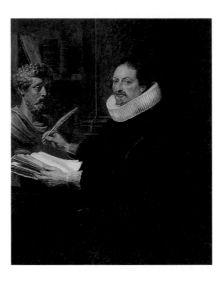

175
Jan Caspar Gevaerts,
*c.*1627.
Oil on panel;
120×99 cm,
47¼×39 in.
Koninklijk Museum voor Schone Kunsten, Antwerp

176
Theodoor van Thulden,
The Front Face of the Arch of Philip.
Copy after Rubens,
1635–42.
Etching

from gout and unable to partake in the festivities he had done so much to create.

Traditionally, the Joyous Entry was precisely that – an occasion for the citizens to celebrate their new ruler and express hope for the future, which they did with appropriate flattery. To a large extent, Rubens' designs conformed to the conventional scheme: there were arches and stages depicting the virtues and achievements of Ferdinand – his victory at Nördlingen offered a great example – and the illustrious history of the House of Habsburg (176). Towards the end of the procession, however, the new governor was confronted with images of a quite different sort.

On two stages, Rubens and his advisers chose to depict the real situation in the country. The plight of Antwerp, in particular, was the theme of one of the stages – her dwindling trade indicated by the departure of Mercury, god of commerce, while subsidiary scenes illustrated the contrast between prosperity and economic decline. During the last years of Isabella's reign an attempt had been made to treat with the Dutch once again for the reopening of the River Scheldt, but at this time the Dutch had the military advantage and saw no reason to boost the trade of Antwerp, which

they regarded as a Spanish city, to the detriment of Amsterdam. With the archduchess's death, the negotiations collapsed, and the city council's hopes now lay with their new governor. It was Rubens' task to stress the seriousness of the situation.

War and Peace formed the subject of the stage called *The Temple of Janus*, a two-storeyed edifice surmounted by a dome (177). On either side of the central scene was a projecting portico with columns; the stage-like space thus created in front of the 'temple' was filled with painted figures enacting a tableau of War and

177
**Theodoor
van Thulden,**
*The Temple of
Janus.*
Copy after
Rubens,
1635–42.
Etching

178–179
*The Temple of
Janus,*
1634.
Oil sketch for
*The Entry of
Ferdinand.*
Oil on panel;
70×68.8 cm,
27½×27 in.
Hermitage,
St Petersburg
Above left
Detail

Peace. The painting that filled the centre of the stage was *The Temple of Janus* (179). The temple is that of the Roman war god Janus which, as Rubens wrote on another occasion, 'in time of peace, according to Roman custom, remained closed'. It was presented thus in other Joyous Entries, but the artist, dispensing with flattery and decorum, felt compelled to tell the real story, albeit in allegorical form. However, even without knowledge of ancient Roman customs, the fearsome figure, blindfolded and brandishing a sword and a flaming torch, bursting out of the open door of the temple, leaves us in no doubt of his evil intentions.

In the porticoes on either side of the central painting are scenes depicting the benefits of peace and the hardships of war. Peace, holding a caduceus in her right hand while a horn of plenty lies at her feet, tries with both hands to close one of the temple doors, aided by the Archduchess Isabella wearing the habit of the Poor Clares, and the figure of Piety, dressed in white, holding the patera (libation dish) over her flaming altar. Personifications of Security and Tranquillity, with poppies, ears of grain and a palm branch, spell out the blessings of peace. Even for the educated viewer of the time, these figures may not have been immediately recognizable, since their iconography is based on Roman coins. Fortunately, Rubens supplied identifications on the oil sketch.

On the other side, Discord, with snaky hair, and Tisiphone, one of the Furies, open the other door still wider. Between them they have overturned an urn from which flows blood. Death itself, a haggard figure with a scythe and the uplifted torch of pestilence, enters from the left, and Famine, a harpy with wings and tail of a dragon, flies above this group. But what is particularly eloquent of the inhumanity of war is the soldier pulling a mother away from her child by the hair (178). Rubens' well-established cast of pagan gods, personifications and historical personages has been expanded to include ordinary human beings. It is mothers and their children who are the innocent victims of war and who will come to play an ever more central role in Rubens' imagery.

For Rubens, his last decade was a period of enormous artistic freedom. He was more or less at liberty to choose both which commissions to accept and how he would approach them. He was also able to devote himself to work that was not necessarily intended for sale or public display. This combination of circumstances means that Rubens' work of this period often powerfully reflects his deepest private concerns. He continued to work on numerous different types of painting simultaneously: mythological paintings, allegories and large-scale religious commissions had featured throughout his career, and his late works of all three kinds variously provide an eloquent, sometimes idiosyncratic, summation of themes that had long been present in his *oeuvre*.

180
*Diana and
Callisto*
(detail of 189)

If Helena Fourment was the sensuous inspiration behind Rubens' creative powers in these years, Titian was his artistic source. While in Spain in 1628–9, Rubens had made copies after Titian's Ovidian mythologies (see 141, 142); back home in Antwerp he turned to the Venetian master once more. In two beautiful canvases, *The Worship of Venus* (181, 182) and *The Bacchanal of the Andrians*, he recreated works that Titian had painted around 1520 for Alfonso d'Este, Duke of Ferrara. Unlike the mythologies Titian produced for Philip II, these are not illustrations of particular stories but reconstructions of ancient pictures described by the Greek writer Philostratus, showing gods and mortals in landscape settings. Titian's paintings were in a Roman collection when Rubens was in Italy, where he undoubtedly saw them, but his copies are evidently much later. Stylistically they relate to his paintings of the 1630s, and their technique suggests that they postdate the copies after Titian that he made in Madrid. Since the originals (now in the Prado, Madrid) were in Rome when Rubens was in Spain, his immediate models were probably copies brought to Antwerp by an artist

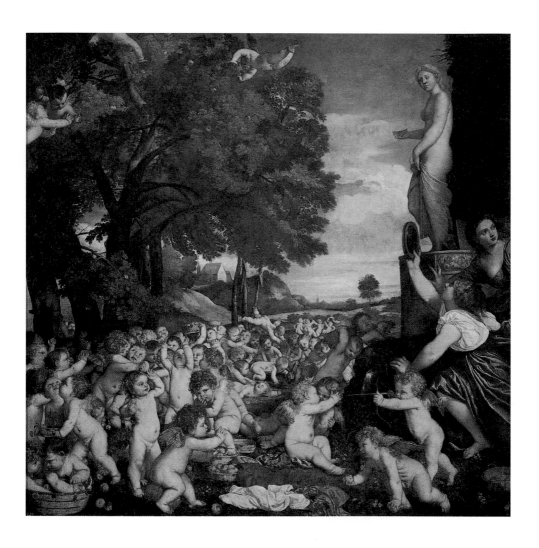

181
Titian,
*The Worship
of Venus*,
1518–20.
Oil on canvas;
172×175 cm,
67¾×68⅞ in.
Museo del
Prado, Madrid

182
*The Worship
of Venus,*
*c.*1635.
Copy after
Titian.
Oil on canvas;
195 × 209 cm,
76¾ × 82¼ in.
National-
museum,
Stockholm

who had, in turn, copied Titian's pictures in Rome. This artist may have been Anthony van Dyck.

As with his paintings after Titian's so-called *poesie* (see Chapter 7), Rubens' *Worship of Venus* is a faithful copy of the original, but for two significant exceptions: he added Venus' chariot in the sky, thereby giving presence to the 'real' goddess, represented by Titian as a statue, and he changed some of the little cupids into girls. In the case of Titian's boy cupid, with arms raised, who is about to feel the force of another cupid's arrow, the change of

sex is only too apparent (183, 184). Other male cupids were given wings to distinguish them from the females. As a classical scholar, Rubens certainly knew that cupids are by definition male (the original Cupid was Venus' son). Rubens thus emphasized that, for him, love was essentially a male–female phenomenon, a preliminary and necessary stage towards procreation. Fertility and fruitfulness were part of the natural order of things – thus the fullness of Helena's body in *Helena Fourment in a Fur Wrap* (see 159), at least partly the result of bearing children, was a source of beauty to Rubens.

The playful putti, eternally fated to remain children, will of course never procreate. But Rubens used other means to underline the theme of fruitfulness: the apples on his tree are more plentiful than in Titian's original; there is more water in the picture as well as references to water (a lake in the background and a dolphin behind Venus' statue, alluding to her birth from the sea); and by creating a path between the two groups of cupids, he gave more prominence to the rabbit, known for its fecundity. It was, however, not only his personal view of nature that guided Rubens when he introduced these changes. His female cupids may not be philologically correct, but the life-giving aspect of love introduced by their presence has a valid ancient source. Rubens knew that Venus was the goddess of fertility as well as of love. If love and fertility formed the subject of the picture, it followed that it had to be heterosexual love. Hence, even Rubens' celestial children obey nature and its procreative impulse.

Titian's influence, however, went far deeper than providing models for imitation, as can be seen in Rubens' own recreations of the ancient myths. He had painted Greek gods and heroes before, in virtuoso displays of perfectly modelled nudes, based on his knowledge of classical sculpture and Michelangelo (see 94, 107 and 108), but he had paid little attention to the narrative or emotional content of their stories. It was only after the encounter with Titian's mythologies in Spain that Rubens made the narrative and, more importantly, the emotional content of these ancient stories his primary concern.

The main literary source for Rubens' late mythologies was Ovid's *Metamorphoses*. In addition to numerous independent works, he designed over sixty paintings for the Torre de la Parada, Philip IV's new hunting lodge outside Madrid, of which the majority illustrate stories from Ovid (the paintings, many of which have not survived, were almost entirely executed by assistants, but Rubens was responsible for all the oil sketches). Following his usual habit, Rubens turned to the original Latin text for source material; despite his thorough knowledge of the poem, in

185–186
Titian,
*Venus and
Adonis*,
1551–4.
Oil on canvas;
186×207 cm,
73¼×81½ in.
Museo del
Prado, Madrid
Above left
Detail

187–188
*Venus and
Adonis,*
c.1635.
Oil on canvas;
197·4×242·8 cm,
77³⁄₄×95⁵⁄₈ in.
Metropolitan
Museum of Art,
New York
Above right
Detail

January 1637 he purchased a new edition of the *Metamorphoses* while working on this commission.

Of all the classical authors, Ovid traditionally had the greatest appeal for painters, so much so that the *Metamorphoses* became known as the 'painter's bible'. Its stories of fantastic transformations of gods and mortals fascinated and challenged artists: Daphne, pursued by Apollo, turned into a tree; Arachne, who challenged Minerva to a spinning contest, was transformed into a spider; and Jupiter used many disguises to seduce unsuspecting nymphs and mortals. Behind these mysteries there were passions and desires that could grip an audience intensely. There is nothing particularly noble in the passions that prevail in Ovid's world; there is eroticism, often linked with humour (as in Jupiter's lecherous transformations into a golden shower, a cloud, a bull, a swan), but there is also great cruelty. Many of the young women are virgins seduced against their will, and there is a sadistic element in the enchanting yet unattainable beauty of Diana and Atalanta. Characters are constantly pitted against each other in competitions in which the odds are generally uneven, and the penalty for losing is often death.

Rubens had painted Ovidian subjects before, but, as in his mythological works based on other classical sources, the emphasis was on beautifully modelled nudes and on their allegorical content. Now, with a full life's experience behind him, he no longer read the poems as source material for dramatically displayed nudes or didactic interpretations, but simply as stories about love and passion and their sequels of betrayal, loss and vengeance. Where Titian's late mythologies are sometimes brutal, however, as in his horrific *Flaying of Marsyas*, Rubens humanized the stories, investing them with compassion, humour and understanding.

One example is the story of Venus and Adonis. Venus conceived a helpless passion for the handsome young hunter Adonis, and – as Ovid tells it – left her lover at dawn after making him promise not to go hunting that day. Adonis later broke his promise and was slain by a wild boar. Titian, who painted the subject for

189
Diana and Callisto, c.1639. Oil on canvas; 202×323 cm, 79¹⁄₂×127¹⁄₈ in. Museo del Prado, Madrid

Philip II, took some liberties with Ovid's account by showing
Venus pleading with Adonis as he is about to depart for his fatal
hunt (186). Rubens made a copy of the picture, now lost. His own
interpretation of the theme, painted several years later, not only
reversed the figures but also introduced another change (187).
Titian's Cupid sleeps under a tree in the background to the left;
love thus rendered powerless as Venus' amorous pleas have no
effect on the hunter. Rubens had no taste for such passivity: his
Cupid, by contrast, vigorously pulls Adonis' leg, trying to restrain

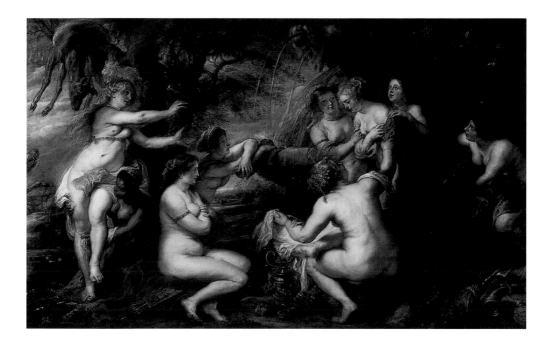

him by force. If love cannot stop the impetuous hunter, stronger
measures are needed.

In Rubens' late painting of *Diana and Callisto* compassion trans-
forms the story from one of vengeance to one of love (189).
Diana (the Greek Artemis) was a virgin huntress, attended by
nymphs who were expected to be as chaste as the goddess herself.
One of them, Callisto, is seduced by Jupiter who cunningly
disguises himself as Diana in order to gain the nymph's affection.
Callisto's pregnancy is eventually discovered by the goddess,
who punishes her by changing her into a bear, whereupon she is

pursued by her own son, the hunter Arcas. Jupiter snatches her up to heaven just in time, where she and Arcas form the constellations of the Great and Little Bear. Rubens had made a copy of Titian's painting while in Madrid. In the latter (see 141), Diana, on the right, confronts Callisto, pointing accusingly; her outstretched right hand holds the exact centre of the composition. Callisto is pushed to the left edge of the picture; her robes are drawn aside to reveal her pregnancy. Two nymphs hold down her arms in a violent figural configuration; she is exposed and vulnerable before the wrath of Diana.

In Rubens' recreation of the theme, both its compositional and emotional content are modified. The two protagonists are equally balanced, and Titian's nymphs supporting Diana have moved over to Callisto; their manner is comforting rather than condemning. More importantly, Callisto is standing and clothed, thus making her pregnancy less apparent. Her dress is closer to seventeenth-century than to antique fashion, a fact which, combined with her elaborate coiffure, gives her a dignified, 'civilized' look contrasting with the nakedness of Diana and the other nymphs. Meanwhile, the goddess, with her loose, flowing hair, presents a 'pagan' image.

Ovidian narratives offered the perfect pretext for the representation of the female nude, but what saves Rubens' paintings from licentiousness is his serious approach to mythology. He used mythological figures to make an alien world of deities accessible to ordinary sensibilities and to give them contemporary relevance, so recognizing in the ancient myths the entire spectrum of human desires, frustrations, obsessions and failings. His paintings of Greek gods and mythical mortals are really about the human condition; that reference to classical sources allowed this condition to be presented in the nude, so to speak, created an added attraction.

This conviction behind Rubens' interpretation of the classical world is the reason why his nudes never seem coy, inhibited or obscene. Even their notorious plumpness can be read as a product

of Rubens' classical learning. Signifying vitality and good health, they embody the famous quotation he had inscribed above the arch of the portico in his courtyard, 'Mens sana in corpore sano' ('A healthy mind in a healthy body'). This belief is perhaps the reason why Rubens avoided Jupiter's more outrageous transformations. With a few exceptions – notably copies after other artists' works, such as Michelangelo's *Leda* and Titian's *Rape of Europa* – he was not interested in the couplings of women with swans or bulls. While Rubens' approach to Ovid was too human to reject his eroticism, he did not exploit the stories' bizarre erotic possibilities in the manner of an artist such as Correggio. On the other hand, his belief in the ancient world was too serious to ridicule these subjects, as Rembrandt did when he depicted the youthful Ganymede being abducted by Jupiter's eagle to serve the god's bisexual tastes as an ugly, grimacing baby, pissing in anger and fear.

While Rubens was greatly indebted to the Renaissance tradition, his late mythologies are highly personal statements. Another personal preoccupation that came to the fore in his last decade is the theme of war and peace, which informs numerous works executed both for private patrons and for his own purposes. Like Rubens' public commissions, they reflect the transition from the optimism inspired by the successful conclusion of his Spanish–English mission to the final recognition that peace was not about to come to the Netherlands. The celebration of peace finds its most glowing expression in the painting Rubens presented in 1630 to Charles I, *The Allegory of Peace* (190), on which he worked at the time the subject matter for the Whitehall paintings was being decided. There is, however, a significant difference in visual rhetoric between Rubens' public projects and his more private single works, and it is in the individual political allegories that we find his most imaginative and meaningful iconographic invention: the fusion of the personification of Peace and Venus, goddess of love.

Though predating Rubens' return from London to Antwerp, *The Allegory of Peace* is central to this transformation. In the

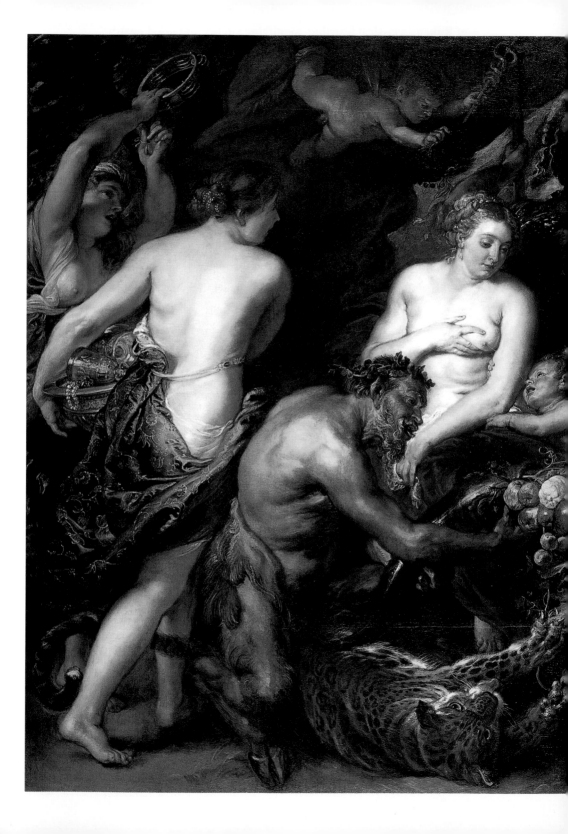

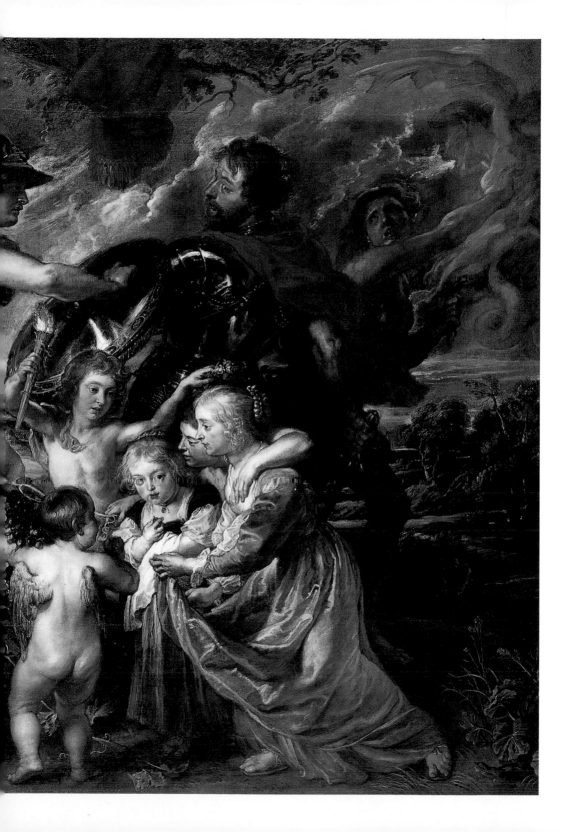

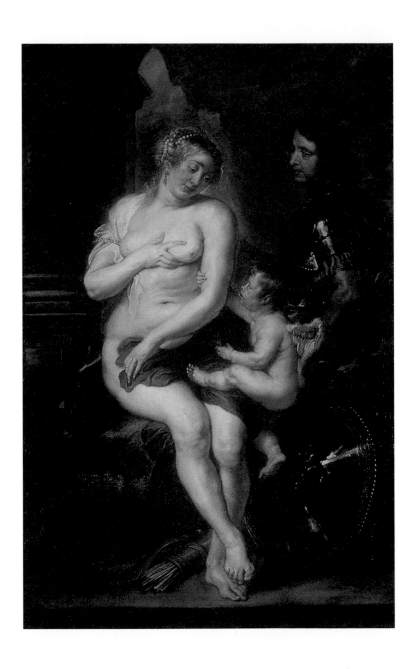

centre is the figure of Peace, expressing milk from her breast to feed a child, commonly identified as Plutus, god of wealth. She is protected from the heavily armoured Mars, god of war, and his attendant Furies (one of which is the bat-like creature seen in *The Temple of Janus*; see 179) by the helmeted Minerva, goddess of wisdom. Two young girls are led forward from the right, one to be crowned by the torch-bearing Hymen, god of marriage, and both to receive the fruits which spill from a cornucopia held by a satyr (the models for Hymen and the two girls were provided by the children of Balthasar Gerbier, Rubens' host in London; see 146). A leopard rolls on its back, clawing playfully at the trailing vine tendrils. Two young women rush in from the left, celebrating the joys of peace. One brings a bowl filled with precious vessels and pearls; the other shakes a tambourine. Above the head of Peace a winged putto holds an olive wreath and a caduceus, symbols of peace.

While the form the allegory takes may be obscure to modern viewers, the message is clear: Peace brings prosperity and wealth (the precious vessels and pearls), bountiful harvests (the overflowing cornucopia), stable family life (the crowning of the young girl by the god Hymen) and general happiness (the playful leopard, the girl with the tambourine). It must be vigorously protected from the ever-present threat of war. But even for viewers versed in classical allegory, the painting's imagery is unusual, particularly the figure of Peace.

Traditionally the personification of Peace is winged and dressed; her attributes, the caduceus and olive branch, are held in her hands or, alternatively, she wears an olive wreath on her head. True, Rubens never showed Peace with wings, which he reserved for Victory, Fame or other, less common personifications. But more disturbing than her wingless state is her nakedness. The figure of Peace who tries to close the temple door in *The Temple of Janus* is dressed in the appropriate loose garments and carries the caduceus (see 179). Similarly, in the scene of *Peace and Plenty Embracing* on the Whitehall ceiling (see 171), Peace is draped,

190 Previous page
The Allegory of Peace, 1629–30. Oil on canvas; 198×297 cm, 78×116⅞ in. National Gallery, London

191
Venus, Mars and Cupid, c.1630. Oil on canvas; 195.2×133 cm, 76⅞×52⅜ in. Dulwich Picture Gallery, London

though here she lacks attributes as well as wings. Were it not for the putto carrying the olive wreath and caduceus above the woman in *The Allegory of Peace*, her identity would be puzzling indeed. Without these symbols, and taking into account that she is beautiful, sensuous, naked and accompanied by gods and other mythical creatures, this mother feeding her child is most closely linked to Venus.

The image of Venus feeding her son Cupid is not uncommon in Renaissance art. It was depicted by Rubens in a work of approximately the same date as *The Allegory of Peace*, which shows *Venus, Mars and Cupid* (191). Indeed, the bodies and poses of the women in these two works are identical, suggesting that in Rubens' visual memory, a fusion had already taken place between the figure of Peace and the goddess of love. Once the woman in *The Allegory of Peace* has been identified as a Venus-like personification of Peace, the creatures around her can be seen as images specifically related to Venus rather than generalized symbols of joy and prosperity. Read as the latter, the imagery seems somewhat surprising: a leopard, however playful, is not exactly a peaceful animal; and a satyr, associated with sexuality, is also an unusual choice.

In fact, both the leopard and satyr are creatures associated with Bacchus (leopards drew his chariot and satyrs were his attendants), as is the woman, or Bacchante, who plays the tambourine. Their presence in the painting thus helps to identify the central figure, for it is Venus who is associated with the wine god in the phrase by Terence 'Without food and wine Venus freezes', of which Rubens had painted several versions in the decade after his return from Italy, including one in which the places of Bacchus and Ceres are taken by a satyr holding a cornucopia (see 107). While these pictures are more or less literal interpretations of the famous maxim, the message of *The Allegory of Peace* is more serious and universal.

Despite the glowing colours, the sumptuous imagery and sensuous female nudes, the picture is a political allegory rather than a guide to sex – its message is peace, not physical pleasures. Rubens

thus inverts Terence's metaphor to 'With food and wine Venus warms herself' (*ie* there is love) and transforms it to 'When Peace warms herself' (*ie* when there is peace), 'there is food and wine' (*ie* prosperity). The language of love has become the language of peace; the content has changed, but the imagery is the same.

While the message of the work is peace, there can be no doubt that love plays an important role in it – not physical love, as in *Venus, Ceres and Bacchus* (see 108), but maternal love. Regardless of whether the woman in the centre is Peace or Venus, she is a nursing mother, whose infant is simply enjoying its nourishment, in other words the blessings of peace. And it is children after all, not adults, who are being introduced to this peaceful realm. The presence of the god Hymen is a further indication that Rubens had in mind a peace specifically associated with marriage and children. The artist frequently represented children to illustrate felicity: a circle of dancing putti surrounds the figure of Felicitas Publica in *The Exchange of Princesses* in the Medici cycle (see 128), and processions of putti and animals run along either side of *The Apotheosis of James I* on the Banqueting House ceiling (see 168). Conversely, when Rubens represented the horrors of war he showed mothers dragged from their children. Peace as the protector of maternity, fecundity and children is essentially an ancient Greek idea, expressed in Homer, Hesiod and in Aristophanes' anti-war plays. Although Rubens was familiar with such Greek texts, *The Allegory of Peace* goes beyond them. The idea of Peace as a nursing mother clearly struck a personal chord. By endowing the idea with the physical properties of Venus, Rubens created a new image, at once goddess of love and symbol of peace.

It is in these dual roles that Venus appears in Rubens' political masterpiece, *The Horrors of War* (192). Painted in 1637–8 for Ferdinand de' Medici, Grand Duke of Tuscany, it is the artist's last political statement. By that time he had witnessed the deteriorating situation throughout Europe, marked by the development of the Thirty Years' War. The central figures are again a naked woman, here clearly identified as Venus by the accompanying

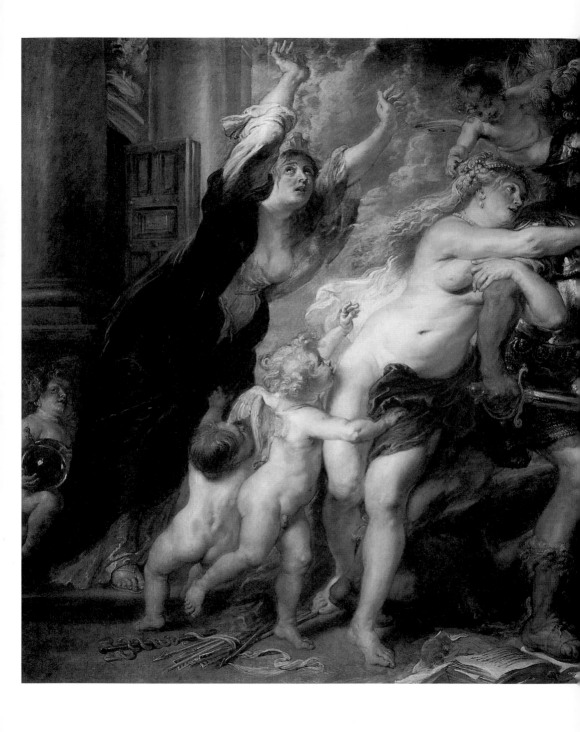

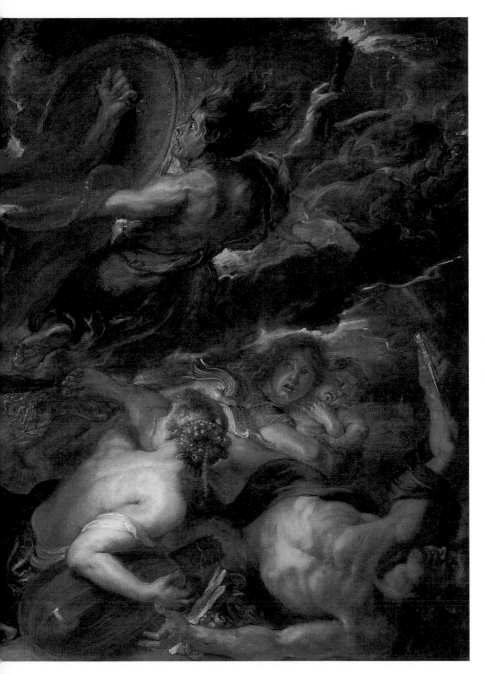

192
*The Horrors of
War*,
1637–8.
Oil on canvas;
206×342 cm,
81⅛×134⅝ in.
Galleria Pitti,
Florence

cupids, and the war god Mars; now, however, Mars is winning, as he and his Fury trample on their victims and sow destruction. Like *The Allegory of Peace*, the theme was Rubens' invention, but whereas the former served, at least partly, as a piece of royal flattery, *The Horrors of War* had no such function. Italy was relatively untouched by the war, and it seems highly unlikely that the choice of subject would have held particular attraction for the grand duke or his court painter, Justus Sustermans (1597–1681), who commissioned the work. The painting demonstrates that, despite retirement from politics and domestic happiness, the war in Europe continued to be a bitter reality for Rubens, one which deeply engaged his thoughts and concerns.

The description of the picture which Rubens sent to Sustermans in March 1638 survives:

The principal figure is Mars, who has left the open temple of Janus (which in time of peace, according to Roman custom, remained closed) and rushes forth with shield and blood-stained sword, threatening the people with great disaster. He pays little heed to Venus, his mistress, who, accompanied by her Amors and Cupids, strives with caresses and embraces to hold him. From the other side, Mars is dragged forward by the Fury Alekto, with a torch in her hand. Near by are monsters personifying Pestilence and Famine, those inseparable partners of War. On the ground, turning her back, lies a woman with a broken lute, representing Harmony, which is incompatible with the discord of War. There is also a mother with her child in her arms, indicating that fecundity, procreation and charity are thwarted by War, which corrupts and destroys everything. In addition, one sees an architect thrown on his back with his instruments in his hand, to show that which in time of peace is constructed for the use and ornamentation of the City, is hurled to the ground by the force of arms and falls to ruin. I believe, if I remember rightly, that you will find on the ground under the feet of Mars a book as well as a drawing on paper, to imply that he treads underfoot all the arts and letters. There ought also to be a bundle of darts or arrows, with the band which held them together undone; these when bound form the symbol of Concord. Beside them is the caduceus

193
Hercules and Minerva Fighting Mars, *c*.1635–7. Gouache over black chalk; 37×53.9 cm, 14⅝×21¼ in. Musée du Louvre, Paris

and an olive branch, attribute of Peace; these also are cast aside. That grief-stricken woman clothed in black, with torn veil, robbed of all her jewels and other ornaments, is the unfortunate Europe who, for so many years now, has suffered plunder, outrage, and misery, which are so injurious to everyone that it is unnecessary to go into detail. Europe's attribute is the globe, borne by a small angel or genius, and surmounted by the cross, to symbolize the Christian world.

With its mixture of allegorical, mythological and ordinary human characters, the painting exemplifies Rubens' rich pictorial

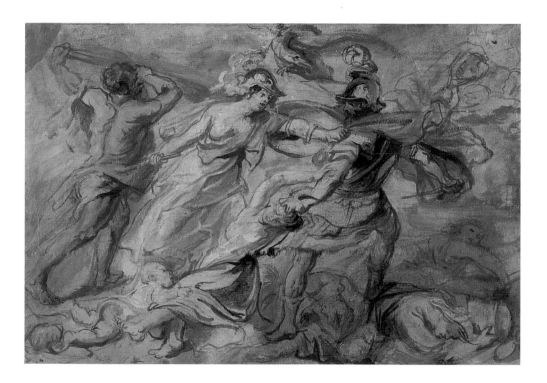

language. As in *The Temple of Janus* (see 178), he again introduced the figures of a mother and her child, eloquent in their simple humanity. What is new in *The Horrors of War*, however, is the combination of allegory and narrative. The paintings for the Medici cycle and Whitehall ceiling are allegories constructed around historical personages; the non-historical scenes for the Joyous Entry of Ferdinand are strictly allegorical, with the occasional addition of historical figures. Similarly, *The Allegory of Peace*

includes children in contemporary dress, whose features are based on the real children of Balthasar Gerbier. In all these scenes, however, Rubens presented a concept – the idea of peace or war. In *The Horrors of War* he presents both a concept and a story.

The central image is the nude figure of Venus set against the armour-clad figure of Mars. Visually most striking, she is also most important thematically, for it is here that Rubens introduced his new image of Venus as symbol of peace. As such she replaces Minerva who, starting with the Medici cycle, played the role of protector of wise rulership against war and civic strife. From the allegory celebrating the victory of peace which Rubens presented to Charles I, he turned, in a watercolour of several years later, to a representation of a more even match, in which Minerva, aided by a club-swinging Hercules, struggles with Mars who is dragging a mother off by her hair (193). The outcome is not entirely clear, since, despite the evidence of destruction on the ground, Mars is outnumbered by the combined forces of Minerva and Hercules.

By 1637–8, when Rubens painted *The Horrors of War*, the situation in Europe no longer permitted such ambiguities. Mars is clearly the victor: he is more heavily armoured than in the watercolour, and his victims, more numerous than before, include the personification of Europe. Nothing, however, makes the point more strongly than the figure of Venus: so lovely in her nudity, yet so helpless, ludicrous even, against Mars' war machinery. Minerva at least had a chance: to the ancient Greeks she was the goddess not only of wisdom but also of war. Unlike Mars, who stood for mindless destruction, she fought a just war, and – armed with helmet, shield and spear – was an equal partner to her adversary. Rubens retires her from his art only after recognizing that reason, diplomacy and the defence of just causes were no longer effective.

However, if Rubens wanted to make a statement on the hopelessness of the current political situation and the horrors of war, why introduce Venus? Undoubtedly, the contrast of the softness of

her flesh against Mars' armour appealed to him visually; and her presence gains meaning from her mythological role as his lover. There is, however, no incident in classical literature which recounts Venus trying to restrain Mars. Rather, the episode Rubens had in mind involved another of her lovers, the hunter Adonis. In an ingenious iconographic and formal transformation, Rubens transposed the image of Venus pleading with her lover Adonis (see 187) into the central motif in *The Horrors of War*. To anyone familiar with the Ovidian myth, the message is clear: as Adonis could not be held back from the hunt, so Mars could not be stopped from going to war.

This is the second meaning carried by the figure of Venus. By invoking the story of Venus and Adonis, Rubens introduced a narrative element into his allegory on the evils of war – the story of the female attempting to restrain the male from a tragic act that will destroy their love. Rubens thus elevated a tragic but purely personal story of love, loss and death to the level of a universal statement. For *The Horrors of War* is as much about love as it is about war, specifically female love: of a woman for her lover, or a mother for her child. It is in the realization of the latter that Rubens introduced his second major visual and iconographic invention. A mother and her baby, as found among the victims on the ground, is by now a familiar motif. For Rubens, it had come to represent the essence of the cruelty of war. Thus it is the image the artist turned to for the figure of Europe, for it echoes the central mother-figure in his great panel of *The Massacre of the Innocents*, painted at approximately the same time (194).

Following the account in the New Testament, the scene depicts the slaughter of infants in Bethlehem and the surrounding district by Roman soldiers at the command of King Herod, who feared that the new-born Christ, 'king of the Jews', would usurp his power. What is remarkable about Rubens' mothers in this story of biblical times is their seventeenth-century costume, which contrasts with the ancient armour or loincloths worn by the men. Rubens used such dress in other mythological or biblical contexts:

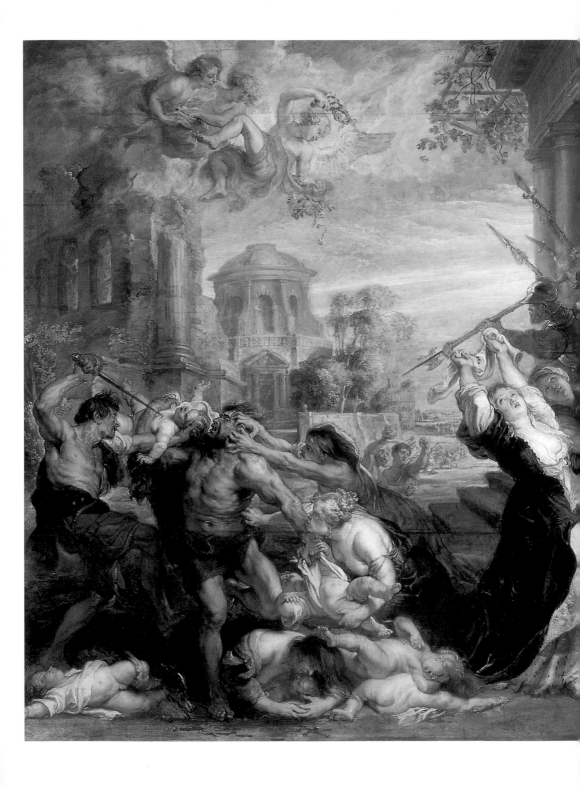

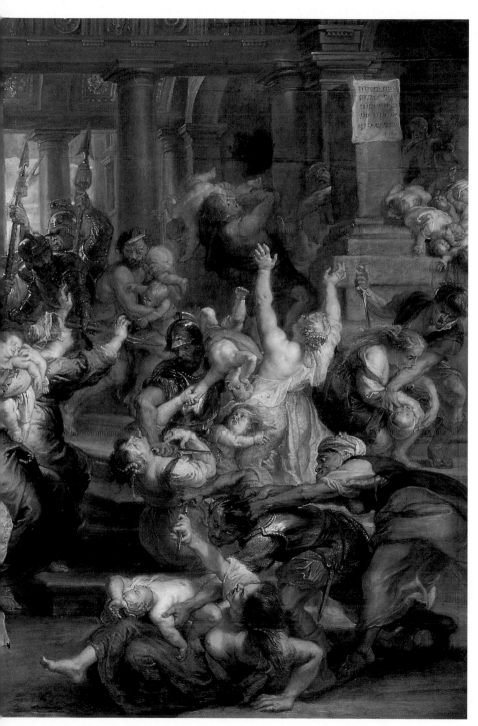

194
*The Massacre
of the Innocents,*
*c.*1635–7.
Oil on panel;
198×302 cm,
78×121¼ in.
Alte
Pinakothek,
Munich

a seventeenth-century gown and chemise (recognizable by the puffed sleeve with its lace cuff) is thrown over the branch of a tree in *The Three Graces*, possibly as a deliberate reference to its contemporary wearer, Helena Fourment (see 157). In *The Massacre of the Innocents*, the message is more serious and, at the same time, more universal – that the slaughter of children is not restricted to Herod's time. Such wholesale butchery – and not only of children but of the entire population – had in fact taken place in the German town of Magdeburg in 1631, one of the worst massacres of the Thirty Years' War. Thus, when Rubens used the image of the central mother in *The Massacre of the Innocents* for his personification of Europe, he did so deliberately. Visually isolated from the gruesome activities around her, from the other women and from her child, she is removed from the narrative account to become a symbol of the suffering of an entire continent.

Given Rubens' concerns at this time, it is not surprising to find that two of the main protagonists in *The Horrors of War* are women: Venus and 'Mother Europe'. In terms of the new role he had developed for Venus, it is not the outcome of the struggle which is important here but the weapon. At a time of war in Europe in which the entire population of a city could be butchered, in which suffering and atrocities were the order of the day, there was for Rubens only one power strong and pure enough to oppose the forces of evil: love. This is the third level of meaning introduced by the figure of Venus. In Rubens' vision, at the end of a life largely shaped by sectarian strife and political power struggles, love may not be a potent force against the cruelties of war, but it is the only force.

The struggle of love (in this case divine love) to overcome cruelty is a theme that also colours Rubens' religious art of this period. One of his most beautiful late altarpieces is *The Coronation of St Catherine* (195), probably painted in 1631 for the altar dedicated to St Barbara in the church of the Augustinians in Malines. It shows the Virgin Mary seated on a foliated throne; on her

195
*The Coronation
of St Catherine*,
1631.
Oil on canvas;
265·8×214·3 cm,
104⅝×84⅛ in.
Toledo
Museum of Art,
Ohio

lap the infant Christ is placing a laurel wreath on the head of the kneeling St Catherine, with St Apollonia at the left, and St Margaret at the right. The subject is unusual, replacing the canonical image of the Mystic Marriage of St Catherine, whose textual source derives from Jacobus de Voragine's *Golden Legend* (*c*.1275), with which Rubens was certainly familiar. There one reads that in Alexandria in *c*.300 AD the young Egyptian queen converted to Christianity, was baptized, and thereafter experienced a mystical vision in which the Christ-child married her. Because Catherine then refused the advances of the emperor Maxentius, she was tortured on a set of wheels that were miraculously destroyed by a thunderbolt. Ultimately, she was killed by decapitation. Rubens' crowning of the saint signifies divine matrimony to God, more frequently depicted by the bestowal of the ring, and thus evokes the same theological concepts inherent in the more traditional iconography of the Mystic Marriage. However, by deviating from this iconography, he placed greater emphasis on Catherine's martyrdom, for the crown is, among other things, an emblem of the Christian martyr.

Since the picture was originally installed as part of an altarpiece dedicated to St Barbara, it is surprising that the saint is absent. It has been suggested that *The Coronation of St Catherine* must have fitted into the structure of the entire altarpiece so that it was surmounted by a sculptural representation of St Barbara. In this way, the altar would have had as its subject the so-called 'Virgo inter Virgines', the Holy Virgin surrounded by the virgin saints and martyrs Barbara, Catherine, Apollonia and Margaret. Parallels for such multimedia ensembles are readily found in Rubens' *oeuvre* and often involve his own designs (see 212).

An autobiographical element has also been discerned in *The Coronation of St Catherine*. As in many of Rubens' late paintings, Helena Fourment seems to have been the model for at least two of the women, Saints Catherine and Margaret. Unlike his earlier representations of female saints, the dresses and hairstyles of all three figures are contemporary. There are also strong references

to secular subjects by Rubens, most strikingly the young women in *The Garden of Love* (see 209). Thus the mystic marriage of St Catherine to the Christ-child and the actual marriage between Rubens and Helena Fourment celebrated in *The Garden of Love* are visually linked: a union of 'sacred and profane love', to use the title given to one of Titian's most famous compositions.

In addition to *The Coronation of St Catherine*, a number of other religious paintings from Rubens' last decade – most famously the so-called Ildefonso Altarpiece, commissioned in 1630 by the Archduchess Isabella in memory of her late husband – take as their theme the Virgin and saints, predominantly female. The other religious subject that occupied Rubens most intensely during this time, especially after around 1635, is that of martyrdom. These two types of images – one calm, beautiful, idyllic, the other violent, agitated, brutal – continue a thematic and formal dichotomy that runs throughout Rubens' *oeuvre*. It is present in the contrast of such early works as *Venus, Ceres and Bacchus* with others, such as *The Lion Hunt* and *The Battle of the Amazons* (see 108, 112 and 114). While the earlier paintings were, at least to some extent, created to satisfy the preferences of the art market, Rubens' later works largely reflect his own choices and concerns.

One of the more brutal martyrdoms that Rubens painted is *The Crucifixion of St Peter* (196), commissioned in 1637 by the Cologne merchant and banking family of Jabach and installed by them in 1642, two years after the artist's death, in St Peter's Church in Cologne, the church that had been the Rubens family's parish church and in which Jan Rubens was buried fifty years earlier. The story of St Peter's crucifixion was widely known from the account in *The Golden Legend*. Following his own request, he was crucified upside-down, because humility prevented him from being crucified in the same position as Christ. Rubens' painting shows four executioners and a Roman soldier in the process of nailing the saint to the cross. They are absorbed in their gruesome task with fierce concentration, while the saint glances at the viewer, who is thus drawn into the reality of the

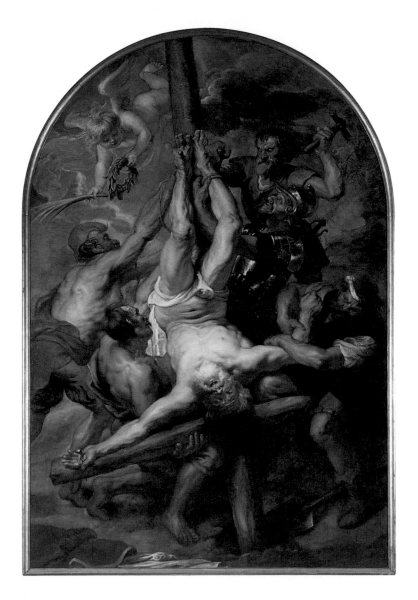

196
*The Crucifixion
of St Peter,*
*c.*1638–40.
Oil on canvas;
328×220 cm,
129⅛×86⅝ in.
St Peter's
Church,
Cologne

terrible event. The scene is placed close to the picture plane to allow no room for distracting details, such as the group of bystanders – compassionate or just curious – familiar from other Rubens compositions such as *The Raising of the Cross* (see 65).

A letter from Rubens dated 25 July 1637 to the Jabach's intermediary, the painter George Geldorp (d.1665), reveals that the theme of the painting was left to the artist, with the provision that it had to be a scene from the life of St Peter, the titular saint of the church. The letter is interesting on several counts. Besides documenting Rubens' role in the choice of subject matter, it shows his professional concern with practical issues, such as the length of time needed for the work and, most importantly, the size and format of the picture:

As regards time, I must have a year and a half, in order to be able to serve your friend [Everhard Jabach the younger] with care and convenience. As for the subject, it would be best to choose it according to the size of the picture; for there are subjects which are better treated in a large space, and others which call for medium or small proportions. But if I might choose or wish for a subject according to my taste, relating to St Peter, it would be his crucifixion, with his feet uppermost. It seems to me that that would enable me to do something extraordinary, yet according to my means. Nevertheless, I leave the choice to the one who will pay the expense, as soon as we know how large the picture is to be.

The crucifixion of St Peter, the most dramatic scene from his life, clearly had special meaning for Rubens at this time. It seems that the Jabach family and their parish priest would have preferred another event, specifically the more popular Rescue of Peter from the Waves, the Denial of Peter or the Delivery of the Keys, a subject Rubens himself had treated earlier.

In Rubens' work of the late 1630s, the theme of violence links his religious paintings (he also painted the martyrdoms of Saints Andrew, Thomas, Livinus and Paul) to that most personal of political allegories, *The Horrors of War* (see 192). All were to

some extent informed by the political situation in the Netherlands, differing in this respect from Rubens' earlier representations of violent subjects. Just as he chose to depict, against convention, the suffering of a continent in a picture destined for a princely court not overtly concerned with such issues, so he chose martyrdoms in preference to the more joyous events in the lives of saints. But in their martyrdoms – in direct succession to Christ's sacrifice – lies salvation and ultimately victory. The little angel hovering above *The Crucifixion of St Peter* not only carries the martyr's palm but also the victor's laurel wreath.

Martin Warnke has observed that the figure of St Peter, turned around so that the head points upwards, resembles Rubens' *Death of Seneca* (see 106). The pose and facial features are indeed similar, especially the eyes and open mouth. More significant, however, is the transferral of meaning. Seneca was a contemporary of Peter and both were condemned to death under Emperor Nero. Moreover, Rubens was certainly familiar with the tradition of seeing Seneca as a near-Christian, even a secret Christian (see Chapter 5). *The Crucifixion of St Peter* demonstrates yet again, therefore, the complexities of Rubens' visual vocabulary. Iconographically, it testifies to his awareness of the connection between Christian faith and Neo-Stoic thought, which had been strengthened by his early contact with Justus Lipsius and his circle. On a personal level, the altarpiece was painted for the church where his father was buried. Though it was commissioned by the Jabach family and destined for the high altar of their parish church, Rubens privately may have intended the work as an epitaph for Jan Rubens.

197
*The Château
de Steen*
(detail of 199)

While Rubens' late allegories evoke a troubled, conflict-ridden
reality in which love is constantly shadowed by pain, an appar-
ently much more stable world manifests itself in the landscapes
he painted during this period. As a subject in its own right, land-
scape had not concerned him greatly before, and here once again
the influence of Titian can be seen in his representation of nature
and man's place in it. In Rubens' earlier mythologies the land-
scapes are no more than a background setting, often assigned
to a specialist. On his first visit to Spain, however, Rubens had
admired Titian's great equestrian portrait of Charles V (see
47). Here Titian used the landscape, bathed in the glow of the
setting sun, to portray the emperor as the defender of Catholic
Christendom. In his *Duke of Lerma on Horseback* (see 48) Rubens,
following Titian's example, turned to landscape motifs to enhance
the status of his sitter. Now, as he withdrew from political life and
its trappings of prestige, he no longer saw nature as an embellish-
ment of man, however powerful. Instead he recognized another
aspect of landscape in the works of his great predecessor: the
interrelationship between figures and the world around them.
His men and women, be they farmers or gods, shepherds or satyrs,
peasant girls or nymphs, are part of their surroundings. Enclosed
by hills and meadows, forests and streams, they are in harmony
with the landscape which defines their moods and controls their
actions. It was this union of man and nature which he saw in
Titian's paintings and which may well have been the Venetian
master's greatest legacy for Rubens.

Titian's mythological pictures are set in idyllic surroundings –
poetic visions of an earthly paradise where gods and mortals
mingle. Rubens' 'earthly paradise', however, was his own Brabant
countryside, and he brought to its depiction not only his new
approach to landscape learned from Titian but also his own native

tradition. Northerners, after all, were particularly popular in Italy as landscape painters. Rubens' friend, Adam Elsheimer, is an example, and his first teacher, Tobias Verhaeght, had specialized in the genre. Rubens' second marriage and his resettling in Antwerp after years in foreign courts seem to have inspired a renewed love of his homeland. In 1635 he bought a country estate, the Château de Steen, or Het Steen, south of Antwerp, and during the last years of his life he spent considerable time there. As he wrote to Peiresc in September 1636: 'To tell the truth I have been living somewhat in retirement for several months, in my country house which is rather far from the city of Antwerp and off the main roads.' With the ownership of

198
Landscape with the Tower of Steen,
c.1635–7.
Oil on panel;
24×30 cm,
9½×11¾ in.
Gemälde-
galerie, Berlin

199
The Château de Steen,
c.1635–8.
Oil on panel;
131.5×229.5 cm,
51¼×90⅜ in.
National
Gallery,
London

the estate came the title Lord of Steen, which Rubens held as his favourite honour and which is written on his tombstone.

The house has survived, but not in its seventeenth-century state. In Rubens' time, it included a moat and bridge as well as a crenellated tower, as shown in two paintings, a small sketch, *Landscape with the Tower of Steen* (198), and the famous large landscape *The Château de Steen* (199). Rubens set his house in open, gently rolling country (the terrain is actually very flat), lit by warm sunlight. Rows of willows and ditches lead the eye to the distant horizon where a town, probably Malines, is just visible. In the large painting, a farmer and his wife set out for market in their

wagon pulled by two horses (197); in the foreground a hunter and his dog, hidden behind a tree-stump overgrown with brambles, stalk a flock of partridges. The picture represents a perfect country idyll, such as Rubens would have enjoyed as a respite from the hectic life of the workshop in the city. Despite the continuing war, the Brabant countryside was relatively peaceful and prosperous, unlike Antwerp which felt the hardship of economic decline much more severely.

Life in the country inspired Rubens to look at nature in a new way. For the first time in his art he carefully and consistently observed

natural phenomena: the local flora, the effect of light, reflections on water and other details. While the landscape paintings were executed in the studio, a series of exquisite drawings of rural motifs, including *Trees Reflected in Water* (202) and *Landscape with a Wattle Fence* (203), were obviously done outdoors. Although the final paintings are ideally composed views which are not always topographically correct, they give the impression of realistic vistas because they are constructed from many correctly observed details.

200
*Landscape with
a Rainbow,*
*c.*1635–8.
Oil on panel;
135·5×233·5 cm,
53⅜×92 in.
Wallace
Collection,
London

201
**Pieter Bruegel
the Elder,**
Haymaking
or *July,*
*c.*1565.
Oil on panel;
117×161 cm,
46×63⅜ in.
Narodnie
Galerie, Prague

Probably as a companion-piece or pendant to *The Château de Steen*, Rubens painted *Landscape with a Rainbow* (200). The panel is divided in two halves: on the right is a wooded area, a stream and a flock of ducks; on the left a haymaking site, a horse-drawn wagon moving along the road, and two milkmaids and a farmer walking from the opposite direction. In the centre is a herd of cows, while a rainbow arches over the entire composition. Judging by the activities (haymaking in the *Landscape with a Rainbow*) and the vegetation (brambles bearing blossoms and fruit in *The Château de Steen*), both pictures depict midsummer.

202
Trees Reflected in Water, 1630s.
Black, red and white chalk; 27·3×45·4 cm, 10³⁄₄×17¹⁄₈ in.
British Museum, London

203
Landscape with a Wattle Fence, 1630s.
Black and red chalk; 35·3×51·4 cm, 14×20¹⁄₄ in.
British Museum, London

It is more difficult to assign a time of day. In *The Château de Steen* the sun is just over the horizon, and from the location of the house it can be deduced that, since the sun is in the east, it is morning. This is supported by the farmer and his wife setting out for market. In *Landscape with a Rainbow* the sun is also low, but the golden tone of the picture indicates late afternoon. The amorous intentions of the farmer nudging the two milkmaids suggest that the day is almost done and it is time for leisure.

The depiction of different times of day and of different rural activities in pendant landscapes is not a new one in Flemish art. Seasonal activities in appropriate landscape settings occur in medieval book illumination, but the closest analogy to these paintings is in the works of Pieter Bruegel the Elder. In the series of the *Months*, Bruegel conceived a set of six paintings, of which five are known; four of these relate to each other as pendants within the group. Rubens was interested in the colour schemes Bruegel devised for each picture according to the time of the year, and he appropriated such colour contrasts to depict morning and afternoon in his landscape pendants. Of Bruegel's five *Months*, *Haymaking* or *July* (201) comes closest to *Landscape with a Rainbow* in atmosphere as well as composition. A road divides the two halves of the picture, with haymakers in the distance on the left, and farmers and women passing each other on the road.

Bruegel was, of course, *the* painter of peasant activities and his scenes opened Rubens' eyes to rural life as much as did his newly established proximity to it. Rubens owned no less than twelve paintings by Bruegel, and had been a close friend and collaborator of his son, Jan Brueghel the Elder (see Chapter 4). Like Titian before him, Bruegel inspired Rubens to see man in harmony with the world around him. While Bruegel's peasants are completely equated with nature, however (he often deliberately obscured the faces of his men and women or merged them with the material of their toil), Rubens' farmers and milkmaids, although at home in their surroundings, remain individuals. Whereas for Rubens the peasant is defined within nature, for Bruegel he is also seen as nature.

The Château de Steen and *Landscape with a Rainbow* revolve around rather ordinary rural activities: harvesting hay, driving cows, going to market, hunting. But, like the love affairs of the nymphs and gods in Rubens' mythologies, these activities remind us that humanity is always at the centre of Rubens' art. It is only in a series of oil sketches that Rubens made nature his sole subject. In these studies, Rubens is primarily concerned with form and

light effects. In *Sunset Landscape with a Shepherd and his Flock* (204) it is the slanting rays and long shadows of sunset that captured his interest. The shepherd is in the lower right corner, his flock submerged in the golden evening light. Continuing his observation of changing light and atmosphere, Rubens produced his most remarkable picture in the group, a *Moonlight Landscape* (205). Devoid of inhabitants apart from a horse grazing by the riverside, it offers a poetic vision of a night landscape under a starry moonlit sky. The warm brown tones of the sunrise and sunset landscapes are replaced by silvery blues, pinks and dark greens. Rubens explores such natural phenomena as the reflections of trees in water, recalling his drawing of the same subject (see 202).

These small landscape panels were probably painted at Steen, where Rubens set up a private studio for himself; they may even have been sketched outdoors. He is known to have had panels from the Antwerp workshop sent to him in the country. In a letter of August 1638 to a young pupil and assistant, the sculptor Lucas Fayd'herbe (1617–97), Rubens wrote from Steen:

I hope that this will find you still in Antwerp, for I have urgent need of a panel on which there are three heads in life-size, painted by my own hand, namely: one of a furious soldier with a black cap on his head, one of a man crying, and one laughing. You will do me a great favour by sending this panel to me at once, or, if you are ready to come yourself, by bringing it with you.

With affection and warmth uncharacteristic of Rubens' correspondence he addressed the letter 'My dear and beloved Lucas', and signed it 'with all my heart, dear Lucas, your devoted friend'. Undoubtedly, Rubens' most personal letters, had they survived – those which he must have written to his mother from Italy, to Isabella Brant from Paris and to his children from Madrid and London – would have revealed similar tenderness, and the letter to Fayd'herbe provides a rare glimpse of the more intimate side of Rubens' character (it is also one of the few written in Flemish). But it also demonstrates, yet again, that the private and public

204
Sunset Landscape with a Shepherd and his Flock,
*c.*1638.
Oil on panel;
49·4×83·5 cm,
19⅜×32⅞ in.
National Gallery, London

205
Moonlight Landscape,
*c.*1637.
Oil on panel;
63·5×89 cm,
25×35 in.
Courtauld Institute Galleries, London

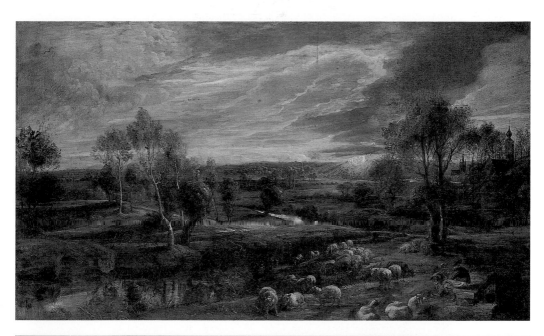

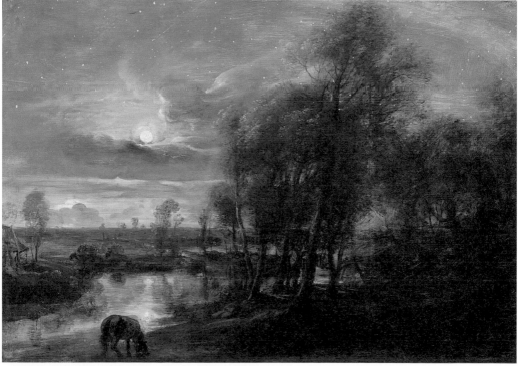

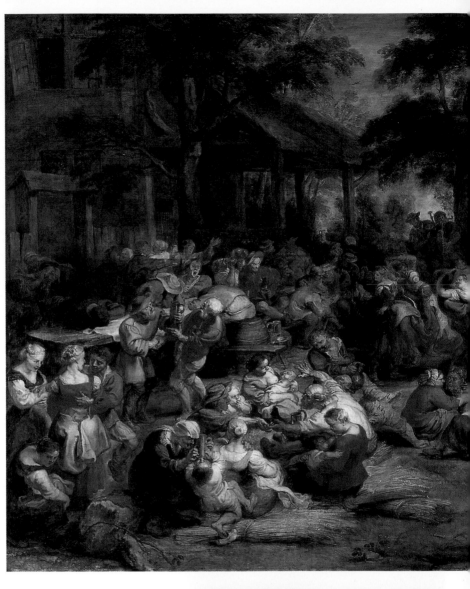

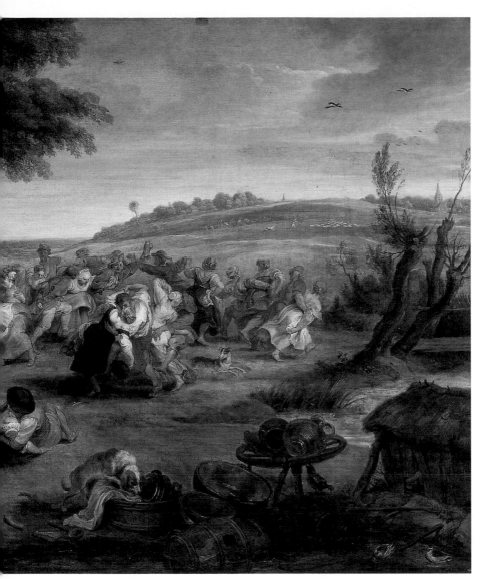

206
Flemish Kermis
or *Kermesse
Flamande*,
*c.*1630.
Oil on panel;
149×261 cm,
58⅝×102¾ in.
Musée du
Louvre, Paris

207
**Pieter
Bruegel the
Elder**,
*A Peasant
Kermis*,
*c.*1567–8.
Oil on panel;
114×164 cm,
44⅞×64½ in.
Kunst-
historisches
Museum,
Vienna

spheres of his life had become less distinct. Perhaps compensating for the lack of artistic interest in either Albert or Nicolas, Rubens' relationship with the young sculptor was more that of a father than a master.

The two dominant pictorial traditions in Rubens' late works, the art of Titian and Bruegel, are also apparent in several genre subjects produced during these years. Clearly painted in homage to Pieter Bruegel, the *Flemish Kermis* portrays a peasant festival (206). It depicts feasting, drinking, the feeding of infants, dancing and kissing; there are bodies slumped over tables in drunkenness,

208
Studies of dancing peasants, *c*.1630. Pen and brown ink over black chalk with touches of red chalk; 58·2×50·2 cm, 22⅞×19¾ in. British Museum, London

vomiting and pissing. All this uninhibited activity is arranged along a diagonal which leads the eye into a sweeping landscape of distant hills; on the left is a tavern, on the right a still life of barrels and pitchers, a lake, a tree and some ducks. The brightness of colour, with its predominant accents of red and yellow, highlights the festive mood.

The gross behaviour of Flemish peasants at their festivals was well known at the time. The Cardinal-Infante Ferdinand wrote to his brother Philip IV in August 1639:

The great festival they call the kermis took place here [Antwerp] yesterday. It is a long procession with many triumphal carts, it seems to me more beautiful than that in Brussels; and after it has all passed by, then they will eat and drink and get thoroughly drunk, because without that it's not a festival in this country. There's no question that they live like beasts here.

But Rubens' painting does not record a specific saint's day kermis, with its mandatory saint's banner. Moreover, the landscape with its rolling hills and distant shepherds tending their flocks recalls the ancient pastoral world rather than the setting of Flemish kermis celebrations, which traditionally took place in the village square (207). The generalized pastoral setting transforms Rubens' painting into a universal celebration of human festivity as embodied in the Flemish peasants. Ultimately, as with so much of Rubens' art, the painting has a broader significance: it evokes Flanders and its cultural heritage, the love of ordinary men and women enjoying themselves and the sheer pleasure of creating. Nowhere else do we find such ecstatic abandonment as in the group of dancers – in the figures of the dancers themselves as well as in the artistic process. This abandonment to the act of creation is even more pronounced in an extraordinary sheet of drawings connected with the *Flemish Kermis*. On the reverse side are shown seventeen pairs of dancers, or, more likely, one pair in seventeen different poses as the dancers move in a frenzied measure across the page (208). Caught up in the vitality of his subject, Rubens created ever more variations on a theme – an endless formation of joined lips, of limbs and bodies twisting and turning to the music. The act of creation assumes here a life of its own beyond any immediate purpose or goal.

The counterpart to this peasant feast is a bucolic gathering reflecting a very different social milieu, the painting listed in an old inventory as a *Conversation of Young Women* or *A la mode*, but known today as *The Garden of Love* (209). Here young women and men in contemporary dress form a fashionable group on a terrace before a richly decorated classical pavilion not unlike that

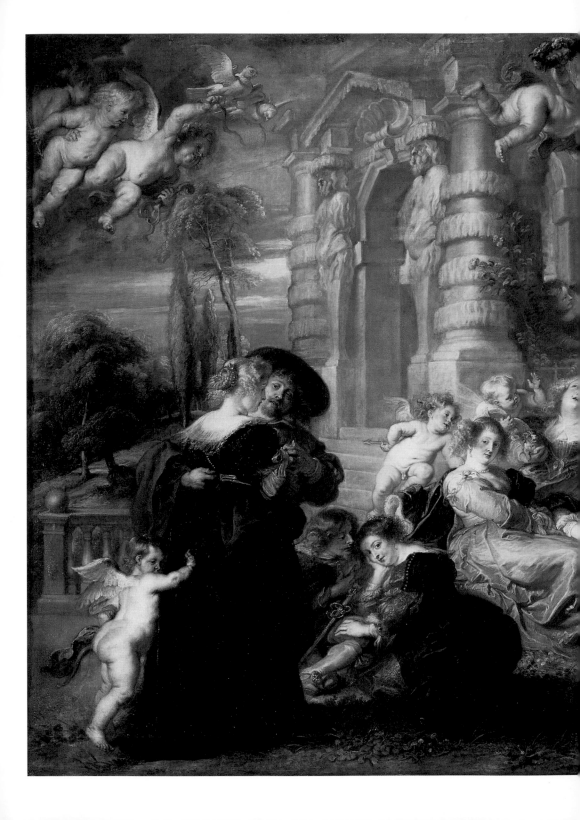

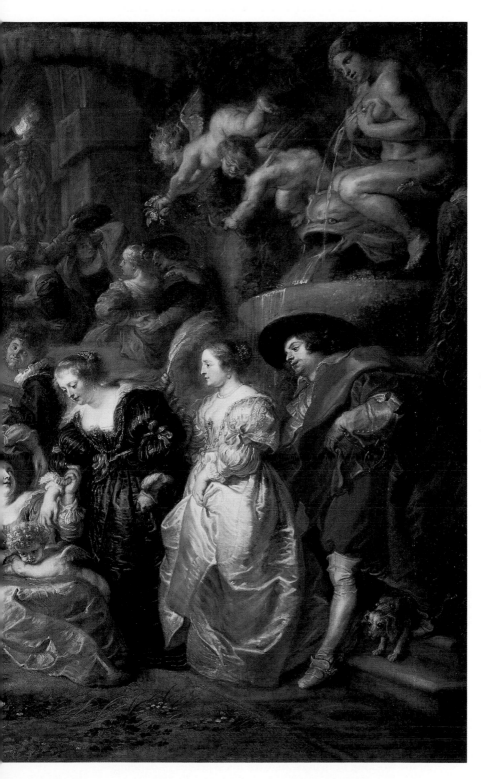

209
*The Garden
of Love*,
*c.*1634–5.
Oil on canvas;
198×283 cm,
78×111⅜ in.
Museo del
Prado, Madrid

in Rubens' own Antwerp garden. Several of the women recall Helena Fourment (especially the lady in the centre, dressed in yellow, who looks out of the picture), and the group might be taken for a high-society outdoor party – a popular genre in seventeenth-century Flemish art – were it not for the many putti invading the picture, cousins of the inhabitants of Titian's *Worship of Venus* and Rubens' copy (see 181, 182). Clearly, the picture not only represents a fashionable gathering but has as its subject love, specifically married love. One of the cupids, in spectacularly rendered flight, holds a burning torch and a crown of roses, another a pair of turtle doves and a yoke, a third, pushing the couple onthe left to join the group in the centre, carries a bow. At the far right, on the rim of the fountain, sits a peacock, attribute of Juno, goddess of marriage.

Apart from the subject itself, we are captivated by the beauty of each figure, the sumptuous silks and satins, the deep, glowing colours, the enchanted setting and the Titianesque evening sky. How carefully Rubens prepared the composition is clear from a series of exquisite chalk studies for both single figures and pairs (210, 211). The large number of such drawings (nine have survived) is surprising at this late date, as Rubens had almost abandoned the practice of preparatory figure studies. In fact, there is no evidence of quite such careful preparation since *The Raising of the Cross* and other works from his first decade back in Antwerp (see 85, 88, 90 and 92). Whereas those studies focused on the anatomy of the human body, however, in the drawings for *The Garden of Love* Rubens paid attention to the play of light over the surfaces of rich fabrics (light and reflections are also a preoccupation in Rubens' landscapes of the time) and to facial expressions which convey tender affection or coy charm – a concern that coincides with the emphasis on human emotions in his late mythologies. It may have been that, with the slightly reduced pressure of his last years, the artist allowed himself the luxury of immersing himself in such an exercise; these large sheets are rather more elaborate and beautiful than strictly required for working drawings. As with his sketches of dancing

peasants (see 208), Rubens was caught up in the act of creation for its own sake.

The drawings for the *Flemish Kermis* and *The Garden of Love* are neither strictly utilitarian preparations for final paintings nor unique works in their own right, but in some sense both. In every aspect of Rubens' orderly and compartmentalized world the boundaries had become less distinct. Life and art merge as Helena Fourment steps in and out of her husband's painted visions (in *The Three Graces* her dress is casually thrown over the branches of the tree ready to be put on again); distant ancient myths become the vehicle for the representation of everyday human joys and tragedies; man in control of nature steps aside

210
A Young Woman Kneeling, mid-1630s. Black and red chalk heightened with white; 40·3×47·4 cm, 15⅞×18⅝ in. Amsterdams Historisch Museum

211
A Young Man Walking, mid-1630s. Black, red and white chalk; 56·1×41·5 cm, 15⅞×16¼ in. Amsterdams Historisch Museum

to let nature take centre stage; fatherly affections once reserved for children are extended to a studio assistant. The result is life as art: joyous, sad, moving, humorous, tender, violent, but above all human.

Peter Paul Rubens died on 31 May 1640. As Balthasar Gerbier explained in a letter to Inigo Jones a few days later, Rubens' death was caused by 'a defraction which fell on his heart, after some days' indisposition of ague and gout'. The artist had first been attacked by gout long before, when on a diplomatic journey in 1627. While in Madrid in 1628, he wrote to Caspar Gevaerts in Antwerp that he was again afflicted: 'These last few days I have

been very sick with gout and fever, and to tell the truth, I could hardly draw a breath between groans and sighs.' The illness proceeded intermittently but was never cured. On the evening of the day Rubens died his body was laid out in the coffin and placed in the Fourment family vault in his parish church of St Jacob. The funeral service was performed three days later, with a procession headed by the clergy of St Jacob, followed by members of the civic, artistic, mercantile and aristocratic classes of Antwerp. During the next six weeks, masses were held in Antwerp churches and in the little parish church of Elewijt, near Rubens' country estate at Steen. In the year after the artist's death a funeral chapel was built for him behind the choir of St Jacob (212). One of his last paintings, *The Madonna and Child with Saints*, was placed over the altar, crowned by a marble statue of the Virgin carved by his 'dear and beloved' Lucas Fayd'herbe. An epitaph composed by his friend Gevaerts was inscribed on a stone laid in the floor of the chapel. It was dedicated to: 'Peter Paul Rubens, knight … Lord of Steen, who, among the other gifts by which he marvellously excelled in the knowledge of ancient history and all other useful and elegant arts, deserved also to be called the Apelles, not only of his own age but of all time, and made himself a pathway to the friendship of kings and princes.' And thus the city of Antwerp buried its most illustrious citizen.

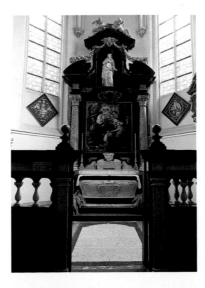

212
Rubens' funerary chapel in St Jacob's Church, Antwerp, with the artist's *Madonna and Child with Saints* and a statue of the Virgin by Lucas Fayd'herbe

Epilogue

Highly esteemed during his lifetime, Rubens continued to elicit admiration throughout the centuries. Not surprisingly, seventeenth-century biographers praised the man – hugely talented, learned, rich, successful – as much as his art; indeed, they saw his art as an extension of the qualities of the man. It was only at the end of the century that an attempt was made at a critical evaluation of Rubens' work. This took place in France, where one of the most curious battles raged between the partisans of Rubens and those of the French painter Nicolas Poussin (1593/4–1665).

Rubens' leading admirer was the critic and minor painter Roger de Piles (1635–1709). He drew up an artistic score sheet, the *Balance des Peintres*, in which he allotted points to each painter for composition, colour, drawing and expression. Each category was marked out of 20: thus Raphael received 18 for colour but only 12 for drawing, Rembrandt 6 for drawing, while Michelangelo achieved 17 for drawing but did very poorly in colour with only 6 points. Rubens, along with Raphael, got the highest score. Out of a possible 80, he was given 65 points, with only drawing receiving a less than outstanding mark.

Rubens' work subsequently had an enormous influence on French art, particularly on the development of the eighteenth-century Rococo style with its sense of graceful vitality. Painters such as Jean-Antoine Watteau (1684–1721) and François Boucher (1703–70) drew copies from his works, especially the Medici cycle. Watteau's conception of the aristocratic open-air *fête galante* and *fête champêtre* owe an obvious debt to Rubens, specifically to his *Garden of Love* (see 209); and the sensuously feminine art of Boucher also pays homage to the Flemish master. Some critics, however, continued to disparage Rubens, especially for his drawing, which was deemed 'incorrect'. It was not Rubens' technical

skill that was denigrated by this term so much as his 'invention', or *disegno* in Italian, in other words the idea on which a design was based. The ideas behind Rubens' compositions, it was thought, lacked dignity; they were too far removed from the classical forms of antiquity – in short, too 'Flemish'.

Rubens' 'inharmonious' forms continued to disturb artists and critics, especially in Germany, where the classicist Johann Joachim Winckelmann complained that 'the great Rubens nowhere approached the Greek proportions, and those of his works that he did before his Italian journey and his study of antique art are the furthest removed from the Greek ideal'. But at the same time the artist was admired without reservation as an example of 'genius', the capacity of some individuals to break conventions and rules creatively. Thus Rubens' 'incorrect' drawing could be forgiven as the permissible, indeed necessary, fault of a genius. Observing inconsistencies in the cast shadows in the late landscape *Return from the Harvest* in the Palazzo Pitti in Florence, the German poet Johann Wolfgang von Goethe praised the artist for the way in which his forms did not merely reproduce the laws of nature but in fact surpassed them. This view of Rubens also informed a change of heart in the English painter Joshua Reynolds. In his earliest *Discourses* or lectures at the newly established Royal Academy of Arts in London, he compared Rubens adversely to the Grand Style practised by Michelangelo, Raphael and the Carracci. Later, however, after visiting the famous Rubens collection in Düsseldorf, he became an ardent admirer.

In the early nineteenth century, while Winckelmann's criticisms on Rubens continued to be echoed by German writers, in France he became the great hero of the Romantic movement. Théodore Géricault (1791–1824) and Eugène Delacroix (1798–1863) were both deeply influenced by Rubens, whose works they copied in the Louvre. Delacroix's *Journal* is full of references to Rubens, with whom he clearly identified in his own aims and ambitions as a painter: 'He dominates, he overwhelms you with so much liberty

and audacity.' Towards the end of the century, the Impressionists' ambivalent attitude to the art of the past included that of Rubens, though figure painters, predictably, continued to study his works, especially the Medici cycle. Pierre-Auguste Renoir painted a copy of *The Council of the Gods*, while Paul Cézanne (1839–1906) drew individual figures and groups from the series. Renoir's nudes and his paintings of his family are perhaps the nearest equivalent in this period to Rubens' handling of these subjects. On completing *The Bathers*, Renoir is said to have pronounced, 'Rubens would have been satisfied with it!' Whatever their response to Rubens' subject matter, painters throughout the nineteenth and early twentieth centuries continued to learn much from his technical skills, in particular his virtuoso brushwork and his ability to achieve the subtlest effects with oil paint.

In the twentieth century, artists representing many different movements and types of artistic practice have been stimulated by Rubens' work. Among the Surrealists, the Italian Giorgio de Chirico (1888–1978) painted a *Self-Portrait in the Guise of Rubens' Mars*, which can be related to Rubens' work in both portraiture and allegory (in its richly symbolic, often eroticized visual language, the latter genre connects with the Surrealist use of Freudian dream imagery in art). In British art, the massive fleshiness explored in the paintings of Lucian Freud (b.1922) has a debt to both Rubens and Rembrandt. Other modern artists, both conservative and progressive, have also drawn on different aspects of Rubens' extensive *oeuvre*. For example, Jackson Pollock (1912–56), the leading figure of the postwar Abstract Expressionist movement, made drawings after Rubens in the 1930s in which the interest lies not so much in Rubens' subject matter as in a certain baroque vision of space and rhythm. This aspect is explored in three-dimensional terms in a sculpture inspired by *The Descent from the Cross* (see 71) by the British sculptor Anthony Caro (b.1924; 214). Another avant-garde artist, the American Robert Rauschenberg (b.1925), centred his 1964 painting *Persimmon* (213) on a silkscreen of the voluptuous nude from *Venus at the Mirror* (see 1), creating a poignant and witty

214
**Anthony
Caro**,
*Descent from
the Cross (after
Rubens)*,
1987–8.
Steel, rusted
and waxed;
h.244 cm,
96 in.
Private
collection

icon that comments on the timeless aura surrounding physical beauty in an age of mass reproduction. Modern, and indeed post-modern, ideas of instability can also be found in the ambiguity created by Venus' face in the mirror as to who – painter, subject or viewer – is viewing whom.

Rubens' continuing relevance for artists and art critics seems undeniable. But what about the viewing public? While it is difficult to gauge accurately the public opinion of past centuries, it seems clear from the comments of museum visitors, from auction prices, book sales and media coverage that Rubens is not the most popular artist today.

This is evident if we compare him with his near-contemporary Rembrandt, whose early career in Amsterdam in the Northern Netherlands overlapped with Rubens' later years in Antwerp in the South. There is no doubt that today Rembrandt's pictures attract the greater audiences: their contemplative, sometimes brooding mood engages the viewer's thoughts; their dramatic use of light and shade holds mystery. Most of all, their subject matter – often portraits or individual figures, sometimes biblical, rarely mythological or allegorical – seems to need little explanation. Moreover, although recent research has partly corrected this view, they give the impression of having been created in isolation – products of the lonely, even misunderstood, genius.

By contrast, Rubens' paintings are, on the whole, large and colourful. His compositions are filled with action; his protagonists make the kind of dramatic, rhetorical gestures so typical of Baroque art, which may appear overstated and exaggerated to modern eyes; and his subject matter is often obscure.

Other obstacles to a true appreciation of Rubens' art concern authenticity and function. We object to the fact that a large number of his paintings were executed by assistants, with no more than final touches of the master's brush. Furthermore, many of Rubens' works are altarpieces or other religious pictures which were meant to be seen in churches, sometimes at a great distance, or in private chapels; others are vast decorative cycles intended for palaces whose owners they glorify. The function of such works is greatly dissipated, now that they hang on museum and gallery walls and their patrons and protagonists are long fallen.

Above all, Rubens is the artist most commonly associated with the nude, especially the female nude, of which he probably painted more than any other artist in history. To the present-day public the Rubensian nude is synonymous with an exuberant sensuality, but also with an ideal of feminine beauty not generally sympathetic to our own. While Rembrandt's naked women are in fact as plump as Rubens', he painted relatively few, and it is the sheer number of Rubens' nudes, as much as their ample

proportions, that can overwhelm the viewer. They have evoked an ambivalent, even hostile response from some critics. What, for example, is Feminism to make of Rubens' art – its paradoxical combination of an unavoidably male gaze with an exploration and celebration, most notably in the works of his last decade, of 'feminine' values? At the very least, such issues continue to provoke discussion; the question of Rubens' posthumous reputation is far from settled.

Perhaps more than any other major artist, Rubens needs to be seen within the artistic conventions of his day. When he was asked to paint an altarpiece, he was generally told exactly what subject to paint, what colours to use and what size the picture should be. Rubens had the capacity to create within these restrictions pictures whose protagonists were instantly recognizable, while at the same time conveying the mysteries of the faith in an exciting and novel way. He painted women plump because of his personal beliefs about femininity, but also because of the conventional ideal of beauty current in Flanders in the first half of the seventeenth century. It is no accident, then, that Rubens' reputation remained consistently high in the eyes of artists, art critics and modern-day art historians. Artists marvel at his ability to instil his forms with life, at his creativity and the sheer quantity of his work; art historians admire his creative power of invention, his intelligence and erudition. It is precisely because they are familiar with artistic conventions that they appreciate how Rubens fulfilled these conventions – and did so with ingenuity, honesty and imagination.

Glossary

Allegory The illustration of abstract concepts through **personifications** and/or symbols. In the seventeenth century, allegorical images lost their static quality and were infused with a sense of animation.

The Antique The revival of interest in ancient Greek and Roman sculpture in Italy during the fifteenth century greatly inspired artists. Antique statues – mostly **Hellenistic** examples or Roman copies – awoke in them a sense of the beauty of the human body and its expressive potential. In the early sixteenth century, northern European artists began travelling to Italy to draw after the antique. Classical statues continued to supply models for imitation well into the nineteenth century.

Attribute In the visual arts figures are often identified by attributes – objects which they carry or which are associated with them, such as Hercules' club or the scales of Justice. Commonly shown with the person or **personification** it identifies, an attribute can also be used individually.

Bozzetto A sculptor's sketch, usually in wax or clay, which serves as a preliminary model for a larger work in a more durable material. The term has been appropriated for mono-chromatic oil sketches on panel sometimes produced by Rubens before he proceeded to execute *modelli*.

Calvinism A Christian religious system based on the teachings of the Frenchman John Calvin, one of the theologians of the **Protestant Reformation**. Calvin diverged from Catholic doctrine in such fundamental ways as rejecting papal authority, accepting justification by faith alone, and emphasizing the doctrine of predestination. He also forbade images in religious worship, leading to widespread **iconoclasm**. Calvinism was one of the leading forces within the Protestant Reformation in the Netherlands.

Collaboration In the visual arts, collabora-tion refers to a method of picture production practised in Antwerp in the sixteenth and seventeenth centuries. It defines co-operation between master painters who each special-ized in specific branches of painting, *eg* still lifes or animals. Such collaboration is distinct from the assistance of workshop apprentices.

Counter Reformation A reform movement within the Roman Catholic Church which evolved in response to the attacks of the **Protestant Reformation**. Unlike the Protestant aim of destroying the old Church hierarchy, the Counter Reformation aimed to remove abuses within the organization. The driving force was the Council of Trent, which convened between 1545 and 1563.

Engraving A print made from an image cut with a burin, or graver, into a metal plate, usually copper. The resulting lines are then filled with ink and these leave an impression on the paper. In the sixteenth and seven-teenth centuries, the engraver either created his own compositions, or, more commonly, transferred the designs of other artists on to the metal plate. Prints of this kind are known as reproductive prints. In Rubens' studio they were used to proliferate his designs and to protect him from plagiarism.

Habsburg Dynasty The ruling house of Austria from 1282 to 1918. Originally restricted to holdings in Central Europe, the Habsburgs rose in power through three important dynastic marriages: (1) that of Maximilian I to Mary of Burgundy in 1477, which brought the **Low Countries**; (2) that of their son, Philip I, to Joanna of Castile in 1496, which gave their elder son, Emperor Charles V, Spain and the Spanish empire; (3) that of Philip and Joanna's younger son, Ferdinand, to Anna of Hungary in 1521, which gave them Hungary and Bohemia. In a series of abdications, Charles V passed the Spanish empire, including the Netherlands, to his son Philip II, while his brother, Ferdinand I, retained Austria, Bohemia, Hungary and various German territories.

Hellenistic A term applied to Greek culture from 323 to 31 BC spanning the reigns of Alexander the Great and Augustus. During this period Greece itself had lost its political importance and new centres of art arose in the Greek kingdoms of Asia Minor and Egypt.

Hierarchy of Genres A system of ranking the various genres of subject matter in art which evolved in the Italian Renaissance. History painting was awarded the highest rank as it dealt with human actions, mainly of a heroic nature, consecrated by time. The second pictorial category was portraiture. Genre painting, which illustrated everyday human actions, had a lower status. Lowest in rank came landscape and still life since they did not concentrate on the human figure.

Humanism A mode of thought centring on human deeds or concerns. During the Renaissance it was associated with the study of Greek and Roman literature, philosophy and history.

Iconoclasts Iconoclasts were image-breakers who opposed the veneration of religious art. During the **Protestant Reformation** the name was given to groups such as the Calvinists who advocated the destruction of religious paintings, statues and sometimes entire churches.

Low Countries Region of northwest Europe comprising the Netherlands, Belgium and Luxembourg.

Modello A drawn or painted design, on a reduced scale, of a composition made for a patron for approval. Rubens' *modelli*, or oil sketches, also served as models for the final work. His *modelli* are in colour and are fairly elaborate and accurate.

Narrative Art A story – in contrast to a landscape, still life or portrait – presented in visual images, usually of human figures. Until the nineteenth century, narrative subjects were mostly taken from the Bible, Lives of the Saints, Greek, Roman and, later, European literature and history. Allegorical subjects were also depicted in narrative form.

Northern Netherlands, Northern Provinces or **United Provinces** That part of the **Low Countries** which in the religious wars of the sixteenth century gained independence from Spain. In 1555 Charles V bequeathed all the Low Countries to his son, Philip II of Spain. Philip's attempt to introduce the Inquisition and abolish self-government caused an uprising, led by William the Silent, which succeeded in expelling Spanish forces from the Protestant north. Spain kept the south, while in 1581 the Northern Provinces were established. The country was officially recognized in 1648, at the end of the **Thirty Years' War**.

Painters' Guild During the Middle Ages, painters and sculptors were regarded as artisans. They formed craftsmen's guilds with metal workers and other trades. In the course of time, artists organized their own confraternities. The training of apprentices took place in a **painter's workshop** licensed by the guild. By the late eighteenth century, guilds were replaced by specialized art schools, the academies.

Painter's Studio or **Workshop** In the Middle Ages and the Renaissance workshops or studios were normally in private dwellings. A workshop belonged to a master painter. Here he (or in rare cases she) performed his or her work and trained apprentices. The master was entitled to become a member of a guild. The term also signifies the artist and his assistants, as in a painting executed by Rubens and his studio.

Personification A human figure representing an idea or concept, *eg* Peace or Justice. Since the majority of Latin nouns signifying ideas or concepts are of the feminine gender, most personifications took female form. As many Greek and Roman gods can also symbolize abstract notions, such as Love and War, the borderline between personifications and divinities is often vague. Features in the physical world – rivers, cities or countries – may also be represented in human form. Personifications are identified by **attributes**.

Prefiguration In Christian art, a person or event from the Old Testament can be interpreted as an antecedent to a person or event from the New Testament, *eg* the Sacrifice of Isaac prefigures the Crucifixion of Christ.

Protestant Reformation A religious revolution in western Europe in the sixteenth century. Beginning as a reform movement against abuses in the Catholic Church, it turned into an attack upon the doctrines and authority of the Church. Begun in 1517 by Martin Luther when he nailed his 95 theses on the church door in Wittenberg, the Reformation quickly spread beyond Germany. The religious movement soon merged with secular issues, foremost the conflict between Church and state.

Romanists A group of Antwerp artists, including **Otto van Veen**, **Jan Brueghel the Elder** and Rubens himself, who had visited Italy to study Renaissance and **Antique** art.

Southern Netherlands, Spanish Netherlands The part of the **Low Countries** that remained in possession of the house of Austria after the secession of the **Northern Provinces**. The marriage of Mary of Burgundy to Maximilian I in 1477 brought most of the Low Countries to the **Habsburgs**. With the abdication of Charles V in 1555, the Netherlands came under the rule of the Spanish branch of the Habsburgs. In the religious wars of the sixteenth century, the mainly Protestant Northern Provinces gained independence from Spain, while the Southern Netherlands (roughly modern Belgium and Luxembourg) remained a Catholic country under Spanish rule.

Stoicism, Neo-Stoicism Philosophical tradition founded by Zeno of Citium (*c*.200 BC) and developed by his followers, the Stoics. A Christian version of Stoicism – Neo-Stoicism – was advocated by **Justus Lipsius**.

Tapestry Cartoon Tapestries are hand-woven textile wall hangings, often with figural compositions. They were popular in Europe from the Middle Ages to the eighteenth century. A cartoon is a full-sized design, usually in watercolour on paper, made for transferring a design to a tapestry. Rubens' cartoons were painted in oil on canvas.

Thirty Years' War (1618–48) A European war fought mainly in Germany. There were many issues – territorial, dynastic, religious – and alliances shifted throughout. The conflict can be understood in terms of the struggle of a number of German princes, backed by foreign powers, against the unity of the Holy Roman Empire and the house of **Habsburg**. The war ended with the Peace of Münster in 1648.

Triptych An altarpiece of three panels, usually hinged so that the outer 'wings' cover the central panel when closed. Carved triptychs took preference in the Middle Ages but were replaced by painted surfaces in the Renaissance.

Twelve Years' Truce (1609–21) The independence of the **Northern Provinces**, declared in 1581, was not accepted by Spain, resulting in continued war between the two countries. The truce was an interruption in that war, and after its expiration the conflict became part of the **Thirty Years' War**.

Brief Biographies

Albert, Archduke of Austria (1559–1621) Albert was the youngest son of Emperor Maximilian II. After an ecclesiastical career, in which he rose to the position of Archbishop of Toledo in 1594, he was appointed governor of the Netherlands by Philip II of Spain in 1596. He married the **Infanta Isabella Clara Eugenia**, daughter of Philip II, in 1598, and they ruled together as sovereign princes from their residence in Brussels. During their joint rule the **Southern Netherlands** enjoyed a period of economic prosperity and cultural revival after the turbulent decades of the late sixteenth century. In 1609 the couple appointed Rubens their court painter. The Archduchess Isabella carried on the government after Albert's death in 1621.

Jan Brueghel the Elder (1568–1625) Son of the painter Pieter Bruegel the Elder. His earliest works are variations on his father's peasant scenes and religious subjects, though rendered in a delicate miniaturist technique. In the late 1580s Jan Brueghel went to Italy where he met Cardinal Federigo Borromini, later Archbishop of Milan, who became his patron. For him he painted allegorical pictures of the *Elements* and the *Five Senses* with exquisitely executed naturalistic details. He also painted small idyllic landscapes with woodland vistas. Eventually, Brueghel became a specialist in flower pieces. He often collaborated with other artists, supplying landscape settings or flower garlands for their figure compositions.

Charles I, King of England, Scotland and Ireland (1600–49) Second son of James I, Charles ascended the throne in 1625 (his older brother Henry had died in 1612). In the same year he married Henrietta Maria, daughter of Henry IV of France and **Marie de' Medici**, a marriage which offended public opinion in England since the bride was Catholic. Strongly influenced by his father's favourite, the **Duke of Buckingham**, Charles's unpopularity was increased by the duke's many costly and fruitless foreign ventures. A bitter struggle between the king and Parliament, which was largely Puritan, ended with the dissolution of Parliament in 1629. Civil and religious liberties were much curtailed during Charles's reign, eventually leading to civil war in 1642. In 1646 Charles surrendered. He was found guilty of treason and was beheaded. Charles was an outstanding collector and patron of the arts, attracting to his court one of the greatest seventeenth-century portraitists, **Anthony van Dyck**.

Pierre Dupuy (1582–1651) French historian and royal librarian, friend and correspondent

of Rubens. The two men met in Paris during Rubens' visits to the French capital in connection with the paintings commissioned for the Luxembourg Palace by **Marie de' Medici**. Their friendship resulted from their mutual acquaintance with **Nicolas-Claude Fabri de Peiresc**.

Anthony van Dyck (1599–1641) Flemish painter of portraits and, to a lesser extent, of religious and secular subjects. Unusually gifted, Van Dyck was apprenticed to Hendrik van Balen, a minor Antwerp painter, at the early age of ten. From *c.*1616 to 1620 he worked closely with Rubens on projects executed by the Rubens studio, including the ceiling paintings for the new Jesuit church. After a brief stay in England, Van Dyck travelled to Italy where, besides visiting the most important artistic centres, he undertook many portrait commissions in Genoa. He spent five more years in Antwerp from 1627 to 1632, painting altarpieces, secular subjects and portraits, before being called to the English court of **Charles I**. During his last years he led a restless life, moving between London, Brussels, Antwerp and Paris. Van Dyck permanently transformed portrait painting, not simply by adopting an elegant and graceful style suitable to his aristocratic sitters, but also by suggesting something of their inner psychology.

Adam Elsheimer (1578–1610) German painter of small-scale religious works and poetic landscapes peopled with biblical or mythological figures, painted on copper. Born in Frankfurt, Elsheimer went to Venice in 1598 and travelled on to Rome in 1600, where he lived until his death. His delicate and painstakingly executed paintings are notable for the way in which light is used to model form and express mood. Due to the slow progress of his work, Elsheimer contracted debts which led him to be imprisoned for a time shortly before his death. His compositions, which became known to a wider audience through engravings made after them, gained him many admirers. While in Rome, Rubens befriended the German painter, whose works he greatly appreciated as artist and collector.

Don Fernando of Austria, Cardinal-Infante Ferdinand (1609–41) Younger brother of **Philip IV**. Like many younger royal sons, Ferdinand began his career in the Church. He was created cardinal in 1619 and Archbishop of Toledo a year later. His preferences, however, were for a military and political life. In 1631 it was announced that Ferdinand would go to the Netherlands to help his ageing aunt, **Archduchess Isabella**,

in the administration of government (he had been selected earlier as her successor), but he did not arrive in Brussels until 1634, a year after her death. Meanwhile, his forces had joined the imperial army at Nördlingen in Germany in one of the most devastating Protestant defeats of the **Thirty Years' War**. Rubens met the Cardinal-Infante in 1635 on the occasion of the latter's entry into Antwerp as the new governor of the **Spanish Netherlands**.

Cornelis van der Geest (1555–1638) Successful Antwerp spice merchant and an important patron and collector of the arts. He was a friend of Rubens and was instrumental in the commissioning of the painter's first important altarpiece in Antwerp, the triptych with *The Raising of the Cross*, which formerly stood in the church of St Walburga (now destroyed; the altarpiece is in Antwerp Cathedral). His art collection was one of the first in Antwerp and was the most renowned.

Balthasar Gerbier (c.1591–1667) Son of Protestant refugees from France, born in the Netherlands. In 1616 Gerbier settled in England where he worked for the **Duke of Buckingham**, **Charles I** and, after the Restoration, Charles II. By profession a painter, Gerbier's talents and background were more suitable for international diplomacy and commercial dealings. He was also an outstanding connoisseur. The form and character of two of the greatest seventeenth-century English collections, that of Charles I and Buckingham, were to a large extent influenced by his taste. Gerbier was Rubens' host during the latter's diplomatic mission to London in 1629–30. In his transactions with aristocratic collectors and contemporary artists, Gerbier was perhaps a forerunner of the modern art dealer.

Jan Caspar Gevaerts, or Gevartius (1593–1666) Classical scholar and humanist, clerk of the city of Antwerp from 1621 to 1662. Gevaerts studied at the University of Louvain. He was internationally famous for his critical edition of the Latin poet Statius, and also wrote an unpublished commentary on the work of the Stoic emperor Marcus Aurelius. He was a close friend of Rubens and provided a humanist education for the latter's eldest son, Albert. As town clerk (in the seventeenth century a position of high prestige), Gevaerts was responsible for the organization of civic festivities, including the triumphal entry into Antwerp in 1635 of **Cardinal-Infante Ferdinand**, the new governor of the **Spanish Netherlands**. The collaboration between Rubens, who designed the structures erected for the occasion, and Gevaerts, who provided the Latin inscriptions, was the most fruitful result of their friendship, commemorated in the publication in 1642 of the *Pompa Introitus Ferdinandi*.

Vincenzo I Gonzaga, Fourth Duke of Mantua (1562–1612) Duke of the northern Italian city-state of Mantua from 1587 to 1612. His second wife, Eleonora de' Medici, was the sister of **Marie de' Medici**. He envisioned for the Gonzaga dynasty a grandiose place on the world stage, participating in no less than three military expeditions against the Turks in Hungary in 1595, 1597 and 1601. Vincenzo was also an enthusiastic patron of the arts. His court painters included Rubens and **Frans Pourbus the Younger**, and he collected old masters on a vast scale and at unprecedented cost.

Gaspar de Guzman, Count-Duke of Olivares (1587–1645) Chief minister of **Philip IV** of Spain from 1621 to 1643. Olivares was a powerful force at the Spanish court and played a considerable part in involving Spain in the **Thirty Years' War**. At home he pursued a policy of centralization and heavy taxation which caused several insurrections and led to the secession of Portugal in 1640. Olivares was Rubens' prime contact during the latter's peace mission to Spain and England. He was a patron of the arts and commissioned works from **Velázquez** and Rubens, among others.

Thomas Howard, Second Earl of Arundel and Surrey, Earl Marshal of England (1585–1646) Statesman, diplomat and patron and collector of art and antiquities. Scion of one of the grandest English families, Arundel was born in obscurity after his father incurred the disfavour of Queen Elizabeth by converting to Catholicism. In 1606 Arundel married Alathea Talbot, daughter of the Earl of Shrewsbury, who encouraged his nascent interests in classics and art. Unusually for an Englishman of the time, Arundel visited Italy in 1612 and again from 1613 to 1614, to study the works of antiquity and the Renaissance. These travels led to the establishment of one of the greatest collections in England of paintings, drawings, antique sculpture and inscriptions, rivalled only by those of **Charles I** and the **Duke of Buckingham**.

Isabella, Archduchess of Austria, née **Isabella Clara Eugenia, Infanta of Spain** (1566–1633) Daughter of Philip II of Spain. In 1598 Isabella married **Albert, Archduke of Austria** and governor of the Netherlands. Following Albert's death in 1621, Isabella ruled the **Southern Netherlands** on behalf of her nephew, **Philip IV**. The Infanta established a particularly close relationship with Rubens and his duties as court painter were often expanded to include diplomatic negotiations with England and the **Northern Provinces**. On her death she was succeeded by **Cardinal-Infante Ferdinand**.

Inigo Jones (1573–1652) The greatest English architect of the late Renaissance and Georgian era; designer and painter. After studying Roman and Renaissance architecture in Italy, Jones was appointed Surveyor of the Works in 1610 by Henry, Prince of Wales. His most celebrated buildings, including the Queen's House, Greenwich, of 1616 and the Banqueting House in Whitehall of 1619–22, exemplify the new classical style he established. Though best known today as an architect, Jones was also highly influential with his theatrical designs for the court masques of James I and **Charles I**.

Jacob Jordaens (1593–1678) Prolific painter of history subjects, genre scenes and portraits; designer of tapestries. Jordaens became the leading artist in Antwerp after the death of Rubens. He was trained by **Adam van Noort**, whose daughter he later married. From 1635 to 1640, while Rubens was increasingly suffering from gout, Jordaens was called upon to work from the older master's sketches and to complete decorations originally commissioned from him, such as the Queen's House in Greenwich (now lost). Although he was greatly influenced by Rubens and continued to borrow motifs from him, his work is characterized by greater realism and a preference for the burlesque.

Justus Lipsius (1547–1606) Distinguished Latinist, philosopher and university professor. After studying at the University of Louvain, Lipsius spent two years in Italy, before taking on teaching posts at various universities in Germany and the Netherlands. This involved some elasticity in his religious beliefs, varying between Catholic at Cologne and Calvinist at Leiden in the **Northern Provinces**, where he spent eleven years. In 1590 he was reconciled to the Roman Catholic Church and settled at Louvain as professor of Latin. Here, **Philip Rubens**, **Jan Caspar Gevaerts** and **Balthasar Moretus** were among his pupils. Lipsius was especially known for his editions of the Roman philosopher Seneca and the historian Tacitus. His doctrine, which combined the Stoic philosophy of Seneca with his own Christian beliefs, was influential in his day.

Marie de' Medici (1573–1642) Daughter of Francis de' Medici, Grand Duke of Tuscany, and Joanna, Archduchess of Austria. In 1600 she married Henry IV of France, and after his murder in 1610, was queen regent until her son, Louis XIII, reached maturity. The relationship between mother and son was far from harmonious, however, and Marie was banished from Paris twice, once in 1619, and again in 1630, never to return. Instrumental in her second exile was Cardinal Richelieu, who had initially been one of her advisers. As minister to Louis XIII, he became Marie's worst enemy. From the time of her second banishment until her death in Cologne in 1642 she intrigued in vain against the cardinal. Marie was more successful as patroness of the arts. Her biggest coup was to employ Rubens as painter of two vast galleries in the new Luxembourg Palace, designed by Salomon de Brosse. The pictures in the first series, which glorify Marie's life, are one of Rubens' greatest triumphs. The second series, devoted to the reign of Henry IV, was never completed.

Balthasar Moretus (1580–1641) Printer and publisher, owner of the Plantin Press in Antwerp and Rubens' childhood friend. The relationship between publisher and artist developed into a close professional association, with Rubens providing title-pages and book illustrations for the Plantin Press. These designs, which distinguished themselves from earlier, purely decorative borders by taking account of the book's content, established a new form of book illustration in Antwerp. Among the volumes published by Moretus were **Lipsius'** Tacitus and Seneca editions, as well as his collected works, the 1637 *Opera omnia*, with a title page designed by Rubens.

Adam van Noort (1562–1641) Flemish painter of religious subjects. Though listed in the register of the Antwerp **painters' guild** as a portraitist, no portraits by him have come to light. Remembered primarily for having served as a teacher to both Rubens and **Jacob Jordaens**, Van Noort left little if any detectable stylistic influence on either of his two famous pupils, but offered them and other pupils sound training in the mechanics and craft of the painter's trade. His earliest paintings are small and display a rather flaccid, dry style. After *c*.1609/10, no doubt in response to Rubens' art after his return to Antwerp, Van Noort began to execute larger, more colourful compositions with substantial figures. The influence of Jordaens is also evident in his later works.

Nicolas-Claude Fabri de Peiresc (1580–1637) French lawyer, archaeologist, naturalist and collector. While ostensibly studying law at the University of Padua, Peiresc showed a preference for the study of antiquities. From 1599 to 1602 he travelled in Italy, visiting museums and galleries and meeting university scholars – among them Galileo. He received his legal degree in 1604 and the following year was appointed senator for Provence. He settled in Paris in 1616, but in 1623 returned to his native Aix-en-Provence where he established a remarkable collection of antiquities, exotic plants, fossils and other curiosities, following the current taste for encyclopedic collections. Although no published writings of Peiresc's are known, he conducted a voluminous correspondence with an international group of scholars – an intellectual network in which Rubens also participated. A shared passion for antiquities created a special bond between the two men.

Philip IV, King of Spain (1605–65) Philip succeeded his father Philip III to the throne in 1621, when he was sixteen. He proved a weak ruler and was completely dependent on his minister, the **Count-Duke of Olivares**. His reign was marked by the political and military decline of Spain, most prominently manifested in the loss of Portugal and the recognition of the **Northern Provinces** as an independent nation in 1648. Like **Charles I**, Philip IV was an outstanding patron of the arts. He had a deep appreciation of, and a genuine affection for, his court painter **Velázquez**. He also favoured Rubens as an artist and a diplomat.

Frans Pourbus the Younger (1569–1622) International court portraitist. The third in a dynasty of painters originating from Bruges, Pourbus started his career in Antwerp painting portraits of the local bourgeoisie. In 1594/5 he settled at the court of the regents of the **Spanish Netherlands** in Brussels,

where he developed the courtly portrait style that distinguished his work. From 1600 to 1609 he worked for **Vincenzo I Gonzaga, Duke of Mantua** together with Rubens. In 1609 he moved to Paris where he became court painter to **Marie de' Medici**, queen regent of France. Pourbus's large-scale portraits are formal and rigid; they draw attention to the status and dress of the sitters rather than their physical appearance.

Nicolaas Rockox (1560–1640) Mayor of Antwerp, antiquarian, patron and friend of Rubens. Rockox was instrumental in obtaining the artist's second important commission for a church in Antwerp: *The Descent from the Cross* triptych for the altar of the Guild of Arquebusiers in the cathedral. Other works by Rubens were painted for Rockox personally, including *Samson and Delilah*, which hung in the latter's house.

Philip Rubens (1574–1611) Rubens' older brother, classical scholar and humanist, favourite pupil of **Justus Lipsius**. After studying with Lipsius at Louvain, Philip Rubens spent several years in Italy in the service of Cardinal Ascanio Colonna. For part of this time he shared a house with his brother in Rome. In 1607 Philip returned to Antwerp, where he became city secretary, a position he held until his premature death in 1611. The two Rubens brothers were close, sharing a love of the art and literature of ancient Greece and Rome. This interest resulted in a joint book on ancient costumes and customs, the *Electorum libri II*, published by their mutual friend **Balthasar Moretus**.

Frans Snyders (1579–1657) The greatest Flemish still-life and animal painter who occasionally contributed his speciality to compositions designed by other artists, most notably Rubens, with whom he painted *Prometheus Bound*. Snyders was trained by Pieter Brueghel the Younger, son of Pieter Bruegel the Elder and brother of **Jan Brueghel the Elder**, and by Hendrik van Balen, who also taught **Van Dyck**. Before settling in Antwerp he spent some time in Italy. Under the influence of Rubens, Snyders moved from still lifes with dead animals to large-scale compositions with live animals, thus becoming the most influential painter of Baroque hunting scenes.

Otto van Veen, or **Otto Vaenius** (1556–1629) Painter of altarpieces and other religious works as well as of allegories and portraits; inventor and designer of emblem books and man of humanist learning. After training in Leiden in the **Northern Provinces** (his birth place), and in Liège in the **Southern Netherlands**, Van Veen spent some time in Italy before becoming painter to Alessandro Farnese, governor of the Spanish Netherlands, in 1587 at his court in Brussels. He later received commissions from the **Archduke Albert** and the **Archduchess Isabella**. In 1590 he was awarded the privilege of serving the court while setting up a workshop in Antwerp. Rubens was his pupil from 1594/5 to 1598 and possibly also his assistant from 1598 to 1600. His considerable influence on the young Rubens extended beyond matters of style to literary and intellectual concerns.

Diego Velázquez (1599–1660) The greatest Spanish painter and a major figure in European art. Velázquez was born and trained in Seville where he remained until 1623, when he was appointed court painter to **Philip IV**. Like all Sevillan painters, he executed religious works. More exceptional were his genre pictures, which combined low-life figures and kitchen still lifes. In Madrid, Velázquez painted mainly portraits of the royal family and entourage, including the court dwarfs and buffoons. Rubens' visit to the Spanish court from 1628 to 1629 brought the young Spaniard into contact with the great Flemish painter, who inspired him to execute narrative works and deepened his desire to go to Italy. He visited Italy on two occasions, from 1629 to 1631, and again from 1649 to 1651. Velázquez's most famous works, *The Spinners* and *Las Meninas*, stem from his last years.

George Villiers, First Duke of Buckingham (1592–1628) English statesman and Lord High Admiral. In 1614 the handsome Buckingham won the personal favour of James I, and from then on became a powerful force at the English court, a position he retained under **Charles I**. In the complex political conflicts at the beginning of the **Thirty Years' War**, Buckingham played a shifting role, siding with Protestants or Catholics as he saw fit. He received credit for preventing the marriage between the Prince of Wales, the future Charles I, and the Spanish Infanta, and promoted instead Charles's marriage to Henrietta Maria, daughter of Henry IV of France and **Marie de' Medici**. Like Charles I, Buckingham was passionate about art. He commissioned Rubens, whom he met in Paris in 1625, to paint portraits of himself and his wife and to supply a picture for the ceiling of his house in London. The duke also acquired Rubens' collection of antique sculpture. After the failure of several naval expeditions, Buckingham became increasingly unpopular. He was killed by a discontented naval officer.

Lucas Vorsterman (1596–1675) Rubens' most talented engraver. Though their collaboration lasted only a few years, Vorsterman developed his style under the master's supervision. Born and trained in the **Northern Netherlands**, Vorsterman entered Rubens' studio in 1618, where he produced title pages and reproductive prints after the master's paintings. Due to a conflict between the two men, Vorsterman left Rubens and moved to England where he worked for the **Earl of Arundel** and **Charles I**. After his return to Antwerp in 1630 he again executed prints after paintings by other artists. He was the most important collaborator in **Van Dyck**'s *Iconography*, a collection of engraved or etched portraits of persons of note.

Key Dates

Numbers in square brackets refer to illustrations

The Life and Art of Peter Paul Rubens	A Context of Events
1577 Peter Paul Rubens born 28 June in Siegen in the German province of Westphalia	
1578 Rubens family moves to Cologne	**1578** Alessandro Farnese, Prince of Parma, is appointed Governor of the Netherlands. Birth of Adam Elsheimer
	1579 The Union of Utrecht is signed by seven provinces of the Northern Netherlands, marking the foundation of the Dutch Republic. The Southern Netherlands formally recognize Philip II of Spain with the Peace of Arras. Birth of Frans Snyders
	1581 The seven Northern Provinces renounce their allegiance to Spain with the Act of Abjuration
	1583 William of Orange accepts sovereignty of the Northern Netherlands
	1584 William of Orange is assassinated. He is succeeded by his son, Maurice of Nassau
1587 Death of Jan Rubens, the artist's father	**1587** Mary Queen of Scots is executed. Birth of Gaspar de Guzman, Count-Duke of Olivares
	1588 Defeat of the Spanish Armada by the English fleet, thereby ending the superiority of Spanish seapower. Birth of Thomas Hobbes. Death of Paolo Veronese
1589 Maria Rubens returns to her native Antwerp with her children Blandina, Philip and Peter Paul. Philip and Peter Paul attend the Latin school of Rombout Verdonck	**1589** Henry III of France is assassinated. His successor, Henry of Navarre, claims the throne as Henry IV
	1590 Galileo begins his investigation into the velocity of falling bodies from the tower of Pisa. Edmund Spenser, *The Faery Queene*
1591 Apprenticeship with Tobias Verhaeght	**1591** Jusepe de Ribera and Guercino are born
1592 Apprenticeship with Adam van Noort	**1592** Rediscovery of Pompeii
	1593 Henry IV, Protestant and former leader of the Huguenots, converts to Catholicism on hearing Mass at St Denis. Birth of Jacob Jordaens. Death of Christopher Marlowe
1594-5 Moves to Otto van Veen's studio	**1594** Henry IV is crowned King of France. Birth of Nicolas Poussin. Death of Tintoretto, Gerardus Mercator and the composers Orlando di Lasso and Palestrina

	The Life and Art of Peter Paul Rubens	A Context of Events
		1596 Archduke Albert of Austria becomes Governor of the Spanish Netherlands. Birth of René Descartes
1597	*Portrait of a Man* [2], first signed and dated painting	**1597** William Shakespeare and his players found the Globe Theatre in London
1598	Becomes a master in the Antwerp Painters' Guild of St Luke	**1598** Death of Philip II. He is succeeded by his son, Philip III, who entrusts government to his minister, the Duke of Lerma. Henry IV publishes the Edict of Nantes in which Huguenots are granted freedom of worship and which temporarily ends the religious wars in France. Archduke Albert of Austria marries the Infanta Isabella Clara Eugenia, daughter of Philip II. Birth of Gian Lorenzo Bernini
		1599 Birth of the English statesman Oliver Cromwell and the painters Anthony van Dyck and Diego Velázquez
1600	Leaves for Italy on 9 May. Appointed court painter to Vincenzo Gonzaga in Mantua. Attends marriage ceremony of Marie de' Medici in Florence	**1600** Marriage of Henry IV and Marie de' Medici on 5 October. English East India Company is founded. Birth of Pedro Calderón and Claude Lorrain
1601–2	Travels to Rome where he paints his first altar-piece, commissioned by Archduke Albert, for a chapel in Santa Croce in Gerusalemme [42, 43]	**1601** Birth of the future king Louis XIII to Marie de' Medici and Henry IV. Robert Essex leads a revolt against Queen Elizabeth I and is executed. Shakespeare, *Hamlet*
		1602 Dutch East India Company is founded
1603	Travels to Spain carrying gifts from the Duke of Mantua to Philip III and the Duke of Lerma. Paints *The Duke of Lerma on Horseback* [48]	**1603** Death of Queen Elizabeth I; her successor is James I, son of Mary Queen of Scots and first king of the Stuart reign
1604	Returns to Mantua	**1604** Johannes Kepler, *Optics*. Shakespeare, *Othello* Caravaggio, *Madonna of the Rosary*
1605	Completion of three paintings for the choir of the Jesuit church of Santa Trinita in Mantua [52]	**1605** Discovery of the Gunpowder Plot to blow up the House of Lords during James I's opening of Parliament. Supported by Roman Catholics distressed by repressive laws against their religion, it prevents any attempt at Protestant–Catholic reconciliation. Miguel de Cervantes, first part of *Don Quixote*. Annibale Carracci completes ceiling frescos in the Galleria Farnese in Rome
1606–8	Returns to Rome where he remains intermittently. Shares lodgings with his brother Philip. Meets the German painter Adam Elsheimer. Receives commission for the high altar in Santa Maria in Vallicella. First version of 1607 [54] is rejected. Second version completed in 1608 [55–57]	**1606** Birth of Rembrandt van Rijn, Adrian Brouwer and Joachim von Sandrart
1608	Death of Maria Rubens, the artist's mother. Rubens returns to Antwerp	**1608** Founding of Quebec in Canada. Birth of the English poet John Milton
1609	Appointed court painter to Archdukes Albert and Isabella at Brussels, but lives in Antwerp where he sets up his workshop. Joins the Romanists. Marries Isabella Brant on 3 October. Paints *Adoration of the Magi* [61] and *The Artist and his Wife in a Honeysuckle Bower* [58]	**1609** Spain and the Northern Provinces sign the Twelve Years' Truce. Catholic League is formed in Germany in opposition to the Protestant Union. Rudolf II grants freedom of religion in Bohemia.

The Life and Art of Peter Paul Rubens	A Context of Events
	The last Moors are expelled from Spain. Tea from China is first shipped to Europe by the Dutch East India Company. Death of Annibale Carracci
1610 Begins work on *The Raising of the Cross* [65] for St Walburga. Buys a house on the Wapper, which he redesigns and extends to include a studio	**1610** Henry IV of France is assassinated. His son Louis, aged nine, is his successor with Marie de' Medici as queen regent. Galileo observes Jupiter's moons. Death of Caravaggio and Adam Elsheimer
1611 Begins work on *The Descent from the Cross* [72] for the altar of the Arquebusiers' Guild in Antwerp Cathedral. The artist's first child, Clara Serena, is born; his brother Philip dies	**1611** Publication of the King James Version of the Bible
1613 Elected dean of the Romanists	**1613** Elizabeth, daughter of James I, marries Frederick V of the Palatinate
1614 *The Descent from the Cross* triptych is completed. Paints *Shivering Venus* [107]. Helena Fourment (later Rubens' second wife) is born. Birth of Albert, the artist's first son	**1614** Marie de' Medici dissolves the States-General of France. Settlement of the Dutch colony of New Amsterdam, later renamed New York. Death of El Greco
1615–20 Jan Brueghel the Elder and Frans Snyders collaborate with Rubens. A series of hunting pictures are produced in the studio	**1615** An exchange of Bourbon and Habsburg brides takes place on the French–Spanish border: Louis XIII of France is married to Anna of Austria; Isabella of Bourbon is married to the future Spanish king, Philip IV. Salomon de Brosse begins construction of the Luxembourg Palace in Paris. Cervantes, the second part of *Don Quixote*
1616 Anthony van Dyck enters Rubens' studio as an assistant	**1616** Under pressure from the Spanish Inquisition, Galileo agrees not to teach the Copernican theory. Death of Shakespeare and Cervantes
	1617 Louis XIII exiles his mother, Marie de' Medici. John Calvin's collected works are published posthumously in Geneva. Heinrich Schütz is appointed 'Kapellmeister' at Dresden. Birth of Bartolomé Murillo in Spain
1618 Rubens' second son, Nicolas, is born. From a list of paintings offered for sale it transpires that by this date the artist has completed *Daniel in the Lions' Den* and, in collaboration with Frans Snyders, *Prometheus Bound* [94]. The *Decius Mus* tapestries are woven in Brussels	**1618** The Thirty Years' War is precipitated by the Defenestration of Prague, when the Protestants of Bohemia rebel against the Emperor by throwing his governors out of an upper-storey window in Prague Castle
1619 Receives privileges for the sale of his reproductive prints in the province of Brabant and in France	**1619** Disagreements within the Calvinist Church in the Northern Provinces leads to the acceptance of an Orthodox Calvinist creed. Frederick V, the Elector Palatine, head of the Protestant Union and son-in-law of James I, is declared King of Bohemia, the 'Winter King'. William Harvey announces his discovery of the circulation of blood. Inigo Jones begins construction of the Banqueting House, Whitehall, London
1620 Receives commission for thirty-nine ceiling canvases and three altar paintings to decorate the new Jesuit church in Antwerp [115–119, 122].	**1620** Catholic League defeats the Protestant Union at White Mountain, near Prague. Protestantism is suppressed in Bohemia. Marie de' Medici is reconciled to Louis XIII.

	The Life and Art of Peter Paul Rubens	A Context of Events
		The Pilgrim Fathers land at Plymouth, Massachusetts, in the *Mayflower*. Dutch inventor Cornelius Drebbel constructs the thermometer. Velázquez paints his *bodegones*
1621	Van Dyck leaves Rubens' studio and travels to England. Rubens receives commission from Marie de' Medici to paint the Medici Cycle for the Luxembourg Palace in Paris	1621 The Twelve Years' Truce between the Northern Provinces and Spain comes to an end. Overtures for a permanent peace are made by the Archduke Albert, governor of the Spanish Netherlands, but as terms are unacceptable to the Dutch, the war resumes. Philip IV succeeds his father, Philip III, to the Spanish throne. The Catholic League occupies the Palatinate; Frederick V and his family seek refuge in the Northern Netherlands. Archduke Albert dies, leaving the government to his wife, the Archduchess Isabella. Bernini creates *The Rape of Proserpine*
1622–5	Travels to Paris a number of times in connection with the Medici Cycle for the Luxembourg Palace [124, 126–128]. Meets Nicolas-Claude Fabri de Peiresc, with whom he had corresponded previously. Begins diplomatic activities on behalf of the Archduchess Isabella to negotiate peace in the Netherlands	1622 Richelieu is called to the Council of Louis XIII. Olivares becomes chief minister of Spain. Birth of Molière
1623	Death of the artist's daughter, Clara Serena	1623 Charles, Prince of Wales, and the Duke of Buckingham arrive in Madrid for negotiations regarding the marriage of the prince to the Infanta. Negotiations fail, provoking a breach with Spain. Velázquez becomes court painter to Philip IV. First Folio edition of Shakespeare's plays
1624	Receives patent of nobility from Philip IV. Sent on secret diplomatic missions to the Northern Provinces by the Archduchess Isabella. Visited by Prince Sigismund of Poland on 25 September	1624 England and Spain declare war. The English form an alliance with the Northern Provinces while the Dutch sign a treaty of non-aggression with France. Frans Hals paints *The Laughing Cavalier*
1625	Inauguration of the Medici gallery. Meets the Duke of Buckingham who is in Paris for the festivities in connection with the marriage-by-proxy of Charles I to Henrietta Maria, daughter of Marie de' Medici. Begins *The Assumption of the Virgin* for Antwerp Cathedral (completed 1626). Portrait of the artist in 1623, requested by Charles, then Prince of Wales, is installed in the royal collection [frontispiece and 148]	1625 Christian IV of Denmark enters the Thirty Years' War. Ambrogio Spinola takes Breda from the Dutch after a siege of eleven months. Charles I succeeds to the throne of England and Scotland after the death of his father, James I. Maurice of Nassau dies; he is succeeded by Frederik Hendrik. Death of Jan Brueghel the Elder
1626	Death of the artist's wife, Isabella Brant	1626 Death of the English statesman and philosopher Francis Bacon
1627	Travels to Rotterdam, Delft, Amsterdam and Utrecht in the Northern Provinces for secret meetings with the English agent Balthasar Gerbier. Begins work on the Eucharist series for the Descalcas Reales in Madrid	1627 Imperial forces under Tilly and Wallenstein advance to Denmark. First German opera, *Dafne* by Heinrich Schütz, is performed in Dresden
1628	Begins work on the Henry IV cycle for the Luxembourg Palace (never completed). Paints *Madonna and Saints* for St Augustine, Antwerp. Leaves for Madrid on diplomatic mission. Meets Velázquez. Paints *Equestrian Portrait of Philip IV* and portraits of the royal family. Copies paintings by Titian [142, 144]	1628 Wallenstein seizes the Duchy of Mecklenburg. Sweden joins the Thirty Years' War. Oliver Cromwell enters Parliament. The Duke of Buckingham is assassinated. Poussin paints *The Martyrdom of St Erasmus*. Birth of Jacob van Ruisdael

The Life and Art of Peter Paul Rubens	A Context of Events
1629 Leaves Madrid on 29 April for England, travelling via Paris, Brussels, Antwerp and Dunkirk to negotiate a peace treaty with Charles I between England and Spain. Receives the degree of Magister Artium from Cambridge University. Paints *Allegory of Peace* [190] for Charles I and *Thomas Howard, Earl of Arundel* [147]	**1629** With the Peace of Lübeck, Denmark withdraws from the Thirty Years' War. Charles I dissolves Parliament. Death of Otto van Veen
1630 Knighted by Charles I before leaving England in March for Antwerp. Marries Helena Fourment on 6 December. Begins work on the Ildefonso Altarpiece for the church of Sint-Jacob op de Coudenberg, Brussels	**1630** Wallenstein is dismissed; Tilly assumes command of his army. Peace treaty between England and Spain negotiated by Rubens is concluded. Marie de' Medici is banished from Paris
1631 Receives Marie de' Medici. Travels to The Hague for further peace negotiations. Paints *The Coronation of St Catherine* [195]	**1631** Tilly sacks Magdeburg, resulting in the worst massacre of the Thirty Years' War
1632 Birth of a daughter, Clara Johanna	**1632** On the death of Tilly, Wallenstein is reinstated as commander of the imperial army. Gustav Adolf of Sweden defeats Wallenstein at Lützen, but is mortally wounded. He is succeeded by his daughter, Queen Christina. Birth of John Locke, Christopher Wren, Baruch Spinoza and Johannes Vermeer. Van Dyck becomes painter to Charles I. Rembrandt paints *The Anatomy Lesson of Dr Tulp*
1633 Birth of a son, Frans	**1633** Death of the Archduchess Isabella. Galileo renounces Copernican theory in his second encounter with the Inquisition. Bernini's *Baldacchino* is completed
1634 Completes canvases for the Banqueting House, Whitehall, London [168]. Designs decorations for the triumphal entry into Antwerp of the Cardinal-Infante Ferdinand [176–179]. Around this time paints *The Garden of Love* [209]	**1634** Wallenstein is dismissed from his command and is murdered. Defeat of the Swedish–Protestant army at Nördlingen at the hands of the imperial army under Ferdinand of Hungary and the Cardinal-Infante Ferdinand. Entry of the Cardinal-Infante into Brussels
1635 The Cardinal-Infante Ferdinand visits Rubens in the days following his official entry into Antwerp. Birth of a daughter, Isabella Helena. Purchases country estate Het Steen, near Malines. Around this time paints *The Feast of Venus* [156], *The Three Graces* [157], *Helena Fourment in a Fur Wrap* [159] and several landscapes, including *Château de Steen* [199]	**1635** France declares war on Spain and sends armies against the Spanish Netherlands. The Thirty Years' War develops into a conflict of France and Sweden against the Habsburgs. Rembrandt paints *Saskia as Flora, The Abduction of Ganymede* and *The Sacrifice of Isaac*. Van Dyck paints *Charles I with his Horse and Groom* or *Roi à la chasse*
1636 Appointed court painter to the Cardinal-Infante Ferdinand in Brussels. Receives commission from Philip IV for decoration of the Torre de la Parada. Around this time paints *The Massacre of the Innocents* [194]	**1636** Establishment of the first American university, Harvard College. Rembrandt paints *The Blinding of Samson* and *Danaë*
1637 Birth of a son, Peter Paul. Receives commission for *The Crucifixion of St Peter* for St Peter's in Cologne (completed 1638)	**1637** The Dutch recapture Breda. Descartes publishes his *Discours de la méthode*. Death of the English dramatist Ben Jonson
1638 Further commissions for the Torre de la Parada. *The Horrors of War* [192] is sent to Florence	**1638** Death of Adriaen Brouwer
1639 Paints *The Judgement of Paris* [158] for Philip IV; around this time paints *Self-Portrait* [164]	**1639** Birth of Jean Racine. Poussin paints *Et in Arcadia ego*
1640 Falls seriously ill with gout; both hands paralysed. On 27 May Rubens makes his will. Dies 30 May. Funeral takes place 2 June	**1640** The English parliament reconvenes. Insurrections in Portugal lead to its secession from Spain

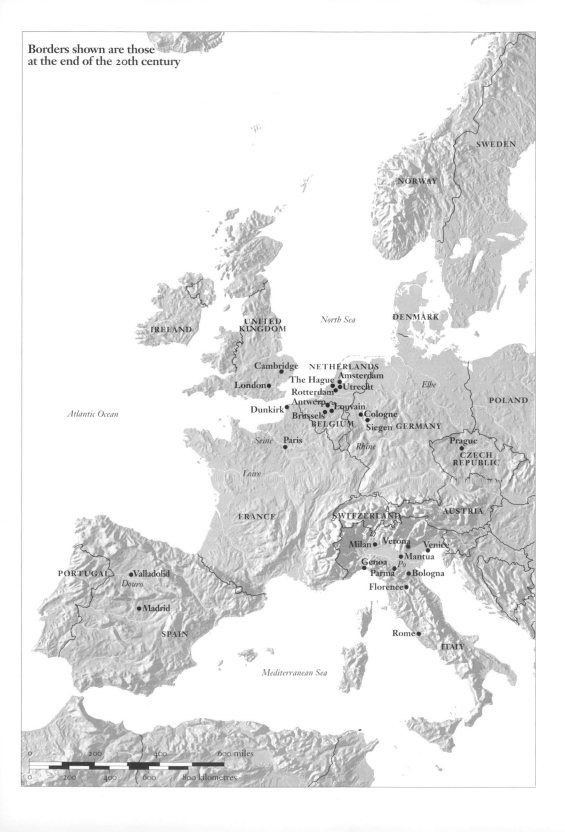

Borders shown are those
at the end of the 20th century

SWEDEN

NORWAY

North Sea

DENMARK

IRELAND

UNITED
KINGDOM

POLAND

Elbe

Cambridge

NETHERLANDS
Amsterdam

London

The Hague
Rotterdam

Utrecht

Dunkirk

Antwerp
Brussels

Louvain

Cologne

BELGIUM

Siegen

GERMANY

Prague

Seine

Paris

Rhine

CZECH
REPUBLIC

Loire

Atlantic Ocean

FRANCE

SWITZERLAND

AUSTRIA

Milan

Verona

Venice

PORTUGAL

Valladolid

Genoa

Mantua

Po

Douro

Parma

Bologna

Madrid

Florence

SPAIN

Rome

ITALY

Mediterranean Sea

0 200 400 600 miles

0 200 400 600 800 kilometres

Contemporary Sources

Caspar Gevartius, *Pompa Introitus Honori Serenissimi Principis Ferdinandi Austriaci* (Antwerp, 1642, facsimile repr. New York, 1971)

Max Rooses and Charles Ruelens (eds), *Correspondance de Rubens et documents épistolaires concernant sa vie et ses oeuvres*, 6 vols (Antwerp, 1887–1909)

W N Sainsbury (ed.), *Original Unpublished Papers Illustrative of the Life of Sir Peter Paul Rubens* (1859)

Ruth Saunders Magurn (ed.), *The Letters of Peter Paul Rubens*, trans. by Ruth Saunders Magurn (Cambridge, MA, 1955, repr. Evanston, IL, 1991)

Books and Articles on Rubens

Svetlana Alpers, *The Making of Rubens* (New Haven and London, 1995)

Frans Baudouin, *P P Rubens* (Antwerp, 1977, trans. by Elsie Callander New York, 1989)

Reinhold Baumstark, *Peter Paul Rubens: The Decius Mus Cycle* (New York, 1985)

Kristin Lohse Belkin, 'Rubens und Stimmer', in *Spätrenaissance am Oberrhein: Tobias Stimmer, 1539–1584* (exh. cat., Kunstmuseum, Basel, 1984), pp.201–22

—, 'Rubens's Latin Inscriptions on his Copies after Holbein's *Dance of Death*', *Journal of the Warburg and Courtauld Institutes*, 52 (1989), pp.245–50

—, 'The Classification of Rubens's Drawings Collection', *Wallraf-Richartz-Jahrbuch*, 55 (1994), pp.105–114

Jacob Burckhardt, *Recollections of Rubens* (Basel, 1898, trans. London, 1950)

Margaret D Carroll, 'The Erotics of Absolutism: Rubens and the Mystification of Sexual Violence', *Representations*, 25 (1989), pp.3–30

Görel Cavalli-Björkman (ed.), *Bacchanals by Titian and Rubens*. Papers given at a symposium in the Nationalmuseum, Stockholm, March 18–19, 1987 (Stockholm, 1987)

Kerry Downes, *Rubens* (London, 1980)

David Dubon, *Tapestries from the Samuel H Kress Collection at the Philadelphia Museum of Art: The History of Constantine the Great designed by Peter Paul Rubens and Pietro da Cortona* (London, 1964)

Hans Gerhard Evers, *Peter Paul Rubens* (Munich, 1942)

—, *Rubens und sein Werk: Neue Forschungen* (Brussels, 1943)

Jennifer Fletcher, *Rubens* (London, 1968)

Elise Goodman, *Rubens: The Garden of Love as 'Conversatie à la Mode'*, Oculi, Studies in the Arts of the Low Countries, 4 (Amsterdam and Philadelphia, 1992)

Mariana Hanstein, *Peter Paul Rubens' Kreuzigung Petri: Ein Bild aus der Peterskirche zu Köln* (Weimar and Vienna, 1996)

Fiona Healy, *Rubens and the Judgement of Paris: A Question of Choice*, Pictura Nova, Studies in 16th- and 17th-Century Flemish Painting and Drawing, 3 (Turnhout, 1997)

Ulrich Heinen, *Rubens zwischen Predigt und Kunst: der Hochaltar für die Walburgenkirche in Antwerpen* (Weimar, 1996)

Julius S Held, *Rubens and his Circle* (Princeton, NJ, 1982)

—, 'Thoughts on Rubens' Beginnings' in William H Wilson and Wendy McFarland (eds), *Papers Presented at the International Rubens Symposium, April 14–16, 1982, The Ringling Museum of Art Journal* (1983), pp.14–35

—, *Rubens-Studien* (Leipzig, 1987)

Frances Huemer, *Rubens and the Roman Circle: Studies of the First Decade* (New York, 1996)

Paul Huvenne, *The Rubens House, Antwerp* (Brussels, 1990)

Michael Jaffé, 'Rubens as a Collector of Drawings', *Master Drawings*, 2 (1964), pp.383–97; ibid., 3 (1965), pp.21–35; ibid., 4 (1966), pp.127–48

—, *Rubens and Italy* (Oxford, 1977)

Elizabeth McGrath, 'The Painted Decoration of Rubens's House', *Gentse Bijdragen tot de Kunstgeschiedenis*, 24 (1976–8), pp.133–46; *Journal of the Warburg and Courtauld Institutes*, 41 (1978), pp.245–77

—, 'Rubens, the Gonzaga and the "Adoration of the Trinity"' in David Chambers and Jane Martineau (eds), *Splendours of the Gonzaga* (exh. cat., Victoria and Albert Museum, London, 1981–2), pp.214–21

John Rupert Martin (ed.), *Rubens: The Antwerp Altarpieces* (New York, 1969)

—, *Rubens before 1620* (Princeton, NJ, 1972)

Ronald Forsyth Millen and Robert Erich Wolf, *Heroic Deeds and Mystic Figures: A New Reading of Rubens' Life of Maria de' Medici* (Princeton, NJ, 1989)

Jeffrey M Muller, 'Rubens's Museum of

Antique Sculpture: An Introduction', *Art Bulletin*, 59 (1977), pp.571–82

—, *Rubens: The Artist as Collector* (Princeton, NJ, 1989)

Peter Paul Rubens. Tekeningen naar Hans Holbeins Dodendans, facsimile edn with accompanying text by I Q van Regteren Altena, 2 vols (Amsterdam, 1977)

Max Rooses, *Rubens* (Philadelphia and London, 1904)

Charles Scribner III, *Peter Paul Rubens* (New York, 1989)

Otto von Simson, *Peter Paul Rubens (1577–1640): Humanist, Maler und Diplomat*, Berliner Schriften zur Kunst, 8 (Mainz, 1996)

Wolfgang Stechow, *Rubens and the Classical Tradition* (Cambridge, MA, 1968)

Jacques Thuillier and Jacques Foucart, *Le storie de Maria de' Medici al Lussemburgo* (Milan, 1967), trans. by Robert Erich Wolf as *Rubens' Life of Marie de' Medici* (New York, 1969)

Lisa Vergara, *Rubens and the Poetics of Landscape* (New Haven and London, 1982)

Martin Warnke, *Kommentare zu Rubens* (Berlin, 1965)

—, *Peter Paul Rubens: Life and Work*, trans. by Donna Pedini Simpson (Woodbury, NY, 1980)

Christopher White, *Peter Paul Rubens* (New Haven and London, 1987)

Catalogues

This section includes catalogues raisonnés and catalogues of collections and exhibitions dealing with Rubens specifically or seventeenth-century Flemish art in general.

U Bazzotti *et al.*, *Rubens e Mantova* (exh. cat., Palazzo Ducale, Mantua, 1977)

G Biavati *et al.*, *Rubens e Genova* (exh. cat., Palazzo Ducale, Genoa, 1977–8)

Didier Bodart, *Rubens e la pittura fiamminga del Seicento nelle collezioni pubbliche fiorentine* (exh. cat., Palazzo Pitti, Florence, 1977)

— (ed.), *Pietro Paolo Rubens (1577–1640)* (exh. cat., Palazzo delle Ragione, Padua; Palazzo delle Esposizioni, Rome; Società per le Belle Arti ed Esposizione Permanente, Milan, 1990)

Helen Braham, *The Princes Gate Collection* (exh. cat., Courtauld Institute Galleries, London, 1981)

—, *Rubens: Paintings, Drawings, Prints* (exh. cat., Courtauld Institute Galleries, London, 1988–9)

Christopher Brown, *Making & Meaning: Rubens's Landscapes* (exh. cat., National Gallery, London, 1996–7)

Ludwig Burchard and R-A d'Hulst, *Rubens Drawings*, 2 vols (Brussels, 1963)

Corpus Rubenianum Ludwig Burchard: An Illustrated Catalogue Raisonné of the Work of Peter Paul Rubens Based on the Material Assembled by the Late Dr Ludwig Burchard in Twenty-Six Parts (London, 1968–)

Vol. 1: John Rupert Martin, *The Ceiling Paintings for the Jesuit Church in Antwerp* (1967)

Vol. 2: Nora de Poorter, *The Eucharist Series*, trans. by P S Falla, 2 vols (1978)

Vol. 3: R-A d'Hulst and M Vandenven, *The Old Testament*, trans. by P S Falla (1989)

Vol. 7: David Freedberg, *The Life of Christ after the Passion* (1984)

Vol. 8: Hans Vlieghe, *Saints*, trans. by P S Falla, 2 vols (1972)

Vol. 9: Svetlana Alpers, *The Decoration of the Torre de la Parada* (1971)

Vol. 10: Egbert Haverkamp Begemann, *The Achilles Series* (1975)

Vol. 13: Elizabeth McGrath, *Subjects from History*, 2 vols (1997)

Vol. 16: John Rupert Martin, *The Decorations for the Pompa Introitus Ferdinandi* (1972)

Vol. 18, 1: Wolfgang Adler, *Landscapes*, trans. by P S Falla (1982)

Vol. 18, 2: Arnout Balis, *Hunting Scenes*, trans. by P S Falla (1986)

Vol. 19, 1: Frances Huemer, *Portraits Painted in Foreign Countries* (1977)

Vol. 19, 2: Hans Vlieghe, *Portraits of Identified Sitters Painted in Antwerp*, trans. by P S Falla (1987)

Vol. 21: J Richard Judson and Carl van de Velde, *Book Illustrations and Title-Pages*, 2 vols (1978)

Vol. 23: Marjon van der Meulen, *Copies after the Antique*, ed. by Arnout Balis, 3 vols (1994)

Vol. 24: Kristin Lohse Belkin, *The Costume Book* (1981)

K Demus *et al.* (eds), *Peter Paul Rubens: 1577–1640* (exh. cat., Kunsthistorisches Museum, Vienna, 1977)

Jacques Foucart *et al.* (eds), *Le siècle de Rubens dans les collections publiques françaises* (exh. cat., Grand Palais, Paris, 1977–8)

G Glück and F M Haberditzl, *Die Handzeichnungen von Peter Paul Rubens* (Berlin, 1928)

Hilliard T Goldfarb, David Freedberg and Manuela B Mena Marqués, *Titian and Rubens: Power, Politics, and Style* (exh. cat., Isabella Stewart Gardner Museum, Boston, 1998)

Julius S Held, *The Oil Sketches of Peter Paul Rubens. A Critical Catalogue*, 2 vols (Princeton, NJ, 1980)

—, *Rubens, Selected Drawings*, 2 vols (London, 1959, 2nd edn Mount Kisco, NY, 1986)

— (ed.), *Rubens and the Book. Title Pages by Peter Paul Rubens* (exh. cat., Williams College Museum of Art, Williamstown, MA, 1977)

David Jaffé, *Rubens' Self-Portrait in Focus* (exh. cat., Australian National Gallery, Canberra, 1988)

— (ed.), *Rubens and the Italian Renaissance* (exh. cat., Australian National Gallery, Canberra; National Gallery of Victoria, Melbourne, 1992)

Michael Jaffé, *Rubens: catalogo completo*, trans. by Germano Mulazzani (Milan, 1989)

Jan Kelch, *Peter Paul Rubens. Kritischer Katalog der Gemälde im Besitz der Gemäldegalerie Berlin* (exh. cat., Staatliche Museen Preussischer Kulturbesitz, Gemäldegalerie, Berlin, 1978)

Walter Liedtke, *Flemish Paintings in the Metropolitan Museum of Art*, 2 vols (New York, 1984)

Anne-Marie Logan, *Flemish Drawings in the Age of Rubens. Selected Works from American Collections* (exh. cat., Davis Museum and Cultural Center, Wellesley College, Wellesley, MA; Cleveland Museum of Art, Cleveland, OH, 1993–4)

Frits Lugt, *Musée du Louvre: Inventaire général des dessins des écoles du nord: École flamande* (Paris, 1949)

Ekkehard Mai and Hans Vlieghe (eds), *Von Bruegel bis Rubens. Das goldene Jahrhundert der flämischen Malerei* (exh. cat., Wallraf-Richartz-Museum, Cologne; Koninklijk Museum voor Schone Kunsten, Antwerp; Kunsthistorisches Museum, Vienna 1992–3)

Gregory Martin, *National Gallery Catalogues: The Flemish School* (London, 1970, repr. 1986)

Hans Mielke and Matthias Winner, *Peter Paul Rubens: Kritischer Katalog der Zeichnungen* (exh. cat., Staatliche Museen Preussischer Kulturbesitz, Kupferstichkabinett, Berlin, 1977)

Erwin Mitsch (ed.), *Die Rubenszeichnungen der Albertina* (exh. cat., Albertina, Vienna, 1977)

Toshiharu Nakamura (ed.), *Rubens and his Workshop: 'The Flight of Lot and his Family from Sodom'* (exh. cat., National Museum of Western Art, Tokyo, 1994). See esp. pp.77–127, Arnout Balis, '"Fatto da un mio discepolo": Rubens's Studio Practices Reviewed'

Rudolf Oldenbourg, *P P Rubens: Des Meisters Gemälde* (Stuttgart and Berlin, 1921)

Matías Días Padrón, *Museo del Prado: Catálogo de Pinturas, 1: Escuela Flamenca Siglo XVII*, 2 vols (Madrid, 1975)

—, *El siglo de Rubens en el Museo del Prado: catalogo razonado de pitura flamenca del siglo XVII*, 3 vols (Madrid, 1996)

P P Rubens: Paintings, Oil Sketches, Drawings (exh. cat., Koninklijk Museum voor Schone Kunsten, Antwerp, 1977)

Peter Paul Rubens, 1577–1640 (exh. cat., Wallraf-Richartz-Museum, Cologne, 1977). See esp. pp.1–11, Kurt Löcher, 'Die Familie Rubens in Köln und Siegen' and pp.13–354, Justus Müller Hofstede, 'Rubens in Italien: Gemälde, Ölskizzen, Zeichnungen'

Konrad Renger, *Altäre für Bayern* (exh. cat., Alte Pinakothek, Munich, 1990–1)

—, *Die Pranke des Löwen: Rubens-Skizzen aus St Petersburg und München* (exh. cat., Neue Pinakothek, Munich, 1997–8)

Max Rooses, *L'Oeuvre de Rubens*, 5 vols (Antwerp, 1886–92)

—, 'L'Oeuvre de Rubens: Addenda et corrigenda', *Rubens Bulletijn*, 5 (Antwerp and Brussels, 1897–1910), pp.69–102, 172–92, 279–330

John Rowlands, *Rubens Drawings and Sketches* (exh. cat., British Museum, London, 1977)

Rubenstextiel/Rubens's Textiles (exh. cat., Hessenhuis, Antwerp, 1997)

A Seilern, *Flemish Paintings and Drawings at 56 Princes Gate*, 2 vols (London, 1955); *Addenda* (London, 1969); *Corrigenda & Addenda* (London, 1971)

Arlette Sérullaz (ed.), *Rubens: ses maîtres, ses élèves. Dessins du Musée du Louvre* (exh. cat., Musée du Louvre, Paris, 1978)

Peter C Sutton, *The Age of Rubens* (exh. cat., Museum of Fine Arts, Boston; Toledo Museum of Art, Toledo, OH, 1993–4). See esp. pp.158–170, Hans Vlieghe, 'Rubens's Atelier and History Painting in Flanders: A Review of the Evidence'

M Varshavskaya, *Rubens' Paintings in the Hermitage Museum* (Leningrad, 1975)

C Whistler and J Wood (eds), *Rubens in Oxford. An Exhibition of Drawings from Christ Church and the Ashmolean Museum* (exh. cat., Christ Church Picture Gallery, Oxford, 1988)

Historical and Cultural Background

Jonathan Brown, *Kings & Connoisseurs: Collecting Art in Seventeenth-Century Europe* (Princeton, NJ, 1995)

Luc Duerloo and Werner Thomas (eds), *Albert and Isabella: A European Court in Brussels*, 2 vols (exh. cat., Musées Royaux d'art et d'histoire, Brussels, 1998)

R Dusoir *et al.* (eds), *Justus Lipsius (1547–1606) en het Plantijnse Huis* (exh. cat., Museum Plantin-Moretus, Antwerp, 1997–8)

J H Elliott, *Europe Divided, 1559–1598* (London and Glasgow, 1968)

Zirka Zaremba Filipczak, *Picturing Art in Antwerp, 1550–1700* (Princeton, NJ, 1987)

Horst Gerson and E H Ter Kuile, *Art and Architecture in Belgium, 1600 to 1800* (Harmondsworth, 1960)

T L Glen, *Rubens and the Counter Reformation* (New York and London, 1977)

M de Maeyer, *Albrecht en Isabella en de schilderkunst* (Brussels, 1955)

Mark Morford, *Stoics and Neostoics* (Princeton, NJ, 1991)

Hans Vlieghe, *Flemish Art and Architecture, 1585 to 1700* (New Haven and London, 1998)

C V Wedgwood, *The World of Rubens, 1577–1640* (Amsterdam, 1967)

Index

Numbers in **bold** refer to illustrations

Acknowledgements

Someone like me who has been a student of Rubens all my adult life must look back to the impetus that set me on this path, and to the memory of my first steps which were taken at the University of Washington in Seattle and the Warburg Institute in London. Since that time my obligation has been mostly to one man who was my inspiration and guide, Fritz Grossmann. In preparing this book I was constantly grateful to the body of scholarship on Rubens that anyone writing a general study must build upon, and especially to the editors and scholars of the *Corpus Rubenianum*, starting with Ludwig Burchard.

During the period in which the writing of this book was the biggest thing on my horizon, I was supported and encouraged by a number of close and valued friends. The first of these was Celina Imielinska, then Henry Sattler, John Conway, Renée Baigell and Getinet Belay. Above all, I know my debt to those friends who read the text and returned such valuable advice and comment: Elizabeth McGrath, Amy Golahny and Nick Belkin.

At Phaidon Press I am beholden to the professionalism of Pat Barylski, Ros Gray and Giulia Hetherington, and to Marc Jordan who commissioned this book, but especially to Michael Bird, who edited the text for Phaidon with such equanimity and good humour, who always understood my meaning and purpose, and who made hard work a pleasure.

K L B

For Paul and Anna

Photographic Credits

AKG, London: 1, 6, 8, 51, 96, 107, 108, 201; Alinari, Florence: 22; Annely Juda Fine Art, London: 214; Artothek, Peissenberg: 41, 58, 98, 106, 110, 112, 114, 151, 194; Amsterdams Historisch Museum: 210, 211; Ashmolean Museum, Oxford: 27, 88, 118; Biblioteca Ambrosiana, Milan: 26, 30, 31, 32; Bibliothèque Nationale de France, Paris: 132, 133; Bildarchiv Preussischer Kulturbesitz, Berlin: 3, 198; Bridgeman Art Library, London: 33, 77, 121, 124, 154, 200; British Museum, London: 17, 74, 95, 97, 101, 109, 131, 203, 208; Courtauld Institute of Art, University of London: 122, 153, 177, 205; Dulwich Picture Gallery, London: 119, 191; Flint Institute of Arts, Michigan: 63; Fogg Art Museum, Harvard University Art Museums: gift of Meta and Paul Sachs 85; Fotomas Index, West Wickham: 176; Photographie Giraudon, Paris: 43; Glasgow University Library, Glasgow: 79, 80, 81; Graphische Sammlung Albertina, Vienna: 92, 102, 104, 135; State Hermitage Museum, St Petersburg: 24, 75; Hispanic Society of America, New York: 138; Crown copyright, Historic Royal Palaces, Hampton Court, East Molesey: 167, 168, 169, 170, 171; House of Orange-Nassau Historic Collections Trust, The Hague: 90; Index, Florence: 192; Collection Fritz Lugt, Institut Néerlandais, Paris: 36; Isabella Stewart Gardner Museum, Boston: 147; Institut Amatller d'Art Hispanic, Barcelona: 181; Koninklijk Museum voor Schone Kunsten, Antwerp: 7, 175; Kunsthistorisches Museum, Vienna: 59, 60, 115, 156, 159, 162, 164, 207; Hessisches Landesmuseum, Mainz: 13; Leo Castelli Gallery, New York: 213; Sammlungen des Fursten von Liechtenstein, Vaduz: 105; photography by Joris Luytens, Amsterdam: 4, 5, 9, 14, 21, 113, 212; Mauritshuis, The Hague: 99; The Metropolitan Museum of Art, New York: 2, 10, 28, 187; Musée Bonnat, Bayonne: 139; Musée des Beaux-Arts, Grenoble: 54; National Gallery of Art, Washington, DC: Samuel H Kress Collection 49, Andrew W Mellon Fund 146; National Gallery, London: 111, 136, 149, 152, 190, 199, 204; National Gallery of Scotland, Edinburgh: 141; Nationalmuseum, Stockholm: 182; Osvaldo Böhm, Venice: 120; by courtesy of Otto Nauman Ltd, New York: 16; Philadelphia Museum of Art: given by the Samuel H Kress Foundation 129, purchased with the W P Wilstach Fund 94; Pierpont Morgan Library, New York: 50, 134; Plantin Moretus Museum, Antwerp: 83; Mountain High Maps, copyright © 1995 Digital Wisdom Inc: p.341; Museo del Prado, Madrid: 47, 48, 61, 143, 144, 145, 157, 158, 185, 189, 209; Queensland Art Gallery, Brisbane: 163; John and Mable Ringling Museum, Sarasota: 173; RMN, Paris: 12, 19, 23, 37, 44, 53, 84, 116, 117, 126, 127, 128, 155, 193, 206; Royal Collection, Windsor Castle © Her Majesty Queen Elisabeth II: 137, 148, 150, 165, 166; St Jacob's Church, Antwerp: 65, 71, 72; St Paul's Church, Antwerp: 64; St Peter's Church, Cologne: 196; Scala, Florence: 22, 29, 34, 52, 55, 56, 57, 68, 82, 140, 160, 161; Toledo Museum of Art, Ohio: 195; by courtesy of the Trustees of the Victoria & Albert Museum, London: 38; Visual Arts Library, London: 42, 178; Rheinisches Bildarchiv, Cologne: 46; Warburg Institute, University of London: 125, 174; Yale Center for British Art, New Haven: 172

Phaidon Press Limited
Regent's Wharf
All Saints Street
London N1 9PA

First published 1998
© 1998 Phaidon Press Limited

ISBN 0 7148 3412 2

A CIP catalogue record for this book is
available from the British Library.

Typeset in Janson Text

Printed in Singapore

Cover illustration An angel from *The Raising
of the Cross* altarpiece, 1610–11 (see p.104)

Card in front